SOLAR DANCE

# MODRIS EKSTEINS

# SOLAR DANCE

## VAN GOGH, FORGERY, AND THE ECLIPSE OF CERTAINTY

HARVARD UNIVERSITY PRESS
CAMBRIDGE, MASSACHUSETTS
2012

Printed in the United States of America

First published by Alfred A. Knopf Canada in 2012

Library of Congress Cataloging-in-Publication Data

Eksteins, Modris.
Solar dance : Van Gogh, forgery, and the eclipse of certainty / Modris Eksteins.
pages cm
Includes bibliographical references and index.
ISBN 978-0-674-06567-3 (alk. paper)
1. Germany—Intellectual life—20th century.
2. Gogh, Vincent van, 1853–1890—Public opinion.
3. Wacker, Otto, 1898–1970.   4. Authenticity (Philosophy)
I. Title.
DD239.E39   2012
943.085—dc23        2011050757

*For AS*
*and her art of being*

# CONTENTS

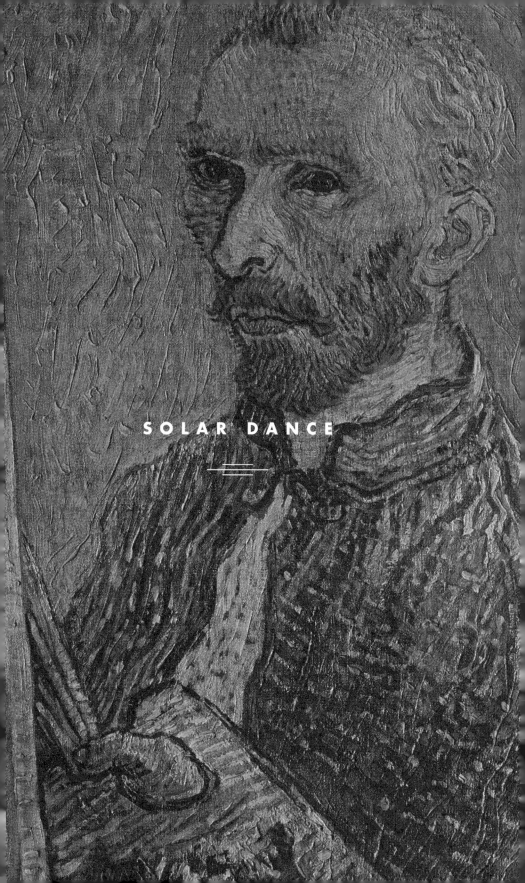
SOLAR DANCE

## THE ISSUE

*. . . my great desire is to learn to make such inaccuracies, such variations,
reworkings, alterations of the reality, that it might become, very well—
lies if you will—but—truer than the literal truth.*

VINCENT VAN GOGH

to his brother Theo, 1885[1]

Vincent van Gogh is the most popular artist of all time. Today
he is everywhere: posters of his paintings are on every other
student dormitory wall; Singapore and Shanghai banks bear his
name; his self-portrait appears on gin and vodka labels; and
Australian oilfields borrow from his renown. Yet during his own
life he was almost completely neglected. Not only was he neg-
lected, he was despised as both man and artist. How do we begin
to explain this turnaround in perception, where the former failure
has become our champion?

If every age chooses its heroes as reflections of its priorities, then
our fascination with Vincent van Gogh tells us a good deal about
ourselves. First and foremost our interest points to the remarkable
reversal that marked the past century, whereby a previous misfit
could be transformed into a victor. We know about the world wars,
the First and the Second, and their devastating violence. We pay
less attention, however, to the violence of the mind that produced,
accompanied, and followed those wars. The story of Vincent van
Gogh's posthumous success documents that turbulence, nourished
as it was by a mounting public anger against established norms and
a corresponding appeal of elemental sensation and spiritual quest.
In the end Van Gogh's greatest brilliance may have been his doubt.
That doubt now pervades our entire enterprise.

Whereas Van Gogh plunged ahead of his own time in the nine-teenth century, an age of laws and absolutes, the later era saw in him and his art the vital personification of its own regret and confusion. In his personal development, in his search for transcendence, Van Gogh turned from religion to art; our own time has followed a similar trajectory, turning art into a religion and, in the process, Van Gogh into something approximating a saint, a strangely demonic saint to be sure—what we currently call a celebrity.

It was in Germany—a Germany defeated, democratized, and demoralized after the Great War—that these tendencies first surfaced strikingly. Though the cost, human and economic, of the struggle had been staggering, the French and the British could at least say they had won the war. The Germans had lost, but they found it impossible to admit, much less confront, the idea that their superhuman effort and millions of casualties had been in vain. A process of denial and reversal set in. Defeat was turned into victory, despair into exhilaration, the critic into the enemy, and, within the difficult darkness, the ancient sun symbol that was the swastika emerged ubiquitous in sundry military and pol-itical formations. As the black icon of the Nazi Party, an upstart political movement surging in popularity by the end of the 1920s, it would become in 1933 the pre-eminent symbol of a Germany reborn as the Third Reich. Through Adolf Hitler, the Führer who had survived four years of war in the trenches, the victim returned as conqueror, the misfit as model, the artist as leader.

Simultaneously, Vincent van Gogh became, as one critic put it, the "marker" for this new age. His personality and his art merged, the one inseparable from the other. A man defamed and ridiculed during his own lifetime became for many a paragon. Prices for his art soared. Yet the meteoric success of Van Gogh in the 1920s, three decades after his death, might not have happened as dra-matically had not another manifestation of reversal transpired,

the arrival on the scene of another nobody, another "man without qualities," a dancer turned art dealer, Otto Wacker. Without formal training in anything, let alone dance and art, Wacker took Berlin by storm as a stage performer and art dealer. In the middle of the 1920s he persuaded a gullible world—a world much like our own—that he had a cache of hitherto unknown Van Gogh paintings. The new works were authenticated by the experts and snatched up by collectors and galleries in a wash of excitement. But gradually questions began to surface. Wacker was eventually put on trial for fraud and found guilty, though the source of the pictures was not and never has been determined.

Otto Wacker is in many ways a symbol of the Weimar Republic—that frenzied fourteen-year experiment in democracy that came between the end of the Great War and Hitler's assumption of power. He represented Weimar's volatility and aspirations, its energy as well as its fate. His story is worth telling because many of the issues confronting Weimar remain issues for us today as well—above all, the question of what is true and what is real. The crisis of Weimar marked in many respects the onset of our own crisis, where, as on Pinocchio's Pleasure Island, art and entertainment have blurred, where information and disinformation have become difficult to separate, where mundane reality and gleaming image often pretend to be the same.

More than ever today, Van Gogh is ours, and we are Van Gogh. And Otto Wacker is one of us.

# THE PALETTE

He wanted to see the sun-god face to face.
LOUIS PIÉRARD, *La Vie tragique de Vincent van Gogh*, 1924

Only the day after tomorrow belongs to me.
Some men are born posthumously.
FRIEDRICH NIETZSCHE, *The Anti-Christ*, 1888

Art is what you can get away with.
MARSHALL McLUHAN WITH QUENTIN FIORE,
*The Medium Is the Massage*, 1967

# VISION

## *The Dance Hall in Arles**

The face is soft and pleasant, the forehead high, the brow clean. This man in his early thirties has wavy auburn hair and a mouth, small and gentle, poised on the verge of a smile that nonetheless never comes. The eyes, too, have a tentative look—perhaps ready to dart fawnlike side to side. The hands, however, are prominent and purposeful. Hands of a pianist? A painter? Perhaps a dancer, designed to lift, suspend, and suggest? This is Otto Wacker. He is on trial in the old Moabit courthouse in central Berlin. He stands accused of knowingly selling forged art. It is April 1932.

Wacker has made a name for himself. Within a few short years he has risen from provincial obscurity to national prominence. First dancer, then art dealer, gallery owner, and publisher, he has turned heads. In March 1928 the Gallery Schulte on Unter den Linden, Berlin's famous promenade, home to libraries, embassies, a university, and the Imperial Palace, holds an exhibition of celebrity portraits from the world of film and theatre. One of those select images is of Otto Wacker.[1] There he is in full glory on a wall of achievement. He represents youth, vitality, success. With his good looks and energy he embodies the

---

* The art of Van Gogh is readily accessible in our online world, especially at the splendid site administered by David Brooks, www.vggallery.com. I do encourage the reader to visit there and to view in full colour the works mentioned at the beginning of each section of this book. For the Van Gogh paintings and drawings, I have used the numbering system established by Jacob-Baart de la Faille (F) for his Van Gogh catalogue raisonné. De la Faille will figure prominently in this story.

aspirations of that postwar generation, enveloped as it is by the odour of death—some nine million had died in the Great War and at least twice as many in the influenza epidemic that followed—and yet exuberant about life.

Suddenly, in that same year, 1928, Wacker's world implodes. He is accused of fraud, of selling forged pictures purportedly by Vincent van Gogh, an artist who lived in provincial obscurity akin to Otto Wacker's experience as a youth but who now, nearly thirty years after his death, has shot like a comet to stardom. The trajectories of artist and dealer have striking similarities. Four years later, in 1932, Wacker's case finally reaches the courts. He pleads innocence.

In the courtroom the young man is beset by a different generation, stooped and grey, bespectacled and earnest. All its members are primly attired, in legal garb or dark suits. The tone, among judges, lawyers, and witnesses, is sombre. Credibility is on the line—the integrity of experts, dealers, the art market, and even the legal system of the postwar German Republic. But beyond that, an entire world is called into question, a world of fixity, defined values, and acknowledged standards. Mired in an ever-deepening depression, the German economy is in shambles. In politics the rise of Adolf Hitler is the talk of the day. In the Moabit courtroom, legitimacy and authority are on trial, along with Otto Wacker.

That Vincent van Gogh is central to this drama is no coincidence. His life story and his art are key evidence of the mounting existential crisis that marks modernism—that spiritual journey of the Western world from a vision of moderation and progressivism to a culture of ever greater extravagance. By the early 1920s his fame is on the rise. His work, with its colour, energy, and implicit tragedy, obviously speaks to people, not just critics and collectors but the broader public. Many feel a deep kinship with this man who, in any conventional terms, was a complete failure in his life

and in his art: he sold but one painting; he hurt people deeply; he spent time in an asylum; and he committed suicide. Yet, within a few decades of his death in 1890, his story is well known and the demand for his work far exceeds the supply. At the same time, as the acceptance in some quarters verges on worship, elsewhere the denunciations multiply. For his detractors, Van Gogh represents disintegration and collapse, the very death of art, of beauty and truth. Vincent van Gogh has become a symbol of the modern condition that some see as an eruption of life, a birthing, and others regard as a hysterical move from stability to excess.

The trial of Otto Wacker lasts for the better part of two weeks. Emotions run high: reputations are at stake, worlds in conflict. The defendant could have been the subject of a Van Gogh portrait—his eyes give him the look of a naïf, a victim. He would fit alongside *Armand Roulin* (F 492), *The One-Eyed Man* (F 532), *Young Man with a Cap* (F 536), or even the iconic *Self-Portrait with Bandaged Ear* (F 527). Wacker's life itself is plausibly a modern work of art: truth and falsehood, beauty and ugliness, all in one, with categories blurring and collapsing.

If modernism and postmodernism, the two dominant cultural "isms" of the past century, have had a unifying motif, it is the quest for authenticity and the concomitant breakdown of previous distinctions. The tale of Otto Wacker and Vincent van Gogh takes us to the very heart of that quest that confronts us all. What is real? What is true?

## SKY AGLOW

*Enclosed Field with Rising Sun*

In documents of the 1930s, Otto Wacker was often listed as a *Kunstmaler*, a painter. Was he a painter? Never seriously, he

would say at one point, though he did try his hand at the occasional drawing, woodcut, and design. However, his father painted, as did his older brother and one of his sisters. Otto came from a family of artists—self-taught, self-made. He was born Heinrich Otto Theodor on August 11, 1898, in Düsseldorf to a working-class family that was artistically inclined to an unusual degree.

The father, Johann Heinrich (Hans) Wacker, made his living in a variety of pursuits. In his youth he had started off, like his own father, as a *Kunstschmied:* a metalsmith—a blacksmith—with an artistic bent, shaping metal in often intricate patterns for gates, railings, and lattices as well as decorative articles for the home. However, an accident had interrupted this budding career, and Hans turned to less physically demanding pursuits. They would include domestic service and porcelain painting, but it was for watercolours and oils that he developed a passion. Düsseldorf, in the west of Germany on the river Rhine, had a vibrant art community dating back to the 1830s, and in this encouraging atmosphere hobby turned for Hans into enterprise. In 1886, at the age of eighteen, he first visited Holland to study the works of the masters. Lured not only by the art but by the verdant landscape and smell of the sea, he would return often.

Eventually Hans Wacker displayed admirable range as an artist, with a particular knack for landscapes, seascapes, and still lifes. Although his work was insistently realistic in subject matter, his accentuated brushstrokes and use of primary colour placed him in the Impressionist camp—the newest style, an art of enthusiasm, assertion, colour, and life. Like all young artists, he did copies of the masters—Frans Hals was a favourite. His pictures, proficient enough to gain local exposure, were nonetheless designed for modest decoration and enjoyment rather than intellectual stimulation. The more prominent Düsseldorf painters Andreas Achenbach and Hubert Salentin, affiliated with the

city's renowned Kunstakademie (Art Academy), included Wacker in a show they put together locally in 1898. The Schulte agency showed his work in the same city in 1907 and then in Berlin right after the war. These moments of attention always spurred the artist to ever greater effort, but recognition remained limited.[1]

In 1892, after three years in the army, Hans married. He and his wife were to have seven children, three daughters and four sons. Otto would be the third child. Two of the children who followed him died within a year, so the family knew illness and tragedy.[2] But the artistic bent was passed to the offspring, especially to Otto's older siblings, Leonhard and Luise. Otto does not appear to have painted with any consistency, but from an early age he helped to sell his father's paintings. He hawked them in city markets and squares, as was the custom. Though modest, the income was essential for the family's survival. Art was a constant in this working-class family, and dealing in art was to become a theme in Otto's life.

Düsseldorf police records indicate that the Wackers led a peripatetic existence, presumably because of the father's unsteady employment. Between 1893 and 1898 the family moved ten times, thrice in 1894 alone. Otto's early years were spent in the Pempelfort district of Düsseldorf, a prosperous, stolid middle-class area of the city, where his father worked as a house servant. Badly destroyed during the Second World War, the area was subsequently rebuilt and still exudes this solidity. To wander its streets is to absorb a sense of decorum, order, and responsibility. The boy was a witness to bourgeois taste and achievement. These impressions of wealth and stability would remain with him, the former a requisite for the latter.

The city registration records indicate a flurry of moves in the three years before the war that was to overwhelm Europe and much of the world in 1914. Hans Wacker was obviously trying to

turn his art into profit, without much success. In October 1911 the family left Germany and moved to Haarlem in Holland, a port city resplendent in associations with Frans Hals and the golden age of Dutch art. Yet things clearly did not go well because, exactly a year later, they were back in Düsseldorf. But they did not stay; by June 1913 they were again in Holland, first in The Hague and then in Amsterdam. The constant movement points to an ever more anxious quest for a lucky break. In Amsterdam the young Otto undertook a new activity, presumably to contribute to the family's limited income: he began, around his fifteenth birthday, to dance in public performance with his sister Luise, not quite two years his elder. The venues for these performances and their nature are not provided in the sparse documentation, but the development indicates that the Wackers, though in economic need, were attuned to the temper of the age and its desire to link all the arts—painting, music, dance, theatre—the visual and the spiritual. In June 1914, however, the family's Dutch experiment ended. They returned to Germany, this time to the capital, Berlin, just before war broke out. Otto was turning sixteen as the war began that August.

For a family like the Wackers, artistic in inclination but forced to fend for itself, the appeal of Berlin was inevitable. The city was abuzz with economic and cultural excitement. Over the past decades it had grown enormously, from a provincial centre to a world capital. After the turn of the century, everyone, it seemed, was rushing to this hub of Prussian and German inventiveness. In 1914, along with the Wackers, Albert Einstein moved there to become a professor at the university, director of the Kaiser Wilhelm Institute for Physics, and a member of the Prussian Academy of Sciences—no small achievement for a Jew from Ulm, the small Swabian city on the Danube. It was as though the provinces were emptying, as though outsiders and secessionists of

every stripe were seizing the initiative in the German capital. The Viennese writer Hans von Flesch-Brünningen captured the excitement in those years just before the war: "You have to realize what Berlin meant to us back then in Vienna. It was everything to us, really. For us Berlin was crazy, debauched, metropolitan, anonymous, gargantuan, futuristic. It was literary and political and artistic (*the* city for painters). In short: an infernal cesspool and paradise in one. Together with a friend of mine I climbed the Glorietta Hill behind Vienna. It was nighttime. To the north the sky was aglow. 'That's Berlin,' I said. That was where we would have to go."[3]

Hans Wacker may have thought in similar terms and passed his anticipations to his children. It is unlikely that at this point the father, let alone the youth Otto, knew much about Vincent van Gogh. But the war and its immediate aftermath would soon link their lives inextricably.

## SUN ON SUNS

*Still Life: Vase with Twelve Sunflowers*

// . . . ("Soufres infernaux, chauds, délétères et aveuglants . . . de torrides disques solaires . . . des atmosphères lourdes, flambantes, cuisantes." After a page of blistering images—blinding sulphurs, torrid solar disks, fantastic furnaces, flaming cypresses, light and life immolating—Gustave-Albert Aurier concluded, "Such is, without exaggeration . . . the impression left upon the retina at the first sight of the strange, intense, and feverish works of Vincent van Gogh."[1] Published in January 1890, Aurier's own feverish prose was one of the first public appreciations of the Dutch artist who, at the time, was recovering in an asylum at Saint-Rémy from a series of incapacitating fits of

madness. He was known to writhe, scream, lapse in and out of consciousness, and on occasion try to drink whatever solvent he could lay his hands on—turpentine, paint, kerosene, lamp oil. Central to many of his hallucinations, Van Gogh complained, was the burning immediacy of God and faith.

Aurier, a poet, critic, and editor, had seen some of Van Gogh's work in Paris just a few weeks earlier at the home of Theo, Vincent's brother, and had prepared his appraisal for the inaugural issue of the French journal of Symbolist ideas *Le Mercure de France*.[2] The Roman god Mercury, after whom the journal was named, had served as messenger to the other gods. He was renowned for his eloquence, had wings at his feet, and was known by the poets of antiquity as the god of commerce—but also of larceny and falsehood. The first major assessment of Vincent van Gogh's art therefore appeared in a publication named after the god of eloquence, commerce, and falsehood. Flair, publicity, and even deliberate untruth were to be key attributes of the modern revolt—a revolt that Van Gogh foreshadowed.

What had Aurier seen? Presumably a fair selection of Van Gogh's recent frenzied output during some eighteen months in the south of France—"that whole series," as Paul Gauguin put it, "of suns on suns in full sunlight." Theo had placed one of his brother's sunflower paintings, done initially to welcome and impress Gauguin, over the mantelpiece in his dining room. Other items were displayed on walls here and there, but most of the canvases were simply stored around the flat. The work, composed largely in Arles and Saint-Rémy, was distinguished by its stunning use of bright colours, especially yellows, and by its stridently thick brushstrokes emitting both high emotion and pressing anxiety. As Gauguin would say later of his former housemate, "everything glowed on the canvas." Then he added, "And in his words as well."[3]

Everything glowed: he likened Van Gogh to an ember. A few years after Aurier, Louis Piérard, a politician from the Borinage, Belgium's black country of coalmines and slagheaps, would write, "Van Gogh! These two simple syllables conjure up in our minds canvases of fire, burning visions, the flaming plains of Provence, enormous suns above the fields as hallucinatory monstrances."[4] Another early commentator likened Van Gogh's work to "the Passion of the Sun."[5] The theme of fire, with its life-giving but also annihilating implication, set against an enervating void of victimhood and suffering, would be central to the Van Gogh story. The existentialist absurdist playwright Antonin Artaud would later associate Van Gogh's paintings with "atomic bombs."[6]

Born on March 30, 1853, in the village of Groot-Zundert in south Holland, near its border with Belgium, Vincent was the eldest son of a provincial Protestant clergyman, Theodorus van Gogh, and his wife, Anna Cornelia Carbentus. The father, "Dorus," who in turn was the son of a Dutch Reformed churchman, never advanced beyond ministry in a country parish, owing, it seems, to a lack of charisma and preaching ability. Although service in the church was the dominant strain in the Van Gogh family, another striking theme was art. Of Theodorus's five brothers, three became art dealers. The eldest, Hendrik Vincent, set up business first in Rotterdam and then in Brussels; Cornelius Marinus established a firm in Amsterdam; and the third, Vincent, first ran a small shop in The Hague but eventually became a partner in the larger Parisian enterprise Goupil et Cie, with its many branches in Europe. From his lavish residence in Neuilly, the smart district to the west of Paris, he would exert great influence on his nephews Vincent and Theo.

This combination of religion and art in the family history would play itself out dramatically in Vincent's life. He felt he had to choose one or the other. A dual loyalty, a synthesis of religion

and art, was suspect. Vincent, like his family, like Protestant Europe in general, was torn between the realms. Although in the end his life and work came to represent both—"There's something of Rembrandt in the Gospels or of the Gospels in Rembrandt," he wrote[7]—nonetheless the emphasis shifted. In his early life religion was his art; in later years his art became his religion. In this he was representative of a tendency in modern Western culture as a whole.

Vincent began his search for a career in the summer of 1869, when at the age of sixteen he moved to The Hague to work as a junior clerk in the Goupil firm. Four years later, in May 1873, he was sent to Goupil's London branch. There, working in Covent Garden, he absorbed all the airs of his adopted city—he even bought a top hat—and, living in a room south of the river in Brixton, he is said to have fallen for the daughter of his landlady. But the girl's affections belonged to another. This emotional blow seemed to turn Vincent demonstratively against the mannerisms of the establishment and the commerce of art. His faith now took precedence. One of his sisters noted in August 1876, "It is a pity he doesn't have a little more energy. He becomes dull with piety."[8]

His faith soon took him back across the North Sea and led him to enrol in the theology faculty at the University of Amsterdam. Within a year, however, he had given up these studies as too difficult and stuffy. One of his teachers described him as "fanatically devout" and uncomprehending as to why ancient Greek might be necessary for his planned ministry to the poor. Vincent's father, who had invested material resources in his son's education, was worried: "We sit and wait, and it is like the calm before the storm."[9] When the young man abruptly abandoned the course of study, his father was deeply disappointed.

For Vincent, one social and academic defeat now followed another. His evangelical bent took him to a mission school at

Laken in Belgium, just to the north of Brussels, but after initial training, he withdrew. He was nonetheless assigned a post in late 1878 as mission preacher in the small town of Wasmes in the depressed Borinage, the vast mining district in the neighbourhood of Mons. Here he preached in a hall used for social dances as well as meetings and witnessed hardship and suffering among miners whose degradation Émile Zola would capture in his novel *Germinal.* Van Gogh's outspoken sympathy for the miners and their families—he gave them his personal possessions—disturbed local authorities, who felt that they could not ignore the interests of the mine owners, and in July 1879 he was sacked. For another year he worked on his own as an itinerant evangelist in the neighbouring village of Cuesmes. During this time, as his personal future and social ideals confronted the ramparts of authority, he began to draw. The church—his father's church—had rejected him; he needed a new outlet for his urges. The black coal heaps of the Borinage would eventually metamorphose into the fiery visions of Provence. His life would be one of extremes, and his art would serve as an outlet for his emotion.

He had no income, no prospects. After a brief stay in Brussels, he felt forced to return to Holland and to move in with his parents. Now he became completely absorbed in his art. "Every day that it does not rain, I go out in the fields," he wrote. One obsession had replaced another. But here, living in the parsonage at Nuenen, unconcerned for the first time in years about food and shelter, he experienced another disastrous romantic affair, this time involving a widowed cousin. Vincent's parents considered the relationship "untimely and indelicate." The cousin's family found Vincent's persistence "disgusting." Devastated emotionally yet again, he fled to The Hague. There, on the outskirts of town, he set up a small studio, and in a gesture befitting his increasingly tempestuous relationship with respectable society, he took up

with a pregnant prostitute. His commitment to art coincided with intense turmoil and a withdrawal from the conventional society in which he had been raised. Friends and relatives in The Hague abandoned him. Vincent refused to budge. He had been standing too long, he said, against a cold, hard, whitewashed church wall.[10]

His early painting was firmly Dutch—dark, brooding, socially aware. He painted weavers and labourers. Colours and emotions overlapped. But mayhem accompanied him everywhere. Another miserable liaison, this time with an older woman, ended in scandal and reverberating recrimination. She attempted suicide. In March 1885 his father, with whom he had feuded often, died. Vincent's letters display little evidence of grief. Estranged from his family, he left Holland once more, travelling first to Antwerp and then Paris.

Theo, Vincent's brother four years his junior, had meanwhile followed his uncles' urgings and joined the Goupil firm in Paris, where he had been promoted several times and become a specialist in contemporary Impressionist painting. His contacts were extensive. In the gallery he ran at 19, boulevard Montmartre, he showed Monet, Sisley, Pissarro, Degas, and Seurat.[11] In March 1886 Vincent arrived, unannounced. He would stay for two years. His view of art would be transformed. That first summer after his brother's arrival, Theo wrote to their mother, "He is much more cheerful than in the past and people like him here. To give you proof: hardly a day passes without his being asked to come to the studios of well known painters, or they come to see him."[12] Vincent met Louis Anquetin, Henri de Toulouse-Lautrec, Camille Pissarro, Émile Bernard, Paul Gauguin, Paul Signac, and Georges Seurat. The colour and light of Impressionist and Post-Impressionist painting and the carnivalesque action captured made him giddy. His own palette brightened and lightened, and

his sombre social realism gave way to an art of temperament as opposed to dreary ideology. "I have faith in colour," he wrote to a friend. "The public," he added presciently, "will pay for it in the longer run."[13]

While Paris was endlessly inspiring and exhilarating, it was also, in its urban intimacy, crushing. When he tried to paint in the street, he got into unpleasant altercations. He was irascible and argumentative; he drank and smoked too much. Theo found him a difficult flatmate: "It seems as if he were two persons," he wrote to his younger sister, "the one marvelously gifted, fine and delicate, and the other selfish and heartless. They present themselves in turns, so that one hears him talk first in one way, then in the other, and always with arguments on both sides. It is a pity that he is his own enemy, for he makes life hard not only for others but also for himself."[14]

Vincent decided to leave the big city. He felt a need to migrate to a land where he could breathe or where he could look, as he put it to his brother, at "nature under a bright sky." He was attracted to Marseille, that great vieux port on the Mediterranean, but as a provisional destination he chose Arles, a little farther inland, where the Rhône begins to split into endless tributaries in preparation for its entrance to the sea. Arles, a former outpost of the Roman Empire, with its amphitheatre and legendary Arlésiennes, would be less costly than Marseille. He had no money; he had sold no pictures; he was utterly dependent on the encouragement and optimism of his brother. He headed south, in search of paradise on the cheap.

Vincent arrived in Arles in February 1888. He expected the sun; instead it was snowing. The *Blossoming Almond Branch in a Glass* (F 392) that he painted early in March, some days after his arrival, captured the expectation, disappointment, and fragility all in one. He took to painting furiously—landscapes, portraits,

still lifes. "It's the only time I feel I am alive," he wrote to his brother, "when I am drudging away at my work." Moreover, his best landscapes, he said, were the ones he did rapidly.[15] He carried his easel and palette for miles. He worked in the wind and in the increasingly hot sun. He depicted orchards, fields, and gardens. He also painted the night. "It often seems to me that the night is more richly coloured than the day," he told his sister.[16] His colours exploded—pinks, blues, reds, greens, and above all yellows. He travelled by diligence through the Camargue, that remarkable nature preserve, to Saintes-Maries on the Mediterranean coast; he walked to Tarascon and to Montmajour. He always wore a straw hat, readily available for a few sous, which he decorated with ribbons, sometimes blue, sometimes yellow. He worked like a fanatic.

He lived first at a hotel just inside the medieval gate of the city. Then in May, convinced that he was being overcharged, he took a room nearby at the Café de la Gare. The proprietor, Joseph-Michel Ginoux, had just opened his establishment. It was to become the subject of the haunting *Night Café* (F 463): "I've tried to express the terrible human passions," Vincent wrote of that work, "with the red and the green. The room is blood-red and dull yellow, a green billiard table in the centre, 4 lemon yellow lamps with an orange and green glow. Everywhere it's a battle and an antithesis . . ." Was he describing a café or his own mind? He presented the atmosphere in the room as a "furnace."[17]

He continued to overindulge in stimulants—wine, coffee, absinthe, tobacco. After an intense day of work, he told Theo, "The only thing that comforts and distracts, in my case as in others, is to stun oneself by taking a stiff drink or smoking very heavily."[18]

He was chided by some that he was not eating properly. He would later admit that he had not looked after his health, which

was precarious when he arrived, but pointed out that "to reach the high yellow note . . . I had to key myself up a bit."[19] He sensed that colour and life, health and art were inversely connected: "The more I become dissipated, ill, a broken pitcher, the more I too become a creative artist."[20] And, while painting his famous series of sunflowers in August 1888, he remarked, "Ah, my dear pals, we crazy ones, let's anyway enjoy with our eyes."[21]

He dreamed of setting up a colony of brethren, a Studio of the South, as a model cooperative. "Two people who get along don't spend—and even three—much more than one," he told Theo. "No more on colours, either."[22] Paul Gauguin, he hoped, would come, as would the young Émile Bernard. With this monastery of "brothers" in mind, he rented a house just beyond the city's northern gate on the Place Lamartine, beside a grocer's shop. The cooperative he planned would signal a regeneration and liberation of art and life. His religious background and learning obviously influenced his vision of this brotherhood, as did his loneliness. He imagined that Theo might resign from Goupil, where he was not happy, and act as manager, dealer, and banker for the collective. He began to use the house as a studio in May. Badly dilapidated, it was painted in June. "My house here," he wrote to his youngest sister, "is painted outside in the yellow of fresh butter."[23]

In September he moved in. Gauguin agreed to join him, and with high expectations Van Gogh decorated the white interior walls with paintings of luxuriant splendour. In the room meant for his companion, he hung two sunflower paintings. They did stun Gauguin, who commented later on the "sunflowers with purple eyes . . . they bathe their stems in a yellow pot on a yellow table."[24] Vincent himself was excited by his efforts. "I'm rather attached to my decoration," he told the long-suffering brother who had to finance everything.[25]

Theo was actually hoping to become Gauguin's primary dealer. He and Vincent had been most impressed by Gauguin's work when he returned from Martinique in November 1887, and Theo had put together a Gauguin showing in his Paris gallery the following January. However, initially he had little success in selling the work. Gauguin, formerly a stockbroker and salesman himself, was desperate for funds. Shortly after his return to France, he joined Émile Bernard at Pont-Aven in Brittany. There he accumulated extensive debts and longed to return to the tropics, sure that it was in these elemental conditions that the next great art would originate. Vincent was taken by this argument, and his move to Arles was conceived as a first stage in his own journey toward the sun.

Gauguin's penury and ill health drove him south. While preparing for his friend's arrival, Vincent was excited and anxious, like a child awaiting Christmas. He staked his emotional future on their relationship. With Gauguin present, the loneliness would end, he imagined, the creativity explode, and the future tremble with promise and prosperity.

Gauguin arrived in October. The relationship with his new partner was tense from the outset. He found Van Gogh's personal habits repugnant. Vincent was messy, dirty, and unpredictable. He drank too much. Even though Van Gogh had tried valiantly to make the Yellow House welcoming as a home and a studio, Gauguin was taken aback by the slovenly condition of the residence and by his companion's constant lack of judgment.[26]

Gauguin stayed for two emotion-laden months. The men painted, and they argued. The art was furious and magnificent, the conflicts intense and debilitating. Neither had extensive formal training; both were rebels by temperament, imbued with opinion. Van Gogh liked to paint outdoors and respond directly to his senses—to what he saw, touched, and smelled. Gauguin

liked to paint from memory, indoors, in a measure of comfort, and insisted that Van Gogh try to do the same. For his *peinture de tête,* as he called it, imagination was more important than naturalism, the eye of memory more penetrating than the eye of perception. Exaggerate and invent, he said. Painting was by definition an abstraction, "as in a dream." Van Gogh resisted. The two men came from drastically different backgrounds: Van Gogh from a rural Puritanism saturated with tradition and responsibility, Gauguin from a worldly Catholicism more tolerant of whim and failing. His mother was partly Peruvian, and he had spent four years of his childhood in Lima. Vincent noted his effect on his companion, whom he had envisaged as *chef de l'atelier:* "I myself think that Gauguin has become a little disheartened by the good town of Arles, by the little yellow house where we work, and above all by me."[27] Gauguin concurred: "I am quite out of my element here in Arles. I find everything—the scenery, the people—so petty, so shabby."[28]

Gauguin announced that he would leave. He said he could not put up with Van Gogh's eccentricities. Whatever happened on that fateful evening of December 23 remains a mystery. We have only Gauguin's account, written years later. According to Gauguin, he went for a walk, alone. He was crossing a square—presumably the adjacent Place Lamartine—when he heard a familiar tread. He spun around to see Van Gogh lunging at him with an open shaving knife. Confronted, Van Gogh stopped in his tracks, then ran back to the house, where at some point later that night, obviously in a frenzy of rage and despair, he amputated part of his left ear. He proceeded to wrap it in a cloth and deliver it to Rachel, his favourite girl at a local brothel. Both Van Gogh and Gauguin had been regular visitors at the local *maisons de tolérance.*[29]

A whole range of frustrations, urges, and images could have led to the self-mutilation. Amputating an ear signals the end of

communication—very simply, the bloody end of an argument. Van Gogh, thoroughly familiar with the Scriptures, would have known that during Christ's agony in the garden of Gethsemane, at the foot of the Mount of Olives, Simon Peter, prompted by anger and loss, drew his sword and cut off the right ear of the high priest's slave, Malchus. Was Vincent acting the slave? Then, attentive to world events, he would also have been aware of Jack the Ripper's exploits in the East End of London from August to early November 1888. The Ripper not only murdered but mutilated the prostitutes he so hated. On September 30, 1888, he killed Catherine Eddowes and then hacked off one of her ears. Was Van Gogh identifying with this victim?[30]

At any rate, Rachel alerted the police, and Vincent was found at the Yellow House unconscious. The next day Gauguin, who had spent the night at an inn, summoned Theo from Paris. The brother, who had just announced his engagement to Johanna Bonger, the sister of his good friend Andries—they were to marry in April 1889—rushed south. He arrived Christmas morning to find Vincent in hospital gravely ill. He stayed the day but felt obliged to return on the night train. On the 26th, back in Paris, exhausted and exasperated, he reported, "There is little hope." Vincent's friend, the postman Joseph Roulin, had the same impression: "I think he is lost."[31] Vincent's mother, informed of the misfortune, said, "Take him, Lord." Gauguin, too, had packed up and left. He would never see Van Gogh again. Yet, in the care of a young doctor, Félix Rey, who was just beginning his career, Vincent appeared to recover. In early January the artist was released from hospital. He returned both to the Yellow House and to his painting, alone once more.

The incident of the ear was reported in the town's newspaper and became local lore. Van Gogh was a minor celebrity, or at least an oddity. Children taunted him; youths were hurtful; and mothers

feared him. Years later the librarian of Arles confessed that he had been involved in the abuse of the Dutch visitor: "I remember and I am bitterly ashamed of it now—how I threw cabbage stalks at him! What do you expect? We were young, and he was odd, going out to paint in the country, his pipe between his teeth, his big body a bit hunched, a mad look in his eye. He always looked as if he were running away, without daring to look at anyone."[32]

In January Van Gogh painted his famous *Self-Portrait with Bandaged Ear* (F 527). He looks like a wounded warrior in the Russian winter rather than an artist in the sensuous south of France. In February he had another attack replete with anguished hallucinations. The Protestant pastor Frédéric Salles reported, "For the last three days he has thought he has been poisoned and all around him sees nothing but poisoners and the poisoned."[33] His neighbours, alarmed by the antics of the mad artist, protested to local officials, and Van Gogh was interned. The Yellow House was closed. Joseph Ginoux, Van Gogh's friend, was one of thirty signatories of the petition that led to the eviction. Later biographers would make much of this persecution of Van Gogh by the community he tried to love. The association with Christ was inevitable.

In May Vincent agreed to seek help at the asylum of Saint-Paul-de-Mausole, a former convent on the outskirts of Saint-Rémy, set among flowing olive orchards adjacent to Roman ruins. There, on the other side of the limestone mountains (the Alpilles) from Arles, Dr. Théophile Peyron diagnosed "acute mania with hallucinations of sight and hearing." That was later shortened to epilepsy. Nonetheless, no definitive diagnosis has ever been made, and the speculation as to precisely what condition afflicted Vincent van Gogh continues.[34]

Most of his fellow patients in the cloister at Saint-Rémy seemed worse off than he, and Vincent was allowed to venture

forth to paint in the gardens and the surrounding orchards. By July his recovery had inspired such optimism that he was permitted to return to Arles to fetch some of his paintings. That visit triggered another attack, however, and for six weeks he was confined indoors. In November he negotiated another trip. That brought on yet another relapse, from which he was recovering when Aurier's article appeared in the *Mercure de France*. Either no one was able to connect his bouts of acute illness with the excursions to Arles or the medical staff had decided to use the visits as a test. In February he was once again granted a two-day leave. He collapsed in town and had to be brought back to the asylum, where he remained in a sorry state through April.

Despite the commotion in his emotional life and his continuing illnesses and incarceration, his output remained prodigious. All told, he produced more than four hundred works—paintings, drawings, watercolours—in the south of France. It was an extraordinary coda to a brief ten years of painting. He painted orchards, flowers, peasants, harvests—and he painted the sun, again and again.

In May of that year, 1890, he persuaded Dr. Peyron to discharge him—*guérison*, cured, reads the last medical report from the asylum, dated May 16—and to permit him to return north to the care of his brother and a Dr. Paul-Ferdinand Gachet. Gachet, who lived in the village of Auvers-sur-Oise, near Paris, had befriended many an artist, including Cézanne and Pissarro, and hoped, through his own love of art as well as his medical expertise, to have a positive effect on Vincent. Initially Van Gogh was cheerful. "There is so much well-being in the air," he exclaimed, and he was even prepared to believe that his condition was "an illness of the south."[35] Lodged at a local inn, the Auberge Ravoux, not far from the doctor's house, Vincent continued to paint with fanatical zeal. He completed seventy paintings and thirty

drawings during his ten weeks at Auvers. Much of the work now seems foreboding—fields of wheat under threatening skies; entangling forests inhabited by shadowy figures. "I made a point of trying to express sadness, extreme loneliness," he wrote.[36] But at the same time, in his own life there was promise on the horizon: he had given up the absinthe; he remained free from seizures; a nephew, Vincent Willem, the son of Theo, had been born—and he had seen the baby in Paris. Some recognition of his work had started to come. Some paintings were exhibited, in Brussels and Paris, and one had sold.

Early in July he visited Paris, and he was deeply disturbed by the situation in his brother's home: the baby had been seriously ill; Theo was considering leaving Goupil (after 1884 it was called Boussod, Valadon et Cie); and Vincent seemed depressed by the way Theo had stored his many pictures all around the apartment, wherever there was room. The sight of old friends, Toulouse-Lautrec and Aurier, also appeared to provoke him. Back in Auvers on July 27, he went out and shot himself. It was a Sunday, a day dedicated to the worship of the sun and of God. He was thirty-seven years old. His friend Émile Bernard wrote to Aurier, "He finally died on Monday evening still smoking his pipe which he refused to let go of, explaining that his suicide had been absolutely deliberate."[37] Madness or lucidity? His departure, like his art and life, defied convention.

He was buried in the village cemetery in Auvers. His coffin was covered with a white linen cloth and, as Bernard described it,

> masses of flowers, the sunflowers which he loved so much, yellow dahlias, yellow flowers everywhere. It was his favourite colour . . . a symbol of the light he dreamt in hearts as well as in paintings. . . . Outside there was a terribly hot sun. . . . Then he is lowered into the grave. Who could not have cried at that moment;

this day was so much made for him that one could not help think-
ing that it could still have made him happy.[38]

"Theodore van Gogh is broken by grief," Bernard added. Theo
died in January 1891, six months after Vincent, age thirty-three.
One doctor's diagnosis read, "chronic illness, excessive exertion,
and sorrow."[39] Theo began to have hallucinations in September;
in November he was transferred to a clinic in Utrecht. Another
brother, Cornelis, had gone to South Africa in 1889, where he
eventually enlisted in the Boer army. He committed suicide in
1900 during a high fever. All three brothers died in their thirties.
Of Vincent's three sisters, the youngest, Willemien, was interned
in an asylum at the age of thirty-five. She spent over forty years in
psychiatric wards until her death in May 1941.

Death in life, life in death; madness as art, art as madness:
Which was which? The old world wanted clear distinctions,
imperative categories. The modern world would ride rough-
shod over all classifications and categories—thesis, antithesis,
and even synthesis.

## SPRING

*Blossoming Almond Tree*

Initially no one took much notice of Vincent van Gogh's efforts
at painting. His three art-dealing uncles were never sufficiently
impressed to consider selling his work. When he moved to Paris
his circle of acquaintance widened, and within the small
independent Parisian artistic community, his name did become
known. As might be expected, his personal eccentricity both
attracted and repelled, but we know that Paul Signac, Henri de
Toulouse-Lautrec, Émile Bernard, and Paul Gauguin were

impressed by some of his paintings. Julien (Père) Tanguy, the old idealistic Communard—"this gentle man of the people," as the French art critic Théodore Duret described him—who sold brushes and colours to artists at his small shop at 14, rue Clauzel, in Montmartre, displayed a few works in a back room.[1] A sampling was put on show at two Paris restaurants, the Café du Tambourin in the spring of 1887 and the Restaurant du Chalet in the autumn. But exposure remained a problem. Word of mouth among artists was not enough. Theo kept the canvases that Vincent dispatched to him at his home, scattered about the flat, almost all of them unframed. A few special visitors such as Albert Aurier saw them, but no one else.

The major venue for exposure remained the various exhibitions. The official ones were the domain of the establishment artists, the doyens of the various schools of fine art and their grovelling pupils. These Écoles des Beaux-Arts, like other schools and universities, were funded by the state and inherently conservative. For the unorthodox and rebellious it was extremely difficult to be accepted for exhibit. This barrier led eventually to the famous salons of the "refused" and the "independent" in Paris, and to "secessionist" exhibits in Vienna, Berlin, Munich, and elsewhere. It was at the Salon des Indépendants in Paris in 1888 that Van Gogh first exhibited three works. In 1889 two more were shown, and then in 1890, ten in all. Six paintings were sent to Brussels in January 1890 to the exhibition of Les Vingt, a group of Belgian rebels. One of those works, *Red Vineyard* (F 495), painted at Arles in 1888, was sold for four hundred francs to Anna Boch, a Belgian whose artist brother Eugène had been the subject of a Van Gogh portrait. While some works were lent and never returned, a few projects done on small commission, and a fair number of canvases exchanged with other artists, *Red Vineyard* is the only painting sold formally during Van Gogh's lifetime.[2]

In the second half of the nineteenth century, as industry and business flourished and as middle-class wealth grew exponentially, art dealers and private galleries took on an increasingly important role in the dissemination of art, assuming some of the functions of the salon and the academy. A connection with a prominent dealer became a key to success, both for artists and collectors.[3] Artists who expressed new ideas were scorned by the establishment, and their only chance of making a living was through the agency of an energetic dealer. The best dealers were able to turn exhibitions into social events, drumming up publicity and interest. But the artist had to be a willing participant. Some, like the transplanted American James Whistler, were adept at handling the promotional role demanded of them. For an exhibit of his Venetian etchings at a Bond Street gallery in London in 1883, Whistler played on the yellow theme in a way that Van Gogh never would. "The quiet rooms of the Fine Art Society were seen transfigured," wrote a critic. "They appeared a symphony of yellow and white." The curtains, flowers, and even the footman's livery were yellow. Whistler, ever the dandy and shameless self-promoter, arrived wearing yellow socks, and his assistants, yellow neckties.[4] In this progressively more important game of campaigning for attention, Van Gogh remained a provincial, and his brother a player of second rank.

The problem was that Vincent both craved and despised success. Indicative was his response to his last exhibition with the Indépendants. Expressions of enthusiasm for his ten contributions multiplied. "Your paintings in the show are very successful," his brother wrote. "Monet said your pictures were the best in the whole exhibition. Many other artists have spoken to me about them." Toulouse-Lautrec challenged the Belgian painter Henri de Groux to a duel when the latter made some disparaging comment about Van Gogh's work. Gauguin wrote to Vincent to

tell him that his paintings were "the best thing in the exhibition."[5] But Vincent remained skeptical, and three months later, as if unable to deal with the indications of mounting acclaim, he ended his suffering. "In a painter's life," he wrote to his mother after Aurier's article appeared, "it is generally the case that success is the worst thing of all."[6]

Nothing much changed after Vincent's death. Theo, ill himself by this point, failed to persuade the distinguished dealer Paul Durand-Ruel to take any of his brother's work. Durand-Ruel, renowned as a promoter of the Impressionists both in Europe and America, was adamant in his refusal to exhibit Vincent. By January 1891 Theo, too, was gone. The young Albert Aurier was planning a biography of Vincent, but he also died prematurely, in 1892, at the age of twenty-seven.[7] Père Tanguy died a year later.

Johanna van Gogh-Bonger, Theo's widow, had the first commercial success with Vincent's works. At the age of twenty-nine, she took over the collection of nearly six hundred paintings and numerous drawings, transported the work to Holland, and, from her residence in the town of Bussum, some twenty-five kilometres from Amsterdam, began organizing and promoting it.[8] That was no easy task. Where was she to store all this work? How could she possibly display it, never mind drum up interest? Without the commitment of this matronly woman, whose world had fallen apart not long after her marriage and shortly after the birth of her son, Vincent Willem, the Van Gogh story would have been very different. Her own grief infused her approach to her brother-in-law's art. When she took up her diary again after Theo's death, her first entry read, "Tout n'est qu'un rêve" (Everything is a dream). In a later entry she wrote, "When this afternoon I came back by train with the child to Bussum the sky was so delightfully beautiful—every time a golden sun shooting out from behind white vapory clouds—it was as if it were Theo's

face—rejoicing in the recognition of his brother!"[9] Richard Roland-Holst, an artist himself, noted that Johanna was instrumental in shaping the early public image of Van Gogh. "Mrs van Gogh considers the best work that which is most bombastic and the most sentimental—that which makes her cry the most; she forgets that her grief makes Vincent into a god."[10]

Johanna managed to arrange shows in Amsterdam, Rotterdam, and then The Hague, where the acclaimed Symbolist Jan Toorop, whose luscious colours and exotic themes had excited imagination, organized a retrospective. The venerable realist Jozef Israëls, whom some regarded as the reincarnation of Rembrandt, was particularly struck by Van Gogh's courage: he had painted the unpaintable—the sun! Word was getting out. A show combining Van Gogh and Gauguin brought warmth to a snow-covered Copenhagen in March 1893. "There burns a fanatical fire in the works of Van Gogh," remarked the poet Johannes Jørgensen.[11] A young Johan Huizinga, who would become the greatest of Dutch historians and whose most famous work, *The Waning of the Middle Ages,* has a distinctly painterly style, helped fellow students organize a Van Gogh exhibition in his hometown of Groningen in 1896. At the opening of that show, the critic and editor August Vermeylen gave a speech that received notice in the Dutch press. Van Gogh captured, he said, the disharmony of his age, a disquiet that science intensified but could not resolve. "He is considered a degenerate ... but degenerates like Van Gogh are the leaders of mankind, they are the ones who prepare the future."[12] Still, despite the growing attention and perspicacity of the critics, few of the paintings sold.

In Paris it was about the middle of the decade, not long after the death of Tanguy, that the young Ambroise Vollard, with his narrow little gallery in the rue Laffitte, began to take an interest in Van Gogh's art and to assemble as much as he could—from

Émile Bernard, the Roulin family in Arles, and the proprietor of the Café de la Gare, Joseph Ginoux. Vollard had come to Paris from the Île de la Réunion in the Indian Ocean to study law, but, frequenting the bookstalls along the Seine, he had fallen in love with painting. Though his display space was tiny, he was just down the street from the big boys, the dealers Durand-Ruel and Bernheim-Jeune. This outsider, by birth and temperament, had an extraordinary eye for the moderns and would make a personal fortune selling Cézanne, Matisse, Picasso, and Rouault, as well as Gauguin and Van Gogh. In 1896, propelled by esteem and success, he moved to larger quarters in the same rue Laffitte.[13]

Then others began to pay attention: Lucien Moline of the Galerie Laffitte bought seven Van Goghs, and the critic and dealer Julien Leclercq organized a travelling exhibition to Scandinavia and Berlin that included five Van Goghs. Selections of Vincent's correspondence with his brother were published in the *Mercure de France* and in a Flemish journal.

In 1901 one of the big players finally joined the mounting appreciation. The Bernheim-Jeune gallery at 8, rue Laffitte, put on a show of seventy-one works by Van Gogh. Alexandre Bernheim and his sons, Josse and Gaston, were crucial agents of the modern in Paris. Alexandre had befriended Delacroix, Corot, and Courbet; his sons would promote Bonnard, Vuillard, Cézanne, Seurat, Matisse, Dufy, Modigliani, Vlaminck, and Utrillo, among others. The critic Octave Mirbeau wrote a glowing review of the exhibit for *Le Figaro*. "His was a restless, tormented mind," he said of Van Gogh, "full of inspired ideas, vague and ardent, drawn perpetually toward the summits where mysteries of human life reveal themselves. One never knew what force was active inside him—whether it was the apostle or the artist." Mirbeau, like Van Gogh, revelled in antitheses and melodrama. He would write a story, "Le Jardin des supplices," reminiscent of

Baudelaire's "flowers of evil," in which the blood and excrement of a torture chamber combine to produce the most glorious floral array. This relationship between agony and ecstasy had fascinated the romantics; the symbiosis of pain and pleasure would achieve a new level of intensity in the culture of decadence promoted at the turn of the century by Joris-Karl Huysmans, Edward Burne-Jones, and Oscar Wilde, and flourish even more in the 1920s after the Great War.

Major exhibitions followed in The Hague and Amsterdam. The latter, in 1905 at the Stedelijk Museum, the imposing city gallery not far from the Rijksmuseum, was the largest retrospective yet, with 474 works on view. Dealers and collectors from all parts of Europe came to look. Then in 1911 Vollard published the correspondence between Émile Bernard and Van Gogh, and in 1914 Johanna van Gogh, who had remarried in 1901 and was now Johanna Cohen-Gosschalk,* brought out a three-volume edition of Vincent's letters to Theo, in Dutch and German versions. The ripple was turning into a wave.

## DEALER

*Portrait of the Art Dealer Alexander Reid*

*II* |t is in Germany that Van Gogh was most appreciated," Théodore Duret would write in 1916.[1] This was an astonishing and courageous statement for a prominent French dealer to make in the midst of a war against Germany. But Duret was right. Present in Paris for an art sale in December 1912, Alfred Lichtwark, the director of the Hamburg Museum, noted German-speakers all around. It was the Germans, he said, who had pushed up the

---

* For reasons of convenience, let us continue to refer to her as Johanna van Gogh.

prices of French pictures.[2] By 1914 Germany did indeed represent the most important market both for French Impressionism and Vincent van Gogh. Many in old Europe now regarded this new state, unified but a generation earlier in 1871, as a threat to the balance of power and to stability in general. Germany was the rambunctious rebel in the international order. Correspondingly, Germans proved to be more receptive to new developments in technology and the arts than their neighbours.

If any one man could be singled out for his role in this development, it was Paul Cassirer, a remarkable member of an extraordinary family. Cassirer was more than the art dealer his business card announced. He was a vortex of energy at the centre of the modern impulse in Germany at the turn of the century. The Jewish Cassirers stemmed from Breslau (now Wrocław in Poland), in Prussia's Silesian hinterland. Two of Paul's brothers, Hugo and Alfred, were industrial entrepreneurs; another, Richard, was a renowned medical doctor specializing in nervous disorders. Cousin Bruno was a publisher, and cousin Ernst a philosopher. Paul was drawn to the arts, especially painting. A stocky man with a round face, he was hardly attractive physically, yet, bursting with ideas and ambition, he radiated enthusiasm. He had studied art history in Munich, been an editor with the satirical journal *Simplicissimus,* and written a few short stories and part of a novel before he set up shop with his cousin Bruno as an art dealer in Berlin. In 1898 they opened a small but elegant gallery on Berlin's Viktoriastrasse, not far from the bustling Potsdamer Platz. They were but two more examples of Berlin's growing magnetism.

Paul Cassirer became without question the most important dealer and promoter of modern French art in Germany. As secretary and, later, president of the Berlin Secession, an art association founded in 1898 as an alternative to traditional art societies and patronage policies, he was a linchpin in the modern

movement as a whole, even though not all its manifestations were to his liking. Although he was pernickety about the Dresden and Munich Expressionists, who in his judgment lacked control, he promoted certain contemporary German artists, including Max Liebermann. His real love, however, was French Impressionism. His friend in the early Berlin days, the writer Julius Meier-Graefe, would claim that it was Cassirer and Germany who were responsible for the "universal victory" of French Impressionism.[3] In 1901, in the gallery in the Viktoriastrasse, in rooms designed by architect Henry van de Velde, that whirling Belgian dervish, Cassirer organized the first German exhibit of Van Gogh.

Nineteen of Vincent's pictures were displayed, in rooms where, as Van de Velde insisted, the art should never be bunched or cluttered. The reaction to that first show was, inevitably, mixed. The established painter Lovis Corinth remembered "ironic laughter and shoulder-shrugging." The critic Hans Rosenhagen, however, saw a "highly original talent" who managed to combine the subtlety of the French Impressionists with the "brute force of the Norwegians." Van Gogh was Claude Monet and Edvard Munch in one, concluded Rosenhagen. He was, in short, both celebration and scream. The author and librettist Hugo von Hofmannsthal, who would collaborate with the composer Richard Strauss on a number of lavish productions, came for a look and said later that he felt as though he had been "struck by lightning." In a story published in 1907, Hofmannsthal depicted a German who, on returning to his homeland, was revolted by the materialism and banality of his compatriots. He visited by chance an exhibition of paintings, lush with colour and implication, and through them discovered meaning in an "inward life," thus overcoming his alienation and malaise. Colour, Hofmannsthal suggested, is more powerful in the end than musical tone. The visual is primary. He, too, picked up on the theme of the sun, as life-giver and -taker.

"For me music, compared to this art, is like the pleasant life of the moon set beside the terrifying life of the sun," he wrote.[4] Thanks to Cassirer, Van Gogh was now a conversation piece in Berlin. That conversation would intensify steadily. Cassirer's own larger-than-life personality would correspond to the art and artists he promoted.

How did Cassirer chance upon Van Gogh? It may have been through his friend Van de Velde, whose network of contacts was endless; or through his connection with Bernheim-Jeune in Paris; or the Berlin artist Walter Leistikow, who had seen some of Van Gogh's work in Copenhagen. At any rate, Cassirer sought out and won the confidence of Johanna van Gogh and, henceforth, became the most zealous promoter of Van Gogh in Germany. Between 1902 and 1911 Johanna sold at least fifty-five works to Cassirer, for a total of 51,000 guilders (approximately $20,000 then or, based on the consumer price index, $450,000 today).[5] Given that the demand for modern art everywhere was still limited, these sales represented a stunning achievement.

In the spring of 1905 Cassirer put on another Van Gogh exhibition, this time with twenty-three works. That autumn, after the summer's much discussed Van Gogh retrospective at the Stedelijk in Amsterdam, Cassirer was able to display another thirty-four Van Gogh works and send them on tour through Germany until the following spring. In 1906 Bruno Cassirer published a selection of Van Gogh's letters, edited by Margarete Mauthner, who herself would later acquire a number of Van Goghs. In 1908, and again in 1910, in October and November, Paul Cassirer showed more Van Goghs at his gallery. By then some distinguished names in the German art world had joined the earlier celebrants, including Karl Ernst Osthaus of the Folkwang Museum in Hagen, and Alfred Flechtheim, son of a Rhenish grain merchant, who at the urging of Cassirer would become the leading

promoter of modern German art.[6] In June 1914 Paul Cassirer hosted yet another Van Gogh exhibition. Coming in that beautiful summer just before the storms of war overwhelmed Europe, the show would be remembered as an expression of both Wilhelmine Germany's cultural vitality and of the anxiety to come. That same duality seemed to govern Paul Cassirer's entire being. His life would be as full of passion and adventure as Van Gogh's, yet reflective of the broader German trajectory, with its dynamism and its tragedy.

An essential part of Cassirer's entrepreneurial life was his marriage, his second, to the celebrated actress Tilla Durieux. As the stormy relationship with the always theatrical but enormously intelligent Durieux would suggest—the novelist Heinrich Mann once described her as "the most perfect representative of the modern"[7]—Cassirer seemed to crave excitement and conflict. When she met Cassirer, Durieux was the wife of Eugen Spiro, an amiable young painter and graphic artist who had offered her friendship and rescued her from the clutches of provincial boredom and parental restriction. Tilla's father, a respected professor of chemistry in Vienna, and her musical mother had wanted their daughter to become a pianist; Tilla, like so many young girls at the time, wanted to be a dancer. When, instead, she turned to the stage and acting, the parents were mortified. In nineteenth-century bourgeois parlance, actress was simply a synonym for prostitute. Durieux and Spiro had become friends in that same city of Breslau where the Cassirers were so prominent. In 1902 she had accepted a contract to work there in the theatre. Spiro, however, was a genuine Breslauer: his Jewish parents had emigrated from Novgorod, and his father was a cantor at the synagogue. He had studied at the Breslau Art School and then with Franz von Stuck at the Munich Academy, before returning home to open a studio.[8]

The Spiro-Durieux friendship blossomed in Breslau, but in the following year, 1903, the couple moved to Berlin. Durieux was engaged by the energetic director Max Reinhardt, and Spiro decided, like so many other artists from the provinces, to try to make his way in the thriving capital city. The twenty-three-year-old Durieux quickly made a name for herself. When Reinhardt's leading lady, Gertrud Eysoldt, fell ill after two performances of Oscar Wilde's *Salomé*, Durieux stepped in. As the lascivious temptress who demanded the head of John the Baptist when he would not satisfy her lust, she was a sensation.

In 1904 the couple married. However, the match was to last but a short time, as the ambitions of both collided. When Max Liebermann, the doyen of the Berlin Secession, sent his card to their residence, Spiro assumed it was an invitation from a fellow artist. It turned out to be a request that Durieux sit for a portrait session. Liebermann wanted her to represent Delilah of biblical fame in a painting he was planning. A little later Julius Meier-Graefe, the critic and sometime art dealer, threw a small party at his apartment on the Lützowplatz and invited the aspiring artist Spiro and his ebullient wife. He also invited his friend Paul Cassirer. Again the young pair competed for attention. Cassirer, a divorcé with two children and a notorious womanizer, much preferred the actress to the artist. Durieux in turn was smitten by the intellectual banter that crackled around her, much of it emanating from the high-strung Cassirer. She lost any sense of time and perspective, she recalled later. Her life seemed to reduce to a stream of consciousness: "Brilliant, cheerful, witty, every moment a different point of view, truth-poetry-untruth, and in the next moment possibly reality, charade-fairy-tale-thousand-and-one-nights."[9]

Cassirer was thirty-three when he met Durieux. Though no Adonis, he was, one observer has written, "a Diaghilev of elegance," a man who indulged all his senses.[10] He liked good wine,

gourmet food, excellent cigars, sparkling conversation, beautiful women, exciting art, fine furniture—in sum, *la vie en rose.* Like so many of his coterie, he had done his social and aesthetic apprenticeship in Paris, where scintillating performance was *de rigueur.* Yet he looked more like a banker than a vivacious bohemian. Ernst Barlach, an artist, sculptor, and dramatist, suggested that Cassirer was a man of multiple personalities, a brilliant gambler who was at the same time a clever manager, a driven adventurer, and an imp.[11] Emil Orlik would draw pencil sketches of Cassirer. One in particular captures the daring and successful art dealer in profile, looking distinctly mischievous, nostrils flared, eyebrow raised, one eye peering naughtily from a half-closed lid. A small cigar protrudes from teeth bared in a smile. Is the smile genuine? Was anything about Cassirer genuine except the performance? Paul Cassirer was a powerful representative of a mesmeric community of aesthetes who looked on style as the best expression of substance.

Entranced by Cassirer, Durieux left Spiro—they would divorce in 1906—and set up house with her new lover. The glamorous couple moved into a large corner apartment, airy and bright, with curved windows and numerous servants, on the Viktoriastrasse, just where it met the Margarethenstrasse. The residence overlooked the exquisite square in front of the Matthäi church.[12] An incident with a very proper manservant was to be indicative of the temper of their lives. This butler, Emil, was extremely attentive to decorum and expected the household to reflect his personal sense of order, but the venturesome couple, while appreciative of the man's concern with detail, found his obsession with propriety irritating, especially since their relationship had not been formalized legally. Nonetheless, they did not have the courage to dismiss him. And so, at a dinner party one evening, they staged a contretemps with a guest, replete with obscenities and threats

of violence. The servant found the behaviour so alarming that he resigned forthwith.[13] Here was theatre trumping life.

Eventually Durieux and Cassirer did marry, on June 24, 1910, a second union for both. "Hurry up, so we can get it over with!" Cassirer is said to have exclaimed to his bride-to-be on the morning of their wedding. No sooner was the civil ceremony over than he declared, "I'm going to the office."[14]

## AESTHETE

*Portrait of Joseph-Michel Ginoux*

A friend of Cassirer's and another of the important promoters of the modern movement in Germany was Count Harry Kessler. In a world riven by social, political, and international divisions, where influence was directly related to power, Kessler would be an intermediary, messenger, and broker. To play this role effectively he had to have both an international reach and a base in every camp. Kessler was an early admirer of Van Gogh, and the latter's growing international appeal would owe a good deal to Kessler's efforts at encouraging and publicizing the modern impulse.

At home in three countries, Germany, Britain, and France, he was the first child of the Paris-based German banker Adolf Wilhelm Kessler and the Irish baroness Alice Harriet Blosse-Lynch. Alice was born in Bombay and grew up in Paris. From the start, Harry's life was surrounded by a blend of both practical and aesthetic concerns. While his father dealt with high finance, his mother was renowned for her beauty and her accomplished mezzo-soprano voice. Kaiser Wilhelm I, the initial emperor of a united Germany, was known to be infatuated with her, and in 1879 he elevated the Kessler family to the ranks of the hereditary

nobility. The young Harry was schooled first in Paris, then at St. George's in Ascot near London, and received his secondary school diploma from the Johanneum Scholars' School in Hamburg. He kept a diary for most of his life, an effort that stands as a superb record of his social circle and his age.

An internationalist before his time, Kessler was, not surprisingly, a man in conflict throughout his life with himself as well as his social and political environment. A youthful diary entry from March 1886, when he was about to turn eighteen, includes a hint of apocalypse: "There's a good chance that we'll have a social revolution shortly. If something is not done soon for the workers, we'll wake up one morning amidst the rubble of our present social order."[1] Appreciative like any sensitive youth to the plight of the lower orders, he was at the same time a devotee of Bismarck, the "Iron Chancellor," who in 1871 had unified Germany under the aegis of Prussia, its Junker aristocracy, and their military virtues. In his later reminiscences Kessler would remark that Bismarck had created a grand Germany by making Germans small.[2] There was self-reflection in that observation. The cosmopolitan Kessler, a social celebrity, was nevertheless intensely introverted. A homosexual in a society where that label was synonymous with criminal activity, an acutely observant outsider in every world he inhabited, he felt forced to perform a high-wire act, balancing between tradition and exigency, conservatism and liberalism, the court and the garret. That involved constant compromise and self-denial, and the tension in his own existence presumably made him appreciate the vibrant ambiguities in Van Gogh's life and art. Edvard Munch painted several portraits of Kessler. In one the count emerges, in vitally elegant pose, from a bright yellow background suggestive of pleasure and excitement. Van Gogh had associated the colour yellow with love; Kandinsky, too, linked it to high emotion.

Kessler had splendid social connections across the continent. He esteemed all the arts and wished to bring them into a more fruitful union, not, like Richard Wagner, in some arrogant architectonic *Gesamtkunstwerk* but in a natural free-flowing relationship where each contributed to the next—painting, poetry, music, drama, myth. Still, he realized that art and politics were inseparable, and that diplomacy, not insistence, was essential if the relationship between artists and the controllers of the public purse was not to degenerate into the irreparable feuding that was always the danger and often the norm. To this purpose he contributed his personal wealth, social connections, and talents as manager and critic.

Always on the move, Kessler had a Berlin flat in the Köthener Strasse right next to the Potsdamer train station and just a skip from another hub, the Anhalter station. He was in Paris and London regularly. However, his home seat was the smaller city of Weimar, associated with the enlightened humanism of the eighteenth century, with Goethe and Schiller, and he hoped to make it a beacon of modern inspiration. From 1902 to 1906 he assumed directorship of the visual arts in the grand duchy of Saxe-Weimar, launching an imposing series of exhibitions, thirty all told, of Impressionism and Post-Impressionism. Germany had never seen such a flurried display of modern art, most of it foreign. The young French writer André Gide appeared in Weimar in 1903 and remarked afterward on "the colour of the desires" that his stay had evoked, a comment with sexual as well as aesthetic implications. The English stage designer Gordon Craig visited in the summer of 1904 and came away similarly entranced. In his note of thanks to Kessler, he wrote, "In England again—& quite at a loss to express in words the pleasure my visit to you has given me. I shall not soon forget the glimpse I have had of the Germany you represent. To me it all seems much like a fairy tale—perfectly

staged—beautifully acted. A whole host of artists moving in and out of the scene—the painters, the musicians—the poets, architects, sculptors . . . all delightful."[3]

Kessler played a leading role in organizing an exhibition of German art in London in 1906. His intention was to use art to improve international relations. Many, right across the political spectrum, were taken by his energy and style. Of his efforts before the Great War, Kessler would later write, "We were thinking of nothing less than turning Germany into a modern art state (*Kunstland*), and of moving it to the centre of world art."[4] The vision here was of the "aesthetic state," a society in which politics and everything else would be judged by aesthetic standards.[5]

Some considered Kessler a terrible snob. The kaiser dismissed him as a *Querkopf*, a halfwit. Julius Meier-Graefe had a good relationship with him over the years, but there were difficult moments. One of these arose in 1909, when Kessler refused to intervene on Meier-Graefe's behalf in a sticky editorial matter. Meier-Graefe was incensed: "You see, such a type is possible only here. A human being who is interested in everything, yet when an opportunity arises to do something truly useful but without éclat, he backs off. A heavenly character for a comedy entitled *The Snob*."[6] Living in a glass house himself, Meier-Graefe should have been more circumspect. But that was not his style.

Kessler's appreciation of the art of Vincent van Gogh was connected to his vision of the aesthetic state. For Van Gogh, art became an alternative to religion—the most important way of interpreting and expressing the meaning of life. For Kessler and other aesthetes, from Serge Diaghilev to Oscar Wilde and Marcel Proust, art became life. Van Gogh inhabited the same world as Kessler and these aesthetes; they were co-religionists, outsiders who nonetheless represented the pulse of their age.

Kessler's extensive private collection of modern art—Georges Seurat, Maurice Denis, Auguste Renoir—included Van Gogh's *The Plain of Auvers* (F 781) and the *Portrait of Dr. Gachet* (F 753). The latter would achieve the distinction of becoming the twentieth century's most expensive artwork.

## SCRIBBLER

*The Sower*

Of all the collectors and celebrants of Van Gogh, Julius Meier-Graefe stood apart. His milieu was the emerging world of the modern media: the inexpensive newspaper whose revenues came from advertising rather than subscriptions; the mushrooming book business; and the ever more notable accent on the visual in modern life. It was his enthusiastic publicist efforts, his journalism, and his bestselling books that helped turn Van Gogh from an acclaimed artist into a hero of the modern. Directed initially at Germans, his writing on art would reach an international audience.

Born in the Banat, a contested border region between Hungary and Romania where Germans had settled in the early eighteenth century and where conservative attitudes were considered essential to survival, Meier-Graefe rebelled early on. A tall, handsome man whose personality was given to extravagance, he had grown up in a home that had no pictures and no interest in art. His father was prominent in the iron industry, and Julius was supposed to become an engineer. Instead he got caught up in beautiful things and beautiful people; he became a collector, a dealer, and finally an art critic and a successful author. He, like Paul Cassirer and Harry Kessler, was a bon vivant, oenophile, and lover of fine art who, like so many of his generation, gravitated to

France for his sensual and aesthetic pleasures—for his Château d'Yquem wines and the Impressionist artists he so admired. Kessler remarked that his friend always seemed to be posing. In December 1894 he recorded in his diary, "Meier appeared in a coffee-brown dinner jacket with black lapels. On the way home he boasted of the ecstatic pleasure he had derived recently from dancing the cancan with Munch, Przybyszewski and Frau Prz."[1] Aside from the Norwegian artist Edvard Munch, who spent time in Berlin, the reference was to the Polish aesthete Stanislaw Przybyszewski and his stunningly beautiful wife, Dagny, who were all part of a circle of writers and artists given to heavy drinking and passionate opinion that gathered at Berlin's Zum Schwarzen Ferkel (Black Pig) tavern. Wherever Meier-Graefe went, he left an impression. Sybille Bedford, Aldous Huxley's companion, recalled him as "a man of vast presence (tall; a fine head; heavy beautiful hands), a life enhancer if ever there was one . . . at the same time oddly delicate, moody, sharp, very difficult."[2] Gabriele Tergit, a historian and journalist, found him "a bewitching conversationalist."[3] Meier-Graefe's closest associates were of similar temperament. Julius Levin, his best friend, was a medical doctor who gained more satisfaction from poetry and violin making than from his medical practice—Albert Einstein approved of Levin's violins. He gave up medicine and moved to Paris in the 1890s, where he met Meier-Graefe.[4]

At that time, Meier-Graefe was at the centre of the aesthetic excitement in both Berlin and Paris. His own move from technology and science to the arts was emblematic. He, like Kessler, thought that the arts expressed profound changes in life, social organization, and even international relations. After the Great War, he wrote that the arts had foretold the violence to come.[5] He, too, was enthusiastically involved in numerous artistic and entrepreneurial ventures, above all those that tried to blend

various forms of imaginative endeavour in a "harmony of the whole." Like Kessler and the designer William Morris, their English inspiration, he wished to bridge the realms of beauty and utility, art and function.

Over the years Meier-Graefe tried his hand at a variety of creative pursuits, including the writing of fiction and some commercial enterprises, but the literary representation of the visual remained his principal métier. He befriended the Scandinavians Edvard Munch and August Strindberg when they resided in Berlin. He was the first to write about Munch, who produced a fine portrait of him to go alongside those of Kessler. After 1895 he lived in Paris for the better part of a decade, founding the journal *Dekorative Kunst / L'Art décoratif* (Decorative Art) and running, together with Henry van de Velde, an elegant shop, the Maison moderne, at 82, rue des Petits-Champs, where he offered beautiful items for the home.* In a photograph from this period, Meier-Graefe is sitting at his desk in an office decorated in art nouveau style. His wife stands nearby as if she, too, were an essential ornament. Aesthetically the enterprise may have been a success, but commercially it was not. Meier-Graefe lost his inherited family fortune in the venture. In writing of Van Gogh's Paris years, he was writing about his own higher education as well: "It was in Paris that the upper school began, not merely as an education in art but in life."[6]

Flamboyant in character, he was a popularizer in the best sense. He is credited by many with having turned art into a matter of general concern for his compatriots. The visual arts in Germany had been subservient to the literary and musical realms for

---

* "Ameublements, décoration d'intérieurs, appareils d'éclairage, tapis et tentures, céramique, verrerie décorative et usuelle, objets de toilette, bijoux, objets d'art, tableaux et sculptures, gravures."

centuries, never more so than during the rise of the *Bürgertum*, the prosperous German middle class, to social and political power in the course of the nineteenth century. Meier-Graefe, more than anyone else, helped Germans rediscover the visual. He focused attention on the achievement of the French Impressionists and interested a whole generation in a new way of seeing. His own excitement and spontaneity he managed to transmit in a prose style bursting with metaphor and drama. He wrote books on Manet and Cézanne. In 1904 he assembled some of his articles under the title *Entwicklungsgeschichte der modernen Kunst*, a two-volume survey of modern art that would enjoy enormous success and go through many editions and translations. The Germans have a problem, he said in that study: they tend to think rather than see. But in this work Meier-Graefe managed to communicate the excitement and importance of painting and seeing. His intuitive analysis of art was an achievement "unattainable by a mere art historian," said Hugo von Hofmannsthal, the Austrian writer, because he was interested in "suprahistorical" connections.[7] According to another reviewer, every sentence in the two volumes evoked discussion. All in all, added the critic and historian Emil Schaeffer, the publication was clearly the product of a real personality, a temperament for whom art is a full-blooded experience—*ein Erlebnis*.[8]

Meier-Graefe had written about Van Gogh as early as 1900, in an article in the journal *Die Insel*,[9] but his fifteen pages on Van Gogh in his immensely readable survey history seemed to galvanize interest. "Van Gogh," he wrote there, "may aptly be called a Vulcan . . . he carried about a sun in his head and a hurricane in his heart."[10] He expanded these remarks in a short biography, the first on Van Gogh, that he brought out with the Munich publisher Piper in 1910. It was to have four editions within eight years. He pointed to Van Gogh as a critical link between the French

Impressionists and contemporary developments in art that emphasized its spiritual side. And he began to connect the life story and the art of Van Gogh to the point where the biography and the artistic accomplishment became inseparable. The art was the portrait of a soul, Meier-Graefe argued. As a fiery personality and rebel against the formalism of the establishment, Van Gogh had been and remained a threat: "His story rattles every castle."

His account of Van Gogh's life remained relatively dispassionate until he reached the Arles period. Then the prose lit up. "He did not paint pictures, he threw them out," he wrote of the artist. "It was terrible to observe the way he painted: an excess, colour squirting forth as if it were blood. He was one with the subject of his painting; he painted himself in the blazing clouds, in which a thousand suns threatened to destroy the earth, and in the trees screaming in horror to the heavens, and in the frightening solitude of his fields."

The dazzling achievement of Van Gogh was that he made madness beautiful and the untamed decorative. As a result, Van Gogh was nothing less than a hero to Meier-Graefe, who referred repeatedly to the artist's *Heldentum* (heroism). With Nietzschean flourish he concluded, "The tragedy is that we like to turn our heroes into anomalies."[11] And, in consequence, Meier-Graefe could not see Everyman connecting to Van Gogh. "It is improbable that the time will ever come when his pictures will be appreciated by the layman; it is more conceivable that pictures should cease to be produced altogether, than that Van Gogh's should become popular."[12] In view of later developments and Meier-Graefe's own role in them, this prediction was a remarkable miscalculation.

Meier-Graefe was not only a writer but a collector too. He bought and sold art, obviously for his own pleasure but also to make money. He purchased Seurat's grand painting *Le Chahut* for a modest sum and sold it for a handsome profit. He would at

various stages own several Van Goghs.[13] He had an irrepressible enthusiasm for the turbulence and excitement of his age, and he revelled in controversy and debate. In 1905 he irked the conservative art establishment with a study critical of the widely revered German artist Arnold Böcklin, and in 1910 repeated the provocation when he proclaimed Hans von Marées, who had generally been ignored by the German academic community, as the greatest German artist of the previous century.

Echoing Oscar Wilde, Meier-Graefe believed that the critic had an important artistic role. An unbiased opinion was worthless. In his biographies of Van Gogh and Cézanne, the artists leapt from the page, and their art took on life through his own descriptive powers. The British artist and critic Roger Fry captured the effect: "His aim has been to use language not so much for analysis, for precise discrimination of values, and for exposition as for the evocation . . . of a feeling."[14] In England literary biography had been developed as an art form, but in Germany there was no such tradition. Meier-Graefe pioneered an approach that, in the 1920s, was followed by writers who were to turn history and biography into a form of spectacle and entertainment.

In June 1914, in response to the tenth Van Gogh exhibit put on by Paul Cassirer, Meier-Graefe's enthusiasm could hardly be contained: "Van Gogh was the Christ of modern art," he proclaimed in the highbrow liberal newspaper *Berliner Tageblatt.* "He created for many and suffered for many more. Whether he is or can be the saviour, that will depend on the faith of the younger generation."[15]

# MADAM
*L'Arlésienne (Madame Ginoux)*

The most compulsive of German collectors of Van Gogh was, however, a woman: Helene Müller, the daughter of a German shipping, mining, and trading magnate. Next to Johanna van Gogh, Helene would assemble the largest collection of Van Gogh work anywhere. Today, housed in a museum near Otterlo, in the middle of the Netherlands, it remains the second largest Van Gogh collection, after that of Amsterdam's Van Gogh Museum.

Helene was the only child of Wilhelm Heinrich Müller, whose company was based in Otto Wacker's birthplace, Düsseldorf, but also had a branch in the thriving port city of Rotterdam. The Dutch connection was strengthened when, in 1888, Helene married Anton Kröller, who became the head first of the Dutch branch of the enterprise and then, when his father-in-law died suddenly the following year, of the whole company. At the age of twenty-seven, he was in charge of a small empire. In 1900 the head office of the business was relocated to The Hague, and, under Kröller's management, the Wm H. Müller Company prospered in the commerce of mineral and heavy industrial goods, with interests stretching from England and Sweden to Spain and Algeria. Though retiring in nature, Anton Kröller would soon be dubbed "the uncrowned king of the Netherlands."

In 1905 Helene Kröller-Müller, pursuing interests and activities expected of someone of her social status, met Hendricus Petrus (always known by his initials H.P. ) Bremmer, a man who, for good or ill, would shape much of the rest of her life. An independent critic, artist, and teacher in The Hague, Bremmer called himself, without a hint of irony, a "professor for practical aesthetics" and gave lessons in good taste to privileged Dutch matrons. Helene joined his classes in art history and appreciation.

The group met at Bremmer's home in the Trompstraat, just off the city's centre, not far from the fashionable Noordeinde with its royal palace and galleries. Bremmer's emphasis on the practical side of art appreciation was meant to distinguish him from the academic art historians and theorists who, in his opinion, were too caught up in context and speculation. He had an intensely idealistic view of art—that it was all about spirit and feeling expressed instinctively and intuitively—and he managed to convey this message with exuberance and conviction. Helene had a similar bent. The school she had attended in Düsseldorf had as its motto "Toward the Noble, Beautiful, and True," and at the age of fifteen she had confided to her diary that her highest goal was "to read the writings of great men and to learn from their lives and characters." She, like many others, women especially, was smitten by Bremmer's charm and knowledge. His own wife called him an "apostle of art," and his devoted following came to be known as the "Bremmer club." Helene decided to become a collector and to take Bremmer on as her adviser—"my counsellor in all aesthetic questions," as she put it.[1]

An early admirer of Van Gogh, Bremmer had befriended Johanna van Gogh after her first husband's death. Between 1903 and 1910 he edited the journal *Moderne Kunstwerken,* and in the twelve issues of the first year's volume, he included reproductions of thirteen Van Gogh paintings; in the eight volumes of those years, a total of sixty-one Van Gogh works were discussed. In 1911 Bremmer published *Vincent van Gogh: Inleidende beschouwingen* (Vincent van Gogh: Introductory Considerations), a 276-page discussion of twenty-eight of Van Gogh's works, sixteen of which were from the Dutch period. In contrast to those Van Gogh worshippers, such as Meier-Graefe, who emphasized the life as much as the work, Bremmer wished "to use the work to show the greatness."[2] It was the first major monograph about Van Gogh's art.

In the years 1913–38, Bremmer went on to edit the journal *Beeldende Kunst* (Fine Art), and he devoted seven issues altogether to Van Gogh. He himself would acquire some twenty Van Gogh paintings and many more drawings. His view of Van Gogh was always positive, interpreting the art as an ecstatic overcoming, a transcendence of suffering. He spoke of "the faith in the grandeur of life" that percolated through the art.[3] This interpretation of Van Gogh as a man of love and goodwill rather than sorrow appealed to many, including Helene Kröller-Müller.

She began her collection with sixteenth- and seventeenth-century Old Masters, but, in 1908, under Bremmer's influence, switched to Van Gogh. She purchased *Edge of a Wood* (F 192) from the early period (1882), followed by *Sunflowers* (F 452) from the Paris phase (1887), and finally *The Sower (after Millet)* (F 689) from 1889. Dipping into the three major periods of Van Gogh's development, she merely whetted her appetite. Over the next four years she added thirty-five paintings and became the foremost collector of the artist. In April 1912 alone she purchased fifteen works, seven in one day in Paris. In that year her Van Gogh collection grew by twenty-eight items. The Kröller-Müller Van Gogh collection would eventually contain some ninety paintings and 180 drawings.[4]

## SPIRIT

*Still Life: Vase with Irises against a Yellow Background*

*II* | n the early twentieth century a wind was blowing in Berlin," recalled the Belgian architect and designer Henry van de Velde in his memoirs.[1] That wind of change could not be confined to Berlin. It reached to Dresden and Munich, where like-minded artists joined together to promote what one of their

number, Wassily Kandinsky, called "the spiritual in art." In 1911 the art historian Wilhelm Worringer was the first to apply the term Expressionism to a new tendency "in which mind declares its autonomy over the experience of nature." Expressionism represented a spiritual rebellion against science, materialism, and law. Emerging from the depths of the human soul, the movement would redeem mankind from the world of matter and connect it to the cosmic, eternal, and godly—or so its proponents promised. One of the principal innovators behind the new development, said Worringer, had been Vincent van Gogh.[2]

By the time Worringer composed his treatise, Van Gogh's influence on contemporary German art was openly acknowledged. The group of painters in Dresden who in 1905 formed Die Brücke (The Bridge), among them Ernst Ludwig Kirchner and Ferdinand Hodler, enthused over the Van Gogh work they had seen at the local Arnold gallery that year. They took their name from a comment by Nietzsche: "What is great in man is that he is a bridge, not a goal."[3] In 1911 a group of artists in Munich formed a counterpart of the Bridge that they called Der blaue Reiter (The Blue Rider). They had first encountered Van Gogh three years earlier, when two Munich galleries, Zimmermann and Brakl, exhibited some of his paintings.

The transplanted Russian painter Alexej Jawlensky, a former military officer who had moved to Munich, bought *The House of Père Pilon* (F 791) from Brakl. He wrote Johanna van Gogh a letter of appreciation: "Van Gogh has been a teacher and a model to me. Both as man and artist he is dear and close to me. It has been one of my most ardent desires for years to possess something from his hand. . . . Never did a work by your late brother-in-law find itself in more reverent hands."[4] Jawlensky would attribute what he called "inner ecstasy" in his own work to Van Gogh's inspiration.[5] His compatriot and colleague in Munich, Kandinsky,

also went through a phase in 1908 and 1909 when Van Gogh's influence, especially in the free use of colour, was obvious.[6] Walter Leistikow, Franz Marc, August Macke, Heinrich Campendonk, Max Ernst, and Gabriele Münter were others who acknowledged the inspiration of Van Gogh, to the point that some made a conscious effort to distinguish themselves from his effect. "I had moments when I hated Van Gogh," said the painter Heinrich Nauen, "because I felt that he was oppressing my spirit; I hated him as lovers can hate when they stifle each other."[7]

The German Expressionist artists borrowed from Impressionism, especially its emphasis on colour and life, but at the same time distanced themselves vociferously from the "French style" that they considered frivolous and superficial. The detail, precision, and loyalty to nature of Impressionism gave way to bolder strokes and more strident emotion. It was the psychic realm that interested the Expressionists. To them and their "raw art," Van Gogh became a demigod. "The whole of French art," remarked Jawlensky, "is nature beautifully, extremely beautifully, observed; but all in all that is too little: one has to create one's own nature, Van Gogh."[8] Here the Dutchman was being turned into a teacher, mentor, and veritable school of his own. The Expressionists were attracted not only to Van Gogh's dramatic colours but also to his mysticism, madness, and death. In 1907 the artist Emil Nolde suggested to the Dresden group that they call themselves "Van Goghiana" rather than "the Bridge." Others were to say later of the Dresden circle that their paintings looked like an encounter of Van Gogh with Nietzsche.[9]

Friedrich Nietzsche, along with his intellectual forebear Arthur Schopenhauer, did indeed provide philosophical ammunition for the Expressionist revolt. For Schopenhauer the world was the product of "will and imagination"; for him the subject determined the nature of the object. For Nietzsche, in a similar

fashion, a spiritual heroism was the only salvation. The mundane, banal, and sterile in life, represented by rules and conventions, had to be overcome. Morality was a denial of life. Courage was not so much an alternative to despair as the urge to move on in spite of despair. Count Harry Kessler was one of the young German generation inspired by the Nietzschean vision of a spiritual aristocracy: "The role of danger as a source of spiritual strength . . . of a powerful and durable will, of sacrifice and courage . . . was something Nietzsche taught us. Here was the cornerstone of a new morality, a morality rooted in heroism rather than God."[10] The influence of Nietzsche would become ubiquitous as the old century drew to its close. After a conversation with the pianist and writer Ossip Schubin at a social gathering at Berlin-Wannsee in 1893, Kessler remarked in his diary, "She doesn't believe that educated Germans can meet for a half hour without mentioning Nietzsche."[11] Nietzscheans were everywhere, even in England. The poet Rupert Brooke would say in 1910 that for his generation, "Nietzsche is our Bible" and "Van Gogh our idol."[12]

A Nietzschean grandeur of tragic proportions was readily applied to the life and work of Van Gogh. He was seen by Meier-Graefe and Kessler as an expression of the *Übermensch,* the superior man. For Van Gogh, they felt, self-assertion through art, through spirit, was everything. Later, the French playwright Antonin Artaud would make a similar comparison. Both Van Gogh and Nietzsche, he said, were able to "undress the soul"; both championed a personal liberation from the constraints of family, society, church, politics, and morality. Both elevated aesthetics to a realm beyond ethics. Both saw conventional Christianity as "a yearning for extinction" and "a sign of profound sickness," in Nietzsche's words. And both men suffered mental breakdown, as did Artaud.[13]

In Worringer's wake, Van Gogh was often pushed under the Expressionist umbrella, but he did not fit well. Although his images

reflect eloquently his loneliness and melancholy, they do not exude the angular and strident anger, the sense of urgency, of most Expressionist work. However, his concern with the theme of redemption, and his association of colour with energy and liberation, greatly influenced those who considered themselves artist-seers, be they painters, poets, or dramatists. "He sees all colours as I see them," exclaimed the young Georg Heym, whose poetic imagery had unmistakable references to some of Van Gogh's most cherished paintings, with trees flickering like green flames toward heaven, and fiery comets threatening jagged towers.[14]

From Berlin, Munich, and Dresden, the winds of change blew westward. In 1912 in the Rhineland, Cologne hosted the largest German exhibition to date of Van Gogh's work. The *Sonderbund* exposition, a huge show that attempted to capture the essence of visual modernism and, by its very name, "Separate League," affirmed the particular against the central, exhibited 125 Van Goghs in all. Amid work by Max Beckmann, André Derain, Henri Matisse, Kees van Dongen, Ferdinand Hodler, Oskar Kokoschka, and even Eugen Spiro, the Van Goghs stood out. "When I visited the Cologne exhibition," the philosopher Karl Jaspers remembered, "where Expressionistic art from all over Europe was shown in a strange kind of monotony around all these magnificent Van Goghs, I could not help feeling that Van Gogh was the only truly great and unwillingly 'insane' person among so many who pretend to be insane but are really all too normal."[15] Jaspers was broaching here the sensitive question underlying the *Sonderbund* show and the modern movement as a whole: What was genuine and what was merely performance and pretence? What constituted sanity and, for that matter, authority? Van Gogh's life and art posed those questions directly.

As a result, Van Gogh's art was bound to elicit vitriolic opposition. Whenever a public gallery in Germany purchased his

art—work by a "foreigner"—controversy invariably ensued. Hugo von Tschudi, the director of Berlin's National Gallery, was fired in 1908, at the explicit request of the kaiser, for his "subversive" acquisition policy. In Bremen the director of the Kunsthalle, Gustav Pauli, met with a storm of protest when he acquired Van Gogh's *Field with Poppies* (F 581) in 1911. The melancholy landscape artist Carl Vinnen, a student of Arnold Böcklin, led the conservative chorus against Van Gogh and the foreign, especially French, influence in Germany. In a widely read pamphlet he objected to an art that needed explanation and interpretation. Genuine art, based on "real values," needs no mediation, he said; its meaning is clear.[16]

The controversy contributed to even greater interest in Van Gogh, and prices for his work steadily increased. When the Galerie Arnold of Dresden took forty-one Van Gogh pictures to Paul Cassirer's hometown, Breslau, in 1912, the exhibition catalogue remarked on the skyrocketing value of the paintings. The collection shown was valued at 300,000 marks ($71,500, or $1.6 million today). "In his own lifetime he considered himself lucky if he could give away his art to a few spiritual friends," wrote the journalist and critic Emil Loeschmann. "Now his pictures are worth their weight in gold on the international market, and a further sharp rise is certain."[17] When the imposing collection of the Dutch businessman and former art student Cornelis Hoogendijk was auctioned in Amsterdam in May 1912, its Van Gogh items fetched much higher prices than the Gauguins, Renoirs, Cézannes, and Corots. Meier-Graefe noted that Van Gogh's art had appreciated some four hundred to six hundred times in the two decades since his death.[18]

Two years later, in June 1914, Paul Cassirer held his largest Van Gogh show yet—151 works. "Many connoisseurs maintain that it is the most interesting Van Gogh exhibition to date," he wrote to

Johanna van Gogh.[19] Though that summer was one of endless sunshine, the diplomatic crisis set off by the assassination at Sarajevo of the Austrian archduke Franz Ferdinand on June 28 proved insoluble. After their stay on the Viktoriastrasse in Berlin, the Van Gogh pictures went on to the Thannhauser gallery in Munich, and then to the Kunstverein in Cologne. From there they were supposed to journey to the Commeter gallery in Hamburg. However, in early August war began. The last available letter from the Cassirer firm to Johanna is dated August 29, almost a month into the war, and signed by Theodor Stoperan, Cassirer's assistant. "Dear Madam," it reads, "Your Van Gogh collection was in safe keeping until now in Cologne. I think within the next few days it can be sent on to Hamburg, where it will be in equally good custody. . . . Should it not yet be possible to return the pictures to Holland when the exhibition closes I should be most willing to have them back here again and to look after them with the greatest of care."[20]

## STORM

*Self-Portrait with Bandaged Ear*

The outbreak of war brought an emotional outpouring of staggering dimension. Never has more poetry been penned than in those heady early days of war. Never have more hymns been sung. Many looked on the conflict as more than a military confrontation. They saw it as a spiritual event, a climactic all-enveloping moment—a fusion of nation, culture, and purpose. "Each one was called upon to cast his infinitesimal self into the glowing mass," wrote Stefan Zweig, "there to be purified of all selfishness."[1] Ernst Barlach compared the mood to being madly in love.[2]

Long anticipated, the war evoked elemental images of cleansing. Many of these images were remarkably similar to those proposed by the pre-war cultural avant-garde, primarily of fire, but also of wind and water. The war had the same purpose as the new art—to purify and revive. After witnessing the German assault on the Belgian fortress town of Namur, Harry Kessler wrote to a friend, "The march of the cockchafers into Namur led by regimental music and accompanied by a thousand young voices singing the 'Wacht am Rhein' will remain forever one of my most powerful memories. All around, the town was burning, but from the flames and the smoke emerged victorious new life. Forward over the graves."[3]

Fire was invigorating, fire was magical. The poet Richard Dehmel spoke in those August days of "miracle flames" and the "cleansing storm."[4] In the same vein, the Austrian composer Alban Berg told his wife that the war had "the task of making the world clean!"[5] Two years later, in 1916, Ernst Troeltsch, a theologian and historian, could still speak of "the wind of the future" that was blowing in, but now he sensed that it was bringing a "world-historical crisis." The old was about to break up; the new would be issued in with shattering effect. The British poet Wilfred Owen used the image of a "tornado, centred at Berlin."[6]

In all countries, artists, along with poets, musicians, and intellectuals in general, rushed to the colours that autumn of 1914. They revelled in the exhilaration of war—the prospect of genuine experience as opposed to humdrum routine. Even those like Hugo Ball, the German author, poet, and artist who soon would turn virulently against the war, were caught up in the early enthusiasm. "Art? That's all finished and comical," he remarked. The war, he already sensed, had dispelled any conventional vision or representation of the world. He attempted repeatedly to enlist but was thrice rejected because of his heart condition.[7] In the

British army the 28th battalion of the London Regiment was called the Artists Rifles. The casualty rate among these idealists was to be much higher than for most other professional groupings. The war for this cohort had nothing to do with territorial or economic gain; it was a spiritual and emotional matter. For Karl Scheffler, a critic and editor of the influential journal *Kunst und Künstler* (Art and Artists), the war was quite simply "an artwork." German youth would emerge from this crisis with a new sensibility, new idealism, and new vitality.

"This war must become a school for talent. Therefore let us bless this war. Let us accept all its grace. Let it be a sign for us that the world spirit is well disposed toward us. Whatever the outcome, a people like the Germans will not perish, and in any case the war will evoke a new spirituality, a more profound culture, and new strength. And when all of this turns in good time into beautiful art, we shall acknowledge that the war, despite death and destruction, is itself something like a work of art. It is a natural work of art."[8]

The moderns had been excited by turbulence, speed, and revolution. Violence had been endemic in their work. They had christened their journals with names like *Blast* and *Sturm* and cherished a *poésie brute*. They aimed at transformation, fundamental and thorough. F.T. Marinetti, the founder of Futurism, equated speed and war with beauty. A specific war may not have been envisaged, but belligerence had been in the air in those years after the turn of the century. When war finally came it was equated with religiosity and art, a struggle both "glorious and holy," according to the fifty-one-year-old poet Richard Dehmel, who volunteered for service forthwith.[9]

His friend Paul Cassirer, though forty-three years of age, rushed to join up too. As late as July 20 Cassirer had been in Paris, where Auguste Renoir was painting Tilla Durieux's portrait at his

studio on the boulevard de Rochechouart. It was Cassirer's chauffeur, not his intellectual friends, who drew attention to the gravity of the international situation: "All the other cars in the garage have left," said the driver. The two Germans departed France by road and travelled through Belgium to their summer home in Noordwijk on the Dutch North Sea coast. But as the diplomatic situation deteriorated, they returned to Berlin on July 28.

Cassirer was accepted by the army and assigned messenger duty at Wervicq, near Ypres. As early as September he was awarded the Iron Cross for bravery. Tilla would not be left out: she took a course for volunteer nurses and found a position at Buch, about an hour's train ride from Berlin, where a mental institution had been turned into an army hospital. Despite physical displacement, Cassirer's entrepreneurial efforts were not halted by the war; he founded a journal *Kriegszeit* (Wartime) and published patriotic items by artists. He opened a new office for this publishing enterprise, at Viktoriastrasse 2, down the street from his gallery at number 35.

In these early days of war, national instincts seemed to crush completely any cosmopolitan tendencies. However, patriotism and nationalism were not necessarily a primary urge for artists and intellectuals. Experience was the lure. For Harry Kessler, France and England had been as much his home in the years before the war as Germany. His pre-war diary took flight when describing the cathedrals at Amiens and Canterbury, the Monets on show in the rue Laffitte, or the works of Turner and Constable in London's National Gallery.[10] Now it was the sights and sounds of war that provided his frissons. He found the war "exciting and exhilarating, like champagne." His reaction to corpses was like his reaction to art: "Their faces looked mostly like a chocolate soufflé in which the eyes, quite small and white like almonds, were stuck."[11] He served in military administration in Belgium,

and then on the Eastern Front, before being seconded for diplomatic activity in Switzerland.

Julius Meier-Graefe, too, joined the war effort in 1914 and found himself on the Eastern Front with an ambulance corps. He was captured by the Russians, sent to Siberia as a prisoner of war, and exchanged in 1916 for the mayor of St. Petersburg.

The artist-soldier, as genus, naturally thought of himself as a storm trooper whose role it was to cross that deadly strip between the fighting lines—that no-man's land, as it came to be called—to defeat the obstinate enemy and deliver the world to a new state of grace. In Walter Flex's novella of 1916, *Der Wanderer zwischen beiden Welten* (The Wanderer between Worlds), the hero, Ernst Wurche, is a theology student. He greets the war as a sacred but also aesthetic moment. Three books give him support and solace: the New Testament, Goethe's poems, and Nietzsche's *Also sprach Zarathustra*. The war, even in its mechanized and dehumanized brutality, is beautiful because it embodies ideals of heroism, sacrifice, community, and duty. The war is the apotheosis of both the religious and the artistic impulse.

The youngster Otto Wacker, who turned sixteen in Berlin as the war began, was in due time called up for service. Ten days later, however, he was released on grounds of *Nervenschock,* nervous breakdown. His response to the war was hardly singular.

## PHANTASMS

### The Night Café in the Place Lamartine in Arles

As the real war on the ground turned in the course of 1915–16 into a devastating and enervating war of attrition, the very antithesis of purity, some soldiers developed a whole new range of metaphor to describe it: muck heap, meat grinder, cesspool.

Yet, as disillusionment threatened individual sensibility, in public quarters, and especially on the home front, images of innocence and propriety intensified. The soldier became a Christ figure, a martyr for humanity. In this crisis, without apparent issue or solution, imagination polarized. The war turned into phantasmagoria.

For a good number of combatants on the fighting and the home fronts, antithesis became the essence of this war, both during the conflict and especially later. Promise seemed to bear no relation to reality. Ideas contradicted the senses. For those who worked with symbols and forms, standard representation in words, images, and sounds became suspect. The artist and writer Fritz Burger, who had set off to battle with unbridled enthusiasm in August 1914, remarked to his wife in May 1916 that his nerves were shattered and that he was overcome with "Van Gogh–like fantasies." He was referring presumably to the swirling skies and blazing suns of Van Gogh's Saint-Rémy visions. Burger was to die at Verdun two weeks later. His *Einführung in die Moderne Kunst* (Introduction to Modern Art) would be published posthumously in 1917. There he argued that Germany was at the forefront of the modern movement, in art and life.[1]

Karl Scheffler lost his hurrah-patriotism quickly and recognized that the real world, with its descent into horror, had in fact outpaced imagination. "Reality seems more full of fantasy than the imagination of the artist," he wrote with dismay in 1915.[2] As words had become mere slogans, language had become the source of untruth. Vision, too, both literally and figuratively, was curtailed. Sound became a matter of inescapable cacophony. Irony, if not utter negation, seemed the only appropriate response to experience—the only means of survival in a godless world. In this context of growing doubt, art remained supremely important: it became less a matter of reflection than an urgent statement,

usually of protest, anguish, and anger. It assumed a negative function. Nowhere was this clearer than among the group that formed in Zürich in neutral Switzerland in 1915, calling itself by the nonsensical name Dada. Appalled that the methodical slaughter of millions was being heralded as a moral necessity, the Romanian Tristan Tzara, the German Hugo Ball, and the Alsatian Hans Arp staged evenings of outrage—"bruitism"—at the Cabaret Voltaire, where they insulted their audiences and challenged all notions of stability and purpose, even their own. To end the opening night on February 5, 1915, Tzara unrolled a wad of toilet paper on which was written the word *merde*. In this art of anti-art, all authority was questioned—military, political, social, aesthetic. Dada was out to destroy all convention, whether expressed in language, image, or sound, because all existing standards were evil—"Gadji beri bimba." The Dadaist was intent, as Arp put it, on "robbing the bourgeois of his sleep."[3]

In 1917 one of Dada's founders, Richard Huelsenbeck, returned from Zürich to Berlin. For him, art had become both manifesto and outrage: "The highest art will be . . . the art which has been visibly shattered by the explosions of last week, which is forever trying to collect its limbs after yesterday's crash." It would be art as event, and event as art—art as a collage of sensation. The moment was aestheticized but at the same time politicized. In 1920 the Galerie Otto Burchard in Berlin would host the first International Dada fair. Under the effigy of a pig in army uniform cascaded a mélange of slogans, paintings, and photomontages representing chaos as affirmation. At a Paris Dada performance, Francis Picabia exhibited a picture in chalk on a blackboard which he then erased on stage. "The picture," said Tristan Tzara, "was valid for only two hours." On that occasion Tzara read aloud from a newspaper with a bell clanging in the background, so no one in the audience could hear him.[4]

Many artists and intellectuals could not cope with the reality of the war and had breakdowns, either at the front or on their return home. Many were killed outright, others broken in spirit. Franz Marc died at Verdun. Oskar Kokoschka was gravely wounded. Georg Trakl took his own life. Ernst Ludwig Kirchner had a mental breakdown in military service. He subsequently painted a portrait of himself in uniform with his painting hand amputated. George Grosz and Otto Dix turned to increasingly lurid themes that expressed a dimension of anger that no one had conceptualized or articulated before the war. *Lustmord*—the crime of passion—became a generic notion implying the destruction of not just the "eternal feminine" but civilization itself as it had been known. Marcel Duchamp fled the Continent for America. He would take the emotion to a new level, turning a urinal into art (*Fountain*) and the Mona Lisa into a hirsute vamp whose probing gaze betrayed her lust (*L.H.O.O.Q.*). "Where there is war, there destruction rules," wrote Meier-Graefe.[5] "Our sun is made of blood," said Hugo Ball.[6]

Paul Cassirer was declared *dienstuntauglich*, unfit for service, in 1915. A decorated hero, he not only turned against the war but also against himself in fits of suicidal depression. He affiliated with the radical political left and began publishing Rosa Luxemburg as well as other socialist writers. The pacifist Leonhard Frank gave readings at Cassirer's home. "We were left of left," remembered Grete Fischer, a co-worker. The military authorities threatened Cassirer with more front-line service and eventually sent him to a detention facility near Küstrin on the Baltic. There his health deteriorated. It took the intervention of friends and medical officials to have him released just before Christmas 1916.

At that point Count Harry Kessler, who was involved in the propaganda effort on behalf of Germany in neutral Switzerland, thought Cassirer would be an excellent addition to his team,

working with theatre groups, art galleries, and the intellectual community and trying to reach out to France in particular. Cassirer agreed to come, but he very much played his own game. He did organize some art exhibitions, but he also launched a joint publishing venture with the Swiss publisher Max Rascher and, among other projects, produced a Swiss-German edition of Henri Barbusse's enormously successful anti-war novel *Le Feu*.

Tilla Durieux did some acting in Switzerland, but the couple became best known for the social events they orchestrated. They set up court at the Hotel Schwert across from the old city hall in Zürich, in a suite of rooms they refurbished, and they even managed to have a few of their precious Manets, Cézannes, and Van Goghs shipped from Berlin. That choice of art, all of it foreign, immediately defined the pair as traitors to the official German cause. Their residence, in a hotel where Casanova and Goethe had once stayed, became home to a motley parade of artists who were associated by bourgeois society with moral indiscretion: the authors Franz Werfel, Else Lasker-Schüler, René Schickele, and Stefan Zweig, the conductor Oskar Fried, and the architect Henry van de Velde. In Zürich, Van de Velde observed, Cassirer behaved as though he were the "Kaiser of Jerusalem."[7] Switzerland, during the war, was full of spies, revolutionaries, and prevaricators of all stripes. Trust became an old-fashioned notion. James Joyce spent the war years there, as did Lenin and Trotsky. In this place, as at the front, truth became a matter of fanaticism or fable, fundamentals or fragments. The age of extremes was in full flight.

The international art trade slowed to a crawl during the war. Johanna van Gogh recorded no sale in her account book between April 1914 and October 1921. Though his extravagant behaviour gave no such suggestion, Paul Cassirer had serious financial difficulties. His reach, particularly to France, was disrupted. He was

denounced in several German newspapers for using his posting in Switzerland for personal gain—selling art from his own collection—and for promoting anti-German ideas.

If the legal trade in art dwindled, underhand enterprise flourished, as it always does in time of war. German soldiers in France picked up cheap artworks, most of them purportedly original but many fraudulent, which they then shipped home. Afterwards, confronted by economic hardship, some tried to sell this work. Corot was said to be the most copied artist. Utrillo was rumoured not to have been able to distinguish between his own work and that of imitators. Vlaminck said that he had painted a picture in the style of Cézanne that the latter had certified as his own.

Three years into the war, Otto Wacker, who had been declared unfit for military service, was arrested by the Berlin police. Nothing is known of his new dance pursuits, but he continued to sell his family's art in what was now a very lethargic market. He also supplied other works, primarily of an Impressionist flavour, to the occasional dealer and private buyer. Business being slow, the family was in dire economic straits. Otto's arrest was occasioned by his sale of a forged painting that he had presented as a Franz von Stuck. In German law the charge of fraud could take effect only if the purveyor of the fraudulent art had acted knowingly. When he was interrogated, however, Otto refused to reveal the source of the work, though it is likely that his brother Leonhard, a few years his senior, painted the picture. Franz von Stuck, a Symbolist prominent in the Munich Secession, was renowned for his portraits of sensuality, and the forgery suggests youthful involvement. Because the source was never established, Otto's role would have been registered as a misdemeanour rather than a crime. He was, nevertheless, now on the police blotter.

When the German military effort crashed, after the failed final assault of the spring and summer of 1918, and revolutionary

turmoil accompanied the armistice in November, the German community in Switzerland mobilized for a return home. Kessler became the German representative in the newly re-created Poland; Tilla Durieux accepted a contract from the Munich National Theatre, and Paul Cassirer joined her in the Bavarian capital. But before he left Switzerland, Cassirer incinerated any document he considered compromising. This ceremony of burning, one the Dada cohort would have enjoyed, was apparently prolonged.

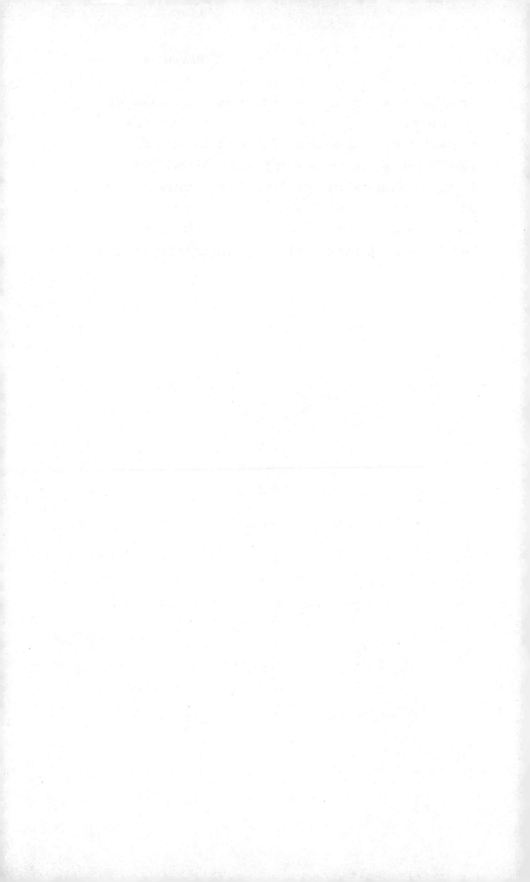

The Samuel Pepys of his day, Harry Graf
Kessler knew everybody and recorded it all in
his endlessly fascinating diary. He was an early
admirer of Van Gogh. Here he is seen, as
portrayed by the Norwegian Edvard Munch in
1906, emerging with high drama from a bright
yellow background. For painter James Whistler,
yellow was the colour of controversy; for
Vincent van Gogh, it was the colour of love.

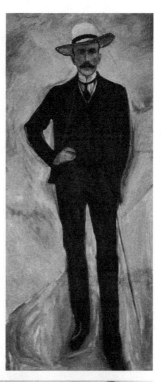

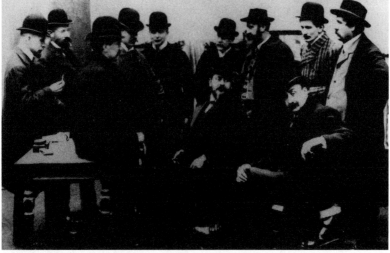

Paul Cassirer was one of the first to promote Van Gogh and the French
Impressionists in Germany. Here with the jury of the alternative art society, the
Berlin Secession, in 1908, he stands, as was his wont in the modern German art
world, at the centre of the picture, facing the camera. Max Slevogt and Max
Liebermann, artists fascinated with theatricality and performance, are seated.
Cassirer, like Van Gogh, would commit suicide.

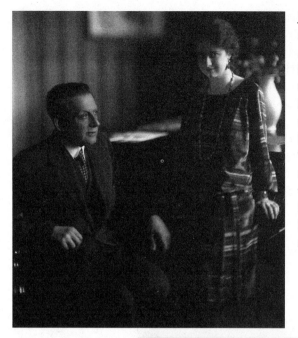

Julius Meier-Graefe met his third wife, Annemarie Epstein, in 1921, when she was fifteen, he fifty-four; in 1925—the year they are portrayed here—they eloped. The personal life of this Van Gogh expert was full of turmoil, like that of the artist he helped catapult to celebrity status.

This photograph of Jacob-Baart de la Faille appeared, without attribution, in the posthumous 1970 edition of his catalogue raisonné of Van Gogh's works. His widow was not pleased: the picture, c. 1925, shows him in the garb of an auctioneer rather than a distinguished man of letters. But perhaps the portrait was apt.

This striking image of the young art collector Helene Kröller-Müller greets visitors at the entrance to a room displaying her favourite paintings at the Kröller-Müller Museum, Otterlo. As her fortune dissipated during the economic calamities of the early 1920s, her dream of a huge private museum did too; in 1935 she donated her collection to the Dutch state.

H.P. Bremmer in 1909, when he was tutoring Helene Kröller-Müller. This aesthete looked on art as above all a spiritual matter. The genuine had to be felt, not documented. For Bremmer, the authority of the soul was superior to any material category.

Otto Wacker, aka Olinto Lovaël, drew a rave review from the society magazine *Elegante Welt* (Elegant World), where this picture appeared in 1924. He pretended he was a Spaniard, and he was believed. He would later claim to have more than thirty previously unknown Van Gogh paintings, and again he was believed.

Ludwig Justi, director of Berlin's National Gallery, seen here c. 1920 in appropriately jaunty attire, would be at the centre of the art wars of the Weimar Republic. His demeanour, often aggressive and impulsive, was at odds with his purpose—to root out the false and affirm the genuine.

# THE PERSPECTIVE

—————

Messieurs, forget about "art." Go to bed instead or to the circus.

ALFRED DÖBLIN, early 1920s

. . . the great public has a chronic and
cannibalistic appetite for personalities.

ALDOUS HUXLEY, *Point Counter Point,* 1928

"You know, Sally," I said, "what I really like about
you is that you're so awfully easy to take in. People
who never get taken in are so dreary."

CHRISTOPHER ISHERWOOD, *Goodbye to Berlin,* 1939

# WINDS

*Olive Trees: Bright Blue Sky*

With the collapse of the Second Reich in early November 1918, the declaration of a German Republic on November 9, and the riotous turmoil that accompanied military defeat and political transition, intellectuals of all stripes were drawn willy-nilly into public affairs. Paul Cassirer joined the Independent Socialists, the adamantly anti-war wing of socialism that had broken with the main party in April 1917. He now published ever more writers and theorists of the left, among them Rudolf Hilferding, Karl Kautsky, and Rudolf Breitscheid. In Munich, where Cassirer and Tilla Durieux would soon reside, poets and artists became directly involved in governance when the Independent Socialist Kurt Eisner seized the initiative and declared Bavaria a republic on November 7, two days before similar events in Berlin. Tensions and engagement intensified when Eisner was assassinated three months later and the Munich Soviet Republic was launched with the participation of the prominent writers Erich Mühsam, Gustav Landauer, and Ernst Toller. Although this radical Communist experiment in Bavaria was to have a brief and unhappy life, the world seemed to be dissolving into an anarchy of fragments. Russia had already had its Bolshevik Revolution in November 1917; Hungary was in chaos; street fighting raged through Central and Eastern Europe.

When the counter-revolution came in Bavaria, it did so with great brutality. Tilla Durieux helped the playwright Ernst Toller escape, and her involvement with the Communists surfaced in the press. One grossly exaggerated report had her in Dachau, just outside Munich, on a frothing steed leading a contingent of

fighters.[1] Paul Cassirer remained skeptical about the prospects of direct intellectual engagement in politics, even though he was sympathetic to much of this activism. Despite being an ardent promoter of Impressionism, he had never been comfortable with the German Expressionist painters. For his taste they were too strident, too engaged. Art, he insisted, should be a spiritual matter, not a vulgarly political enterprise. "Art is art," he declared.[2] But his own behaviour could be deeply contradictory.

The material and human cost of the war had been horrendous. All told, close to nine million men on all sides had died, and some twenty-two million had been mutilated—about seven million permanently. The streets of postwar Europe were literally crawling with invalids and cripples. But while the physical cost could be counted and even viewed, the moral and psychological cost was repressed. If you had won this war, there was some consolation. If you had lost, there was none, except the awareness of effort made and life given. But given for what? For the nation? For the militarists? For the profiteers?

Germany suffered some two and a half million deaths on the battlefield and some three million wounded. On top of that was the economic cost—all investment and assets abroad were lost. The army and navy were dismembered, the colonies surrendered. The national debt was uncontrollable, and the currency suspect in international markets. The Treaty of Versailles declared Germany guilty for starting the war and liable for its monstrous cost. Reparations were demanded, calculated finally in 1921 at a sum that would be repaid over sixty-six years. Germany the heroic had become Germany the destitute. Life had become unmoored, decentred. Even the Reichstag, the German parliament, after national elections in January 1919, had to convene in the provincial town of Weimar because Berlin, the capital city, was simply too dangerous and unpredictable—hence the name Weimar

Republic. After the treaty had been signed, under duress, in June and ratified in early January 1920, Harry Kessler penned a dire entry in his daybook: "A terrible time is beginning for Europe, an intense humidity before the storm, one that will probably end in an explosion more terrible than the world war."[3]

Before the war, Expressionism had been angular and angry; after the conflict it turned dark and demonic. In a café in Dresden, Otto Dix saw mutilated soldiers playing cards. He portrayed them in *Die Skatspieler* (Skat Players). Without limbs or noses, with glass eyes and tubes protruding where once had been faces, these veterans proudly display their medals. "All art is exorcism," Dix stated. "Painting is the effort to produce order; order in yourself. There is much chaos in me, much chaos in our time."[4] His work seemed less to condemn and more to indulge in suffering and morbidity. Horror and exhilaration complemented each other. In her postwar novel *Grand Hotel*, set in Berlin's opulent Adlon hotel on the Pariser Platz adjacent to the Brandenburg Gate, Vicki Baum presented one character, a Dr. Otternschlag, with only half a face: "The other half . . . was not there. In place of it was a confused medley of seams and scars, crossing and overlapping, and among them was set a glass eye." The doctor called this artificial eye his "souvenir of Flanders." The hotel is brimming with dashing elegant life, but for Otternschlag all this activity is merely a façade for despair. "It's dismal," he says. "Always the same. Nothing happens. One's always alone, dismally alone. The earth is an extinct planet—no warmth left in it."[5]

If the glass eye suggested what had happened to vision in Weimar, the fate of the German currency, the stunning demise of the mark in an inflationary death spiral, suggested what had happened to value—in the late summer of 1923 an American dollar cost a trillion marks. Anyone on a fixed income was insolvent. If money could not hold its value, what else might be

threatened—morality, purpose, honesty, self-respect? In one of his satirical poems, Alfred Henschke, the well-to-do son of a respected apothecary, imagined a German worker's death during the inflationary period, followed by a German burial, in a German coffin, in the German earth, in the German forest. But the death of this dedicated German worker was promptly followed by reincarnation—the man returned to life as a "foreign exchange dealer."[6]

"The Expressionists are a statement about our age," wrote Meier-Graefe in 1919. "We have the art we deserve." Their point, he said, was that "the world is falling apart."[7] As the world crumbled, the fragments—fragments of being and fragments of will—became the new reality. Meier-Graefe was inclined to argue that the arts had predicted all the violence that had overwhelmed the world. In this view he was not alone.[8]

Demobilization was awkward, unemployment rife. Family life, and everything else, suffered from the death and dislocation. Crime shot up. Poverty was visible all over Germany. When the composer Ferruccio Busoni returned to his apartment in Berlin in 1920 from his exile in Zürich during the war years, he was struck by the general griminess of the city. Only one building had been given a fresh coat of paint since 1914—the British embassy.[9]

The republican democratic majority, produced by the first national postwar election in January 1919, lasted little more than a year. By June 1920 that majority was gone, for good. Thereafter political instability was a constant. With fear and anger also as constants, the postwar German republic was a culture always on the verge of self-negation. So many of its talented individuals would commit suicide—Walter Benjamin, Kurt Tucholsky, Paul Nikolaus, Paul Simmel. Benjamin spoke of self-destruction as "an aesthetic delight," and Tilla Durieux was struck later by the frequent recurrence of a death wish in her diaries.[10]

Paul Cassirer lost his eighteen-year-old son to suicide in March 1919, and he took his own life seven years later. This most gregarious of souls had become increasingly lonely and depressed in the postwar years. Even though he opened offices in Amsterdam and New York, his art and publishing ventures shrank in size and renown, and he seemed to lose interest. The French connection had been disrupted. Paul Durand-Ruel had died and there had been a major shakeup in the Bernheim-Jeune operation. His relations with the younger French generation were strained, and his health deteriorated. When Tilla Durieux asked, yet again, for a divorce, he decided on a dramatic retort. In the offices of the lawyer finalizing the dissolution of the marriage in January 1926 he set about taking his life with a pistol. Like Van Gogh, he was a poor marksman and required time to die. Apocryphal rumour had it that as he lay in his hospital bed, he asked for newspapers to see what had been written about him. At his funeral, the Lambinon Quartet played, and Max Liebermann and Harry Kessler spoke. His body was buried, in beautiful winter sunshine, in a cemetery off the wide boulevard of the Heerstrasse. Kessler ended his diary entry for Sunday, January 10, with the words, "The death of Cassirer has shaken me profoundly."[11]

Ludwig Justi, the director of the National Gallery in Berlin, who had always had a difficult relationship with Cassirer, suggested that the dealer's inability to connect with the contemporary art scene of Weimar had much to do with his depression and death.[12] This theme of disconnectedness, departure, and death runs through the Weimar adventure: in an essay from 1931 the novelist Lion Feuchtwanger remarked presciently that he felt himself surrounded by "nothing but future emigrants."[13]

On the broader stage, the political assassinations—of the radical socialists Karl Liebknecht and Rosa Luxemburg; of the first finance minister of the Republic, the centrist Matthias Erzberger;

and of the enigmatic but brilliant foreign minister Walther Rathenau, among others—were a form of self-mutilation of the body politic. These four were stars in the political firmament, their light snuffed out prematurely by denizens of a swastika-sun culture, ultranationalists without a smidgeon of tolerance. But murder, extremism, and intolerance were everywhere. The first wife of the film director Fritz Lang died in mysterious circumstances, and though never formally charged, he and his lover Thea von Harbou were never exonerated either. Lang made many spectacular films, in Germany and later in Hollywood, but his masterpiece may be *M*, the story of a pedophile and child murderer for whom the audience is made to feel sympathy. Joseph Roth, the brilliant Austrian journalist and novelist who moved to Berlin in 1920, said at the end of the decade that he could at times no longer distinguish between a cabaret and a crematorium. What was supposed to be amusing made him shudder. Death, correspondingly, could make him laugh.[14]

Life amid omnipresent death meant that the twenties were all about the interplay of light and shadow, and the cinema was to be the perfect venue for this intercourse. Movies became the foremost medium not only of entertainment but also of artistic representation—a stream of light in the midst of darkness. Many shared the excitement of the French writer Blaise Cendrars about the new medium: "The latest discoveries of science, the world war, the theory of relativity, political upheavals, everything indicates that we are heading toward a new synthesis of the human spirit, toward a new humanity, and that a new race of men will appear. Their language will be cinema."[15]

Film represented the future. Words were static, pictures fluid; words divided, pictures united. In social terms, visual images reached further than words ever could. In 1925 Klaus Mann, son of the foremost contemporary craftsman of German prose,

Thomas Mann, apologized for writing; it was such an old-fashioned medium.[16] Siegfried Kracauer, who trained as an architect and engineer before turning into an irrepressible polymath, chose in his cultural criticism to focus on film because he saw it as the incontrovertible art form of the future. In his own writing he was inclined to capture thought in image—what he called *Denkbilder*, thought pictures.[17] Likewise, Alfred Döblin called for a *Kinostil*, a cinema style, in writing.[18] The most popular novel of the interwar period, the first great literary bestseller of the modern age, Erich Maria Remarque's *Im Westen nichts Neues* (All Quiet on the Western Front), consisted of short segments, inspired by the structure of a film script.[19]

The move from painting to photography and on to film proved irresistible. Fritz Lang's and Adolf Hitler's first love was painting. Lang sold personally painted postcards in Paris before the war; Hitler did the same in Vienna and Munich. Both became decorated war heroes. After the war, both turned to film. The difference was that Lang stood behind, and Hitler in front of, the camera. But both were fascinated by the machine and by the transgression—beyond good and evil—that the machine facilitated. In Lang's disturbing film *M*, the camera pauses, in an early scene, on a bookstore window, but the literary items on display are secondary to the advertising gimmicks that attract all the attention.

Weimar was synonymous with movement and evanescence. Weimar was transition, interlude, interregnum. It dislodged, broke up, and disappeared, with surprise as the counterpart to breakdown. The last thing Weimar turned out to be was the Weimar it was supposed to be—a realm of enlightenment, predictability, and authenticity.

In this world of impermanence, everyone liked to strike poses. The architect Ludwig Mies van der Rohe was hardly the

Dutch aristocrat his name suggested. He was born to poverty as Maria Ludwig Michael Mies—*mies* in German actually means "wretched" or "miserable"—and he invented his pompous Dutch-sounding name later. George Grosz, ever the contrarian, would open the door to callers and pretend he was the butler. On his studio walls he had portraits of Thomas Edison and Henry Ford, each with a forged signature and personal dedication. Grosz, like the writer Kurt Tucholsky, made a habit of assuming multiple personae. Grosz was Count Bessler-Orfyrre, Georges Le Boeuf, and Lord Hatton Dixon. Tucholsky used pseudonyms including Kaspar Hauser, Peter Panter, and Theobald Tiger. "I am terribly lonely," Grosz admitted, "or rather alone with my *Doppelgänger,* phantoms in whose forms I give reality to particular dreams, ideas, desires, etc."[20]

This crisis of identity was felt deeply by Theodor Adorno. He was trying to habilitate in philosophy while studying composition with the Austrian composer Alban Berg. The two became fast friends in 1926 as Berg's opera *Wozzeck* was about to debut in Berlin at the State Opera. Based on a theatrical fragment by Georg Büchner, the story is about a soldier whose world turns on him—and who then turns on the world. Berg's score was full of difficult dissonance. Adorno developed a deep attachment to the piece, which had its premiere on December 14. He promised to write a lengthy appreciation, but the more he thought about the work the less he was able to express his feelings about it. The categories of criticism kept shifting, and he came to believe that this opera was the supreme expression of a new social reality—the loneliness of the subject.[21] "Like no other aesthetic creation of our time, Wozzeck expresses truth, and rather than being able to destroy this truth all existence fragments before it."[22]

Adorno noted that in Berg's *Wozzeck* the themes of art and neurosis were linked. Virtually all the creative minds of Weimar

played with this theme of art as illness. Thomas Mann's *Magic Mountain*, Franz Kafka's *Hunger Artist*, Hermann Hesse's *Steppenwolf* were some of the literary manifestations of this romantic notion that sickness was far more interesting than well-being, humiliation far more life inducing than conquest. The 1920s saw a revival of interest in the Marquis de Sade and in sexual perversion as a sign of life. "We no longer believe," wrote Sigmund Freud at the end of his study of the homosexual Leonardo da Vinci, "that health and disease, normal and nervous, are sharply distinguished from each other." "We are," he said in his *Introductory Lectures*, "all ill."[23]

In the middle of his most famous work, *Berlin Alexanderplatz*, first published in 1929, Alfred Döblin, after a sudden discourse in stream-of-consciousness vein on the merits of the banana as "the cleanest fruit," begins, for no apparent reason, to conjugate a verb: "I smash, you smash, he smashes." By juxtaposing an image of nutrition and health with the dark compulsions of his main character, Franz Biberkopf, he captures the dilemma of life in the Weimar Republic.[24] Döblin was one of Weimar's splendid manifestations, a doctor who treated nervous disorders but could not earn a sufficient income from this medical practice to look after his family of three children. He wrote novels and theatre reviews on the side in an attempt to make ends meet. At the same time he was dismissive of "literature" both as an activity and a medium.

Erich Kästner, a teller of tales for children, saw fakery and thievery everywhere. The older generation was corrupt; it stole from children (*Emil and the Detectives*). In his 1930 poem "Ragout fin de siècle" he wrote:

Here no pig feels at home.
The real is fake and the fake is real,
and everything is messed up in the pot,

and pain is fun while pleasure brings anger,
and up is down when back is front.[25]

In this topsy-turvy world of the Weimar Republic, Otto Wacker and Vincent van Gogh would meet and, together, experience a strange yet revealing tale of celebrity, scrutiny, and controversy.

### FEVER

*The Drinkers (after Daumier)*

With essence eviscerated, what remained? *Tanzwut*—dance fever—that's what. In this milieu of movement and fragment, dance, both artistic and social, turned into a prominent metaphor of life. In the 1920s everyone danced. The *Münchner Neueste Nachrichten,* Munich's major newspaper, referred to the "dance plague" that had come to afflict the culture. When Klaus Mann tried in his memoirs to explain the political and economic turmoil of that decade, he resorted repeatedly to images of dance. "The stock market danced. The members of the Reichstag hopped about. . . . Cripples, war profiteers, film stars and prostitutes, retired monarchs and retired teachers . . . all of them threw their limbs about in gruesome euphoria."[1] In Curt Moreck's 1931 guide to "sinful" Berlin, dance was the one motif that connected all forms of sensuality.[2]

Artistic dance had begun to stir creative imaginations from the 1870s on. The Impressionist and Post-Impressionist painters had been drawn to the bright lights of the theatre. Manet, Renoir, Degas, and Toulouse-Lautrec found the theatrical world, where one flitted between illusion and reality, mesmerizing. They painted showgirls, barmaids, ballerinas, and revelled in the moral and physical ambiguity of a life of constant performance. The

Berlin Secessionists were drawn to the flame as well. Max Slevogt made his breakthrough with his painting of the Flamenco dancer Marietta di Rigardo, a Berlin cabaret artist of Philippine background. Lovis Corinth portrayed Tilla Durieux as a Spanish dancer. Wassily Kandinsky linked painting and dance directly as two forms of artistic expression struggling to find new ways of depicting the modern world. What Kandinsky in 1911 termed "the art of spiritual harmony," Serge Diaghilev and his Ballets Russes were promoting at that very moment, thrilling young aesthetes across Europe with a new *Gesamtkunstwerk* that went beyond Wagner's conception and made sensuous movement its unifying element.[3] Like Nietzsche, Diaghilev believed that autonomy and morality were mutually exclusive. To achieve freedom of vision, the artist must have no regard for morality—that realm of the sterile and ugly.

To the growing emphasis on sensuousness in modern dance, Isadora Duncan, Rudolf von Laban, and Mary Wigman added a measure of mysticism. Duncan described herself as a *Seelentänzerin,* a soul dancer. Laban, one of the creators of *Ausdruckstanz*—expressive or Expressionist dance—associated dance with prayer: "The cathedral of the future is a moving temple built by dances that are prayers."[4] He was not only a dancer but a painter and illustrator as well. Over everything hovered the crucial urge of liberation, a pagan life-worship free from restriction and convention, beyond lie and inhibition. Laban was a key figure in the community of Monte Verità, founded at Ascona on Lago Maggiore in Switzerland in 1900, where "life reform" was the goal. There, on the mountainside, he opened his School for the Art of Life and taught a variety of arts, among them music and voice, in association with dance. His protégée Mary Wigman wished to enhance the spiritual dimension of dance by freeing it from the thraldom of music and

theatre—capturing the foundational moment when human beings first encountered the world and movement developed meaning. With her heavy brow and dark eyes, wavy hair and hoarse voice, she exuded both a nervous sadness and an insatiable appetite for engagement. An accomplished pianist, well read in philosophy and psychoanalysis, she set up a studio in Dresden in 1919 and stayed there for twenty-three years.

The theologian Paul Tillich, who always struggled with the dichotomy Christ or Eros and sought to fuse rather than divorce the two, would visit this studio regularly after he took a position at Dresden's Technical University in 1925. He was inclined to find more religiosity in dancers trained by Wigman than in theological commentary and church ritual. Dance for him was "a new encounter with reality at deeper levels." Tillich enjoyed dancing himself, and in remarks he titled "What Dance Means to Me," he argued that if religion was "the spiritual substance of culture," culture was "the expression of religion." Dance incorporated the idea of the holy—"the profane can profess the quality of holiness."[5] In 1926 he completed an article, "Das Dämonische," in which he proposed that the demonic was simply the irrational side of the divine. He always regarded this essay as one of his more original contributions.[6]

Vincent van Gogh would have enjoyed Tillich's formulations. Tillich certainly enjoyed Van Gogh, as he did Munch, Cézanne, and Franz Marc. If Mary Wigman's dancers inspired him, so too did the still lifes painted by Cézanne—he claimed to see more of the divine in them than in all the formal portraits of Jesus. Meanwhile, Marc's boldly abstract horses were, for Tillich, never individual animals but the "essence of horse."[7] The mystical, the demonic, and the erotic—these were increasingly the domains of a man who was to become one of the twentieth century's outstanding theologians.

One of Wigman's most famous dances was her *Hexentanz,* her witch dance, full of twitching, whirling, angst-ridden movement. Was it coincidental that Tillich's wife, Hannah, titled a journal entry for 1929 "The Diary of a Witch"? Her ruminations may have been provoked by her husband's fascination with Wigman or by her own longstanding affair, well known to her husband, with Heinrich Goesch, a spiritualist, psychoanalyst, and student of architecture. The trio in fact vacationed and lived together at various stages, while Goesch kept his own wife and family at a distance in Ascona. Tillich once told a friend, Richard Kroner, that he considered himself a great sinner—"Because I love women, drinking, and dancing." Kroner, in turn, would call his comrade a "demonic saint and a saintly demon."[8] The Tillich arrangement was hardly unique. Many other distinguished couples indulged in a passionate adventurism that decried conventional marriage as a death-dealing institution.[9]

Among Wigman's students was Leni Riefenstahl, before she became a film star and then Hitler's favourite director. The imagery and technique of dance would accompany Riefenstahl through her later work. Her films, especially *Triumph of the Will* and *Olympia,* and then her photography, were choreographed compositions exhibiting an intense and, some would charge, perverse eroticism. Notions of ecstatic consummation surrounded her presentation of healthy German youth and their merger with the *Volk.* In Dresden, under Wigman's tutelage, she produced a cycle called *The Three Dances of Eros.* The first, "Fire," was set to music by Tchaikovsky; the second, "Surrender," to Chopin; and the third, "Release," to Grieg.[10] Of her dance debut in Berlin, Fred Hildenbrandt, the arts critic for the *Berliner Tageblatt,* wrote, "When one sees this girl move to the music, one has an awareness that here is a dancer who will appear perhaps once in a thousand years, an artiste of consummate grace and unparalleled beauty."[11]

Riefenstahl's career as a dancer ended abruptly when she injured her knee. She moved promptly into film. In her memoir this part of her life is grouped together in a section titled "Dance and Film," as if these genres of expression were natural partners. One segment within the section is titled "Dance and Painting."

Another of the more provocative personalities in an era rife with provocation was Valeska Gert—this "virtuoso of the grotesque," as one critic called her.[12] Gert, too, was a dancer, perhaps not of the stature of Mary Wigman and Isadora Duncan, but certainly in the next rank. Leni Riefenstahl adored her.[13] Born Gertrud Valeska Samosch in Berlin in 1892, Gert began dance lessons about the time Anna Pavlova and her fellow Russians were conquering Europe. For her, Pavlova was "the most beautiful woman. . . . She had a tiny face. . . . She danced with the delicacy and lightness of a petal."[14] However, the 1914–18 war exhausted this culture of prettiness. Pavlova became *the* dying swan, expiring not elegantly and quietly but in agony. Attuned to the temper of her time, Gert felt compelled to devise and perform what she called her *Grotesque Dances,* expressions in dance of anguish and antithesis. She staged these first in October 1917 in the resplendent Four Seasons Hotel in Munich. According to the *Münchner Neueste Nachrichten,* they were greeted with "wild applause."[15] Gert began to exult in a culture of opposites. Dark and short in stature, this "white Negress" performed brief experimental numbers that questioned all notions of continuity and connection. One critic asked, "How could someone as unsweet, unblonde, unsoft and unbeautiful be popular with a mass audience?"[16]

After the war Gert revelled in the anxiety-choked culture of defeat that was Weimar. She parodied popular dance fads such as the tango and the Charleston and heaped scorn on the kicklines that were the essence of Weimar *Girlkultur.* She danced the underside of life and cultivated eccentricity and rebellion. One of

her most striking performances was called *Canaille,* her dance of the prostitute. "Provocatively I sway back and forth with my hips, lift my very short black skirt, reveal the white flesh of my thighs above the long black silk stockings and the high-heeled shoes . . . I am a sensitive whore." She sinks slowly to her knees, opens her legs wide, and reclines. As if stung by a tarantula she jerks high and then undulates. "I was dancing the coitus." The playwright and poet Bertolt Brecht was spellbound; he brought her to Munich. He organized an evening in the Kammerspielen. "Brecht played the lute and recited his ballads," Gert recalled. "I danced the *Canaille* to organ music."[17]

"She is the most intelligent of the dancers," wrote the critic for Berlin's *Vossische Zeitung.*[18] Gert had dances for all human moods: anger, despair, humility. She saw dance as the most intensive expression of the collapse of category: the modern dancer performed on the ruins of tradition.[19] "What she represents is not people, not even types," wrote the dance critic Harry Prinz, "they are ghosts. . . . What she represents is the appearance of appearance—and yet this is the only truth behind the myriad of lies that swagger every evening in the spotlights."[20] She even had a number called *Death* that Fred Hildenbrandt described as "inimitable, unsurpassable, powerful and unforgettable."[21] "I play corpses with pleasure," Gert would write in her 1931 memoir.[22]

Another enchantress of dance was Lucie Kieselhausen; her looks were said to be dazzling, her artistry more modest. At home one day, attired in a diaphanous morning robe, she was using petrol to do some cleaning. A spark ignited the fluid; the dancer turned into a human torch and burned to death.[23] Dance has always been associated with fertility and life. In Weimar it seemed so often to represent breakdown and death. In Anita Berber's routines, her stage companions wore ghostly makeup to evoke the dead.

Social dance followed a similar pattern, ranging from the knock-kneed excitement of the Charleston to the almost mechanical stomping and strutting of the Black Bottom. Hans Ostwald, a former goldsmith turned novelist, saw in the dance craze evidence that the social order was falling apart: "Grandma with bobbed hair danced in a short skirt with young men in the foyer, in a hotel, in a coffee-house: wherever she found an opportunity. Mama danced with friends. The nanny took the opportunity and danced as well—and the children were left all alone."[24] In recalling the nature of the dancing, the German writer Curt Riess could not help thinking that these dancers—all of them—had just been released from a "madhouse."[25]

## SODOMIA

### Les Peiroulets Ravine

If Laban, Wigman, and Gert represented dance as an intellectual challenge, the revue theatres and nightclubs stood at the other end of the spectrum. After the Great War, Berlin became a beacon of sensuality. Its nightlife, already vibrant before the war, now took on dimensions that made other European capitals look positively prudish—even those known previously for their licentious daring. Article 118 of the Weimar constitution, drafted in 1919 and ratified by the National Assembly in August of that year, stated that there would be no censorship. Though amended later, that article opened the floodgates to a cultural liberality without match. The writer Oskar Maria Graf would speak not of the political but the "sexual democracy" of Germany, and Thomas Mann would refer to Eros as a "statesman" of the Weimar Republic.[1]

The celebrated American dancer and singer Josephine Baker, no slouch at judging such action, thought that Berlin's nightlife

had "an intensity Paris doesn't know," and she considered staying in the German capital after her first visit in 1926. "Berlin is where I received the greatest number of gifts," she noted with a smile. She had taken Paris by storm in 1925 with the *Revue nègre,* but Berlin seemed to love her even more. Max Reinhardt, the director, offered her a three-year contract at the Deutsche Theater, insisting that he would make her "the greatest star in Europe." She was tempted, but in the end she returned to Paris and the commercial glamour of the Folies-Bergère.[2]

Berlin's appeal extended to the entire gamut of sexual inclination—to a life force of infinite variety. Restrictions collapsed. Clubs for all tendencies sprang up. Free love, in its various mutations, became chic. "Perversion was the fashion," noted Curt Riess.[3] The ancient city of Sodom had nothing on modern Berlin. To the Russian novelist and diplomat Ilya Ehrenburg, "the ordinary modest street-walker who makes tactful advances to the passer-by seems a paragon of virtue."[4] Many besides Riess considered Berlin a madhouse—the words *toll* and *Tollhaus* run through much of the commentary. Others spoke of a *Verwilderung der Sitten*—literally, the return of morality to the wild.

Drug use was widespread, cocaine the analgesic of choice. It was available, Riess remembered, in every other club from the woman supervising the toilets.[5] Alcoholic beverages flowed freely: the average annual intake of beer by Germans jumped from thirty-eight litres in 1920 to ninety by 1929.[6] The artist Käthe Kollwitz, certainly not prissy, was shocked when she and her husband, Karl, visited the Café Dalles on May Day, 1922, on their way home from a cold and rainy workers' celebration in the Lustgarten. "It was crazy there," she wrote in her diary. "A pimp and criminal band the likes of which even the *Caveau des innocents* [in Paris] couldn't match. Girls—half children—totally wasted. At the back of the club sat a young fellow at a piano and played while people

sang. We couldn't take it; it was all too aggressive and uncomfortable."[7] Kollwitz noted that the new eroticism went by the name "religious Bohème": "That reminds one of the Anabaptists and the days when, as now, the apocalypse was announced and the thousand-year Reich was said to be imminent."[8] Curt Moreck suggested brandy soda as the best drink in these clubs. The brandy would be awful, but the soda always splendid.[9]

In the White Mouse cabaret on the Jägerstrasse, the ninety-eight seats at ten marks apiece were sold out night after night. Guests who wished not to be recognized could acquire a mask at the door. Fred Hildenbrandt, the feuilleton editor of the *Berliner Tageblatt* from 1922 to 1932, found the performances "perverse" but admitted that he attended for just that reason. "That it was basically intolerable, we knew. But we probably had a hankering for the obscure and even the obscene, an urge well hidden and well guarded in the depths of every soul but lurking there nonetheless. At this time after midnight the guests were ready for the apocalyptic sight of several unrestrained maenads on the other side of the footlights." He was invited to visit Anita Berber in her dressing room. Berber made Valeska Gert's grotesqueries seem like mild confections. She took the themes of dissolution, decadence, and death and enacted them in life as well as on stage. "We dance death, sickness, pregnancy, syphilis, madness, dying, plague, suicide," she told Hildenbrandt, "and no one takes us seriously."[10] Charlotte Berend, the wife of the painter Lovis Corinth, produced eight lithographs in 1919 dedicated to Anita Berber, showing the dancer as *Dirne*, or whore. Otto Dix painted Berber in 1925 in his famous portrait in red where the dancer appears snake-like and depraved. When Klaus Mann met the infamous Berber, he had the impression that she did nothing but lie.[11]

To homosexuals around the world, Berlin was a beacon in the 1920s. Homosexuality, though still illegal, was the fashion of the

day. Many joined in, Curt Riess asserted, who were *stinknormal*—
stinking normal.[12] The physician Magnus Hirschfeld had estab-
lished the first homosexual lobby group in 1897, for amending
Germany's laws on sexuality. After the war the Republic's lack of
censorship brought on a tidal wave of gay literature and film. In
1919 Richard Oswald produced a remarkably progressive film,
*Anders als die Andern* (Different from the Others), in which a
well-to-do bourgeois homosexual, played by the esteemed actor
Conrad Veidt, is blackmailed by his lover. Anita Berber had a role
in the film, and Magnus Hirschfeld played the part of a doctor
who delivers the line "Respected ladies and gentlemen, take heed.
The time will come when such tragedies will be no more. For
knowledge will conquer prejudice, truth will conquer lies, and
love will triumph over hatred."

The number of homosexual locales multiplied. Hirschfeld
estimated that in 1896, when he arrived in Berlin from Magdeburg,
there were perhaps a half-dozen such places; between 1900 and
1910 this number probably doubled; but in the next decade it
increased at least tenfold. In 1922 the socialist newspaper *Vorwärts*
counted 150 gay bars in Berlin. Hirschfeld thought that number
a little high, but he agreed that it was increasing all the time. He
attributed this trend not to the "brutalization of values" but to
the more tolerant attitude of the police. The police, he said, were
much happier to have the gay community meeting in clubs than
in the street.[13] In 1922 a Berlin police commissioner estimated
the number of homosexual men in the city at more than 100,000.
By 1930 the estimate had reached 300,000.[14] The pressure to
repeal Section 175 of the criminal code, which criminalized
"coitus-like" behaviour between men, was mounting by the late
1920s, and some have suggested that had Hitler not come to
power, the decriminalization of homosexuality would have been
achieved in 1933.[15]

The British trio of Christopher Isherwood, W.H. Auden, and Stephen Spender were but some of the thrill-seeking foreigners attracted to Berlin. Auden couldn't get over how good-looking and cheap the boys were. "The buggers daydream," he called Berlin, ignoring as he so often did the issue of apostrophic attribution. Was he dreaming of himself or of his entire cohort indulging? "There are 170 male brothels under police control," Auden continued with excitement, counting presumably the gay bars in that number. "I could say a lot about my boy, a cross between a rugger hearty and Josephine Baker. We should make D.H. Lawrence look rather blue. I am a mass of bruises." Auden apparently liked the rough stuff, and Berlin was prepared to give it to him in spades. The renowned occultist (and bisexual) Aleistair Crowley could hardly contain himself during a visit: "I haven't done anything like this since I was in Port Said," he burbled.[16]

But Berlin beckoned not only as the bugger's daydream but as the rebel's fantasy too. Berlin was the capital city of the defeated, the forlorn, the lost. It embodied an oppositional culture in every sense. Auden, Isherwood, and Spender went there not simply for the sex but because Berlin stood for antithesis and contradiction. The sex was but part of a broader rebellion against the respectability of elders and homeland. Spender denounced what he called "English censorship," and for him Germany became "the front line" in the war against it. Auden wore a German workman's cap and smoked cheap cigars. Isherwood, whose father had been killed in the war against Germany, had now withdrawn from Cambridge without completing his degree. For all of them, moving to Berlin was a political as well as a moral gesture.[17]

No one of the stature of Oscar Wilde was ever put on trial in Germany for "unnatural acts." On the contrary, it was well known that the German youth movement, the *Wandervogel,* as well as the alternative-lifestyle crowd, the *Lebensreformbewegung,* and

even the paramilitary *völkisch* organizations of Weimar, including Hitler's SA and SS, were rife with sexual innuendo of every stripe.

## SUN CHILD

*The Garden of Saint-Paul Hospital*

After all the violence inflicted on the human body in the Great War, that body was celebrated in the postwar world. After the nightmare of the trenches, the body became the focal point of a renaissance, an affirmation of life. Mary Wigman, it was said, made art out of her own body.[1] When Josephine Baker danced at the Folies-Bergère, her sublime figure was reflected and multiplied in endless mirrors and lights. "All around us," remarked one observer, "we had thousands of Josephines, reflections and shadows, dancing."[2] In his famous 1929 piece in *Der Querschnitt* titled "The Charm of Berlin," Harold Nicolson, who had served as counsellor in the British embassy, described the city as "a girl in a pullover." Stephen Spender went a step further. "Nakedness," he wrote in the wake of his experience of Germany in that same year, "is the democracy of the new Germany." The Germans, he said, "worshipped the body, as though it were a temple."[3] The nudity was of course not all sweetness and light. As a nude dance craze swept the country in 1922, one critic remarked that much of it reminded him of "farmers' displays."[4]

If the body was worshipped, so was the sun. In the drab dawn of the world after the Great War, the sun was a source of hope and power. The sun represented rebirth and vitality. George Grosz titled his allegorical 1926 painting about the greed and corruption of the old elites and the mood in Germany as a whole the *Eclipse of the Sun.* All his angry and anguished work can be seen as a plea for the very opposite: the return of the sun and the

resuscitation of life. The fifth section of Alfred Döblin's "criminal novel" *Berlin Alexanderplatz* ends with a celebration of the sun. The swastika that the Nazis adopted as their symbol of regeneration was an ancient sun symbol.

This attention to both the body and the sun merged in the notion of the *Sonnenkind,* the child of the sun. This creature was a combination of dandy, rogue, and naïf.[5] The dandy was flamboyant, openly sardonic, and preoccupied with existence as theatre; he was concerned above all with making an impression. The rogue was motivated by rebellion, the act of opposition, generational and aesthetic. For him, the hoax and practical jokes were powerful stimulants. The naïf, by contrast, radiated innocence, honesty, decency, and a need to eliminate complexity.

The naïf was the purest version of the *Sonnenkind* and the most attractive.[6] He posed as victim, but the vulnerability became a form of agency as well, in that it invited aggression and obsession. The dancer Vaslav Nijinsky, who loved art and music and thrilled the world, was a naïf. Charlie Chaplin's little tramp, buffeted ruthlessly on the road of life, was a naïf. Erich Maria Remarque, whose phenomenally successful *All Quiet on the Western Front* was on everyone's mind at the end of the twenties and who generated his own identity from the boyish and beautiful victim-soldier of the Great War, was a naïf.[7] The youthful poet Stephen Spender, who carried much of the aesthetic ambition of the Oxbridge postwar generation on his shoulders, exuded a similar charm. Cyril Connolly, the literary critic, called him "an inspired simpleton, a great big silly goose."[8] In the commentary from the late 1920s and '30s, Spender is surrounded by a shimmering aura. The British novelist Rosamond Lehmann remarked how he would come "bursting . . . into rooms like a fiery sunrise, beaming, beaming, beaming."[9] He seemed the embodiment of Byron's "Sun in human limbs arrayed." The

American expatriate composer and author Paul Bowles met Spender in Berlin and visited him in his rooms on the Motzstrasse. From that visit he carried away an image of the young Spender, blond and sunburnt, standing in the middle of his room with the setting sun pouring through the window so that he looked "as though he were on fire." Spender responded with comparable associations. His poems of the period are full of sunlight and "bronze-faced sons." It is as though he saw the world as a reflection of himself.[10] Other moderns, too, followed the dictates of the sun. André Gide, always willing to obey his physical desires, declared that "to grow straight you need nothing now but the urge of your sap and the sun's call." He was in Berlin during the summer of 1930. "I wanted to taste this summer petal by petal, as if it were my last."[11]

Authentic experience was the quest of the *Sonnenkind*, but the very urgency of the quest suggested that the idea of the genuine had become a will o' the wisp. Gide had been playing with this theme of authenticity for some time and, in 1925, developed his latest thoughts in his novel *Les Faux-monnayeurs* (The Counterfeiters). Following in the steps of Friedrich Nietzsche, Charles Baudelaire, Joris-Karl Huysmans, and Oscar Wilde, he posited that counterfeiting was not a crime but an invocation of life. Ambiguity was not uncertainty; it was a celebration of multiplicity. For Gide the novel itself, in its attempt to replicate some form of reality, was a counterfeit product. Gide grappled with form as much as content, so that the realms became inseparable. *Les Faux-monnayeurs* is in fact the title of a novel that one of Gide's characters, Édouard, is writing. He is asked what the subject of his novel is. "Il n'en a pas," he replies— It has none.[12] The shadow casts its own shadow. Perhaps all is shadow, desire unfulfilled. Art, too, is but a form of shadow, the counterfeiting of life.

"We live in a time of false imitation," wrote the psychiatrist-philosopher Karl Jaspers in 1922, "of the transposition of all that is spiritual into bustle and institution."[13] In this world where any notion of essence was the real sin, the rebels were the heroes, the transgressors the pure of heart. Equivocation on every level was the norm.

Such was Otto Wacker's world.

## SHOWTIME

*Vincent's House in Arles (The Yellow House)*

Otto Wacker sensed very well the direction of these postwar cultural winds. He would live the transgressive essence of Weimar to the full. Survivor of poverty, vagabond in life, he took up Argentine and Spanish dance with its exotic passion and tragic innuendo. Simultaneously he developed a more serious interest in a career on the stage. His father was a self-taught painter, and Otto a self-taught dancer. He devised a stage name for himself, Olindo (later Olinto) Lovaël, and, together with his sister, Luise, set about performing "old Spanish dances" (*altspanische Tänze*). He partnered Luise at the outset, then her fiancé, Erich Gratkowski, and finally developed his own routine.[1]

According to his later account, at this time he met Ernst von Wolzogen, a pioneer of cabaret theatre in Germany, and was invited to join the Schall und Rauch (Noise and Smoke) company in Berlin's Grosses Schauspielhaus (Grand Theatre). His associates recalled that he often appeared in a sailor's blouse and cap—a costume indicative of sexual inclination. In his guide to Berlin, Curt Moreck described a scene in a gay bar: "At one corner of the table two fellows in blue sailor suits have deposited themselves. The suits are much too blue and the faces hardly weathered; the

only ship they've ever been on is a Wannsee boat. But there are supposed to be clients here who have a preference for sailors."[2]

The affiliation with Noise and Smoke was sporadic. The good-looking young man attracted attention. Otto arranged to put on a number of solo performances at the Blüthner-Saal, the famous Berlin concert hall named for the piano manufacturer. After they proved successful, he went on tour. One of his programs announced a wide range of exotic Spanish and Argentine performance: "Dances . . . battle, religious grotesque, gaucho, torero, legerdemain." The reviews were often glowing. In 1924 the society magazine *Elegante Welt* ran a feature article about him with pictures calling him "a new dance phenomenon":

> To the list of dance individuality was recently added a personality of phenomenal ability that Berlin audiences have already had an opportunity to see. Olindo Lovaël, the Spaniard, dances the richly textured rhythms of his southern homeland. He brings sacerdotal sculpture to life in dance, in part without music. His being is filled with religious intensity and all his movement is replete with spirituality. Thus it is logical that his appearance here has been accompanied by extraordinary acclaim. His evenings of dance in the Blüthner-Saal left a lasting impression on all visitors. Doubtless he will have great triumphs on the foreign tournée that he is undertaking to Switzerland—to St Moritz and Davos—together with Valeska Gert.[3]

Obviously, no one had bothered to investigate the background of this "new phenomenon." And now, for his tour, Wacker was teaming up with Valeska Gert, a rebel as well as a dancer. She was a star, a punk, and a goth ahead of her time. Otto Wacker, the young and delicate Düsseldorfer, was no longer just a pretty provincial sideshow but part of the metropolitan headline.

While the bravos for Wacker appear undeniable, the extent and the depth of the enthusiasm are harder to determine. A file on "Olinto Lovaël" in the German Dance Archive in Cologne includes several pages of ecstatic reviews purportedly from German and foreign newspapers, ranging from the left-wing *Vorwärts* to the conservative *Deutsche Tageszeitung*. However, this list of notices, compiled in typescript by Wacker after 1945 when he was trying to resume his dance career, is suspect. No dates of publication are provided, and the detail seems too good to be true. All the references are to Olinto rather than Olindo, as he was known at this early stage in his career. To the *Neues Wiener Journal* is attributed the comment that the Vienna State Opera should try to win Lovaël for its enterprise. To Amsterdam's *De Telegraaf* the question, "This dancer has had sensational success in all the cities of Europe. When will we see Olinto Lovaël again?" To his hometown *Düsseldorfer Nachrichten* the remark: "He was fantastic. . . . We hope that he returns soon."

## PALACE REVOLUTION
### *The Courtyard of the Hospital at Arles*

The political upheavals in Germany at the end of the war, as military defeat forced a reconsideration of all assumptions, engulfed the public world of art as well. At the National Gallery in Berlin a drama played out that was every bit as exciting as that at the Imperial Palace just down the street, where on November 9, 1918, the royal family packed up and left, driving by motor car into exile in Holland. While some had been suggesting that he head for the war front and find himself a bullet, the kaiser was in no mood for romantic gestures.

With the abdication of the Hohenzollerns and the assumption

of power by socialists, temporary though it proved, an opportunity arose to assign new purposes to the royal palaces in the centre of Berlin. Through the intercession of the banker and art lover Hugo Simon, the Kronprinzenpalais (Palace of the Crown Prince) on Unter den Linden, adjacent to the State Opera and Humboldt University, was accorded to the National Gallery—and then assigned to house the modern collection. Simon seemed more a character in an Expressionist play than a banker. Like Paul Cassirer, he had joined the Independent Socialists because of their principled opposition to the war, and he served briefly as Prussian finance minister after the armistice. An avid art collector, he also sat on the boards of the illustrious Fischer and Ullstein publishing houses and acted as Cassirer's financial adviser.

The director of the National Gallery, Ludwig Justi, was an equally energetic, even restless, figure who, as soon as he was appointed in 1909, had begun to lobby for a museum for twentieth-century art. Though the century was still young, he suggested in a memorandum to the kaiser, it needed a new building to house its already distinctive art. The main National Gallery complex on Museum Island in the heart of old Berlin—where artifacts from some 600,000 years of human history were housed in a group of buildings including the famous Pergamon Museum—simply did not suffice. "For the art of the next decades," he argued in another document, "a building has to be created by a master who has our age in his nervous system."[1]

The turmoil at the end of the war suddenly gave Justi his opportunity. In August 1919, on the strength of Simon's efforts, Justi opened the Gallery of Contemporary Art. The location of the new gallery, a short walk from the main branch on Museum Island, and the choice of pictures displayed there carried a powerful political and aesthetic message. The ground floor of the Kronprinzenpalais displayed the French Impressionists and the

Berlin Secessionists from the late nineteenth century, and the whole upper storey housed the more recent German Expressionists. The new gallery became a hotly contested institution, subject to endless controversy and tirade. Franz Marc's sensational blue horses made the public gasp, as did Max Pechstein's unusual flowers. In its symbolic central situation, on a broad avenue dominated by the iconic architecture of Karl Friedrich Schinkel, with a statue of Frederick the Great on horseback in close proximity, the new gallery was nothing less than a provocation.

One leading museum director called the modern gallery a "chamber of horrors"; others derided it, especially the upper floor, as the culture of Bolshevism, which in turn was described as the politics of the back alley. Contemporary art, the conservative opposition insisted, did not belong in a museum but on the street. It was "asphalt culture," superficial, juvenile, soulless. Its natural habitat was the café, newspaper office, or, better still, hospital emergency ward. History, not politics, should determine the content of museums and acquisition priorities, these critics fumed.[2]

Immediately after the war, the National Gallery had limited funds for new items. Still, because the price of most contemporary art was extremely low, a few purchases were made. Before many years passed, however, the weakness of the mark and the rapidly accelerating inflation had wiped out what little there was in these acquisition funds. Only when the currency had stabilized in the middle of the decade did new state monies become available. By then, differences of opinion within the gallery's board about the direction in which the collection should go made any prominent purchases difficult. Some art lovers had lost all faith. For a frustrated gallery director like Fritz Wichert of the Mannheim Museum, the morass of immediacy that constituted postwar life undermined the importance of art completely.[3]

For its time, the Kronprinzenpalais had the most venturesome display of modern art anywhere. Neither Paris nor London had a venue that could compete. Alongside the permanent collection, a number of special exhibitions—Ernst Ludwig Kirchner in 1921, Franz Marc in 1922, Paul Klee in 1923, and Otto Dix in 1924—drew international attention. In 1927 a major show of the work of Edvard Munch attracted crowds. The Kronprinzenpalais would serve as a model for Alfred H. Barr Jr., who visited in 1927, and for his plans for the Museum of Modern Art in New York, which would open its doors two years later. Barr wrote to Justi, "Our institution seeks to fulfil the function of a Kronprinzenpalais! I cannot tell you how delightful and exhilarating my visit was! Here Picasso, Derain and Matisse rub shoulders with Klee, Nolde, Dix, Feininger and the best of the modern Germans. . . . In New York we are much handicapped by the fact that there is only one art museum, and it has shown practically no interest in modern art."

Then Barr asked for help: "We would appreciate some statements as to the advantage of maintaining a separate institution devoted to modern art."[4]

As Barr's appreciation indicates, while Justi and Berlin's National Gallery may have led the way, modern art was making inroads elsewhere. In France in 1920 both the Salon d'Automne and the Salon des Indépendants, the leading prewar showcases of artistic independence, were for the first time granted a measure of official sanction when they were permitted to use the state's Grand Palais, the large glass hall built for the Paris Exposition of 1900. Indeed modern art, or for that matter modernism in all its manifestations, came to be widely accepted in the course of the 1920s, despite all the criticism levelled at abstraction, technicism, sensationalism, and subjectivity. The influential visual art critic Paul Westheim argued at mid-decade, after

viewing the much-applauded *Exposition Internationale des Arts Décoratifs et Industriels Modernes* (International Exhibition of Modern Decorative and Industrial Arts) in Paris, that the general public had come to accept modern art, even if most people did not necessarily understand or endorse it. The new art, he pointed out, was to be seen everywhere—in commerce, the home, and the cinema. Contrary to the intentions of most modernists, art had become a commodity—*Sachwert*—instead of an idea. Function and utility were central to all contemporary conceptions and their reception. The 1925 Paris show, so widely admired as an expression of the aesthetic and even the moral impulses of the age, certainly seemed to underline Westheim's point.

In the move toward style, as opposed to ideas, Westheim saw danger. High art would not be able to compete, he felt, with sport, technological sensation, and the cinema.[5] By arguing in this manner he was still resorting to old categories, underestimating the degree to which process had already overtaken substance in modern life and the extent to which designations such as "high" and "low," "elite" and "popular," were no longer adequate. It was not just art that was being influenced by scientific and technological change, by social and political radicalism, and by a general craving for newness. Imagination as a whole, in every realm, was caught up in the aesthetics of style. The Great War had undermined authority, and along with it authoritative meaning, at every level.

In the economic conditions of the early 1920s, collections, both public and private, would often shrink rather than expand. For example, Article 247 of the Versailles Treaty demanded, as part of the reparations process, the return to Belgium of Belgian art lodged in the Berlin Museum since the early nineteenth century. Many private collectors, too, were forced by economic circumstance to sell their treasures. Others saw opportunity in

the turmoil, as currency instability turned *objets d'art* into investment. When Käthe Kollwitz, known for her socially conscious art, saw one of her pieces get a bid of 90,000 marks at auction in November 1922, as inflation raged and prices shot up, she was deeply disturbed. She knew that commercial considerations would undermine the integrity of her work, at both the creative and the public stages: "And so my pages become objects of speculation," she said.[6] In a similar mood, Tilla Durieux remarked that Cézanne and Van Gogh were now regarded as "stocks that will continue to climb." Much of the old wealth in Germany, which had viewed art primarily as objects of beauty rather than investment, was ruined by the inflation. The newly monied had a more basic approach: Is the piece worth buying for the future? A dealer like Paul Cassirer found the change in atmosphere depressing. Instead of serving as an adviser, a moral and aesthetic force in the community, he found himself a merchant of wares. Simply turning a profit was of no interest to him, and he began to lose his passion for his trade. The younger generation of artists did not excite him; he left them to his colleague Alfred Flechtheim.[7]

Confidence evaporated along with savings. Though the transformation did not occur overnight and the economic woes were only part of the story, the educated German middle class, the *Bildungsbürgertum,* gradually yielded cultural dominance to the promoters of mass culture, the new moguls of film, radio, and street spectacle. These people and their progeny were a new genus. Thomas Mann's 1925 story "Unordnung und frühes Leid" (Disorder and Early Sorrow) is set in the inflationary period. The main protagonist is a forty-seven-year-old professor of history, with a wife and four children. The children call their parents "the ancients" and their grandparents "the ur-ancients"; the eldest son—seventeen at the time—wears eyeshadow and wants to

become a dancer, cabaret artist, or waiter. His role model, Ivan by name, is "an artist of the new school who stands on the stage in strange, highly mannered, and unnatural poses and screams in anguish." "For a professor of history," Mann writes, "this is impossible to take in."[8] Nothing, the Austrian writer Stefan Zweig would remember later, ever embittered the Germans as much as the inflation. Thomas Mann concurred. Having been robbed of their savings and wages, the Germans, quite naturally, he said, "became a nation of robbers."[9]

If political and economic tumult seemed to overwhelm leadership and planning in those early Weimar years, the modest stabilization that came after 1924, with currency reform, a revised reparations plan, and a measure of political compromise at the national level, was accompanied by a new sobriety in the arts—a practical temper accorded the soubriquet *neue Sachlichkeit*—new objectivity. "Reason" was the oft-invoked motif of this successor mood. Someone who supported the republic of Weimar not out of passion but out of necessity was called "a republican by reason."

Even international tensions showed signs of abating in the years after the middle of the decade. The Locarno Treaty of 1925, by which Germany acknowledged as permanent its western boundary, inaugurated a surge of positive diplomatic activity. Over the next four years Germany was admitted to the League of Nations, the terms on disarmament were mildly modified, another gentler plan on reparations was proposed, and the Kellogg-Briand Pact abolishing war as a means of diplomacy was signed. Gustav Stresemann, the German foreign minister who presided over this new sobriety in international relations, was accorded the Nobel Peace Prize, along with his French counterpart, Aristide Briand.

The widely read arts critic Paul Fechter was nevertheless skeptical whether anything had really changed. People were speaking

of the "post-Expressionist period," he said, but only a phase had ended—one that was but a small part of a general upheaval that might last for a century.[10]

## STORIES

*Portrait of Doctor Gachet*

In Germany in the 1920s, in an emergent celebrity culture *avant la lettre,* biography as a literary form became all the rage. That most perceptive interpreter of popular culture Siegfried Kracauer, the journalist, film critic, and intellectual extraordinaire, called biography the "art form of the new bourgeoisie,"[1] of that social grouping—the clerks, managers, and service personnel—disgorged by the second phase of the Industrial Revolution at the end of the past century. Friedrich Gundolf's *Goethe* (1916), Ernst Bertram's *Nietzsche* (1918), Berthold Vallentin's *Napoleon* (1923), Ernst Kantorowicz's *Kaiser Friedrich II* (1927), Friedrich Wolters's *Stefan George* (1930), as well as an endless stream of studies by Emil Ludwig—on Goethe, Napoleon, Wilhelm II, Bismarck, Lincoln, Schliemann—were some of the enormously successful books that celebrated the ideas of genius and charisma. Included in that number was Julius Meier-Graefe's *Vincent,* his biography of Van Gogh. It was serialized in 1920 and published in book form the following year.

This celebration of charisma, a concept the sociologist Max Weber had formulated before the war, seemed to infuse the culture as a whole. The poet Stefan George gathered around himself a circle of devotees who referred to him as "master." Kantorowicz, close to George, argued that the myth surrounding a historical personality was an integral part of the historical reality: his protagonist, Friedrich II, the medieval emperor who in his own time

was known as *stupor mundi*, bore within him the greatness that would later be ascribed to him. Aura and imagination, while spiritual, were but an extension of reality. The dance critic Else Gellhorn followed this line of thinking by insisting, with Pavlova, Nijinsky, Duncan, and Wigman in mind, that personalities, not theories or schools, were the key to all great art, and Paul Westheim concurred wholeheartedly.[2] Accordingly, in the public mind, film stars and death-defying pioneers assumed godly dimensions. The mob scenes accompanying the funeral of the actor Rudolph Valentino in 1926 and Charles Lindbergh's aeronautical heroism some months later, when he flew the Atlantic solo, revealed strikingly the popular hunger for larger-than-life personalities. Politics, in an era of never-ending crisis, came to be obsessed with leadership. Kracauer saw in biography a welcome condensation of history that otherwise had become "blurred and ungraspable." Biography provided meaning. A duce or a führer could provide meaning too.

Fitting into this pattern, Meier-Graefe's *Vincent* was a resounding success. The novelist Elias Canetti would recall that "around this time, the Van Gogh religion began." His choice of words was intentional. The experience of art in its evocative multidimensionality and mystery, he was saying, was similar to the experience of religion. With the help of Meier-Graefe, Van Gogh had become more than an artist. He and his work had blended into a formidable myth that assumed transformative power. In the person of Van Gogh and in his legacy, defeat was turned into victory, poverty into wealth, disputation into reverberating spiritualism. Germans wallowing in self-pity could readily identify with the artist and his art. After the appearance of the biography, Van Gogh became the main topic of conversation in the dining room of the Frankfurt boarding house where the young Canetti and his mother were living. One resident of this *Pension Charlotte*,

a teacher, confessed that after reading Meier-Graefe's life of Van Gogh, she finally understood what Jesus Christ represented.[3]

The literary dimension in this wave of biography was as important as its content. The authors aimed to produce works of art in their own right. Meier-Graefe, along with other biographers like Emil Ludwig, questioned the idea of historical objectivity and described their work as historical fiction, biographical novel, or, in the case of *Vincent*, a *Künstlerroman*. The latter term was appropriately ambiguous. It could mean an artist's novel or a novel about an artist. Both Meier-Graefe and Ludwig readily admitted that they imposed contemporary concerns on the past. For Meier-Graefe, the art and personal life of Van Gogh were not any kind of static truth but interconnected symbols. "If eventually Van Gogh's bold intervention in art should fade, if his figures and his skies should lose their power," he wrote to his publisher, Reinhard Piper in Munich, "one thing will remain, his heroism."[4]

On the relationship between life and art, Meier-Graefe took his cue from the artists he admired. So much of life, he pointed out, was cantankerous and ugly; art provided a refuge. "The age sounds a retreat," he wrote. "If only one knew where to withdraw. The church has gone cold, and those other places that used to offer a sense of community have shattered windows. . . . Let's build a wall and withdraw into ourselves. . . . We'll fortify the exterior and decorate the interior with brilliant damask. And we'll carry whatever we can inside. We'll be extravagant. Once we have a little joy, we'll deal, composed and confident, with the leers from outside."[5] Meier-Graefe repeatedly regretted the loss of community in his secular world, but his own escape into aestheticism, into his own Yellow House, did nothing to counter that loss.

Many with a social conscience were offended by this retreat from social values into a realm of self-gratification. The Dutch historian Johan Huizinga, an early admirer of Van Gogh, was

profoundly discouraged by such an attitude, particularly when it carried over to historiography and scholarship. The overt fictionalization of history was in his eyes a crime. "As soon as the past is converted into the language of the novel . . . the sacred essence of history has been adulterated," he wrote in 1929. He reminded his reader of Goethe's comment to his friend Johann Peter Eckermann: "When eras are on the decline, all tendencies are subjective; but . . . when matters are ripening for a new epoch, all tendencies are objective." The present era was not favourable to the historian, Huizinga concluded. The levelling effect of democracy was turning history into literature. Beyond Huizinga, the historical profession as a whole, especially in Germany, was deeply concerned about what was regarded as the loss of objectivity.[6]

The relationship between historical writing and imaginative literature reached the program of the national convention of German historians, held at Halle, in 1930, where Ernst Kantorowicz gave a keynote address. "The free artist and the free academic," he postulated, "obviously walk hand in hand today, in the same way that generally historical scholarship and historical fiction are, despite their mutual animosity, rightly interchangeable concepts." Many academicians were stunned and offended by this claim that history and fiction had much in common. History, they insisted, had nothing to do with invention and imagination, and everything to do with the faithful reconstruction of a past reality. A report on the convention in the *Berliner Börsen-Zeitung* saw in Kantorowicz a symptom of social breakdown: German youth, led by young intellectuals like him, were turning away from the principles of positivism and the values of the Enlightenment toward inwardness and mysticism. The world, this correspondent warned, was in danger.[7]

Although Meier-Graefe was read and applauded by the public, he had no lack of detractors. His success was derided by many of

his associates in the art world, and his critical abilities were questioned. The academicians who had hitherto dominated art history dismissed this interloper as a hack. Ludwig Justi, at the National Gallery, turned into a bitter foe. Much of the animosity was rooted in envy: Meier-Graefe attracted a readership about which Justi and the professoriate could only fantasize. The young nonconformist historian Eckart Kehr spoke of "the bitter war" between the university establishment and the fabulously successful literati.[8]

An English translation of *Vincent* was quickly prepared by John Holroyd Reece, Meier-Graefe's talented translator and British publisher. In the United States, Herbert S. Gorman, the author of some twenty historical novels and biographies, was most impressed by the English version: "The book moves like a poem, a highly intellectualized poem that is yet vibrant with the impulses of life. Beneath the sliding cadences of exquisite sentences . . . the figure of a man reveals itself, grows to more than life-stature and eventually stands as a typification of a certain art-urge."[9] In his appreciation, Gorman emphasized the life and downplayed the art.

After Meier-Graefe's *Vincent*, the Van Gogh wave in Germany, and increasingly elsewhere as well, rolled on with added energy. Art journals like *Der Cicerone, Ganymed, Kunst und Künstler,* and *Das Kunstblatt* printed endless reproductions of Van Gogh's work. Hermann Kasack, a poet, playwright, and pioneer of German radio broadcasting, completed a play in the summer of 1923, *Vincent: Schauspiel in fünf Akten* (Vincent: Play in Five Acts), which had its premiere in Stuttgart the next year and was then performed in a number of other German cities—Nuremberg, Leipzig, Cologne, Weimar, Essen, Hamburg, Bremen, and Breslau. Forgotten today, it was a series of tableaux depicting the artist as a tragic hero and the world of art as a realm of miraculous

possibility and great danger. The fourth act, portraying the deadly confrontation between Gauguin and Van Gogh, ended with the biblical invocation from Matthew 18: 8–9: "If your hand causes you to sin, cut it off. . . . And if your eye causes you to sin, pluck it out. It is better for you to enter the kingdom of God with one eye than to have two eyes and be thrown into hell." To this Kasack had Vincent add, "If your ear troubles you because it gives false witness against your neighbour, then tear it off—Then tear it off." The last act ends with a credo that mutates into a cry of despair. The wind howls. A strong gust extinguishes the light in the room. The curtain descends.[10]

As an author and a reader for the publishing houses of Kiepenheuer and S. Fischer, Hermann Kasack was a stalwart of the literary culture of the Weimar Republic, but he was also an important link between literature and the new media. In the middle years of the republic, 1925–27, he produced a successful radio series devoted to contemporary authors that he called *Stunde der Lebenden* (Hour of the Living) and was also involved in the production of radio plays.[11] That someone so significant in the culture industry was profoundly affected by the life and art of Vincent van Gogh speaks to the influence of this phenomenon and to the mood, cultural and moral, of Weimar. Van Gogh's life and art—his loneliness, his constantly futile quest for friendship, and his artistic brilliance—resonated. The naïf, the vagabond, the eternal artist-victim had metamorphosed into a hero comparable, in a way, to that other Christ figure of the age, the unknown soldier, the *Frontsoldat*. In fact, the soldier and the artist were one and the same. Adolf Hitler, would-be artist and decorated veteran, certainly thought so.

In 1923, as Meier-Graefe's *Vincent* was being read widely and as Kasack was writing his play, the Expressionist novelist and playwright Carl Sternheim completed another version of an essay

on Van Gogh that he had been working on for years. At the height of his own success before the war, he had bought a number of Van Goghs but recently, out of economic necessity, had been forced to sell seven of them. The artist continued to haunt Sternheim, as did the relationship of art and money, creativity and success. His own predicament, the applause that had been replaced by material need, cried out for explanation. If in the past, Sternheim argued, Germans had looked to art for salvation, tending to fuse religion and art, they now looked to art for a quick fix. Aesthetics had replaced religion, and, if the current situation was any indication, commerce was likely soon to overwhelm aesthetics. The country was flooded with art books and journals; every little village, he quipped with savage irony, seemed overrun by art historians. Publishers who used to inflict the proverbial German *Dichter*—the writer who was by definition a poet—on the land had now turned to churning out art books. No distinction was made between the work of Frans Hals and some local fool trapped in everlasting puberty. "And so Van Gogh, the greatest painterly genius in centuries, could become the acknowledged artist-god of races and masses, because an army of art critics, Germans first and foremost, saw epitomized in him all those qualities that a complete human being and artist never could have and naturally never has had."

The public reception, the mythologization, had stripped Van Gogh of distinctiveness and turned him into an object of "petit-bourgeois kitsch," with "the likeness of a collectively minded idiot."[12] Sternheim, looking for people to blame for the fate of Van Gogh, for his own plight, and for the wider crisis of mind and politics, was clearly directing these remarks at the eminently successful celebrity biographer Julius Meier-Graefe.

The Van Gogh motif surfaced repeatedly in Weimar discourse. Literary references abounded. Hermann Hesse, the venerated

author of *Demian* and *Steppenwolf,* took material from Van Gogh's Arles period for his story "Klingsors letzter Sommer" (Klingsor's Last Summer). Klingsor is a painter, an artist magician who produces a self-portrait that, in turn, portrays the entire world. The playwright Bertolt Brecht, who knew the Van Gogh pictures in the Pinakothek in Munich, and who in 1920 read Van Gogh's letters, remarked in his diary the following year that the theatre crowd should establish somewhere a "yellow house" in which ideas and creations could be examined, discussed, and traded. In 1929 Siegfried Streicher published yet another biography of Van Gogh that hovered between fiction and history. Streicher imagined Vincent thinking, "The final victory is something very sad."[13]

Among the themes to emerge especially strongly in the German commentary on Van Gogh after the war was that he was a Germanic painter—a solitary Nordic *Übermensch* battling a world of complacent imbecility.[14] Oskar Hagen, who had studied musical composition with Engelbert Humperdinck and then taught art history at Göttingen from 1918 to 1925, said of Van Gogh's art, "It had found the latest formula as to how the modern German sees, understands, and interprets the world." "Vincent," he said in language reminiscent of the war, "makes the impossible possible. . . . Van Gogh belongs to us!"[15] The widely respected director of the Mannheim Art Gallery, G.F. Hartlaub, used much the same formulation two years later—"He is ours." It was Van Gogh's purity of vision and expression that supposedly made him Germanic. In contrast to other peoples of the Western world with their rampant materialism and spiritual barrenness, said Hagen, Germans cherished truth and beauty and equated the two.[16] In the same vein, in his conclusion to *Vincent,* Meier-Graefe claimed that Van Gogh was a representative of modern *germanische Malerei* (Germanic painting), its most important

contributor since Rembrandt. Pointing to the heroic significance of the man and his art, he noted that Germany was very much in need of such heroism.[17]

A contemporary who had the same kind of response was a physically handicapped misfit and intellectual, Joseph Goebbels. He would acquire a doctorate from Heidelberg University but no appropriate employment. Later, as Hitler's propaganda minister, he would oversee first the denigration and then the eradication of much modern art in Germany. Yet this career path was hardly a given. In his novel *Michael,* which he wrote in 1923 but did not manage to publish for six more years, he had his working-class hero visit an exhibition of modern art in Munich: "We see a lot of new nonsense. One star: Vincent van Gogh. In this milieu he already seems tame, yet he is the most modern of the moderns. . . . Modernity is a new way of experiencing the world. Modern man is necessarily a seeker after God, perhaps a Christ-Man. Van Gogh's life tells us more than his work."[18] Van Gogh is mentioned several times in the novel, always with admiration, always as an expression of the new spirit—the re-spiritualization—that will be essential to German recovery.

Van Gogh is us / We are Van Gogh. That had become the refrain of many Germans by the end of that desperate decade.

## SAILOR BOY

*Vincent's Bedroom in Arles*

In Otto Wacker's file in the German Dance Archive in Cologne, one of the tributes to "Olinto Lovaël," Wacker's stage name, stands out strikingly. It is a rhapsodic description supposedly from an undated letter by Julius Meier-Graefe to Paul Cassirer. Lovaël's dance is compared to the art of Vincent van Gogh! "The

same genial improvisation of a Vincent van Gogh is to be found in his art. . . . Olinto is a dancing relative of El Greco. . . . One senses the darkness of Rembrandt. His creativity is enormous. No flirting with technique. Everything is fluid and convincing. No empty gestures. The colours of his costumes have class—he definitely comes from a background in the fine arts. His dance is imbued with a secret purity and naturalism. Slevogt should paint him. . . . One could write a book about this dancer Lovaël."

In the 1920s, of course, Wacker called himself Olindo, not Olinto. That slip immediately makes the excerpt suspect. And what about the wish "Slevogt should paint him." Max Slevogt had indeed produced memorable portraits of other characters who appear in our story, among them Bruno Cassirer, Hans Rosenhagen, and Tilla Durieux. He, like many other visual artists, was enthralled by the symbolism of dance and the theatricality of life. He had painted the flamenco dancer Marietta di Rigardo in 1904, the Russian prima ballerina Anna Pavlova in 1909, and another flamenco specialist, La Argentina, in 1926.[1] A portrait of the "Spanish dancer" Olindo Lovaël would have fitted the pattern nicely—too nicely, perhaps.

Did Meier-Graefe pen this effusion? He might have, but the association of Wacker with El Greco, Rembrandt, and Van Gogh is more likely the product of Otto Wacker's later imagination than of Meier-Graefe's earlier prose. By the time Wacker started using this material to promote himself in post-1945 Germany, Meier-Graefe was long dead and could hardly protest. So was Paul Cassirer. This item, along with other rave press reviews of Lovaël, reeks of fictionalized self-promotion rather than critical assessment.

Who was Olindo—or Olinto—Lovaël? Who was Otto Wacker? Which was which?

The man who presented himself in these various guises never

regarded himself as merely a dancer. He thought himself an artist in the broadest sense. In 1919, while pursuing his dance career, he had established a partnership, which he called the Alte und neue Kunst Handelsgesellschaft m b.H. (Old and New Art Company Ltd.), with his sister's friend Erich Gratkowski. In a sense it was a formalization of his long-standing engagement as a dealer of art. The venture, located physically in one room at Zimmerstrasse 98, near the gallery district in central Berlin, remained modest in scale in its early years, handling antiquities and occasional pictures, but it did garner some attention in the art community. Wacker claimed later that he did business with dealers such as Hermann Schulte (who had displayed his father's work), Alfred Flechtheim, Carl Nicolai, and Paul Cassirer, as well as the antiquities section of the huge Wertheim department store. "We were not newcomers," he would insist.[2] However, documentation for such extensive business relationships, as for much else in the life of this high-stepping chameleon, is lacking. Nevertheless, for the next stage of Wacker's life there is considerable evidence. In 1925 his operation moved in a wholly new direction.

Wacker's dance career had coincided with a mounting economic crisis, especially spiralling inflation. As his stage success grew, his income seemed, by contrast, to evaporate. At the same time the art market—which he knew as well as the world of dance—revealed many opportunities as the frightened upper bourgeoisie began to look on art as security. In February 1920 the journal *Kunst und Künstler* reported, "The art market is feverish. Things are being bought without even being seen, and there is a shortage of goods everywhere. . . . In exhibits, every third item has a slip of paper marked 'sold.' And since a reactionary art does not exist anymore, and since everyone paints and draws in the modern style, the Expressionist laughed at yesterday becomes a publicly renowned artist and capitalist overnight.

Now he begins to grumble about the paper money himself, fears the capital levy, seeks to buy houses or farms and begins to hold back his works."[3]

Johanna van Gogh, the executor of Van Gogh's work, fitted this mould well. As the value of money declined, she became increasingly reluctant to sell. Successful shows at the Montross Gallery in New York in 1920 and the Leicester Galleries in London in 1923 created demand, but the number of Van Goghs available for purchase seemed to diminish. Johanna's relationship with Paul Cassirer turned cold. The Cassirer gallery, which had played such a prominent role in the dissemination of Van Gogh before the war, moved no Van Goghs in the early 1920s. Even in the Parisian galleries, a Van Gogh became a rarity. When in January 1924 Johanna agreed to sell one of the renditions of *Sunflowers* (F 454) to London's National Gallery, she remarked that she was doing this as a "sacrifice for the sake of Vincent's glory."[4]

In 1925, in the midst of this growing demand for and yet paucity of Van Gogh pictures, Otto Wacker stunned the art world when he began releasing onto the market a series of oil paintings by none other than Vincent van Gogh. It was as though he had located the Holy Grail.

## CERTIFIERS

*Portrait of Patience Escalier*

Otto Wacker sold the first lot of these new Van Goghs without any indication of provenance, where an artwork came from and who owned it over time. He told the dealer Hugo Perls, who in 1925 acquired *Cypresses* (F 616), a swirling fusion of trees, rocks, and suns, that revealing his source would endanger his whole enterprise, for other dealers would immediately descend on it.

Perls seemed to understand. Secrecy was normal practice if more than one item was to be sold from a collection.[1] When Wacker began to sell a second lot, however, another of his buyers objected to the dearth of information on origins. Wacker therefore turned to a relatively recent practice—authentication by experts.

For certification of his pictures, he did not go to some friend or unknown dealer. Rather, he went right to the top and sought authentication from the foremost Van Gogh experts at the time— Julius Meier-Graefe in Berlin and Jacob-Baart de la Faille and H.P. Bremmer in Holland.

Meier-Graefe was obviously a knowledgeable choice. He was Germany's most prominent expert on Van Gogh and its most widely read author on art and art history. Aside from writing the major biography of Van Gogh, he was the art critic for the left-liberal *Berliner Tageblatt*, a position he kept until 1930, when he moved to the staid and prestigious *Frankfurter Zeitung*, a daily published in Frankfurt but read in educated circles throughout Germany. He was more than a critic too—an entrepreneurial intellectual, as anyone who had to make a living from writing had to be. He was constantly on the lookout for opportunity. Moreover, his lavish tastes, against the backdrop of a precarious economy, made him preoccupied with financial matters. Income was always an issue, and his correspondence is full of mundane financial concerns. Art authentication brought in modest amounts, and requests were always welcome.

In testimony later, Meier-Graefe revealed that his relationship with Wacker dated from 1923. These two men, captivating performers in thrall to their aesthetic ambitions, had clearly been drawn to each other. In the early days Wacker brought Meier-Graefe a variety of Dutch and German art for authentication, by Hendrik Willem Mesdag, Hans von Marées, Andreas Achenbach, and Carl Schuch.

When the Van Gogh paintings arrived, Meier-Graefe seems to have had no doubts about their authenticity. To him, Wacker's story that the pictures came from a Russian émigré who had escaped Bolshevism was perfectly plausible. Several well-known Russian collectors, among them the businessmen Ivan Morozov and Sergei Shchukin, had been enthusiastic patrons of the Impressionists and their successors. "Soon your pictures won't ever be seen again except in Moscow," a friend had said to Henri Matisse in 1910.[2] Morozov assembled close to two dozen Van Goghs, including the celebrated *Night Café*. After the Revolution, both Morozov and Shchukin lost their cherished collections. Their houses, along with their art, were confiscated and turned into Soviet museums. Morozov was appointed "assistant curator" of his own collection. Shchukin slipped out of Russia quietly with forged papers and settled in France, spending winters in Nice. Morozov was permitted to seek medical treatment abroad in the summer of 1919 and never returned, settling in Germany first and then in Paris. In those early years of Communism a fair amount of art was smuggled out of the Soviet Union, with a second wave of emigration and surreptitious export coming after the death of Lenin in 1924. Some of the art was sold openly in the West by Soviet authorities.

Meier-Graefe was a major conduit for this trade. During the war he had been an ambulance driver on the Eastern front and had briefly spent time in Russian captivity. The story is told that the industrialist Shchukin, who had read his books, sent the German prisoner of war greetings along with a warm hat. In 1925 Meier-Graefe's friend Carl Moll organized an exhibition of nineteenth-century French art in Vienna, including a number of works from Russian collections that, for the first time, were on display in the West. In 1928 the Berlin auction house Lepke would hold a major sale of Russian art. Much of the work that arrived in

the West from Russia was authenticated by Meier-Graefe.[3] Wacker's account of provenance was hardly unusual, then, and Meier-Graefe would have found it entirely acceptable.

Meier-Graefe was the authority whom Wacker came to trust the most. Though thirty years apart in age, they established a relationship so warm that Meier-Graefe found it almost impossible to look at the Wacker paintings with any degree of objectivity. He would continue to defend Wacker, long after others had deserted him, as an "honest" man. He would write cryptically of "psychological moments that . . . complicate the matter uncommonly." Clearly Meier-Graefe's ties to Wacker went beyond the professional realm.[4] At the time he met Wacker, his second marriage was on the rocks and, then in his late fifties, he was involved with a passionate young painter, Annemarie Epstein. They met when she was fifteen, and four years later, in 1925, they eloped and married in Munich. One of the earliest and poorest of the Wacker pictures, *Plate with Bread Rolls* (F 387), was reproduced in the March 1925 issue of *Der Cicerone,* a sumptuous art magazine with which Meier-Graefe had connections. A stream of certifications followed. On March 27, 1928, Meier-Graefe authenticated the sensational *Self-Portrait at Easel* (F 523), which would achieve long-lasting notoriety in the collection of the American financial magnate Chester Dale and end up with the rest of his collection in the National Gallery in Washington, D.C. In his validation, Meier-Graefe wrote that it was "one of the most important works by Van Gogh." The last authentication by Meier-Graefe came on December 19 that same year, well after Wacker's credibility had been called into question.[5]

Another expert approached by Wacker was Jacob-Baart de la Faille, who lived in the pretty North Sea town of Bloemendaal, near Haarlem, in Holland. He was known to be preparing a catalogue raisonné of Van Gogh's work, the first attempt to produce

a comprehensive and annotated list of the artist's oeuvre. He had been at this project for about a decade. Though not a particularly prominent dealer or critic, he was active in both areas and was part owner of a small Amsterdam auction and publishing house, the firm of A. Mak. Having studied at Utrecht, Berlin, Brussels, and Paris, he was, like many Dutchmen, a skilled linguist and had a significant range of international contacts. His goal for the catalogue was to make it as complete in documentation as humanly possible.

Yet the problems of a Van Gogh compilation were endless. The artist's sloppy demeanour, from personal hygiene to careless distribution of his work; his repetition of themes and of pictures; his vagrant existence; and the random storage methods of both his brother Theo and his sister-in-law Johanna—all turned the issue of provenance into a gargantuan headache. Forgers and copiers had been many. In Paris, dealers talked of the "factories" that had produced copies. As a result, De la Faille was inclined to downplay the importance of provenance and to emphasize the distinctiveness of the art and the documentation Van Gogh himself had provided for his pictures in his extensive correspond-ence with Theo and other family members.

De la Faille's concerns were compounded by basic questions of ownership and location. As the value of Van Gogh's work increased, some collectors became reluctant to disclose ownership. Publicity would attract attention from the taxman, the criminal class, and the febrile and intrusive art world in general. Some collectors, wary of this kind of attention, hesitated to come forward. As De la Faille's project neared completion, the cataloguer's ability to guarantee precision seemed to recede correspondingly. Urgency and anxiety beclouded the last stages of his work.

From his home in Bloemendaal, De la Faille had heard rumours of new Van Goghs appearing on the Berlin market. Such news

was electrifying, particularly when it appeared that a veritable cache of hitherto unknown pictures had been discovered. Keen to be as comprehensive as possible, he greeted with enthusiasm a cable from Wacker on March 24, 1926, and the German's arrival on his doorstep three days later. He was intrigued and excited, as both a scholar and a dealer. He accepted Wacker's explanation for lack of provenance—the story of the Russian émigré and his wish to protect his family—and apparently added that in a similar position he would do the same.

Wacker had brought with him a landscape in which all was in movement under the impress of a blazing sun. De la Faille proceeded to authenticate that first picture, according it the classification F 729. This was just the beginning, however. All told he would endorse some twenty pictures, travelling to Berlin on several occasions. There, on November 13 and 14, 1926, he validated a small *Self-Portrait* (F 385) and *Two Poplars* (F 639), pictures that would be prominent in the disputatious days to come. In July 1927, again in Berlin, he authenticated *Self-Portrait at Easel* (F 523), the picture that would gain special notoriety. Fluent in French, De la Faille delivered his endorsement in the language not only of diplomacy but of art appreciation: "Le soussigné déclare qu'il a examiné la peinture. Il considère cette peinture comme une oeuvre authentique et charactéristique de Vincent van Gogh"—authentic and characteristic. "Authentic" is the minimum requirement. "Characteristic" goes to the next level by pointing out that a particular work fits smoothly into the oeuvre. Wacker paid De la Faille 25 guilders ($10) for each validation.

De la Faille eventually added all Wacker's pictures, not merely the ones he had authenticated, to his catalogue raisonné, which he titled *L'Oeuvre de Vincent van Gogh*. The first volume appeared in November 1927, followed shortly by three more. The last authentication of a Wacker picture by De la Faille dates from April 1928.

All dealers and most buyers were satisfied by De la Faille's seal of approval. No other validation was necessary. However, the fact that De la Faille was a dealer himself, had a financial stake in a company involved in the visual arts, and himself became involved in the sale of Wacker paintings should have been matters of concern. The conflicts of interest were glaring.

The documentation available gives the impression that Meier-Graefe and De la Faille were competing for Wacker's approval—and perhaps affection—rather than the other way round. Both craved to be known as the foremost Van Gogh expert. Neither could stand aside as the news of a major Van Gogh find spread. Wacker seemed to be prepared to play these "experts" against each other. But more than art was involved. Egotism and sensuality, aestheticism and provocation mixed together, as they did in modernism generally. The mood of Weimar Berlin, with its cascading convolutions, was in full evidence here.

H.P. Bremmer, Helene Kröller-Müller's adviser, also provided a number of critical authentications. He had a proprietary approach to Van Gogh, leading Gabriele Tergit, an astute Berlin reporter, to say that Bremmer presented himself as a "herald and discoverer of Van Gogh."[6] Bremmer liked to have the first and last word on issues relating to Van Gogh. Wacker, with his brother, Leonhard, in tow, first visited Bremmer in The Hague in 1926, bringing two pictures for the Dutchman's assessment, the *Self-Portrait at Easel* (F 523) that Wacker was showing widely and an olive grove rendition (F 715a). Bremmer decided that the self-portrait was indisputably genuine, whereas the second picture was not. Pompously self-assured in his ability to "read the quality of a work out of the picture itself," as he put it, he did not bother to ask Wacker about provenance. To a real expert, he always insisted, provenance is incidental. Authenticity is a matter of intuition; it must be sensed, not confirmed by affidavits.[7] Subsequently Bremmer would

endorse more pictures, the last on December 14, 1928. He would stick to his validations through thick and thin, even persuading Helene Kröller-Müller to buy one of the contested items. His own reputation was at stake, but he more than anyone else played the nationality card, turning an intellectual debate into a crass art war pitting the Dutch experts against the Germans. The Germans knew nothing about art, fumed Bremmer. They had no feel for it; they had no real history of visual art. Their achievement in painting paled beside that of the Dutch. Bremmer's legions of supporters would act as a chorus and argue in the same vein.

Another "expert" to whom Wacker turned was the widely read art historian and critic Hans Rosenhagen. He was getting on in years. His star had risen together with the Berlin Secession. Like Meier-Graefe, who was expected to become an engineer, Rosenhagen had trained in practical matters, in his case banking, but by the late 1890s, when he was in his forties, he was devoting himself entirely to his love of art. He edited a journal, *Das Atelier*, and then became the art critic for the newly established Berlin daily *Der Tag*. He was friends with the leading Secessionists— Max Liebermann, Wilhelm Trübner, Lovis Corinth, Fritz von Uhde, and Max Slevogt. Corinth and Slevogt produced impressive portraits of him. He wrote intermittently for the *Frankfurter Zeitung* as well as the *Münchner Neueste Nachrichten,* and his polemical and witty formulations made him a favourite of artists and the art-loving public alike. He had reviewed the first Van Gogh exhibition in Germany at the Cassirer gallery in 1901. Rosenhagen initially encountered Otto Wacker in 1924, when the dancer-dealer came to him requesting certification of an Uhde painting, and he eventually authenticated fourteen of the Wacker Van Goghs. His last validation was given on November 11, 1928.

Others who joined the Wacker camp—for apparently 40 to 80 marks ($10 to $20) a validation—were the respected Dutch art

restorers A. Martin de Wild and J.C. Traas. Both De Wild and Traas worked regularly on restoring paintings in the Kröller-Müller collection.[8] Their opinion counted.

And so, in short order, Otto Wacker acquired a strikingly wide range of professional support for the paintings he had for sale. He might have expected greater hesitancy, caution, and skepticism, but he met with few reservations from any of these "experts." Some thirty-three works were eventually authenticated and released for sale.

As the Wacker affair was brewing in Germany, Julien Benda published his famous diatribe in France about the "treason of the intellectuals." These thinkers, he said in *La Trahison des clercs,* had descended, during the war and its aftermath, from the symposium to the battlefield. In so doing they had surrendered impartiality and respect, and as a result the world had become menial and shallow. They had soiled themselves and betrayed their calling. They, like Adam, deserved to be expelled from paradise.

## CAVEAT EMPTOR

*Encampment of Gypsies with Caravans*

The Wacker trove was snatched up, as authentications put minds at ease. The provenance for all these works was given simply as "Collection privée suisse." Wacker was no fringe creature. With his double-breasted three-piece suits and pocket handkerchief, he cut a fine figure and exhibited a gentle, self-deprecating manner. He knew important people. Curt Glaser, the director of the State Art Library and arts critic for the *Berliner Börsen-Courier,* introduced him to Hugo Perls, and the dealer then included *Cypresses* (F 616) in his Impressionist show as early as 1925. Julius Elias wrote the introduction to the catalogue. A friend

of Paul Cassirer's and an authority on Impressionism, Elias had literary as well as art expertise, having translated the Scandinavians Henrik Ibsen and Bjørnstjerne Björnson into German.[1] Julius Meier-Graefe and Carl Sternheim were among those who viewed that show and expressed admiration for *Cypresses*. The cognoscenti were excited.

Shortly after his exhibit closed, Perls purchased *Cypresses* from Wacker. He paid 18,000 marks ($4,300 then, or roughly $53,000 today).[2] He then sent the painting, accompanied by Elias, to the Hamburg Kunsthalle, to be viewed there by interested parties, including Gustav Pauli, the museum's director. Before the war, Pauli had been the director of the Bremen Art Museum and instrumental in developing its modern collection, purchasing Van Gogh's *Field with Poppies* (F 581) in addition to a broad range of modern French and German works. The *Cypresses* picture, now with an asking price of 32,000 marks ($7,600), went from the Kunsthalle to the home of Elsa Essberger, formerly Wolff, for a private viewing. She was the wife of a Hamburg shipping magnate and a friend of Elias's. At the viewing, everyone was enthused, and an excited Elsa, bubbling with superlatives—"such a first-class Van Gogh"—announced that she was ready to purchase the painting. Perls tried to persuade her to exchange a Cézanne or Pissarro from her collection for the purported Van Gogh, but in the end she traded a Toulouse-Lautrec for the Wacker picture and paid 19,000 marks on top of that. "Your picture has set a standard for quality and has kept us from buying something less worthy," she told Hugo Perls with pride.[3]

Wacker sold at least eleven of the new pictures to Perls. His prices began to rise quickly, as other suitors rushed in. Franz Zatzenstein of the Matthiesen gallery bought several pictures early in 1927, paying 36,000 marks for *Two Cypresses* (F 614), twice the price Perls had paid a few months earlier for the comparable

F 616. Wacker in turn purchased a Van Gogh olive grove picture (F 710) for 22,000 marks from Matthiesen. Not long afterwards a second, remarkably similar, olive grove picture (F 710a) appeared on the market.

Wacker released his pictures gradually. He never told anyone that he had a specific number of them. Perls would recount that he was constantly asking Wacker if he had anything more to sell, but only after persistent inquiry would Otto inform him, reluctantly, that he did indeed have one more Van Gogh. Perls put on another exhibition in January–February 1927 that he called *French Painting of the 19th Century* and, absolutely convinced that his Wacker pictures were authentic, retrieved a number of them from his recent purchasers for inclusion. That show drew some ten thousand visitors, an enviable number for a private gallery exhibit.[4]

Wacker's other buyers included the Goldschmidt gallery in Berlin, Commeter in Hamburg, Thannhauser of Munich and Berlin, and the renowned Bernheim-Jeune house in Paris. Bernheim-Jeune included a Wacker in its 1927 Impressionist show.[5] Goldschmidt displayed nine of the Wacker pictures in an Impressionist exhibition at its gallery on the Tiergartenstrasse in February–March 1928, and Meier-Graefe wrote the introduction to the catalogue.[6] Through these dealers the Wacker paintings entered distinguished private collections in Germany and abroad: the furnace magnate Otto Krebs of Holzdorf, near Weimar, who assembled a notable collection of French Impressionists, most of whose pictures would end up in the Hermitage in Leningrad after the Second World War; the metal goods entrepreneur Max Silberberg of Breslau, who had an outstanding collection of some 140 artworks; Elsa Wolff-Essberger, with her Hamburg shipping connections; Sigmund Gildemeister, a successful Hamburg importer of marble and fine wood, who lived in a palatial estate

built early in the decade in art deco style;[7] the American entre-
preneur and art enthusiast Chester Dale, who purchased the
much discussed self-portrait (F 523); and the American publisher
Ralph H. Booth of Detroit. Gildemeister and Krebs were so
excited by the opportunity that they picked up several items
each.[8] The landscape with sun (F 729), the first picture that De la
Faille had certified, went from the Galerie Matthiesen to the
Detroit Institute of Arts, which moved into a grand new building
in 1927 and had a large acquisition budget because of wealthy
local benefactors including the Scripps, Ford, and Booth families.
Prices paid for the Wacker pictures ranged from 25,000 to 65,000
marks ($6,000 to $15,500).

# FAME

*Cypresses*

In 1927, pulsing with profit, Otto Wacker moved from his tiny
quarters in the Zimmerstrasse and set up shop in the
Viktoriastrasse, in the heart of the gallery and embassy district.
He was just around the corner from the humming Potsdamer
Platz, which claimed to be the busiest intersection in the world.
Traffic, human and motorized, from six streets and a train station
emptied into the famous square, with a policeman trying to
control the congestion from a tower in the middle. The district
had no slum housing; on the contrary, rents were steep.[1] Wacker
paid 3,000 marks a month ($715 then, or almost $9,000 today) to
lease space at number 12, in a building that had been designed and
built in 1908–09 by the court architect Ernst von Ihne. Ihne had
left his mark on much of Berlin, including that regal axis Unter
den Linden, where he had designed the Royal Library.[2] On the
Viktoriastrasse, Paul Cassirer's gallery was nearby, at number 35,

as were those of Alfred Gold and Alfred Flechtheim. Italy's embassy was on the street. Other prominent galleries beckoned on the adjacent Bellevue and Tiergarten avenues.[3]

Wacker could not have chosen finer quarters. With high ceilings and imaginative lighting, the new gallery suggested opulence. Wacker now formalized connections not only with his Berlin colleagues but with dealers and galleries abroad, among them Wildenstein in New York, d'Audretsch in The Hague, and Hodebert and Rosenberg in Paris. He hired an assistant to help out with sales and bookkeeping.

For his inaugural show in December 1927, Wacker worked in tandem with the Cassirer gallery. Paul Cassirer had died the previous year, but through Jacob-Baart de la Faille, Wacker had established a friendly relationship with Cassirer's successors, Grete Ring and Walter Feilchenfeldt. With the help of De la Faille, the group came up with a capital idea. The Cassirer people would put on a major exhibit of Van Gogh oil paintings, reminiscent of the gallery's great pre-war shows, while just down the street Otto Wacker would organize a genuine art/historical event—the first extensive exhibit of Van Gogh's drawings and watercolours. Attention had always been focused on the oils, and the drawings had never been gathered together for a major show. Assisted by De la Faille, the two galleries cooperated in finding appropriate works in private collections.

The Wacker exhibit, inaugurating the gallery, opened first. "Vincent van Gogh—first major exhibition of his drawings and aquarelles, weekdays 10–6, Sundays 10–3," read the widely distributed notice.[4] The pictures had been assembled from German and Swiss collections as well as from the artist's nephew, Vincent Willem van Gogh. They were tastefully hung and softly lit against a silver background. The critic for the trade journal *Kunst und Künstler* commented on "the beautiful, grand, quiet and

exquisitely appointed rooms." Years later a reporter for the
*Berliner Morgenpost* would remember the mood: "It all looked
high class and distinguished. One tiptoed about and sighed 'Ah!'
The confluence of light looked 'refined.'"[5]

De la Faille gave a talk at the opening—his expression of grati-
tude to Wacker for the young man's significant additions to his
Van Gogh catalogue. The exhibition committee consisted, apart
from De la Faille, of a list of names that immediately captured
attention: Gustave Coquiot, the Parisian critic whose portrait
Picasso had done in 1901 and who had published an appreciation
of Van Gogh in 1923; Paul Gachet, the son of the doctor who had
treated Van Gogh in Auvers; Professor Curt Glaser, a critic, early
collector of Edvard Munch, and director of the Berlin State Art
Library; Max Liebermann, Germany's most distinguished living
painter; Julius Meier-Graefe, who had done so much to popular-
ize Van Gogh in Germany; and Wilhelm Waetzoldt, a former
professor of art history at the University of Halle and, since 1927,
director general of the Berlin state museums. The Otto Wacker-
Verlag, a publishing enterprise Otto set up in tandem with the
gallery, produced the catalogue: *Vincent van Gogh, der Zeichner*
(Vincent van Gogh, the Drawer), edited by Meier-Graefe, with
an extended introduction by De la Faille. It had forty-eight pages
of text in "northern Antiqua" print and fifty-two illustrations pre-
pared by the graphics company Ganymed, which Meier-Graefe
had founded in 1917. This impressive work was produced on heavy
paper free of wood pulp. The influence of Meier-Graefe and
Harry Kessler, aesthetes who loved beautiful books, was palpable.

In his introduction, De la Faille put the drawings, ranging
from the Brabant period to the final years in Provence and Auvers,
into broader context. Van Gogh began with drawing, De la Faille
pointed out, and even in his moments of fiery ecstasy as a painter,
he never forgot the importance of the line. "One could say that he

drew his pictures in colour." The frontispiece of the catalogue was devoted to a picture that Wacker and his friends had championed, the *Self-Portrait at Easel* (F 523), which had since been sold to Chester Dale in New York and exhibited there.[6]

The show opened to fine reviews. In the *Berliner Tageblatt,* Fritz Stahl said the drawings revealed that Van Gogh was both a genius and a character. Those who wish to see will see in the drawings what a struggle Van Gogh's life was—"a martyrdom, an unbroken chain of trouble and humiliation." At the same time, Stahl continued, the drawings, with their evidence of exactness and control, will correct the image of Van Gogh as a wild man.[7] The widely read cultural commentator Bruno E. Werner was agog with excitement about Wacker's enterprise: "In Berlin where art galleries sprout from the ground, the new art salon of Otto Wacker has opened with a remarkable show. . . . The drawings provide a grandiose overview of the creation and development of the artist, in a way that a display of the paintings could not. But even more significantly, they provide a profound insight into the soul of this great man and his importance for artistic creativity today."[8] *Kunst und Künstler* noted that the exhibit had been assembled "with great expertise. . . . Its success is rightly huge."[9] In the next issue the enthusiasm continued: "As a critical experience it will be unforgettable; it belongs to those shows that can be called historic."[10] Because of what followed, this exhibition— the first to appreciate the importance of the drawings in Van Gogh's oeuvre—has never received its due in Van Gogh appreciation and scholarship.[11]

In late 1927 Otto Wacker was at an apex of fame and fortune— he had conquered Berlin and many of its most prestigious art critics and experts. He helped his father, Hans, to rent a small flat in the city and to buy a property in Ferch am Schwielowsee, a renowned artists' community just to the west—a manageable

distance by train from his son and his new repute. His brother, Leonhard, too, was often in Berlin.

Otto had moved from one form of theatre to another. "For me a gallery is absolute theater," Alexandre Iolas, another dancer turned art dealer, would say. "Arranging the exhibitions, the lighting, the openings—it all goes together, and if it's well done, it's magnificent. I've always thought of myself as a performer."[12] No doubt Otto Wacker thought in similar terms, and the world was impressed by the performance. He was on his way.

On this wave of success and admiration, he began planning his next show—an exhibition of modern French drawings. The list of dignitaries associated with the proposed exhibit was outstanding.[13] The French ambassador to Germany, Pierre de Margerie, who had a penchant for the arts, was involved,[14] and in Paris both the Louvre and the Bibliothèque nationale were set to cooperate. Meier-Graefe, the acknowledged authority in this field, urged the Cassirer gallery to participate with the loan of several Impressionist drawings. At this very point, however, when the art establishment was applauding wildly, Otto Wacker's world began to crumble.

## SOURCE

*The Painter on His Way to Work*

As Otto Wacker told his story, it was while dancing at the Blüthner-Saal in Berlin in the winter of 1923–24 that he had been approached by a visiting Russian who came to see him in his dressing room. They hit it off. The Russian, said Wacker, echoing the mantra of all aesthetes, loved everything beautiful. They became fast friends. They met often at the Hotel Esplanade on Unter den Linden, where they dined. When someone

mentioned a homosexual relationship, Wacker did not protest. The young Russian émigré lived, according to Wacker, in southern Switzerland, where he had fled after the Bolshevik Revolution, leaving his prominent family behind in the Soviet Union. The family, it was rumoured initially, had connections with the Romanovs, and the sad fate of those royals everyone knew. The Bolsheviks had massacred even the children.

Otto recounted that he had ventured south frequently to visit his new friend in Switzerland. He was met in Lörrach, on the German side of the border from Basel, by a chauffeur and driven into Switzerland secretly. The Russian lived in a medium-size house with several Russian-speaking servants. There, as Otto told the story, he was exposed to a set of paintings that amazed him, thirty-six in all, by Vincent van Gogh.

Three or four paintings, he said, were on the walls of the study, the rest in storage, all framed poorly or not at all. The family's journal, claimed Wacker, indicated that the paintings had been acquired twenty to twenty-five years earlier for next to nothing. The most expensive, the *Self-Portrait at Easel* (F 523), had cost 800 marks ($190). The paintings had been spirited out of Russia after the Revolution without an export licence and with the help, ostensibly, of a British diplomat. Wacker would provide no names.

The Russian apparently had no genuine interest in this art, or in any of the Old Masters he had inherited, and because he was short of funds, he agreed that Otto, with his family background and good knowledge of art and its market, should try to sell some of the pictures. But he insisted that Wacker never, under any circumstances, reveal the source of the paintings. Otto gave his friend what he termed his *Ehrenwort,* his word of honour.

Did any of the story's constituent components carry credence in the cultural chaos that was Weimar? Word, honour, word of

honour? Wacker's story would be dismissed by many as fantastic. Was it? Berlin had a large Russian community in the 1920s. Some 300,000 Russians converged on the German capital in the course of the decade. As a centre of Russian cultural activity it was surpassed only by Moscow and Petrograd, though for Russian book publishing it was more important than any Soviet city. In 1924 eighty-six Russian publishing firms operated in Berlin, and the huge German firm Ullstein, publisher of newspapers, magazines, and books, even became involved in producing Russian materials. The sociologist Pitrim Sorokin felt "revitalized and happy" in Berlin after his escape from Communist Russia: "Lady Fortune seemed to be smiling at us again." The diplomat and author Ilya Ehrenburg lived in the German capital for several years in the early twenties and was fond of it. "Berlin is the only modern city in Europe," he declared, "... and could be the capital of Europe.... It is only in Berlin that one feels the pulse of Europe." One of Ehrenburg's novels, *Julio Jurenito,* was published first in Berlin, in 1922. The Leon café on the Nollendorfplatz and the Landgraf on the Kurfürstendamm teemed with Russian literary émigrés.[1] Eventually some of these Russians would move on to Paris, others to Prague, and some to Switzerland. On the surface, Wacker's story was not as preposterous as many implied.

Meier-Graefe, who had extensive contacts in Berlin's Russian community, certainly believed Wacker's story. At one point, feeling pressure himself, he begged Wacker to come clean and to reveal the Russian's identity. Wacker continued to refuse to provide names, but he did show Meier-Graefe a letter purportedly from the Russian, with the salutation and signature folded over. It spoke of an older artwork and then of several of the Van Gogh pictures in question. Meier-Graefe was convinced that this letter, in broken German and written in an apparently Russian hand, was the real thing and that Wacker was on the

up and up. He even asked Wacker to forgive him for having doubted him.

## ALARUM

*Still Life with French Novels and a Rose*

It was Grete Ring and Walter Feilchenfeldt, the new owners of the Cassirer gallery and Wacker's partners on their mutual Van Gogh project, who raised the alarm. As they unpacked the six pictures that their neighbour Otto Wacker had sent over to them in preparation for their major exhibition of Van Gogh paintings due to open on January 15, 1928, Feilchenfeldt paused. "These are fakes," he said first to himself and then to his colleague. Comparing the items—*Boats at Saintes-Maries* (F 418), *Self-Portrait with Bandaged Ear* (F 527a), *Zouave* (F 539), *Haystacks* (F 625a), *Sower* (F 691), and *Cypresses* (F 741)—to the well-known Van Goghs that were already hanging on the gallery walls, he was dumbfounded by the lack of quality in the Wacker contributions. The themes were familiar, but the colour and texture of the works so different. Sure that at least four of the six pictures were fraudulent,[1] Feilchenfeldt and Ring promptly contacted De la Faille, who had not only included all six items in his catalogue raisonné but curated their show as well, to express their doubts.[2] The trio decided to confront Wacker.

While Feilchenfeldt and Ring had worked in Paul Cassirer's shadow before his death, both were major figures in their own right in the German art world. Grete Ring was an accomplished art historian in addition to being Max Liebermann's niece. She had intellectual and social gravitas. Her opinion mattered. Walter Feilchenfeldt had contacts throughout Europe. He would become a friend and artistic adviser to Erich Maria Remarque when the

young author achieved international celebrity in 1929–30 with his bestselling novel *All Quiet on the Western Front*.

When Otto Wacker arrived, the group studied the pictures, new and old, side by side. De la Faille, aware of the calamity brewing, tried once again to get Wacker to reveal the specific source of the paintings, without success. Wacker always reverted to his *Ehrenwort*. He agreed to take back the four contested paintings but then proceeded to display them prominently in his own gallery, where the Van Gogh drawings were being exhibited. He was not backing down. Moreover, the Cassirer catalogue had already been printed and included all six Wacker items.

The Cassirer exhibition opened in mid-January 1928 and ran for a month. Like Paul Cassirer's pre-war shows of Van Gogh, this one was again considered a great success. The journal *Kunst und Künstler* called it "one of the most significant events of the age."[3] Many of the same items had been borrowed again from the illustrious collections of Margarete Mauthner, Alfred Tietz, Paul Kempner, Otto Krebs, Samuel Fischer, and Max Liebermann. The catalogue made the point that the French Impressionists were easy to understand—they were "problemless." In contrast, "Van Gogh remains a problem, remains contentious despite the popularity of his work. Thus it is precisely he who must become a model for the new German art." Van Gogh, so ran the argument, was closer to the controversial German art of the modern era and to its conflicted soul than to French art.

Feilchenfeldt and Ring were reluctant to report Wacker to the police, concerned about the impact of such revelations on the art market and hesitant to openly question the certificates of authenticity that colleagues, especially De la Faille, had issued. Moreover, proof of forgery was necessary under German law before charges could successfully be laid. For the moment there was no such proof. Without it, no one was willing to move against Wacker.

At this stage, De la Faille's behaviour was critical. His catalogue had just appeared. Everyone regarded him as the great expert on Van Gogh. Two major Van Gogh shows were running on the Viktoriastrasse in which he had played a central role. Doubts had been cast on work he had certified as genuine. What was he going to do? Not only did he not sunder the connection with Otto Wacker but he continued to authenticate Wacker's paintings for four more months, into April 1928, and to sell the Wacker items himself, dealing directly with two Americans and acting as intermediary for Paul Rosenberg in Paris, who sold three of the Wacker paintings. As long as the accusations of fraud were not in the public domain, De la Faille carried on his business as usual.

He was concerned, however. Although the doubts about Wacker had not surfaced publicly, rumours were circulating. In March, De la Faille approached Vincent Willem van Gogh and asked whether he knew personally, or from his mother's account books, of any major unheralded collector who might have assembled some thirty paintings. Vincent Willem replied that Paul Cassirer was the only person who had purchased that number of paintings from his mother, Johanna. Even that information did not deter De la Faille from his business transactions, but by the summer he was stewing.

His fellow authenticator Meier-Graefe had left for the United States early in 1928 and did not return to Germany until the summer. Once he reappeared in Berlin, he was confronted with direct questions about the Wacker pictures and his personal validations for them. He was shown the Cassirer catalogue and asked if anything struck him as untoward. In the context of the large number of Van Goghs whose provenance was beyond dispute, the Wacker pictures did seem odd with their vague attribution "Collection privée suisse." He promptly contacted De la Faille, and they discussed the situation. Meier-Graefe went on

about the need to establish provenance, but De la Faille down-
played provenance: "I answered him that this was immaterial
because provenance could not make a reproduction genuine or a
genuine picture false." Nevertheless, they agreed to investigate
matters further before making any public statement.

A show of Van Gogh paintings in Hanover included five pic-
tures stemming from Wacker. De la Faille turned down an invita-
tion to attend. Among those who did attend, support for the
Wacker pictures diminished dramatically.[4] In late November 1928
the press finally got hold of the story—and all hell broke loose:
"Millioenen Vervalsching," "Unechte van Goghs," "Alleged Picture
Forgeries" were some of the headlines. London's conservative
*Morning Post* was abuzz with excitement: "If the works are finally
proved not to be genuine they will be some of the most refined
forgeries that have ever been placed on the art market. To begin
with they are not copies, but works painted on some of Van Gogh's
favourite subjects in his own style. Secondly, the style is that of
the period of Van Gogh's life when he lost control of his mind, so
that their origin is most difficult to prove. Finally, they have the
black dusty rim characteristic of so many of the artist's paintings
owing to his habit of storing piles of his own canvases."[5]

The *Daily Telegraph* reported that some of the Van Goghs in
Britain were most likely fakes and alleged that "several such pic-
tures have been successfully sold, especially to American buyers."[6]
Everyone considered the Americans the most suitable dupes. In
a letter of mid-December to Franz Zatzenstein of Berlin's
Matthiesen gallery, the Detroit publisher and collector Ralph H.
Booth noted that American newspapers had been reporting on
the story at length.[7]

In early December, Jacob-Baart de la Faille dropped his bomb-
shell. After declaring to the world over the past three years that
the Wacker pictures were genuine, he now proclaimed that all of

them without exception were fakes. He made this formal statement first in Amsterdam's *De Telegraaf* on December 1, 1928, and, later that month, in a small volume titled *Les faux van Gogh* (The Fake Van Goghs), which listed 138 pictures, including 33 associated with Otto Wacker. Without having examined them closely a second time, he condemned the Wacker paintings out of hand. "I kept silent until I was absolutely certain of the imitations," he told The Hague's *Het Vaterland* newspaper. Germany, he asserted, was the principal terrain, and France the main source of the fakes. Beyond Wacker, many of the fraudulent items emanated from the Duret firm in Paris. De la Faille admitted that Meier-Graefe had approached him in the summer of 1928 and urged him to attend to provenance. When he was convinced that the pictures were fakes, he informed Meier-Graefe of his position. "It was not the discovery of the provenance of the pictures that gave me the cue to break silence. This came from certainty that the works in question were false."[8]

What kind of "expert" was this, many started to ask, who one day affirmed that everything was genuine and the next that everything was false? De la Faille's difficulties were only beginning.

## ALEXANDERPLATZ
*Paul Gauguin's Armchair*

In the course of that year, 1928, Jacob-Baart de la Faille was in constant contact with Otto Wacker, pressing, urging, begging him to reveal his secrets. Instead of opening up, the dancer-dealer withdrew, and the warm friendship between the two men dissolved into acrimony. De la Faille informed Wacker that for the sake of his own reputation, he had to make a public announcement—and it would not be favourable.

Wacker responded by threatening legal action but then disappeared from the Berlin scene. In November he surfaced in Holland. To the chagrin of the Berlin police, who had finally moved into action and wished to sequester the Wacker artworks, he had with him nine of his pictures, and he intended to gather support for them. Even if De la Faille had turned against him, he still had guarantees from a good many other experts. Meier-Graefe, Rosenhagen, and Bremmer were still onside. His Dutch supporters in particular, apart from De la Faille, seemed to show no sign of wavering. The chemist, restorer, and artist Martin de Wild would confirm that the paint on the Wacker pictures he had been asked to examine was thirty to thirty-five years old.[1] Why worry? Reassured by these Dutch contacts, Wacker telephoned the Berlin police and announced that he was ready to cooperate. He was brimming with confidence: Bremmer had declared seven of the nine pictures he had just seen "absolutely authentic"—as though the notion of authenticity could be qualified.[2] Wacker arrived in Berlin from The Hague on Saturday, December 1. The next day, Sunday, he met with the police.[3]

Although the interrogation that day took place, for reasons of convenience, at the Polizeiwache am Zoo, next to the famous train station named after the nearby zoological gardens, police headquarters in Berlin were some distance away on the Alexanderplatz. Here was the hub of the modern age, where old and new, fixity and movement, truth and falsehood collided. Curt Moreck pointed to the irony that this square, with its "fortress of legality," the centre of police operations, was also the centre of criminal activity in Berlin, the focus of pimping and prostitution. Nowhere else in Berlin were there as many little taverns or seedy hotels. The fashionable West of Berlin met the dishevelled East here, the bored bourgeoisie encountering the powdered proletariat. "Keep your eyes and your pockets shut," advised Moreck in his

tourist guide to "depraved" Berlin. Within walking distance from Museum Island and the Kronprinzenpalais, the quarter was in dire disrepair by the end of the twenties but also in the process of development and reconstruction. American-style skyscrapers were rising from the rubble, and five train stations, for converging subway, tram, and intercity travel, were planned. Decay and revival confronted each other boldly at the Alexanderplatz. Nowhere in Berlin was the term *tempo*—the buzzword of the age—more fitting. Not surprisingly, Alfred Döblin's great Expressionistic novel of 1929 about the confrontation between reality and imagination took its title from the square. Here—where, according to Moreck, a "limitless approach to life" held sway—the Otto Wacker affair would gestate.[4]

The scandal that erupted in 1928 caused agitation and sensation not only in Germany and Holland but throughout the art world in general. In early December Paul Westheim remarked, "The thirty questionable—one can actually say forged—Van Goghs that the Wacker gallery in Berlin has put into circulation, are causing more excitement in the public than all the genuine Van Goghs ever did."[5] Rather than hurting the market for Van Gogh, the scandal sent prices for indubitable Van Goghs sky high. The satirical journal *Die Weltbühne* had a similar impression: the Wacker scandal had done more for Van Gogh's fame "than his prophets had achieved in thirty years."[6] A year later, in December 1929, the *Berliner Morgenpost* estimated that prices for Van Gogh had risen more than 100 percent since the scandal broke.[7] Julius Meier-Graefe is said to have quipped, "Watch out. That fellow Wacker will make Van Gogh so famous that every taxi driver will have one over his sofa."[8]

With his enterprise in question, with police and lawyers knocking at his door, Otto Wacker closed his gallery in the Viktoriastrasse. He moved to more modest quarters, at

Schumannstrasse 66, near the Friedrichstrasse train station. The next tenant at Viktoriastrasse 12 was, ironically, a Braille library for blind veterans of the Great War.

## COUP

*Café Terrace on the Place du Forum, Arles, at Night*

At the very moment the Wacker affair was breaking, Ludwig Justi managed to give the scandal a sensational backdrop. He arranged for the display in Berlin's National Gallery of the Kröller-Müller collection of Van Gogh paintings. Justi was to claim later that the exhibition had long been planned, but the exchange of letters between him and Helene Kröller-Müller in 1928 indicates that the arrangements were rushed and the timing was dictated by Justi's mounting involvement in the Wacker contretemps.

The Wm H. Müller Company had flourished during the war, when the firm was uniquely placed in neutral Holland to benefit from the supply needs—for foodstuffs, coal, and iron ore—of the various belligerents, especially neighbouring Germany, and Anton Kröller had become a key economic adviser to the Dutch government. Helene meanwhile built up a formidable assortment of modern art that remains a testament to her energy and bravura. Impressionism was well represented—Seurat's *Le Chahut*, once owned by Meier-Graefe, was her favourite prize from that school, acquired in 1922 as her last major purchase—but so were other groups and tendencies too. She was alive to new developments in art, but she also knew what she liked. The Dutch Impressionist Isaac Israëls, son of Jozef, was one of her favourites—his *Mata Hari* from 1916 was to have a prominent place in the collection; she enjoyed Eugène Boch and Maximilien Luce; but Vincent van Gogh spoke to her in a way no other artist did. In 1917 the first

catalogue of her collection was published listing 408 works. Then in 1921 Bremmer put together a catalogue that ran to 232 pages. All told, Helene Kröller-Müller would assemble a collection of some 11,500 *objets d'art*.

She had plans to build a monumental museum for this collection, first at Wassenaar, a short distance from The Hague, where the Kröllers had purchased an estate, and then in the Veluwe region in central Holland, where Anton Kröller was acquiring extensive property in pursuit of his own passion, hunting and riding. He would assemble some six thousand hectares in all. The architects Peter Behrens, Ludwig Mies van der Rohe, Hendrik Petrus Berlage, and Henry van de Velde submitted ideas and plans for buildings at various stages. Behrens and Mies suffered rejection. Berlage was chosen first, to build grand living quarters for the Kröllers, the St. Hubert Hunting Lodge, which he largely completed during the war years. When he resigned in 1919, over differences of opinion with the Kröllers, Henry van de Velde was invited to design the new museum. Van de Velde, the long-time friend of Julius Meier-Graefe, Harry Kessler, and Paul Cassirer, and designer of the Cassirer gallery, had been another early admirer of Van Gogh, whose work he had seen at the Brussels exhibition of the local Symbolist artists group Les Vingt in February 1890.

In February 1921 construction began on the "large museum" at Veluwe. A special local railway was built at huge cost to transport gigantic pieces of sandstone imported from Germany. However, in the following year, the finances of the firm collapsed—yet another victim of German inflation. In May construction on the museum was halted, and in August Helene Kröller-Müller informed her art adviser, H.P. Bremmer, that all art purchases had to cease. The grandiose dream of a privately administered museum had been shattered. Anyone who now wished to see the collection had to apply in writing.

In March 1928 Helene Kröller-Müller transferred her collection to a registered foundation. The intent was to make it more difficult to break up the collection if the family business foundered completely. However, to justify this manoeuvre to the legal and financial authorities, she had to display her art publicly. Consequently, she put out a message to the museum world that she was prepared to send the collection, especially her Van Goghs, around Europe.

Museums jumped at the opportunity. Exhibitions took place in Basel, Bern, and Brussels. Then in September 1928 the Kröller-Müller Van Goghs, 143 of them, arrived in Germany, showing first in Düsseldorf and then in Karlsruhe. Helene was particularly pleased with the exhibition at the Art Museum in Düsseldorf, the former home of the Wackers and still the residence of Leonhard, Otto's older brother, where she thought her paintings had never looked finer.[1] At this point, however, the impromptu schedule hit a road bump. Stuttgart was listed as the next stop, but the Stuttgart museum suddenly informed Helene that it could not take the exhibition until June 1929. Here Ludwig Justi leapt into the breach. "Ausstellung sofort hier möglich"—exhibition possible immediately—he cabled Helene Kröller-Müller. The Karlsruhe show ended on Sunday, December 2, 1928, just as the Wacker affair was capturing attention and Otto Wacker was being interrogated by the Berlin police. On December 4 a contract for the Berlin exhibit was finalized. Everyone moved into high gear. Van Gogh and the Wacker scandal were the talk of Berlin. A catalogue was hurriedly prepared, and on Thursday, December 20, Justi held a preliminary viewing of the Kröller-Müller Van Gogh collection for a select audience. The next day at noon the exhibition opened to the public.[2] Justi was interested in the art, but as an administrator he was obsessed with the politics of art. He hoped that the display of genuine Van Goghs would

expose blatantly the weaknesses of the Wacker pictures and ruin the reputations of fatuous amateurs such as Julius Meier-Graefe. He was infuriated by the "rank provincialism" that surrounded art criticism in Germany. Someone like Meier-Graefe, with no formal training in art and with only superficial enthusiasm as motivation, had no right to pontificate on art in general or on artists—including Vincent van Gogh.

To make the comparison between the genuine and the fraudulent striking and consequential, the two categories had to be brought together. The police, too, were interested in such a comparison. In the days preceding the show's opening, Justi's assiduous assistant, Ludwig Thormaehlen, worked furiously to persuade owners of the Wacker pictures to show them alongside the Kröller-Müller masterpieces: "Privy councillor Justi requests of all owners of the so-called dubious Van Goghs that they submit the disputed works briefly to the National Gallery for a small exhibition, so that both experts and amateurs can judge the objects for themselves and decide on this interesting question." Thormaehlen then played a game of cat and mouse with the collectors: "Personally I'm not entirely clear whether the list drawn up by De la Faille contains unequivocal fakes. Of the few pictures I have seen from the De la Faille list only one can be designated a provable fake."[3]

However, Justi and Thormaehlen's plan to assemble the Wacker pictures in one place was more readily conceived than accomplished. The legal difficulties were considerable. Some owners were shattered by the suggestion that they had been swindled. Others were simply unwilling to accept the evidence because of the shame it cast on their knowledge, taste, and social standing.[4] While Thormaehlen shrewdly suggested to the owners of the Wacker pictures that authenticity was still an open issue, Justi, outraged by the whole scam, refused to be so gentle. On January 27, 1929,

in the prominent *Vossische Zeitung,* he declared of the items Thormaehlen had assembled by then, "The ten pictures with a Wacker connection that are currently in the Kronprinzenpalais have to be declared fakes as unequivocally as possible."[5]

Despite the passion and anxiety in the air, Justi and Thormaehlen managed to round up fifteen of the Wacker pictures. They came in one by one. The Matthiesen gallery, which had retrieved several of the pictures from its clients, readily surrendered them to the police, who in turn passed them on to the National Gallery for safekeeping. Justi's legal counsel advised him not to display any of the Wacker pictures openly because if it turned out that any one of them was not a forgery, the National Gallery could be accused of defamation. As a result, these paintings were available to invited guests for private viewing in Justi's chambers.

Once the owners had surrendered their Wacker pictures, they had immense difficulty in retrieving them. In some cases they were told that the police had sequestered the items for their investigation. But Elsa Essberger wanted her painting back so that her lawyers could proceed with a suit against Hugo Perls, the gallery owner who had sold her the item. Sigmund Gildemeister wanted his works back simply because he did not want his good name associated with corruption and crime. He deeply resented the backhanded approach of Justi and Thormaehlen—their suggestion that the verdict was up in the air—to get his two Wacker paintings in the first place.[6]

The affair became even more complicated and nasty when Helene Kröller-Müller made a startling announcement. She told the world that on Bremmer's advice, she was acquiring the disputed Wacker picture *Boats at Saintes-Maries* (F 418). With the Berlin show still running, she insisted, to Justi's dismay, that her new piece be hung for public viewing among the rest of her Van Gogh paintings. Justi could not believe what was happening, and

at first he simply did not fulfil Frau Kröller-Müller's request. When the *grande dame* visited the exhibition in early February 1929, she was distressed to discover that Justi had ignored her instructions and that her new picture was confined to Justi's antechamber with other Wacker "fakes." She insisted that the picture be moved to the main exhibit and displayed in the "Arles room." As soon as she arrived back in The Hague, she reiterated her demands in an angry missive to the director: "That you consider the picture false ought not to hinder you, because *I* take the responsibility for the pictures displayed upstairs, and I wish to make it clear to you that I am not offended if you regard this Van Gogh as a fake and say so. I'd simply like to give the broad public an opportunity to see this so-called 'fake' and to be able to compare it on the spot."

One of the conditions demanded by Helene Kröller-Müller in the contract agreed to by Justi the previous December had been that her people hang and remove the pictures. Justi could do no other than reply submissively. However, even though a public display of the Wacker pictures had been his intention originally, he did not adhere to either his initial plan or now his promise.[7] The *Boats at Saintes-Maries* stayed in Justi's chambers. Subsequently it would remain an acknowledged part of the Kröller-Müller inventory, although in 1947 it was removed from public viewing. By then Helene Kröller-Müller was in her grave.[8]

The sale of pictures besmirched by doubt floored many in the art community. When Paul Westheim heard that Wacker pictures suspected as fakes had been sold, he was flabbergasted. "That a collector is fooled by a fake, that happens all too often; that love is blind, that's common knowledge; however, that a love of art leads to the purchase of generally acknowledged fakes, that is a first."[9] Despite his respectful and compliant approach to the well-heeled, Justi had doubts about more than *Boats at Saintes-Maries*.

He found a half-dozen other pictures in the Kröller-Müller collection suspect, pointing out that Helene had started collecting Van Goghs rather late in the day, when the best pictures had already been sold. He voiced these doubts to a number of close colleagues, including the director of the Art Museum in Basel, but he was not prepared to air these issues publicly at the time.[10] To do so while the National Gallery was benefiting from the Kröller-Müller collection would have been most impolitic.

Justi's effort had all the trappings of a campaign. A long list of critics, directors, and dignitaries were invited to his private showing of the purported fakes. Many accepted. As Thormaehlen wrote in mid-February to Paul Ortwin Rave, the eminent historian of Berlin's architecture, "Here the issue of the Van Gogh fakes is keeping us very busy. Every day we have visitors who want to see them. We chatter away until four o'clock every afternoon."[11]

Yet when H.P. Bremmer came to Berlin for the exhibit, he was deliberately ignored. He received no special welcome, no invitation to Justi's private exhibit, and when he made overtures about buying more of the disputed pictures, the police were promptly informed. They intervened and forbade further sale.[12] On his return to The Hague, Bremmer vented his frustration. He and his supporters deplored German arrogance and rudeness. The journalist and critic Cornelis Veth was caustic toward Justi, who had the gumption to declare all the Wacker pictures fakes: "For the initiated it is simply ludicrous that the director of the National Gallery presents himself as an 'authority' on Van Gogh in the presence of Bremmer." The problem, suggested Veth, was that Bremmer, despite his acknowledged expertise, had no official position and institutional authority, and for the Germans titles were everything.[13] In this budding Dutch-German confrontation, all the standard ethnic clichés were being summoned from the arsenal.

With the controversy and the resulting publicity, the Kröller-Müller exhibit in Berlin was a great success. The show was meant to run until the end of January, but the public demand was so impressive that the closing date kept being pushed back, first to early February, then to the end of the month. The exhibition finally closed only on March 2. Over twenty-three thousand visitors came to see the paintings, including more than six thousand students.[14] The appeal cut across class and political lines. "Rarely has a show come at such an appropriate psychological moment," wrote Paul Ferdinand Schmidt, the critic for the socialist *Vorwärts*. Van Gogh's life work, he noted, was "written and sealed with blood."[15] From Berlin the Kröller-Müller collection went to Hamburg, where another ten thousand enthusiasts saw it. The European tour culminated in Amsterdam in 1930 at the Stedelijk Museum. There some fifty thousand visitors saw Helene Kröller-Müller's prized Van Goghs.[16] Despite the aggravations encountered in Berlin, Helene was more than pleased by the attention her collection had received.

## SURREALITY

*Crab on Its Back*

Shortly after his interrogation on December 2, where he was fully cooperative but unflinching in his story, Otto Wacker travelled to Paris and then on to Switzerland in search, so he claimed, of the Russian. However, his source had apparently decamped for foreign lands—Egypt, it was said. The Berlin police stepped up their investigation, assembling as many of the dubious pictures as possible and housing them with Ludwig Justi at the National Gallery. Jacob-Baart de la Faille was interviewed at length while he was in Berlin for the Kröller-Müller

exhibition. In turn, Kriminalkommissar J.A. Thomas of the Berlin police travelled to Holland. On January 17 he took a deposition from Vincent Willem van Gogh at his offices on the Herengracht, the beautiful canal street in central Amsterdam, where he worked as a consulting engineer. Accompanied by Chief Inspector Simon of The Hague police, Thomas went on to Delft, where he saw the chemist Martin de Wild, and then to The Hague, to interview H.P. Bremmer. Meanwhile, two Soviet officials—Professor Tarnoviets, an expert on Western art, and Alfred Kurella, the commissar for art—declared that they would have known of any major collection of Van Gogh paintings in Russia and, moreover, that if these paintings had been moved out of Russia before 1923, no one would have opposed their sale abroad.[1] That put another dent in Wacker's story.

At this point the plot thickened immeasurably. While the Berlin police official was in Holland, Wacker, too, returned to The Hague and then visited Leiden, where, between January 26 and February 3, he stayed at the Hotel Rijnland on the Beestenmarkt. This small establishment, on a central square not far from the train station, had obviously been recommended to Wacker by Bremmer, because it was owned by Bremmer's sister and run by her son and daughter, Willem Cornelis and Wilhelmina Cornelia Feltkamp. The name of the hotel (the Rhineland), the location (the Animal Market), and the preposterously repetitive Christian names of the Feltkamps might have been invented by some black satirist. From Leiden in early February, Wacker informed the Berlin police that he was returning shortly with new information about the Russian.

At the Hotel Rijnland on February 3, at 8:15 in the morning, Otto Wacker was found unconscious on a staircase. He was promptly rushed to the local Elisabeth Hospital and treated by the doctor on call, A. Gans, who concluded that Wacker had

suffered a heart attack and damaged his arm when he fell. However, when Wacker regained consciousness, he refused to accept the diagnosis, checked out of the hospital, and charged that someone had tried to poison him—someone who was afraid that he might divulge information. When urine and stool samples revealed no trace of poison, Wacker responded that the doctor must have been involved in the plot. He would later attest that on the day before his illness, he had been approached by a man in Amsterdam, "bearded and rustic in demeanour," who spoke German and said he was interested in purchasing art. They had a meal together, and it was there, Wacker believed, that he had been poisoned.[2]

In Wacker's room in the hotel, however, were found two small bottles, one with valeric acid and the other with a peppermint-like fluid. Valeric acid, though used as a food additive, is toxic in larger quantities. Did he poison himself? Wacker had begun his stay at the hotel in a room on the first floor, but, claiming that he could not sleep because of coughing in an adjacent room, he had asked to be moved to the floor above. That night he returned to the bathroom on the first floor, however, and had some sort of attack. He was found on the staircase between the floors. A waiter in the hotel would inform police that Wacker had several visits from a gentleman roughly his own age.[3] Who was this gentleman? Was there a homosexual tryst?

This whole bizarre incident seemed to echo Van Gogh's own psychological problems in Provence, his delirium and belief in February 1889, reported by Rev. Salles, that someone had tried to poison him. Had Wacker come to identify so intensely with Van Gogh that he set about re-enacting the artist's stations of the cross? Or was he engaging in some surrealistic playacting worthy of a Salvador Dali or a René Magritte? In 1929 Dali, together with Luis Buñuel, released *Un Chien andalou*, a short feature film

in which characters swoon and collapse and where states of consciousness and dreaming blur. The famous opening scene involves the slitting of an eyeball with a razor—the violent termination of vision and comprehension but the repudiation also of cinematic pleasure. Magritte produced the painting *Ceci n'est pas une pipe . . .*, his important lesson on the distinction between image and language, that same year. Surrealism was a serious joke. Was Otto Wacker a serious protagonist of surreality?

The Dutch police investigated, interviewing hospital personnel as well as Bremmer's niece and nephew, but found no satisfactory explanation for the strange incident. Otto's brother, Leonhard, came from Germany to visit him in hospital—a parallel, perhaps, with Theo's visit to Vincent in the hospital at Arles? While in Leiden, Leonhard was interrogated by the local police. Willem Feltkamp revealed subsequently that Otto Wacker told him he had met with the Russian in Paris earlier in January and that the Russian, angered by developments, had tried to poison him. The Berlin press found the whole story preposterous, suggesting that it had been staged by Wacker as a cover for his inability to produce the Russian. The Dutch press, however, was not as quick to jump to conclusions.

In May 1929 Otto Wacker was back in Berlin, apparently ready once again to face his accusers. Paul Westheim thought his return a positive development and hoped that the sorry affair could finally be brought to a speedy conclusion. The Berlin art market needed a boost. The Americans in particular had become suspicious, and there was even talk of a formal boycott of the Berlin market.[4]

Again, nothing much happened to clarify matters. Wacker's basic story remained unchanged: he had received the pictures from a Russian; to his knowledge they were genuine; it was the task of his accusers to prove they were not. As the year 1929 drew

on, the earlier flurry of attention subsided. By 1930 the affair seemed all but forgotten. In July of that year Wacker told Bremmer's friend Willem Scherjon that he was working on a brochure "that will cast light on the Van Gogh affair." He added that he would need money to publish it and that he was in the thick of a business opportunity that might yield such funds.[5]

Fiction and life, life and fiction: Where was the dividing line?

## SENSATION

### *Self-Portrait*

Otto Wacker's career as an art dealer had blossomed in those few years in the mid-1920s when the German economy finally began to look up from the thraldom of war and inflation. By 1928, however, the recovery had slowed. A speculative frenzy on Wall Street promised far greater returns than any loan to Germany, and American investors withdrew their monies from Europe. The stock-market crash in New York in October 1929 darkened the already threatening sky. Hugo von Hofmannsthal, Gustav Stresemann, and Serge Diaghilev died that year. "One piece after another of the world, as I and my generation knew it, disappears," wrote Harry Kessler despondently on October 3, several weeks before the market crash. "Truly an *année ter-rible*."[1] The German economy went into another freefall in the months and years that followed: banks closed; businesses shut; unemployment rocketed skyward. Hitler's National Socialist party, which had been founded on simplistic economic doctrines condemning the "dictatorship of interest," grew markedly in 1929 and produced a major political earthquake in the national elections of September 1930, when its representation in the German parliament jumped from 12 to 107 seats. Never before

had there been such a dramatic shift in the German multi-party political constellation.

The economic depression that struck with full force in 1929 did not, however, put art prices into the same downward spiral as other commodities. In the United States, Walter K. Gutman, who was all at once a stock-market analyst, writer, and artist, would tell his readers as late as February 1932, some two and a half years after the crash on Wall Street: "One can say dogmatically that no investment is as secure and as liable to be profitable after a reasonable passage of time as a work of art of recognized importance. Works of art of this class do not suffer from any of the serious diseases of other securities. They cannot be overproduced. They cannot be bankrupt through mismanagement or misfortune. They are not vitally affected by changes of fashion or new usages. They do not suffer from debased currency." Good art, Gutman advised, is "the most conservative as well as one of the most profitable forms of investment."[2]

As Van Gogh interest grew in 1928, with the Cassirer exhibition opening the year, the Wacker affair blossoming in the course of it, and the spectacular Kröller-Müller show closing it out, Ludwig Justi began to feel that his National Gallery was naked without any examples of the most sought-after artist of the modern age. He concluded that he simply had to acquire some Van Goghs, cost what they might. In 1929 his efforts—and his hubris—culminated in the purchase of not one but several Van Goghs: *The Lovers* (F 485), which Meier-Graefe had once owned, from the Arles phase; one of the harvest pictures (F 628) from the Saint-Rémy period; and a second version of *Daubigny's Garden* (F 776), thought at the time to be the last picture Van Gogh painted. In what seemed like one bold stroke, Justi had landed three noteworthy Van Goghs, each from a different period of the artist's creative life. The cultural moguls were genuinely surprised.

In view of the paucity of Van Gogh work on the market, one picture would have been a major acquisition, but the purchase of three was a dazzling development. Still, some were aghast at the prices paid: for *The Lovers,* 100,000 marks ($24,000), for *Daubigny's Garden,* 240,000 ($57,000)—sums that the National Gallery's acquisition fund simply did not have. Complex financing arrangements had to be drawn up, which in turn were subject to scrutiny and rumour. Funds from an American foundation, available to the National Gallery from well before 1914, were said to have been used, as well as an interest-free loan from the Darmstädter und Nationalbank (Danatbank) arranged by the art-loving financier Jakob Goldschmidt. Ironically, the Danatbank would go bankrupt in the financial crisis of 1931.

Max Liebermann, the president of Berlin's Academy of Arts and a man whose ego appeared to inflate with age, turned on Justi with a vengeance. In one breath he denounced him as "the absolute monarch of the National Gallery," implying that he behaved like a seventeenth-century tyrant, and in the next as a "dictator" no different from Mussolini or Lenin.[3] How could he, the director of the National Gallery, spend such outrageous sums on a foreign artist, who, Liebermann had decided, was not all that good anyway, when German artists were going hungry?[4] In this criticism of Van Gogh, Liebermann was giving voice both to an unworthy envy and to a thread that Karl Scheffler, among others, had introduced before the Great War, when Liebermann was still genuinely excited by Van Gogh. "To be a master of painting," Scheffler had written, "Van Gogh lacked the peace, the joy of craft, and the pleasure of quiet creation."[5]

The schoolmasterly Scheffler, still a weighty critic at the end of the 1920s, was as unimpressed as Liebermann by Justi's acquisition policy. The only foreign works Justi had purchased for the National Gallery were three paintings by Edvard Munch and

these three by Van Gogh. There was, to Scheffler's chagrin, no new French art. Ten years earlier, when he was organizing the new wing of the National Gallery, Justi, protested Scheffler, had been influenced by the wave of Marxism that had overwhelmed the world. That is what had led him to devote such attention to the German Expressionists. Now he was responding to nationalist currents. That was no way to acquire art, said Scheffler.[6] Given his own political engagements in the past, particularly his enthusiasm at the outbreak of the First World War, Scheffler might have shown a little more modesty in his criticism. But in the art world, modesty has always been in short supply.

Still, hostile as he was toward Justi and his administration of the National Gallery, Scheffler was prepared to admit that Van Gogh stood as the artistic "marker" (*Grenzstein*) for the age. Never had the name of an artist been "so widely vocalized. . . . Never before, it seems, has painting had such effect, evoked such tempestuous discussion, represented so obviously the image of the revolutionary. In the West an entire generation stands surrounded by the suggestiveness of Van Gogh's name." But what was it, asked Scheffler, that made Van Gogh so attractive? It was "a fierce but diseased idealism, with a social dimension." Van Gogh's art had ceased to be purely representative; it was no longer concerned with capturing timeless values and feelings. With Van Gogh, painting strove to intoxicate and to provoke rather than teach.[7]

The growing popularity of the artist was accompanied, as is always the case, by a mounting vulgarity in the reception. That, too, repelled Scheffler, Liebermann, and other aesthetes. Near the end of 1929, Count Harry Kessler dined at the residence of the socialite and art collector Baby Goldschmidt-Rothschild on the Pariser Platz, the grand square on the east side of the Brandenburg Gate. "Eight to ten people, intimate party, extreme

luxury," he noted in his diary. "Four priceless masterpieces by Manet, Cézanne, Van Gogh, and Monet respectively on the walls. After dinner thirty Van Gogh letters, in an excessively ornate, ugly binding, were passed around with cigarettes and coffee. Poor Van Gogh! I feel like instituting a pogrom. These people should be slaughtered. Not out of jealousy, but disgust at the falsification and levelling of intellectual and artistic values to mere baubles, articles of 'luxury.'"[8]

Van Gogh the creator, or Van Gogh the destroyer? Which was it? Perhaps he was both, and his success in a bifurcated Berlin, wallowing in self-pity but also celebrating life beyond convention and conscience, was evidence of that. Berlin in the 1920s was the capital of contraries. In the nineteenth century, as the French Revolution cast its shadow over all political endeavour, Paris had been the focal point of radicalism, artistic as well as political. Although its beauty and allure as a city continued to reverberate into the twentieth century, it had ceased to be the cauldron of revolution and the source of provocation. That role passed after the Great War to the capital city of the defeated—Berlin.

George Grosz, whose art of the grotesque had assumed more colour and amplitude by the late 1920s, thought in 1931 that Germany was "the most interesting and complex country in Europe" and that it might be called on soon to play "a great role." He had the feeling that his was an age of great transition, comparable to the waning of the Middle Ages. Humanistic values and ideas were in decline. Life itself was of no great value. "The masses and the little man are trump," he noted. But the machine trumped even them. In prose reminiscent of the angular and unstable clutter that made up his pictures—his *Berlin-Friedrichstrasse*, for example—he wrote, "The palaces of the age, the seven-storey office towers, the department-store cathedrals, the radio palaces, the film temples are dedicated to the unknown idols of a senseless

machine production." And what about artists? Most were broken cripples. "The art of the age is pale, like a child with excessively large head and horn-rimmed glasses." He regretted that Germany didn't have a Kazimir Malevich, the Russian painter who had the courage to present an empty white canvas.[9]

What Germany did have was a Felix Nussbaum, a young Jewish artist from Osnabrück, born in 1904, whose work bore a direct affinity to Van Gogh's. Nussbaum painted sunflowers, boats, and endless portraits. His colours blazed, yet their essence was melancholy. In 1929 he visited Arles—to walk where Van Gogh had walked, to paint where Van Gogh had painted. Nussbaum was a brilliant disciple. No one took much notice of him while he was alive: he died in Auschwitz in August 1944 and was rediscovered in the 1970s. For Van Gogh, yellow was the colour of love. For Nussbaum, yellow would be the colour of the Star of David.[10]

## RAVENS

*Vincent's Chair with His Pipe*

By the time the Depression hit Europe and especially Germany with its devastating force, Jacob-Baart de la Faille and Julius Meier-Graefe, who for years had cooperated in matters relating to Van Gogh, had become bitter enemies, each claiming to have been the first to harbour doubts about the Wacker pictures.[1] If De la Faille had doubts at the time of the Cassirer exhibition in January 1928, why did he not reveal them then? asked Meier-Graefe. The only sure proof of authenticity was unequivocal provenance, he argued; style proved nothing. De la Faille responded that Meier-Graefe was "an excellent but fickle individual who permits himself to be influenced out of sheer goodwill."[2] Was the

raven belittling blackness? By early 1929 the two Van Gogh experts were pecking at each other's throat.

H.P. Bremmer was also merciless in his castigation of De la Faille. To make a mistake was human, he wrote, but thirty mistakes, one after the other? "It is my conviction that Mr. Baart de la Faille is not in any position to give an authoritative judgment on the authenticity of any picture," he insisted. "The authenticity of a work of art must be felt, must be 'lived.'" Of the contested self-portrait that Chester Dale had bought (F 523), he said, "I have had the portrait in question before me, and I am absolutely certain that we are dealing with an original work by Van Gogh."[3] The picture had been brought from the United States to Holland in 1929 for an exhibition in Utrecht, where it was displayed alongside another universally recognized genuine self-portrait (F 626) owned by the Tutein Nolthenius family of Delft.

Bremmer's long-time friend and associate Willem Scherjon of Utrecht joined the campaign on behalf of Dale's self-portrait. In a note to Dale he pointed out that Van Gogh's own letters proved the authenticity of the portrait. A letter of September 1889 mentioned two self-depictions: one on a dark violet-blue background, the head, in Vincent's words, "whitish with yellow hair," and another on a light background. In a subsequent letter he told his brother that in the second portrait "my face is much calmer. . . . I have tried to make it simple." The Dale portrait, Scherjon insisted, had the light background. "So the authenticity of your portrait is established," he wrote.[4] Others, including W. Jos de Gruyter, Jan Engelman, Meier-Graefe, and Just Havelaar, lined up behind Bremmer and Scherjon. The veteran critic Havelaar, who had published a biography of Van Gogh a decade earlier, called the portrait Van Gogh's "most mature work."[5]

Willem Scherjon purchased *Two Poplars* (F 639) from Wacker and took offence when De la Faille denounced it as a fake along

with the rest of the Wacker pictures. Scherjon insisted he had seen the picture in the home of Johanna van Gogh. De la Faille countered that Scherjon was confused: he might have seen a similar picture of an Alpilles landscape (F 638). *Two Poplars* had been returned to Wacker by the Thannhauser gallery in October 1928, and the Thannhauser and Cassirer galleries had declared it to be a fake.[6] Nevertheless, it bore certificates of authenticity from Meier-Graefe, Rosenhagen, De Wild, and Traas, among others.

The eddies were turning into whirlpools. One man's saint proved to be another's ogre, but all threatened to go under in the maelstrom. Ludwig Justi found Meier-Graefe to be the most objectionable personality in the whole affair, a man devoid of substance. According to Justi, Meier-Graefe had written some "fat books" on Van Gogh and somehow persuaded the public to regard him as an authority. "He considered himself one too," added Justi in late January 1929, in one of the landmark press articles in the case. Largely due to Meier-Graefe's shameless pomposity, "Berlin is the butt of jokes," he wrote. The journalist had authenticated some twenty-five of the Wacker pictures, but now he was taking the hypocritical position that provenance was crucial to authenticity. Why didn't he do so earlier? Moreover, Justi went on, Meier-Graefe claimed that Van Gogh had "weak moments" and, as a result, much of his art was second-rate. "Whoever cannot see the difference now is betraying his inability to see at all; he may write more fat books but he certainly shouldn't write any more certificates of authenticity, or cheat gullible collectors of their money or make fun of the little respect that our mechanized civilization still has for artistic genius."[7]

Justi, who insisted that art was the "dedicated and precious formulation of spiritual values,"[8] would argue all along that Van Gogh's genius was evident in every aspect of his work. Every one of his paintings exuded brilliance, he claimed. He made such

assertions despite evidence in Van Gogh's letters that the artist himself had considered some of his work weak and even unacceptable. Vincent had announced to his brother in a letter from April 28, 1889, "I'll send 2 crates of paintings by goods train shortly. You mustn't feel awkward about destroying a good number of them."⁹ Despite the vulnerability of some of his own arguments, Justi went on a crusade against Meier-Graefe.

The Dutch railed against the Germans and vice versa. But the lines were not always clearly drawn. Meier-Graefe had Dutch defenders, while De la Faille was assailed from all sides. The powerful *Nieuwe Rotterdamsche Courant,* the *NRC,* wondered about De la Faille's credibility on any level. What if he were a witness at a criminal trial? One moment he would say he saw something, and the next moment he would deny having seen anything.¹⁰ The disagreements revolved around not only art theory but practical and even scientific matters—the origin of the canvas material and the age of the paint. Willem Scherjon played an increasingly aggressive role in the affair. He claimed, for instance, that the Utrecht police had found a fingerprint on the poplar picture he had acquired in 1928 (F 639) that matched prints on some uncontested Van Gogh canvases such as *Night* (F 329) and *Interior of Restaurant* (F 342), and he considered this evidence sufficient proof that *Two Poplars* (F 639), like its counterpart of the Apilles landscape (F 638), was genuine. The painting had hung for some time in the Centraal Museum of Utrecht, where Scherjon had a printing business and gallery. In 1930 he opened a smart new gallery, Huinck en Scherjon, on the exclusive Herengracht in Amsterdam, where Vincent Willem van Gogh also had offices. *Two Poplars* was displayed there alongside works by Delacroix, Monet, and Ensor.¹¹ In 1932 Scherjon would add to his Wacker collection by acquiring a small self-portrait (F 385) and a large cypress picture (F 614).

The foreign press tended to find the whole business more amusing than disconcerting. The art critic Frank Davis commented in the *London Illustrated News* in June 1930: "I am more intrigued by the cleverness of these rascals than horrified by their villainy—and my enjoyment is increased by the extraordinary circumstance that the victims are so often mere bargain-hunters whose knowledge of art is in inverse proportion to their self-advertised omniscience."[12]

Berlin was not the only site of these cultural convulsions. In 1929 a trial took place in France at Versailles in a case brought by a British collector, Sir Robert Abdy, against two local antiquarian dealers who had sold him 124 paintings purported to be by Corot, Delacroix, Diaz, Sisley, Daubigny, and others. Experts recognized immediately that the items were fakes, and Abdy wanted his money back. The case was of added interest because Abdy had just opened a gallery in Paris, and one of the first pictures he had displayed there was a Wacker Van Gogh—a self-portrait (F 521) that he had acquired from Hugo Perls in Berlin![13]

## EVIDENCE

*Still Life: Blue Enamel Coffeepot, Earthenware and Fruit*

To many in the art community, the evidence against Wacker appeared compelling, but the police and the state prosecutor were still not convinced that they could proceed successfully. To make their case the prosecution would have, first, to prove that the art was fake by locating its source and, second, to assemble evidence that Wacker knowingly disseminated fraudulent art. The bar for the prosecution was high, as Wacker no doubt realized.

Van Gogh had been sloppy in his life and his work. Much of his output had gone astray, in Holland and also in Arles. The

artist's peripatetic existence and then his illness had created, as De la Faille discovered to his chagrin, almost insurmountable problems of documentation. Furthermore, it was well known that Van Gogh made multiple copies of his own work. In September 1889, for instance, he wrote to his brother, "At the end of the month you can rely on 12 no. 30 canvases I dare say, but there will be almost the same ones twice, the study and the final painting." The problem was compounded by the fact that many of these pictures were repeats of the same theme, such as wheat fields and reapers—an image that preoccupied Van Gogh that September.[1] Some of his pictures he signed, others not. He gave away pictures, and some of his recipients are known to have thought little of his gift. This repetition and yet irregularity, along with stories about carts full of lost art, made Van Gogh a favourite of forgers.[2]

Elsa Wolff-Essberger found out about the difficulties of convincingly demonstrating bad faith in her suit against Hugo Perls. Her lawyers made a straightforward argument: a collector depends on the integrity and honesty of a dealer, and if there are any doubts about the provenance of a work of art, they must be disclosed to a prospective buyer. In this case, the dealer had not done so. Perls, who was not much loved in the Berlin art world, refused to admit error. He had trained as a lawyer before turning to art, and he argued that the entire international art community, from Amsterdam to New York and Detroit, had been taken in by Wacker. There was, moreover, no clear proof that the paintings were in fact forgeries. He himself had acted in good faith, he said, and felt no moral obligation to recant or apologize.[3]

The eagerly awaited decision in the Perls-Essberger case came in the spring of 1930. It favoured the dealer. Perls was heartened by his victory and remained impenitent toward Frau Essberger, fortified by the utterances of several "experts." These developments must have given Otto Wacker a shot in the arm as his own

legal problems mounted. The authorities who wished to proceed against him were deeply dismayed by this turn of events. They did not, however, give up.

Though in the end hardly anyone aside from Meier-Graefe was willing to accept Wacker's story about the Russian family, the fact that the source of the questionable paintings had not been ascertained made the legal situation murky and the criminal police reluctant to lay charges. It took almost three years for the state prosecutor to put together a case. Finally, on September 4, 1931, Otto Wacker was formally indicted, accused of having knowingly sold some thirty pictures that were falsely attributed to Van Gogh. Paul Westheim and others were surprised by these developments: "For the longest time we heard nothing about this matter . . . and it began to appear as if the case—so often the result in questions of fraud—would simply disappear."[4]

The next day, September 5, the Berlin police revealed that in a raid on Leonhard Wacker's studio in Düsseldorf back in May 1929, they had found a forged painting with a Van Gogh signature; the painting corresponded to a copy of *Wheat Field with Reaper* in Otto Wacker's possession. A large framed photograph of a Van Gogh self-portrait (F 626) had also been found. They assumed it had served as the basis for *Self-Portrait at Easel* (F 523). In all, they had seized twelve oil paintings and two watercolours during the raid. For the first time, Leonhard Wacker was now featured in the press. The name Bernard Wacker, of Paris, was more familiar, because it had appeared in De la Faille's catalogue as the former owner of *Haystacks* (F 625a). Now Leonhard was suddenly a public figure—and it turned out that he and Bernard were the same person! Did he have a gallery in Paris? reporters asked. Otto explained that Leonhard had been planning one. The father, Hans Wacker, had earlier escaped attention too. Raids on his flat in Berlin, on the Königgrätzer Strasse, also in May 1929,

and on his studio in Ferch in August had led to the seizure of twelve oil paintings, watercolours, and drawings, several of which were thought to have distinct Van Gogh motifs. Two of the pictures taken by the police were signed "E. Pirmont" and "C.H. Mertens." Hans Wacker claimed that they were by his daughter, Luise. Suspicions were also aroused by the lack of recent work in the father's studio, suggesting that the latest efforts had been removed in anticipation of a raid.[5]

To many it now seemed like an open-and-shut case.[6] However, it rested on being able to prove that the paintings Otto Wacker sold came from his brother's or his father's studio and that Otto knew he was selling fakes. The state prosecutor's office was not as confident as the police, considering the evidence largely circumstantial and the connections insufficiently tight. Nobody had been caught in flagrante, dripping paintbrush in hand.[7] Otto Wacker continued to stand his ground. The Van Gogh experts had, after all, authenticated all the works he sold. What more could he have done to protect himself against the kind of charges that were now being levelled against him? Moreover, an expert like Bremmer still appeared to be willing to affirm the authenticity of a number of the Wacker pictures. As for the absence of accounting records, Wacker's response was straightforward. "Have you ever heard of a dancer who was also an accountant?" In April 1930 the Berlin paper *Montag Morgen* had predicted that the whole affair would come to nought, that it would, in that lovely German expression, trickle away in the sand—*im Sande verlaufen.*[8]

The wits went to work. The satirically minded weekly *Die Weltbühne* found the whole battle most enjoyable. It was not about Van Gogh's art, it noted; it was about greed, egotism, and the power of the press. A battle that Wacker seemed set to lose had suddenly turned into a genuine struggle. With the *Frankfurter*

*Zeitung* and the *Berliner Tageblatt* pulling for Wacker, thanks to Meier-Graefe, and Ullstein's Berlin paper *Vossische Zeitung* opposed, the score was "almost even," wrote a columnist under the pen name of the eighteenth-century philosopher Martin Knutzen. "What the experts are currently doing would make poor Van Gogh, were he able to look down from the clouds, lose his mind all over again." All that was missing, Knutzen concluded, was the suggestion that Van Gogh had forged the pictures himself.[9] Knutzen should have known that this charge would be coming too, in some form. It was, after all, the era of Franz Kafka, Joseph K., and *The Trial*—a story in which the defendant is found guilty of a charge that remains a secret.

In March 1932 Cornelis Veth, the art critic for *De Telegraaf,* published a small volume attacking the German and defending the Dutch "experts"—all except De la Faille.[10] Veth derided the commercialism that surrounded Van Gogh and blamed De la Faille for exacerbating this trend. He developed the view, held by many of the Dutch, that some of the pictures were genuine and that Wacker had built his enterprise around them. Veth accepted the validity of the *Two Poplars* (F 639) and the *Boats at Saintes-Maries* (F 418). He also reiterated Scherjon's "irrefutable" argument that clear support for the Chester Dale portrait was to be found in the Van Gogh correspondence. Other evidence—fingerprints and age of paint—confirmed the authenticity of these various works. Veth suggested that people had been too quick to jump to conclusions and that more than art was involved. National considerations were in play, and the very notion of art, let alone the name and reputation of Van Gogh, was being harmed.[11]

In Berlin Paul Westheim, who had followed the case closely from the earliest whiffs of malfeasance, concluded by the summer of 1931 that the Wacker affair had become "one of the greatest fraud scandals of all time."[12] And all the while Germany slumped

ever deeper into economic misery, unemployment numbers ballooned, and a major bank, the Danat, collapsed.

## CELA N'EST PAS . . .

*Self-Portrait (Dedicated to Paul Gauguin)*

By 1932 Otto Wacker, who said he loved beautiful things, was in deep financial difficulty. But so was Count Harry Kessler, who also loved beautiful things. Kessler had squandered his inheritance, and for several years now he had been begging his sister in France, Wilma, the marquise de Brion, for assistance. In an attempt to summon sympathy he told her that he was thinking of selling his extensive collection of art: "Of course I intend to sell the Cézanne and the Renoir as soon as somebody offers me a decent and normal price. They are worth 100,000 marks each under normal conditions. . . . The Van Gogh is of course worth much more; in fact, it is difficult to value it at all, as it is one of his outstanding and celebrated pictures and there are very few Van Goghs left in the market, most of them being already in public collections."

Despite his sister's ongoing magnanimity, in the autumn of 1931 Kessler was finally forced to sell his last Van Gogh, *The Plain of Auvers* (F 781), for 100,000 marks ($23,800) to pay pressing debts and bills. "Tout cela n'est pas amusant," he commented—not at all amusing. In February 1932 he informed his sister that all he had in the house was a bottle of beer and some tea.[1] Otto Wacker was in similar straits: he claimed he could not afford even a tram ticket.

## PRESENT SENSE

*Still Life with Bloaters and Garlic*

Since the spring of 1930, the German parliament had been dysfunctional: a majority government could not be formed, and radicalism was on the rise. Street battles between Communists and Nazis raged. Normal fiscal legislation, allowing the state to function, had to be signed into law using Article 48, the Weimar constitution's emergency clause that assigned executive power to the Reich president. That presidential office was now pivotal in the political process.

The president was elected by popular vote—and new elections were due early in 1932. Field Marshal Paul von Hindenburg, the incumbent, ran again, not entirely willingly. Eighty-four years old, he was desperate, after a lifetime of public service, military and now political, to retire to his country estate to spend his remaining years in peace. However, he had been drafted by the political centre and left as the only candidate able to defeat the remarkable upstart Adolf Hitler, the Austrian German whose National Socialist movement had gained prominence as the Depression deepened and the Wacker affair was brewing. Once again Hindenburg's Prussian sense of duty prevailed over self-interest. In the first round of the election held in March, he emerged as the clear frontrunner but failed to win a majority. In the runoff in April, with 53 percent of the vote, he defeated Hitler, who could still boast that he gained the support of 36 percent of Germans. No other party leader in the badly fragmented German political system came close to such popularity.

Through the summer, as the Depression continued its downward spiral, the Nazi appeal grew. Deprivation and hardship

were visible everywhere. In the national parliamentary elections of July 1932, the party's Reichstag representation jumped from 107 to 231. If the 89 elected Communists were added to that radical bloc, for a total of 320 seats out of the 608 in parliament, it meant that the two extremist parties now controlled Germany. Nazism and Communism dominated the German mindscape. Both were parties of revolution. Germany was in a state of incipient civil war.

The violence of the street had as counterpart a violence of the mind—at every level, popular and refined, scientific and intellectual. In the realm of physics, for example, 1932 came to be known as the "miracle year." The neutron was discovered, and the first artificially induced nuclear transmutation took place. In April in Copenhagen, as the Wacker affair was reaching its crescendo in Berlin, Niels Bohr hosted his annual gathering of some forty leading physicists, including Werner Heisenberg, Lise Meitner, and Paul Dirac, to discuss the fundamental nature of matter and the state of their science. In keeping with tradition, the younger cohort was required in a closing ceremony to entertain the group with a theatrical skit. Since the year marked the centenary of Goethe's death, the German physicist Max Delbrück devised a parody of the Faust story, with classical and quantum physics locked in struggle. Fixity confronted uncertainty. How was one to find the true position of an electron, or for that matter of anything? Could the photon be both particle and wave? Could categories and distinctions blur and blend? Beyond the skit, Niels Bohr, following Heisenberg's cue in his 1927 theory of uncertainty, argued that the photon could be one or the other depending on the tools used for detection. Dirac, in turn, was predicting the existence of antimatter. What was that? He spoke of changes so great that they would exceed the power of human intelligence to formulate the new concepts in any

existing terms. Particle. Wave. Matter. Antimatter. Physics was on the cusp of a new era, one that would defy definition and introduce atomic destruction.[1]

Yet the developments in physics were part and parcel of a general upheaval, cultural and political, shaking all of Europe and much of the world to the very core. Germany was the epicentre of the tremors.

## SEANCE

*Spectators in the Arena at Arles*

In this febrile atmosphere of relentless tension—political, social, and intellectual—the trial of Otto Wacker opened on Wednesday, April 6, 1932, a few days before the German presidential runoff vote.

The venue was the oath courtroom in the lay assessors' court of central Berlin.[1] Solid barriers divided the hall into protagonists and spectators. Judges, lawyers, defendant, and witnesses were seated at the front, with the audience cramped behind in the small gallery. Not one seat remained empty. The headline in the *Vossische Zeitung* later that day read, "Massendrang zum van Gogh-Prozess"—"massive crush at the Van Gogh trial." The press was there—reporters, photographers, critics—but the curious public, too. The cultural critic Siegfried Kracauer was present, as was the artist Emil Nolde. Cameras were not permitted in the courtroom, but the photographer Leo Rosenthal, who was working for the socialist newspaper *Vorwärts*, smuggled his in and took a few pictures surreptitiously. The throng gave the lie to the argument that the public was not interested in serious art, observed Max Osborn, art critic of the *Vossische Zeitung*.[2] The woman who managed the refreshment room was heard to remark,

"Had I known that such smart people would be coming, I would have prepared more ham rolls."[3]

Witnesses would be called, experts would give testimony. Berlin was spellbound. Were the Wacker paintings forgeries or not? Which of the experts, with their wildly divergent views and changing stories, was to be believed? Many saw that more was involved here than the authenticity of a few paintings. What *was* art? A difficult question, and beyond any definition lay more complex issues of authority and legitimacy as they related to institutions, laws, and values—even to the state itself.

The political right—Adolf Hitler most virulently—claimed that the entire constitutional system set up in Germany after the war was illegitimate, based on defeatism and treachery, indeed, on the criminal activity of the political left. The radicals on that political left, the Communists, argued in turn that the Weimar system had been a stopgap creation to protect capitalist exploitation and that the genuine socialist revolution had been aborted in 1919 by moderates and turncoats. Who was responsible for this regime? Deceitful foreigners and their execrable lackeys, answered the radicals of right and left. Weimar was an unlawful regime, propped up by the lie that was the Versailles Treaty. Authenticity, said these extremists, belonged to the true representatives of the interests of the people. Otto Wacker, working-class boy from Düsseldorf, saw himself as a representative of this exploited and abused mass.

The year 1932 would see the Wacker trial—and the endgame of the Weimar Republic.

## SCRIPTS

*Portrait of the Postman Joseph Roulin*

The trial was held under the direction of Landgerichtsdirektor (state court director) Dr. Neumann.[1] The judge cut an impressive image, "very business-like and dignified," in the words of one reporter.[2] The courtroom, in the central Moabit district of Berlin, just to the north of the Tiergarten park, looked more like an art gallery than a legal venue. Sixteen paintings were displayed at the front of the room, all without frames. These Wacker paintings would be passed around from hand to hand as necessary among the expert witnesses. One spectator remarked on the "startling masses of colour in the otherwise dark and colourless surroundings."[3] At the close of daily proceedings, all the protagonists in this drama—lawyers, prosecutor, experts, defendant, and even the substantial usher at the door—would participate in moving the pictures into storage. The next day they would be returned and, invariably, placed in different order. A congress of art experts and an exhibition of art was what the reporter for Berlin's *8-Uhr-Abendblatt* called this trial.[4] Siegfried Kracauer had the impression that he was attending an academic event.[5]

Otto Wacker's father, Hans, was present, as was his older brother, Leonhard. "The father has an almost demonic face," remarked Gabriele Tergit, a court reporter for the *Berliner Tageblatt* whose work was also published in the satirical weekly *Die Weltbühne*. "On his thick dark locks sits a large black Mexican slouch hat."[6] Tergit was only one of the well-known reporters present. Her own life reflected the implications of the event. What is what? And who is who? Is anything fixed, firm, and real? She was actually Elise Hirschmann, born in Berlin in 1894, and wrote under a pen name. She had a doctorate in history, having studied with the renowned historians Friedrich Meinecke and

Erich Marcks after the war. She had then turned to journalism, rendering the German courtroom into a fascinating mirror of society. "For several years now Moabit has been a source for understanding the age," she wrote.[7]

She was also a novelist. A year earlier, in 1931, she had published *Käsebier erobert den Kurfürstendamm*, about a folksinger, Georg Käsebier (literally George Cheesebeer), who, through an outrageous campaign of publicity and promotion, managed to climb from proletarian roots to stardom in Berlin—for a season, until his agent went bankrupt and the theatre built for him closed. Then Käsebier disappeared into anonymity once more. Rudolf Olden, a lawyer, fellow journalist, and one of the first biographers of Hitler, was taken by the book. It presented, he said, "a terrifying picture of the destruction that we are experiencing, a contemporary portrait even if it seems to make fun of our times. It is a battle painting, of the battle we are in the process of losing."[8] It was unlikely that Otto Wacker, with all his problems, had read Gabriele Tergit's novel. Had he, he might have recognized himself in its pages. In Tergit, the historian, court reporter, and novelist, genres criss-crossed and blended, in the same way that morality, definition, and authority collided in both the trial of Otto Wacker and the trial of the Weimar Republic.

Not surprisingly, legal jostling took up much of the first morning. Fifteen potential experts were present, Dutch, French, German. Who would be invited as an expert witness (to comment on the broader issues of art) and who called as a material witness (to speak to the specifics of the case)? For the defence, Ivan Goldschmidt, a small finicky man with large horn-rimmed glasses and a reputation for astute analysis, tried to discredit potentially hostile testimony, protesting that Ludwig Justi and Jacob-Baart de la Faille, for instance, had *parti pris* positions that they had already revealed publicly. Justi had been antagonistic

and aggressive toward Wacker, and De la Faille had been a busi-
ness associate of Wacker's. How could either give impartial testi-
mony? Goldschmidt had a point, but all the other potential
experts seemed equally compromised.

State prosecutor Alexander Kanthack made that same point
about Bremmer. As well as being an adviser to Helene Kröller-
Müller, Bremmer had accepted pictures from Wacker that the
Berlin police had ordered sequestered. He had been an acces-
sory to breach of promise, one of the charges against Wacker.
Therefore, argued Kanthack, he could have no credibility as an
impartial expert.

The épée thrusts continued. After due consideration, the
court rejected the objections against Bremmer, De la Faille, and
Justi. They would appear as expert witnesses. The prosecution's
request to have the owners of the Cassirer gallery testify as
experts was, however, denied, on grounds that they would add
nothing to the expert testimony. They would be heard as material
witnesses. It was difficult to follow the distinctions that the judge
was making between the various potential witnesses, but, at this
early stage of the trial, he knew little about the mischief that had
already transpired.

After a brief recess, Otto Wacker was the first to be heard. He
took a seat at the front of the court, his head framed by many of
the pictures he had brought to the art market. Were the pictures
what he said they were? And who was he? Dancer? Dealer? He
looks like a boy, said the reporter for the *Berliner Morgenpost*. No,
countered others: on the contrary, with his delicate features and
soft mouth, he looks more like a girl. That lack of clarity on the
basic issue of age, gender, and sexuality was telling of the situation
as a whole. Which was he? Man, woman? Child, adult? "Decadent
look" was the judgmental conclusion of a Dutch observer.[9] Ever
since Oscar Wilde and Joris-Karl Huysmans had grabbed

attention with their exuberant skepticism at the turn of the century, anything that did not readily fit standard categories had been dismissed by established authority as decadent.

In response to questions, Wacker spoke slowly and deliberately, weighing his words. Many were impressed that this young man did not seem to be intimidated by the situation—his future on the line in a courtroom packed with dignitaries and press. Asked about his youth and his interest in Van Gogh, he related that from the age of twelve, he had helped to organize travelling exhibitions of the artwork of his father and brother and that he had begun his dancing career in Amsterdam in 1913 at the age of fifteen. In Berlin he had continued to dance, with his Spanish stage name, and to sell art on the side. He had been able to survive as a dancer, he said, because of the commissions he had earned as a salesman. His interest in Van Gogh had been ignited when he had attended an exhibition in Düsseldorf. Immediately, he had purchased all the literature on Van Gogh.

Judge: Did you paint as well?
Wacker: Yes, but I didn't sell my pictures.
Judge: What was your style of painting?
Wacker: That's hard to say, but I can bring in some of my work tomorrow.
Judge: Good, do that.

Did his father paint in the style of Van Gogh? he was asked. No, answered Wacker; he had a different style. But his father, he continued, did do restoration on all of the works in question. Yes, Wacker admitted, he did establish a "relationship" with De la Faille and his firm, A. Mak. To queries about his bookkeeping, Wacker replied that he kept track only of his profits. Strange accounting, remarked the judge.

Questions about the Russian followed. The Swiss police had suggested that the Russian in question might be Prince Nicholas Galitzin of Riga, who was wanted for questioning by the Bern authorities. No, replied Wacker, that was wrong. But he refused to provide any details, not even the age of the Russian, other than to say that his name had a musical ring. He then described how he had visited the Russian in the south of Switzerland and seen his extraordinary collection of paintings. When the judge pointed to contradictions in Wacker's story and indicated that the Swiss police should have no trouble in finding such a Russian if he existed, Wacker simply maintained his quiet demeanour. Moritz Goldstein, a legal reporter for the *Vossische Zeitung*, commented on Wacker's deportment: "He speaks with an air of fatigue and unconcern, in a monotone and unclearly. Quite simply, he mumbles. . . . He is asked to speak up; he is moved here and there; but he remains consistently incomprehensible. Before speaking he shifts his glasses down his nose, but that makes no difference to the clarity of his utterance."[10]

Yet Wacker never lost his composure, and he won admiration from some of the journalists. Martin de Wild, the Dutch chemist who was listening and taking notes, insisted that he could hear Wacker perfectly.[11] Did these strikingly divergent responses to the proceedings speak to the substance of the issues or to broader incompatibilities—of nationality, sexuality, class, and self-interest—that transcended the art in question?

After a brief lunch break, the court reconvened and Wacker's testimony continued. How much did he pay for the pictures? Very little, replied Wacker—a few thousand marks. The large self-portrait (F 523), at 800 marks, was the most expensive. How had the pictures been transported to Berlin? The Russian, Wacker said, brought most of them. He himself had made one trip by car and, on that occasion, brought two or three pictures. What about

the money transactions? He had given the Russian cash when the latter was in Berlin and when he, Wacker, visited Switzerland. But the Russian had been very generous: he had advanced a large sum for the new gallery in the Viktoriastrasse. The only condition he had placed on the relationship was that his name never be revealed. Wacker repeated his standard mantra: he gave the Russian his *Ehrenwort*, his word of honour. It was this honour, he said, that was at stake here in the courtroom—and he would not surrender it.

He then told the court that when the suggestion had surfaced in 1928 that the paintings might be forgeries, his friends had urged him to reveal the Russian's name. He had promised Meier-Graefe that he would seek to be released from his *Ehrenwort*. He and his brother-in-law Erich Gratkowski had travelled to Düsseldorf and then on to Switzerland by car in search of the Russian. At the Russian's residence they had learned that the family had left for Egypt but might still be reached in Genoa. The two Germans had then headed for Basel to acquire visas for Italy, but they had run out of money. In a small hotel in Zürich they had been arrested, allegedly for not paying their bills, but Wacker now suggested they had been suspected of espionage. Espionage? This bizarre assertion arrived out of the blue. It smacked of fear and hostility, but the judge did not pursue the matter.

Instead, Judge Neumann looked directly at Wacker: You knew that everything could have been resolved had you revealed the name of the Russian, he said—that was still the case. But Wacker failed to make his escape. His response came slowly and deliberately: he simply could not trust the authorities on that score. "I never had complete confidence that the name would not be released," he said quietly.

And what about the letter you showed Meier-Graefe, where you covered up the top and bottom of the page? What did you do with that letter?

"I burned it," answered Wacker, "because I feared that it would be discovered in a house search."

Asked if he had requested that his brother, Leonhard, produce a sketch of a field with haystacks, Wacker answered yes. But he asserted that he had asked Leonhard to produce something only in the style of Van Gogh, not a copy. To a question about quality, he replied, Yes, he knew that some of the pictures he received from the Russian were weak, but certification by the experts put his mind at ease.

The proceedings of that first day adjourned at 3 p.m. Martin de Wild remarked that nothing new had surfaced, though he then voiced a personal conundrum. "It is conceivable," he commented in his notes, "that he [Wacker] really is covering for someone in an ongoing homosexual relationship. But it is also possible that the Russian is entirely imaginary."[12] Gabriele Tergit had a similar impression: "He is a dancer inclined to a love for young boys. He has that air. . . . Is there a Wacker tragedy? Is he, caught up in relationships, covering for someone to whom he is indebted or who is blackmailing him?"[13]

The journalists raced to file their reports. That evening Vincent Willem van Gogh sent a postcard home to his wife: "A lot of people. A lot of talk." He remarked on the pretty stamps he had put on the card—*voor de jongens,* for the boys.[14] Here was one touch of humanity and tradition in the midst of cultural quicksand.

## SEQUENCE

*Harvest in Provence*

The next day, Thursday, April 7, proceedings began at 10 a.m. The correspondent for the *NRC* reported that the interest in the case was "even greater than that shown yesterday"; the

courtroom was "completely packed."[1] Everyone seemed to be waiting for some explosive revelation. Art, money, love, international intrigue, and transgression—all the ingredients for a fabulous story were present. Reporters and the public remained on tenterhooks.

That morning Otto Wacker continued his testimony. He had brought with him some of his woodcuts as well as a poster from his days as a dancer. At the very outset he was asked to speak up, since even the court authorities, let alone the spectators, had not always been able to hear him the day before. Wacker promised to do so, but then quickly relapsed into his disconcerting whisper. He took occasional sips of water; they had no effect on his timbre or volume.

He began with an acknowledgement of error in the previous day's testimony: it was his brother, Leonhard, not his father, who had done the restorations on the paintings. He then confirmed that Leonhard had indeed produced a sketch of *Wheat Field with Reaper* for him after he acquired this painting from De la Faille. This correction and admission were noted but not pursued by the judge or the prosecution. And then, continuing in this confessional mode, head tilted and eyes lowered, Wacker announced that he himself had doubts about several of the paintings he had sold, especially the small rendition of *The Sower* (F 705) and the oft-maligned *Plate with Bread Rolls* (F 387). Since when have you had these doubts? asked Judge Neumann. Since the close of yesterday's session, answered Otto.

He was then asked if he had informed the Russian about his legal difficulties. Wacker replied calmly that these matters were his problem as a dealer, not those of his client. As for a question on all minds—how much had he earned from all this trading?—Wacker testified that he had received 65,000 marks ($15,500) for the portrait sold to Chester Dale (F 523), 19,322 marks ($4,600) for

*Two Poplars* (F 639), and an advance of 9,000 marks ($2,200) from Bremmer for *Haystacks* (F 625a). However, this accounting spoke to only a fraction of the paintings he had moved; yet he was not asked for details about the rest. He did mention *Boats at Saintes-Maries* (F 418), which Helene Kröller-Müller purchased through Bremmer in 1929, but was unwilling to disclose his earnings from that exchange. The Russian, he did reveal, lent him 100,000 marks ($23,800) to set up the new gallery. This had been, to be sure, a loan, but the lender had not indicated when he wished the money repaid. All this testimony remained murky, including the curious precision of the income from the sale of *Two Poplars*. Yet, again, the judge did not ask for elaboration at this stage.

He did, however, ask Wacker about his health. "I'm fine," replied Otto with emphasis, raising his voice for the first time as if to illustrate his point. He reaffirmed to the court that he had refused to seek clemency under Section 51 of the criminal code, which defined "irresponsibility." But what about the incident in Holland? he was asked, in reference to his collapse on the hotel staircase in Leiden. "I suspect that someone tried to murder me," he declared in a once more barely audible voice. He denounced the doctor who had treated him as an "adversary."[2]

At this point the defendant was excused. The questioning had been mild. He had not been pushed on any of the critical detail.

Now, at 11:10 in the morning, there was a buzz of excitement as Vincent Willem van Gogh, Theo's son, was called as the first witness. Lean and spare, he had the appearance, said the correspondent of the *Berliner Tageblatt,* of an academic who had spent his life reading. "He looks so like the master himself that one could say that he is a living self-portrait of Van Gogh," remarked another journalist.[3] Siegfried Kracauer was inclined to agree, except that in the nephew the uncle's mien had become "bourgeois, without the demonic of the original."[4] That word *demonic*

kept cropping up in the commentary. Born the year his uncle died and now forty-two, Vincent Willem was by profession an engineer. Unlike Julius Meier-Graefe and others who by upbringing and education were supposed to become engineers and scientists, he had not been seduced by that temptress Art. He had a practical bent.

Since his mother's death in 1925 he had looked after his uncle's patrimony. The nephew spoke carefully and precisely, answering questions for forty-five minutes. He was unequivocally negative about the Wacker pictures. His mother, he told the court in reasonably fluent German, kept an account book and diary in which she recorded all sales of Van Gogh's work. Asked about the self-portraits in particular, he replied that there was indeed mention in the account book of a self-portrait, but the self-portraits in the Wacker series bore no relation to either that original item listed in the account or any of the other self-portraits Vincent Willem knew. Moreover, the one winter scene in the Wacker collection, of cottages in Saintes-Maries with smoke swirling from chimneys (F 421), was notably different from the winter picture Vincent Willem cherished (F 420): the colour in the Wacker picture was unusual and the roofs of the houses were much steeper. The other Wacker pictures had no resemblance to those he was familiar with. Most damaging, he was not aware of any foreign collection of some thirty Van Gogh paintings. The only extensive collection he was acquainted with was that of Ivan Morozov, who had assembled about twenty Van Goghs, which were now in a museum.

Ivan Goldschmidt, Wacker's counsel, asked the nephew if he remembered from his youth, after his mother had remarried, that his uncle's pictures had been piled up around the house "like old newspapers."

"Like old newspapers? Hardly," replied Vincent Willem with a smile. "That there were many paintings, that I do recall."

"Do you know that pictures were stolen in Arles and Saint-Rémy?"

"No," answered the nephew. He said his uncle had moved from time to time during his stay in Provence, and it was entirely possible that the odd picture had been left behind.

"Do you know that his pictures were sold by the cartful?"

Those were the "black pictures," replied Vincent Willem, from the Brabant period, not the French pictures in question here.

Goldschmidt's reference to a cartful of pictures no doubt came from a study by the Dutch researcher Benno Stovkis, who in 1926 had published a book that elucidated the story about lost Van Gogh pictures from the early period at Nuenen. When Vincent's mother and sister had moved from Nuenen, after his father's death, Vincent's work, along with some family furniture, had been packed up and left with a carpenter in Breda. Although the furniture had eventually been retrieved, the artwork had ended up with a junk dealer named Couvreur. Stovkis had caught up with Couvreur shortly after the war, when the latter was in his mid-eighties, and had asked him how many works he had acquired. Sixty framed paintings, 150 loose canvases and two portfolios with about 80 pen-and-ink and maybe 100 to 200 crayon drawings had been the answer.[5]

After this relatively brief and uneventful testimony, Vincent Willem van Gogh was free to go. "Thank you," said Judge Neumann, "you may return to Holland." Many had been expecting more sensational testimony from Van Gogh's blood relative and namesake. Here was a star, a genuine Van Gogh . . . and he had nothing exciting to say. No personal revelations, no emotional outpourings. As Vincent Willem left, he seemed to take much of the courtroom's fervour with him.

He was followed as witness by a number of the dealers who had got caught up in the Wacker web. The first was Justin Thannhauser.

His father, Heinrich, was a legendary figure in the modern movement in Germany. After cooperating with the opera singer Franz Josef Brakl in a Munich gallery called Brakl & Thannhauser, which held a major Van Gogh show in 1908, he had launched his own gallery in 1909 in the Arco-Palais in the glamorous Theatinerstrasse. Kandinsky thought it the finest exhibition space in the city. In the historical heart of old Munich, Thannhauser had promoted many of the avant-garde artists who came to constitute the Blue Rider group of Expressionist painters, making rooms available to the circle for its activities. Owing to illness, the father had by 1921 largely withdrawn from the business and left its operation to his son. Justin, recognizing how the centre of gravity in the German art world had shifted since the war, had opened a Berlin branch in 1927 in the Bellevuestrasse, around the corner from the Viktoriastrasse. The Munich gallery had closed the following year. For their Berlin opening, in January, the Thannhausers had organized a major showing of modern French art, with some works by Van Gogh as well. Meier-Graefe had reported glowingly on the show: "An exhibition of this quality has not been seen in Germany since the best days of Paul Cassirer, and even in Paris shows of this dimension are unusual in the context of the art trade." In the largest room, Cézanne had been displayed on one wall and Van Gogh on the opposite: *Irises* (F 608) was there, *Two Poplars* (F 638), *Roadway with Underpass* (F 683), and one of the *Arlésienne* pictures.[6]

Justin Thannhauser now told the court that in January 1927 Wacker had approached the gallery, asking if they wanted another Van Gogh painting for their show. Thannhauser had agreed to meet Wacker in a room at the Esplanade Hotel, not far from the Bellevuestrasse, and there Wacker had showed him a second *Two Poplars* (F 639), purportedly another version of F 638. Asked about provenance and authenticity, Wacker had pointed to the

guarantee of De la Faille and assured Thannhauser that there were more paintings to come from this collection. For the moment, however, he did not wish to reveal names for fear that competitors might take advantage of this information. Thannhauser had accepted the explanation, bought the picture, and added it to his show. There it had been viewed by German and European experts, among them De la Faille and Ludwig Justi. In fact, Justi had visited several times. Wacker's *Two Poplars* had then gone on to Paris to Bernheim-Jeune. It was only when De la Faille's catalogue appeared later that year that doubts arose, when people were struck by the number of works without pedigree emanating from the Wacker gallery.

Thannhauser then recounted that his gallery, in a joint venture with the Matthiesen house, had purchased one of the self-portraits (F 521) and *Plate with Bread Rolls* (F 387) from Hugo Perls, not knowing initially that these paintings, too, had come from Wacker. When suspicions surfaced, they had asked Perls to take the pictures back, but he had refused. Wacker apparently had told Thannhauser that the previous owner had informed him that the self-portrait had hung in Johanna van Gogh's house for twenty years.[7]

After a short break for lunch, Walter Feilchenfeldt and Grete Ring, the current owners of the Cassirer gallery, gave their witness statements. They said that some two weeks after Cassirer's death in January 1926, they had been offered a purported Van Gogh landscape (F 729) representing a blazing sun over the Alpilles. Although Wacker's asking price at the time, 8,000 marks ($1,900), had been modest, they had considered the work weak and rejected it. De la Faille had authenticated the picture some weeks later, in March, and it had eventually gone to Detroit. They then recounted the dramatic confrontation with Wacker in December 1927 during their final preparations for their own Van Gogh

exhibition. Feilchenfeldt added that he had visited the Soviet Union in 1930 and had been told categorically by officials that there was no significant private collection of Van Gogh pictures in Russia. That had come as no surprise because the Soviets had nationalized all the significant collections. The Morozov and Shchukin treasures had been combined in 1923 to form the State Museum of Modern Western Art and housed from 1928 on in Ivan Morozov's former residence.

Asked by the judge if, in view of this testimony, he was now prepared to give his Russian friend a name, Wacker replied with a curt no.

The *NRC* correspondent found the whole show highly theatrical. "Wacker continues to play his part," he remarked.[8] The Dutch journalist was not the only observer who felt that he was watching a mannered drama unfold. But in contrast to the precisely structured plays of yesteryear, this one, some were beginning to suspect, might not have a tidy ending. The big questions loomed ever larger. What was genuine and what was false? Who was the truly guilty party? Was it the victim or the agent? But the answers to those questions might be fading away. The trial, like modern art, was threatening to fragment and turn in on itself. What remained was what the moderns would always celebrate, life as experience rather than moral tale.

## ETCETERA

### *Wheat Field with Sheaves*

By the third day of the trial, Friday, the eighth, the thrill of the event was gone. The correspondent for the *NRC* was already jaded; he found that the proceedings had become too detailed to remain interesting.

In the morning the police officials who had investigated the case were heard, Detective Dr. Heinrich Uelzen and Detective Superintendent J.A. Thomas. They testified that already in early 1928 they had been investigating foreign press reports about art forgeries surfacing in the Rhineland and Hamburg. This investigation had dovetailed with the Wacker case when it broke later that year. Kriminalrat Uelzen said he was convinced that the defendant had always had an alibi ready.[1] At the prodding of defence counsel Ivan Goldschmidt, Uelzen admitted that he was related to Walter Feilchenfeldt of the Cassirer firm. Obviously trying to uncover a conflict of interest and cast doubt on the objectivity of the witnesses, Goldschmidt remarked on the strange coincidence. More bizarre revelations of this sort would follow, indicating how difficult it was to separate truth from self-interest.

The next witness, Franz Zatzenstein, was the thirty-four-year-old owner of the Matthiesen gallery, which had been extensively involved with Wacker, purchasing *Plate with Bread Rolls* (F 387), the peripatetic landscape with sun (F 729), and a version of the sower (F 691). When he had sold the first picture, Wacker had said nothing about Russian or Swiss provenance, Zatzenstein recalled, and at the outset he had had no particular concerns about authenticity. He had simply been delighted that Van Goghs had reappeared on the market. Subsequently he had acquired two more paintings, the self-portrait (F 385) and one of the cypress pictures (F 614). For the latter he had paid 36,000 marks ($8,600). As partial payment, Wacker had received the unquestionably genuine olive grove picture (F 710), which had been in the Margarete Mauthner collection in Berlin and for which Zatzenstein had paid 22,000 marks ($5,200). A few months later, Zatzenstein related, the dubious F 710a, a virtual duplicate of F 710, had showed up for sale. For him, that was too much.

After that he had wished to have nothing more to do with Wacker. Zatzenstein speculated in his testimony that the Wacker performance could go on for so long only because of De la Faille, a previously unknown dealer and critic whose only credential was his claim to be assembling a catalogue raisonné. He concluded his own performance with a haughty sneer, so common in the art world, and called De la Faille a *homo novus,* a parvenu. An outright obscenity could not have been more pejorative.

In the afternoon Wacker's chauffeur testified that he knew the entire Wacker family and that he had driven Wacker to Düsseldorf, and then to Switzerland and Italy, in search of the evasive Russian. Wacker's longstanding friend Max Renkewitz came next. They had known each other since they were boys during the war. When Wacker had opened his new gallery in 1927, Renkewitz had joined him as his secretary. He had earned, he attested, 250 marks ($60) a month. With his help, four paintings (F 418, F 523, F 527a, and F 639) had been sold, two of which had gone to the United States—the now famous self-portrait at easel (F 523) and a smaller self-portrait with pipe and bandaged ear (F 527a). Why was there no record of any of these transactions in the books? Renkewitz was asked. Notes were made from time to time, he recalled, but only if there was some hint of difficulty or misunderstanding with the previous owner. Did you know anything about the Russian? No, answered the witness, only that Wacker gave him his word of honour. Did you not see any documents relating to the Russian? Just the letter Wacker showed to Meier-Graefe, replied Renkewitz. "I did not look closely because I did not want, if the investigation intensified, to have to name names." But he had seen the striking handwriting, he told the court. Judge Neumann could not resist asking whether the letter had been in the form of a poem. No, it was prose, replied the witness amid titters from spectators.[2]

When the next witness was summoned, the *NRC* reporter awoke. He would call this turn of events a "sensation"—but only briefly.[3] The witness was none other than Wacker's lawyer, Dr. Ivan Goldschmidt. Wacker had agreed that he should testify. So Goldschmidt stepped forward, removed his legal garb, and approached the witness table. He had some very surprising things to say. It turned out that Goldschmidt had been acquainted with Wacker for some years, owing to an earlier business relationship. He admitted to having purchased items from the dealer. Alas, once more the judge did not pursue the specifics of these transactions. Goldschmidt attacked the credibility of other witnesses because they had had business dealings with Wacker, but here it turned out that he himself had had such dealings with his client! Yet this issue of impartiality and credibility remained unclear and peripheral in the proceedings, perhaps because it was insoluble. Everyone seemed to be tainted in one way or another.

Judge Neumann then addressed the central issue: "Where do the pictures come from?"

Goldschmidt's reply was, "Yes, that I, too, do not know."

The lawyer went on to point out that he had tried to communicate with the Russian through an intermediary at a Parisian club. This intermediary was supposedly a close friend of the Russian's and in constant contact with him. A few weeks earlier a registered letter had been sent. Then, just days before the trial, a telegram had gone off to the club management, asking about the fate of the registered letter. "Two days ago," said Goldschmidt, "I received an answer from the club that the letter was never picked up. It has now been returned."

> Judge: You are not allowed to name this middle person?
> Goldschmidt: No. But because the reply from the club mentions the name, the person must exist.

The *NRC* correspondent was profoundly disappointed by Goldschmidt's testimony. He had expected a bomb blast. He heard only flatulence. His conclusion: "The whole of this story proves that there is little need for counsel."

An accountant who had worked for Wacker followed, and then Erich Gratkowski, Wacker's brother-in-law and business partner. Despite their close relationship with Wacker, neither was pushed on any vital details. The day ended with an assessment from the head of the psychiatric department at Berlin's Charité Hospital, who had examined Wacker and concluded that there was no evidence of mental illness. At this point the hearing was adjourned for the weekend.

After three days, little had been resolved. Testimony had produced no surprises. Cross-examination had been remarkably mild. The Hague's *Het Vaderland* reported that the first week's sessions "cast no light on this mysterious affair." Wacker's story had been assaulted but not destroyed. Moreover, he had won over some skeptics with his performance. "Wacker is a remarkable figure," wrote the correspondent for *Het Vaderland*. "His replies are given in a soft and calm voice, masterly in style—in a word, polished, and, without any emotion or hesitation, he gives the fullest information." Although he was unwilling to reveal the name of the Russian, his answers to other specific questions commanded "respect." Still, remarked the reporter, "it is not outside the realm of possibility that a sensational revelation may yet be forthcoming."[4]

Siegfried Kracauer, too, was impressed by the calm consistency of Wacker's demeanour. Kracauer saw him as a "stylish, slightly sad sort, who certainly would cut a good figure on the dance floor."[5] His attraction to Wacker was perhaps not surprising: he too suffered from sexual ambiguity and identity problems. He once had made a pass at Theodor Adorno, but it had not been reciprocated. He had always been interested in the "little man"

and the "mass ornament"—he wrote about film, shopping arcades, street culture. He found the underdog appealing.

## PLUS ÇA CHANGE . . .

*Street in Saintes-Maries*

The trial resumed on Monday morning, April 11. The Moabit courtroom was again full. Second in the day's parade was the witness many had been waiting for, Jacob-Baart de la Faille, the potential star in this comedic enterprise—fifteen experts in search of an artist—more preposterous than any Luigi Pirandello concoction. The Italian's absurdist play *Six Characters in Search of an Author* had been a *succès de scandale* on the stages of Europe since 1922. As recently as March 18, Vincent Willem van Gogh had expressed his support of De la Faille, thanking him in a written statement for his efforts in consolidating the Van Gogh oeuvre.[1] But the knives were out. Some regarded De la Faille as the one unabashedly guilty party in this singular affair.

In the course of a long examination he told of his own background and then recounted the familiar details of his relationship with Wacker: the first meeting in Bloemendaal, the subsequent encounters in Berlin, the authentications. Still, contradicting his published pronouncements where he had insisted that provenance had nothing to do with authenticity, De la Faille now told the court that he had been troubled by the question of pedigree. During a stroll with Wacker through the Tiergarten, Berlin's central park adjacent to the gallery district, De la Faille had begged him to reveal the name of the Russian because new pictures kept appearing. On that occasion Wacker had calmed De la Faille by promising to take him and Meier-Graefe to Switzerland to meet the Russian.

It was, he told the rapt courtroom, during the Cassirer exhibition of Van Goghs in late 1927 and early 1928, a show he had curated, that he had had his first serious doubts. Nonetheless, even after this show he still had sold three of Wacker's pictures, including *Boats at Saintes-Maries* (F 418) and *Haystacks* (F 625a), to the Dutch dealer d'Audretsch for a combined sum of 94,000 marks ($22,400).

> Judge: How could you sell pictures when your trust had been shaken?
>
> De la Faille: I doubted some, not all the pictures.

But then, said De la Faille, in the course of the following year he had become convinced that all the Wacker pictures were fakes and felt compelled to make his decision public. In December 1928 he published *Les faux van Gogh,* an addendum to his catalogue raisonné.

Then came the explosive announcement. De la Faille reached into his pocket and removed a piece of paper that he proceeded to unfold and read to the court. He declared that through his daily encounters with the pictures in the courtroom and through repeated examination of Van Gogh's letters, he had come to the conclusion that five of the Wacker pictures were genuine after all! He was convinced that he had been rash in 1928. Caught up emotionally in the fraud and in its implications for his own integrity and his life's work, the catalogue raisonné, he had lost his ability to be objective. But now, he said, he had regained the necessary distance, and, with his concern for truth, he had to backtrack. The five pictures in question were in the hands of different parties: *Boats at Saintes-Maries* (F 418), the Chester Dale portrait (F 523), *Haystacks* (F 625a), *Two Poplars* (F 639), and a second *Haystacks* (F 736). "I attach the greatest importance," he concluded, "to

making this statement in writing at this moment in order to contribute to the removal of certain misapprehensions and, finally, in order to serve the ends of absolute truth."[2]

Absolute truth—*die reine Wahrheit?* What was he talking about? Some in the audience presumably suppressed guffaws as he mouthed these words.

Even Judge Neumann seemed perplexed: "What brought you to this new conviction?"

> De la Faille: I have looked at these pictures again. The paint work in this one haystack accords completely, for instance, with the written description that Vincent van Gogh gave to his brother.
> Judge: Why are you telling us this only today?
> De la Faille: Because I thought that I should do so in my testimony to the court.
> Judge: No other considerations are in play in this declaration of authenticity today?
> De la Faille: None.

Martin de Wild commented sardonically in his diary, "De la Faille does not tell, however, how he has been pressured by Scherjon in the last two days to make this declaration."[3] De Wild did not expand on this comment in his written notes. What kind of pressure? Commercial? Moral? Or purely intellectual? Scherjon owned *Two Poplars.*

> Judge: Did you tell Wacker at your first meeting that you had been forewarned about his pictures?
> De la Faille: I had been warned in a letter about Van Gogh fakes on the Berlin art market. I myself had already seen at least 250 fake Van Goghs. But I told Wacker at the time that I considered his pictures to be genuine.

Defence lawyer Goldschmidt then asked a question that brought a hush to the courtroom: "Did you not offer a business partnership to Wacker, even after you decided that the pictures at Cassirer were fakes?"

De la Faille was noticeably agitated. As he prepared to respond to this devastating question, the judge intervened. He asked the defence attorney to reserve such questions until a decision had been made whether to call De la Faille as an expert.

For the moment De la Faille was off the hook. He did say, however, that Wacker had never behaved improperly.

What did this last remark mean? Wacker stood accused of outrageous fraud, of lying, corruption, greed, of being an evil Dr. Mabuse in youthful Mephistophelean disguise. Yet here was De la Faille offering that Wacker had never behaved improperly. Was he saying that Wacker was innocent or simply that he was a gentleman thief?

As a result of his startling testimony, Jacob-Baart de la Faille, the world's foremost "expert" on Van Gogh, compiler of a catalogue still used and cited today, would not be called as an expert witness. Not all the press coverage of De la Faille's testimony was negative. *Het Vaderland* commented, "One can only admire Baart de la Faille because he did not shrink from stating his reconsidered conviction in regard to the genuineness of the five pictures, although he was undoubtedly aware that such a reversal of opinion might inflict a new blow to his reputation."[4] Blow? The effect was more that of a wrecking ball.

## APPRECIATION

*Portrait of Père Tanguy*

The next witness was the effervescent and controversial Julius Meier-Graefe, the sixty-four-year-old author of three books about Van Gogh and authority on modern art in general. Although still writing for the German press, he was living in the south of France. The German art wars and two difficult marriages had taken their toll; in 1930 he had moved house with his young third wife to Saint-Cyr-sur-Mer, just west of Toulon on the Mediterranean coast. There the summer heat was torrid but nowhere near as debilitating as the figurative furnace that was the Berlin art world.

Meier-Graefe revealed to the court that he had made Wacker's acquaintance well before De la Faille—about four years prior to Wacker's sally into the high end of the art market and the opening of his gallery in the Viktoriastrasse. The court was left to calculate that the relationship would date back to 1922–23, to the height of the monetary inflation and about the time Wacker supposedly first encountered the mysterious Russian. Well before this Russo-German affair had begun to percolate, Otto had brought Meier-Graefe a variety of Dutch and German art for authentication. Only later did a number of Van Goghs appear for similar validation. In the end he authenticated twenty-five of the paintings Wacker attributed to Van Gogh.

During the Cassirer exhibition in early 1928 he had been in the United States. On his return he had seen some of these pictures again, and it was, he said, as though "the scales fell from my eyes." Yet he had not broken off his relationship with Wacker. The latter had reassured him in various ways that the truth would eventually be revealed. First he had promised to take Meier-Graefe to Switzerland to meet the Russian. Then he had showed

him the letter allegedly by the Russian but with all identifying details hidden. However, nothing had come of the promises. Meier-Graefe left the impression of a jilted lover, full of melancholy rather than anger. His conclusion: "All the pictures that I have had a chance to see again I consider to be fakes."

At first there was silence in the courtroom, then a stirring. As the celebrated author moved away from the witness table and returned to his seat, the whispers could easily be interpreted as reprimands. Could this man's reputation as a critic and journalist withstand his testimony? For Meier-Graefe the experience was so painful that either he or his wife would cull any mention of this public humiliation from his private papers. Virtually no trace of the affair, so critical to his later life, remains in his letters, notes, and diary. Alfred Hentzen, Ludwig Justi's young assistant at the National Gallery, was present at the trial and felt deeply sorry for Meier-Graefe.[1]

The parade of star witnesses continued that April Monday. H.P. Bremmer came next, a sixty-year-old who continued to describe himself as a "private tutor for practical aesthetics." He was hardly known in Germany, but on the Dutch art scene he was a major player. Despite his pomposity, Gabriele Tergit found him a sympathetic sort, with the appearance and manners of an English gentleman who testified in court as though he were chatting to a friendly gathering at tea. "Truly an original," said Tergit, presumably aware of the irony implicit in her description. If the art that he handled was not necessarily genuine, Bremmer was.[2]

In his testimony, which the German newspapers hardly covered but the Dutch press raved about—"the presentation . . . is heard with great reverence"[3]—Bremmer said that he considered six of the Wacker pictures genuine and the rest false. This possibility had been in the air for some time, but De la Faille's

testimony and now Bremmer's gave it momentum. De la Faille had said five; Bremmer, six.

Provenance, Bremmer told the court, was a secondary issue in art appreciation. One could understand art without knowing anything about it. "It is an inner path that leads me to judgment." For that reason, he announced proudly, he rarely authenticated pictures. But many in the courtroom knew full well that he had authenticated a number of the Wacker paintings; Martin de Wild remarked in his diary that the judge "smiled furtively" at this point in the testimony. Gabriele Tergit noted that Bremmer liked to use words like *Tiefe* (depth) and *Inneres* (inwardness); he seemed to sit in front of paintings, she postulated, waiting for them to hypnotize him. She considered this "a highly question-able way" of declaring six Wacker pictures to be genuine. "But we Germans like that sort of thing, don't we?" she added with rhetorical flourish.[4]

When court resumed in the afternoon, the first witness was Hans Rosenhagen, the seventy-three-year-old art historian and critic—as much an institution or even icon as he was a personal-ity. Wacker had approached him, Rosenhagen announced, as early as 1924. The Van Gogh material had come later, most of which he had considered weak. Nevertheless, there was still-weaker work by Van Gogh that was indubitably genuine, he proclaimed. That theme of genuine weakness would reverber-ate. He insisted that a number of the pictures were indeed the real thing.[5]

Willem Scherjon was the last of the distinguished quintet that day. It was his birthday; he was turning fifty-four. He recounted how Martin de Wild, the chemist and restorer who was sitting in the audience and taking notes, had telephoned him one day and said that he, Scherjon, had to come over and see two Van Gogh pictures, *The Sower* and *Two Poplars*. The first Scherjon

had rejected as a poor imitation, but the latter (F 639) he had considered the genuine article and had promptly purchased it from Wacker at what he considered a bargain price, 20,000 marks ($4,800). He told also of his visit in the early years of the century to the home of Johanna van Gogh and recounted that the Van Gogh pictures had been stored in piles in the loft. Anyone interested in Van Gogh could visit, climb to the attic, and rummage through the pictures without supervision. Johanna had told him that many pictures had in fact disappeared. Many had also been lost earlier in Arles and Saint-Rémy. Moreover, Scherjon added, it was now acknowledged that in the Netherlands, Van Gogh collections had existed that had not been publicized—among them Bremmer's collection of some seventy items (paintings and drawings) and the Ribbius Peletier collection of some twenty Van Goghs. With Bremmer's help, Gerlach Ribbius Peletier of Utrecht, heir to a tobacco trading fortune, had by 1928 amassed a major though little known collection of around 170 pieces, featuring Van Goyens, Versters, and above all Van Goghs. Scherjon was in complete agreement with Bremmer, his old friend, about which pictures were genuine and which not.[6]

## EXPERTS

*A Pair of Leather Clogs*

On Tuesday, the twelfth, the expert witnesses testified. But many of the material witnesses returned. Meier-Graefe's humiliation continued.

> Ivan Goldschmidt: What value does authentication have anyway?
> Meier-Graefe: Precious little. People who buy pictures on the
> basis of authentication alone deserve to be cheated.

Laughter.

Hans Rosenhagen, too, was recalled. Meekly he proclaimed "limited knowledge" of the work of Van Gogh. Nevertheless, this expert with limited knowledge still considered six paintings genuine. Seven others that he had authenticated he now considered fakes.[1]

H.P. Bremmer was asked, "Do you know any Dutch painters who could copy Van Gogh in a masterly manner?"

"No, I don't know of any good copies of Van Gogh," he replied proudly. He then reaffirmed his belief that six of the paintings were genuine, asserting that there could be no scientific "proof" of authenticity. Authenticity could only be felt, "on the basis of inner knowledge." At the end of his testimony Bremmer turned to Ludwig Justi and congratulated him and the Berlin National Gallery on their purchase of one of the finest Van Goghs. The reference was to the *Daubigny* that Justi had acquired in 1929. Bremmer was either unaware that his colleague and friend Scherjon would shortly denounce this painting as fake or he was being brilliantly sardonic.

Willem Scherjon followed, giving his own justification why six of the paintings were authentic. Franz Zatzenstein, whose Matthiesen gallery owned two of the pictures, *Cypresses* (F 614) and the small *Self-Portrait* (F 385), listened attentively. Scherjon would shortly approach him about a purchase, and Zatzenstein would ask Scherjon to propose a price.[2] The deal would be done. Expertise and self-interest would blend.

Justi was summoned at 12:20. He was the fourth "expert" witness to be heard in less than an hour. The speed at which the other experts were processed indicated how little the court respected their expertise. Justi, however, demanded attention. As director of the National Gallery he was the foremost spokesman for art in the land. With his black attire, smooth pate, and serious

demeanour, the fifty-six-year-old civil servant and diplomat exuded authority. Although he admitted that he was no authority on Van Gogh, he claimed that on account of his years of experience, he could recognize quality and craft, and he dismissed all the Wacker paintings, proclaiming them to be "as false as any pictures can possibly be." For Bremmer and the Dutch collective of Van Gogh specialists, Justi had no patience. To him they were a group of pansies whose knowledge of art was superficial and whose instincts were correspondingly unreliable.

Distinguishing the genuine from the false was an optical matter, he said, not a question of intuition. Justi was sure that all the Wacker paintings came from the same source and that their difference in quality was simply a matter of the forger's improving his skills with practice. "Van Gogh's pictures were painted with such artistic obsession and display such sophisticated taste that it is impossible to consider any fake as genuine." The struggle with the motif, so striking in all genuine Van Goghs, was missing from the Wacker pictures. Asked how he responded to Bremmer's approval of six of the pictures, Justi insisted that even those were fakes. The small self-portrait (F 385) that Bremmer considered "wonderful" was one of the "worst pictures" he had ever seen.

## PROOF
*Portrait of Doctor Félix Rey*

On the thirteenth, the Wednesday of the second week, the scientists appeared. Cornelis M. Garnier, the head of Utrecht's criminal identification service and a specialist in dactyloscopy, the science of fingerprinting, was called first. He reported that at the request of Willem Scherjon, he had examined *Two Poplars* (F 639) and found a fingerprint that matched traces of

prints found on undeniable Van Gogh works in the Kröller-Müller collection.

Garnier's testimony produced a reaction in the courtroom. Newspaper reporters scribbled furiously in their notepads. Was this the deciding evidence for the authenticity of the *Two Poplars* and for much of the rest of Wacker's cache?

The next witness, Berlin Detective Superintendent (Kriminal-kommissar) F. Müller, Garnier's German counterpart on finger-print science, promptly pricked the bubble. He challenged Garnier's reading of the evidence. He, too, had examined both genuine and doubtful pictures for fingerprints and reported that the traces found by Garnier on *Two Poplars* were not sufficient to identify them with any accuracy. International convention demanded that fingerprints correspond at a minimum of twelve points in their loops, whorls, and arches for an acceptable match. Garnier could produce only five matching points—and that was an insufficient number to serve as proof.

Next, the chemist Martin de Wild, in attendance since the start of the trial, was asked to come forward. A quizzical man with a wry sense of humour, he had a wealth of experience in art res-toration—he had restored portraits by Frans Hals for the Haarlem Museum and attended to some fifty paintings in the Kröller-Müller collection—and had even written a book on the scientific analysis of paintings. He had examined the paint in twenty-two genuine Van Goghs and in a number of the Wacker works, including two that had been at the centre of attention in recent days, *Two Poplars* (F 639) and *Boats at Saintes-Maries* (F 418). The composition of the paint and fixing agent in all the indisputable works was identical, he declared. And that same composition was to be found in F 639 and F 418. By contrast, the paint in a number of other Wacker pictures thought to be counterfeit contained a high percentage of resin, a fixing agent that kept the paint from

undergoing noticeable change as it aged. As a result, it was not possible to determine the age of the paint in these other pictures. No resin was to be found in the paint of the genuine Van Goghs, including *Two Poplars* and *Boats at Saintes-Maries.* Willem Scherjon, who had purchased *Two Poplars,* and H.P. Bremmer, who urged Helene Kröller-Müller to acquire *Boats at Saintes-Maries,* appeared to be vindicated by this evidence from their Dutch associate.

Later that day Kurt Wehlte, a thirty-four-year-old artist but also a teacher of colour theory, was invited at the request of the prosecution to present a report on his X-ray investigation, done at the bidding of the National Gallery, of genuine and dubious paintings. Using large enhanced X-ray images as illustrations and speaking clearly and precisely, Wehlte captured the attention of the courtroom. A number of German reporters would pronounce his testimony as the high point of the prolonged trial. Using Van Gogh's *Sower* (F 422) as the example, he showed how the X-rays reveal bold strokes and a sure hand in the original, with contours of paint clearly visible, whereas in the Wacker *Sower* (F 705) the images revealed layer upon layer of paint as if the perpetrator, unsure of himself, was piling on colours. Just two days earlier, on the Monday, the court had heard Willem Scherjon recount Martin de Wild's early enthusiasm for Wacker's *Sower.* The Dutch chemist and the German X-ray specialist were not on the same page.

The divisions evident among the critics had reappeared among the fingerprint and colour experts. No one mentioned at the time that the Dutch police official Garnier was a relative of Scherjon's. The conflicts of interest in this case—this Garnier-Scherjon family relationship and that of Inspector Uelzen of the Berlin police and the dealer Walter Feilchenfeldt, as well as the intense friendships and bitter rivalries in the art community as a whole— symbolized and at the same time magnified the problems of

objectivity and authenticity. Art and cause merged, along with truth and wish. The conflicts and emotions here were as virulent as those in the politics of the day.

## SOUL

*The Iris*

That same Wednesday the practising artists were invited, by defence and prosecution, respectively, to give opinion. Who should be called by the defence but Eugen Spiro, the first husband of Tilla Durieux! After being humiliated by Durieux and cuck-olded by Paul Cassirer, he had moved to Paris, where he lived and worked until 1914. After the war he re-emerged as a fixture of the Berlin art scene, acceding eventually to the presidency of the Berlin Secession, a position that Cassirer also once held. The cross-currents were many. Spiro had even produced a fine portrait of Julius Meier-Graefe, one of Wacker's most fervent supporters.[1]

Could Spiro be an impartial witness? Did he still bear a grudge against Paul Cassirer? Cassirer's successors had played a major role in the assault on Wacker. Spiro, though experienced and knowledgeable as an artist, was hardly an expert on Van Gogh. Goldschmidt, Wacker's attorney, must have sensed an opportun-ity here of using Spiro to attack the establishment, and Spiro in turn could hardly have suppressed his personal hurt from the past.

With goatee, dark-rimmed spectacles, and balding pate, Spiro played his role well—he looked and acted the expert. He said the Wacker pictures, wherever displayed, were at a marked disadvan-tage because they were poorly prepared and badly framed in comparison with the originals. Those on show in the courtroom had no frames at all and, as a result, exuded inferiority.[2] Spiro admitted that he doubted the authenticity of most of the works,

but he did contradict Justi's opinion about a small landscape, seeing in it both the spirit and the colours of the master. He then declared that he would find Van Gogh's *Sower*, not just Wacker's copy, dubious were there no appropriate evidence for its authenticity. Asked if Van Gogh could be copied, Spiro said that he himself had copied one of his paintings.

The prosecution then asked Leo von König to come forward as an expert witness. He, like Spiro, was a well-known member of the Berlin art community, but he, too, had fought in the art wars of the capital city since the turn of the century and had the scars to show for it. He had been in and out of the board of directors of the Berlin Secession. Yet, when called to witness, he was not Ludwig Justi's marionette. He considered *Two Poplars* (F 639) as "indisputably genuine." The Wacker *Sower*, which the X-ray specialist Kurt Wehlte had denounced, was in König's view possibly authentic, but then the rest of the pictures he considered unequivocally bad and false. Some, he said, were truly childish copies. The artists were clearly as confused as the scientists and the critics.

In the next day and a half, the rest of Wednesday and all of Thursday, the procession of experts continued: Ludwig Thormaehlen, an art historian and curator at the National Gallery and a loyal assistant for seventeen years to Ludwig Justi; Helmut Ruhemann, the chief restorer for the State Picture Gallery of Berlin; Theodor Stoperan, a long-time employee of the Cassirer firm; and two chemists from the state museums. They gave opinion on matters ranging from the style of painting in the Wacker pictures to the type of canvas used. No one helped Wacker's cause, but neither did anyone deliver a knockout blow.

The deliberations seemed to have become what the French sardonically call *une conversation des sourds*—a conversation of the deaf.

# SUMMATIONS
*Les Alyscamps*

At long last, on Friday, the fifteenth, the proceedings wound down. State prosecutor Alexander Kanthack gave his summation. His speech lasted for an hour and a half. He drew attention to the bizarre nature of the trial, a courtroom turned into an improvised art gallery in which genuine Van Goghs looked like "jewels" compared with the "glass splinters" that were the fakes. Experts had come from the south of France and from Holland to give evidence and opinion. These experts had approached their subject from both technical and critical standpoints. In the case of eleven of the sixteen works displayed in the courtroom, there could be no doubt whatsoever that they were fakes. Wacker had exploited the insatiable appetite for Van Gogh to his personal advantage and defrauded dealers and collectors. In any judgment, special attention had to be paid to the considerable damage inflicted on the reputation of the German art market. In international circles, people were saying that overt forgeries were being brought to the Berlin market for huge profit. Against such charges, Wacker had no reply except a story that might have come from a "bad society novel of the prewar period." After using false assertions about origins and behaving fraudulently toward clients, Wacker was without a doubt guilty of the charges against him. His otherwise clear record was the only reason the state was not seeking an even stiffer sentence for him. In view of the crime—"falsification of documents, fraud, and breach of trust"—Kanthack requested a sentence of one year, six months, and two weeks.

Wacker's attorney, Ivan Goldschmidt, then had his say—for several hours. Some in the audience found his summation rambling and incoherent; others applauded it as an aggressive and

effective statement. Goldschmidt dismissed the testimony of Vincent Willem van Gogh, claiming that he, an engineer, knew little about his uncle's art. De la Faille, who was no longer in the courtroom, Goldschmidt called a "statistician." "He has never been a connoisseur and no doubt never will be." Goldschmidt then turned to Ludwig Justi, who was sitting directly in front of him, and accused the director of the National Gallery of ignorance. Before this trial no one, he protested, had ever heard of Justi as an authority on Van Gogh. Moreover, Max Liebermann had gone so far as to suggest that Justi knew nothing at all about modern art. Goldschmidt read from an article by Justi in which the director had asserted that one look at the Wacker pictures revealed they were fakes. He then asked Justin Thannhauser, who had displayed some of the Wacker pictures, whether Justi had visited his gallery. "Certainly, several times," Thannhauser replied. Goldschmidt had his cue for a rhetorical flourish: "And at the time it never occurred to him that the pictures were fakes? I thank you."

Wacker obviously had sympathizers in the courtroom. Some of Goldschmidt's remarks evoked stomping and applause.[1] At one point the proceedings were paused and a vociferous spectator was removed. When the session resumed, Goldschmidt went on to praise Bremmer and De Wild. The Dutch had an interest in protecting their stellar artists, he said. If, indeed, the Wacker pictures were fakes, it should be the Dutch, not the Germans, who denounced them as such. Yet the most passionate defence of these pictures came from H.P. Bremmer, who had devoted his life to the study of Van Gogh. Given the contradictory testimony, Goldschmidt continued, the fingerprint evidence presented by the expert Cornelis M. Garnier was more persuasive than any of the denunciations levelled by the German experts. Goldschmidt then played his ace. Because the experts had demonstrated utter

confusion, Wacker could hardly be found guilty. His plea was to find his client, "who has always conducted himself like a gentleman," innocent of the charges.[2]

Wacker had the last word. His statement was short and straightforward. He said that he was still convinced that the previous owner had acted in good faith.

The outcome of the trial was no foregone conclusion. Wacker had impressed many with his calm and generally unerring responses. One Berlin newspaper called him a "sharp young man."[3] The Dutch press was inclined to see him as more victim than agent. He may have done something wrong, but he was guilty of at most a misdemeanour. The culture as a whole was thought to be at fault. It was the establishment that was rotten. The art market had gone berserk, and Otto Wacker simply got caught up in the frenzy. Berlin's *Der Abend* newspaper found fault in the prosecution for not pursuing the matter of origins. Who had actually produced the forged paintings? An answer to that question was crucial to the outcome. Siegfried Kracauer thought that the prosecution and defence had scored roughly equal points.

In its reflections on the two weeks of the trial, the *Berlin Börsen Zeitung*, one of Berlin's leading financial newspapers, commented that Wacker seemed gradually to disappear from the proceedings. The art and the experts took centre stage, and the spectators seemed to forget about Wacker. The expert testimony had about it the air of a *drastische Komik*—drastic comedy.[4] Some were inclined to say the same about the politics of the day.

Guilty or not? The oddsmakers saw no obvious verdict.

## SENTENCE

*Ward in the Hospital in Arles*

The verdict came on Tuesday, the nineteenth. Not everybody stayed until the end. Meier-Graefe could not bear the shame and slipped off to his home in the south of France days before the judgment was delivered. When his closest friend, Julius Levin, tried to get in touch with him, he received a note from Meier-Graefe's assistant. "Dear Herr Levin," it read, "Ju[lius] left some days ago. He didn't wait for the end. The affair cost him too much time and trouble."[1] That was a gentle way of saying that Meier-Graefe had not been able to stomach any more of the degrading affair.

Kurt Tucholsky, the politically engaged satirist and editor of the weekly *Die Weltbühne*, advised the presiding judge to find some dice to roll. Such an outcome, he said, would satisfy everybody, especially the experts who had testified.[2] That Tuesday morning the *Berliner Morgenpost* published an acerbic piece, "Immer Wacker"—a play on words that could be read as "always Wacker" but also "always valiant"—by an author who called himself Himmel (Heaven). "The judgment is awaited today in the Wacker trial," the piece began. "The decision is aided by the outstanding testimony of experts, testimony that has been clear and helpful and divides into four categories: 1) all the pictures are genuine; 2) some are genuine, others not; 3) all are fake; 4) some are fake, some genuine." Himmel then went on to say that everything was upside down. In the old days, collectors had bought a painting because they liked it, regardless of the painter; nowadays they bought a painting for the name of the artist, regardless of whether they liked it. Artists were venerated, but only if they were dead; those living were allowed to starve. "Wacker, you are free. Go forth and stay away from Van Goghs, whether they are genuine or false," the article concluded.

For the announcement of the verdict the crush of spectators was so great that the hearing was moved from the smaller room of the Moabit courthouse to its larger hall. The *NRC* correspondent sensed that the majority of spectators expected a not-guilty verdict "owing to lack of proof."[3]

At precisely eleven o'clock the judge and his retinue appeared and, moments later, delivered their verdict. Judge Neumann sketched Wacker's life story and then got down to the business of the authenticity of the Wacker pictures. The experts—critics, dealers, art historians, and artists—had, despite all their differences of opinion, agreed that, at the very least, eleven of the paintings were fakes. For some of these pictures, provenance had obviously been disguised. As for individuals, the judge found De la Faille hardly credible because he changed his mind so often. The other Dutch experts, Bremmer and Scherjon, while no doubt knowledgeable, were in Neumann's opinion too caught up in their enthusiasm for "the great son of their homeland" to be able to consider matters dispassionately. The judge was impressed by the expert opinion of Justi, as well as the scientific testimony, and on this basis found four of the pictures that the Dutch experts considered genuine to be false as well. The court did not find the proof of authenticity brought by Cornelis Garnier and Martin de Wild, using fingerprint and chemical evidence, to be convincing. On two of the pictures considered authentic by the Dutch, the court reserved judgment. Of the Wacker pictures not available in the courtroom, the judge found two to be genuine and all the rest false. Even if one or two of these pictures turned out to be genuine after all, this would not affect the general situation, he declared.

The question remained, "Did Wacker know that he was dealing in fakes?" He certainly knew, Neumann pointed out, when he had a genuine picture. Shortly after purchasing the real

thing from the Matthiesen gallery, Wacker had produced a variation of that picture which turned out to be a fake. The court's purpose was not to air the issue of expertise. "The fact that painted canvases could be brought to market as genuine Van Goghs tells us more than writing and words about the value of expertise."

The court was aware, continued Neumann, that in Wacker's circle, mysticism, bonding, and loyalty played a great role, and one could readily imagine that a word of honour was regarded as binding. The matter of the word of honour had, however, to be true to life and convincing. What Wacker had alleged on the subject of honour rang completely untrue.[4]

The judge dismissed the story of the Russian in no uncertain terms—"completely improbable, silly, and untrue." Even Wacker's attorney had had to admit that he did not know who the Russian was. How different the case would have been had Goldschmidt been able to say under oath, "I know the previous owner and have dealt with him, but professional discretion prevents me from revealing his name." To be found innocent, Wacker would have had to admit that he had been duped by the Russian, but Wacker was not ready to do so because then his entire defence would collapse.[5]

On the charge of "persistent fraud, partially coincident with grave and persistent falsification of documents," Wacker was found guilty and sentenced to one year in prison. He was placed under immediate arrest.

## APPEAL

*Madame Roulin Rocking the Cradle (La Berceuse)*

Ivan Goldschmidt promptly launched an appeal. On the promise that he would report to the police twice weekly, Wacker was released.

If the *NRC* correspondent lost interest in the details of the trial early on, it seemed that the rest of the world did too. Beyond the German and the Dutch press, coverage after the first few days had been sporadic and brief; even the verdict received little notice. That, however, was less an indication of a lack of public interest than of a lack of clear direction in the trial. The narrative line seemed simply to peter out, like the letter of Weimar's law, the Versailles Treaty, or the world's certainty about truth and justice. The Weimar constitution was in tatters by 1932, the peace treaty steadily losing respect, and the League of Nations, set up to act as arbiter of international disputes, a shambles. In the Wacker trial, Judge Neumann had come to a decision that, for many, was not convincing, on the basis of evidence that was often deeply flawed. The trial had been an embarrassment for the system.

At the end of April, Ludwig Justi was approached by a patriotic public affairs organization, the Deutsche Gesellschaft 1914 (German 1914 Society), to give a talk on the Wacker affair. The club, dating from 1915, had an impressive membership list of well over a thousand dignitaries from business, politics, the military, and the arts. The composer Richard Strauss and the artists Max Liebermann and Max Slevogt were members. In his letter of invitation, the secretary, Otto Liebmann, pointed out that the group had had a most distinguished array of speakers over the past winter, politicians and cultural figures, including the conductor Wilhelm Furtwängler and the former chancellor and Reichsbank president Hans Luther, but the Wacker affair and its implications were now on everyone's mind. "The darker the times, the more we see attempts to fake everything, even pictures." Liebmann's comments were an indication of how the Wacker affair was seen as a symptom of a widespread malaise, a general dishonesty both public and private.[1]

Through the summer of 1932 the Nazi bandwagon rolled on. Parliament was unworkable. In the wake of the July national elections, Franz von Papen, the former Catholic centrist and monarchist manipulator, tried to form a government "above parties" and to involve Hitler, but the Nazi leader remained aloof, demanding the chancellorship that he regarded as his just deserts as the leader of the largest party by far in the Reichstag. Both the Reich president, Paul von Hindenburg, and the chancellor, Papen, refused Hitler's wish. But the Reichstag was unmanageable, and new national elections were called for November. The situation became even more tense when a strike by transport workers began in Berlin three days before the elections. Nazis and Communists collaborated in that strike, an ominous sign. Extremism appeared to be on the verge of victory.

The Wacker appeal began on October 18 and ran until December 6, with only a brief adjournment in the second week of November. This second hearing lasted more than twice as long as the first. Most of the same witnesses appeared. This time expert testimony was prolonged. One day Willem Scherjon was allowed to hold forth for seven hours without break.

Much the same ground was covered as in the original trial, but at far greater length. The experts were seated at two tables facing each other, "in the manner of enemies in the trenches," according to the *Het Vaderland* reporter: Bremmer, Scherjon, and Meier-Graefe at one table, Justi and his staff at the other. "They are polite toward each other but do not go farther than that." Everyone seemed to have a shorter temper. There would be many skirmishes. It was as though counsel for the defence had encouraged a more vigorous stance. One day, when the presiding judge asked whether Wacker had a good appreciation of art, Bremmer launched into one of his renowned discourses, but this time, according to one report, with "an unusual impetuosity."

Art was not a matter of knowledge, Bremmer insisted petulantly, as though reprimanding inattentive children, but a question of experience. He concluded with a melodramatic comment that he was trying to defend art against its "murder" by scientific knowledge.[2]

Wacker, too, began his testimony in a more emphatic manner, by protesting about the treatment of his pictures. Paint, he stated angrily, had been scraped away and holes punched in the canvases. He spoke with sarcasm of the "theatre of experts" and blamed them for mutilating his pictures. He asked why he was the only one on trial. Why not the dealers who had sold these paintings—Franz Zatzenstein from the Matthiesen gallery, Justin Thannhauser, Hugo Perls? They knew their art: "Why am I the only one in the dock? I did everything by the book. I went to the foremost experts on Van Gogh and received certificates of authenticity. Only on the basis of this encouragement did I proceed. I could not have been more correct or conscientious. But you drag my name through the mud, destroy my business and my future."

He had a point. If reaction to the first trial was at all indicative of public sentiment, there was considerable sympathy for him on all sides of the political and intellectual spectrum. Van Gogh had claimed that he was seeking an inner truth through art. But by moving away, his critics charged, from an external reality toward a subjective interpretation of the world, Van Gogh, and the other moderns with him, had upset a long-standing balance and moved not toward but away from truth, in the direction of distortion and falsehood. In Karl Scheffler's formulation, Van Gogh forged himself—"*van Gogh hat sich zuweilen selbst gefälscht.*" According to Mussia Eisenstadt, an art historian and expert on the eighteenth-century French painter Antoine Watteau, this idea was now suspended over the courtroom like an unofficial

motto.[3] It was not Wacker who was guilty but Van Gogh himself!
"Van Gogh hat sich selbst gefälscht!"

The atmosphere in the courtroom was sour. If a measure of
civility was retained in verbal testimony, the body language, espe-
cially of the German experts and dealers, was scathing. The repor-
ter of Amsterdam's *Algemeen Handelsblad* commented on the
endless shrugs, grimaces, and poisoned looks. It was all, he said in
inflammatory imagery, in preparation for the heavy artillery that
the Germans were moving into position. And the man responsible
for all this animosity, proclaimed the Dutch reporter, was none
other than Ludwig Justi, who, with his "distasteful and personal
attacks," had turned an intellectual argument into a crusade, a skir-
mish into a war.[4] "Shoulder to shoulder with his squires . . . he is
fighting for his reputation, but we fear that his position is lost."[5]

Reluctantly, Julius Meier-Graefe had come once again from
the south of France. He remained mortified by the whole affair.
If there was a guilty party, he said at one point, to the astonish-
ment of many in attendance, it was not Wacker but De la Faille
and himself. This statement of abject humility by a once widely
respected public intellectual, author, and commentator, friend of
the powerful, had to be a high point in the long drawn-out affair.

Much attention was devoted this time to technical evidence,
and in view of the disagreements and animus in the air, that may
have been the only direction in which the court could go. At one
point the judge dismissed aesthetic judgments and arguments as
*Mist*—bullshit.[6] "The concern in this appeal," wrote Mussia
Eisenstadt, "is not with Van Gogh but with fingerprints, bank
withdrawals, falsification of documents, and oaths of manifesta-
tion."[7] Kurt Wehlte returned and produced thirty-four X-ray
images that again made a strong impression on the court.

In his summary on December 2 the prosecuting lawyer,
Alexander Kanthack, emphasized this X-ray evidence. He

admitted that having listened to the evidence during the appeal, he was even more convinced that Wacker was guilty of the charges against him. Wacker was talented and bright, that was clear; he had put paintings he knew to be counterfeit on the market and had given deliberately false statements about their origin. His story about the Russian was pure myth. This time Kanthack called for a sentence of two years and one month, arguing that the previous sentence had been too lenient.

Ivan Goldschmidt's summary for the defence seemed less aggressive than in the first round in April.[8] He stressed that no one had been able to find any conclusive evidence of forgery, even though four years and ten months had elapsed since the investigation began. Experts had contradicted not only each other but themselves, changing their opinions repeatedly. The case represented a battle for power, pitting established authority and "official art" against a small dealer who was simply trying to make his way. This argument, and especially the turn of phrase *small dealer*, with its evocation of Hans Fallada's highly popular and shattering novel *Kleiner Mann was nun?* (Little Man, What Now?) about the impact of economic hardship on little people, must have produced some sympathy and agreement.[9] Otto Wacker, the little man, was in a fight for his life against the suffocating power of the established order.

Goldschmidt then turned to the divisions that had been so striking between the Dutch and German experts. The Dutch representatives had been treated with contempt by the Germans. He now understood, he said, why Germans were so little liked abroad. You didn't have to be the director of a museum to have an opinion on art, he insisted. He pointed out that those who had any right to speak about this case were Bremmer, Scherjon, and Meier-Graefe. They had devoted their lives to the work of Van Gogh. Witnesses such as Hans Rosenhagen, Eugen Spiro,

Leo von König, Ludwig Thormaehlen, and Helmut Ruhemann had no particular knowledge of Van Gogh. As for Ludwig Justi, he had showed no interest in Van Gogh until the Wacker affair was under way. Only then did he purchase works by Van Gogh for the National Gallery. The merit for that was entirely Wacker's, insisted Goldschmidt, to the amusement of the courtroom. As humorous as that statement appeared to the audience, Justi must have been squirming, because he knew it had validity. Moreover, he knew that responsibility for the enormous attention accorded the work of Vincent van Gogh over the past four years could be assigned in large part to Otto Wacker.

Goldschmidt then returned to the painful issue of the Russian. As long as the prosecution was unable to pinpoint another source for the disputed paintings, Wacker's statements about the Russian could not be contradicted. Guilt had not been proved. Therefore, Wacker had to be acquitted. He was already a ruined man. Meier-Graefe had been "absolutely correct" when he had stated that it was not Wacker who was guilty but De la Faille and himself. Those were, said Goldschmidt with a flourish, "the finest words" uttered at this trial.[10]

Four days later, on December 6, the judgment was delivered. Otto Wacker was once again found guilty. The sentence this time was harsher: nineteen months' imprisonment, a fine of 30,000 marks, forfeiture of civil rights for three years, and an extra three hundred days should the fine not be paid. Wacker, moreover, had to bear the cost of the proceedings. He listened to it all impassively. Mussia Eisenstadt was impressed: "Wacker accepts the severe judgment calmly and without trace of emotion."[11] In the end, Eisenstadt pondered, the case remained mysterious and troubling—"One never really delved properly into the background of this puzzling case."[12] Perhaps she, the Watteau expert, was thinking of one of Watteau's clowns, Pierrot, the comedic

figure who seemed always on the verge of tears. All humour is of course rooted in tragedy.

In December 1932 the studio of the Jewish artist Felix Nussbaum in Berlin burned. Arson was suspected. He lost 150 of his paintings in the conflagration.

# THE RESPONSE

Life laughs, the sun beams, and the dead Vincent paints in reams.

ALFRED KERR, theatre critic, 1930

> Bursts of light flashed everywhere in the darkness like Christmas trees lifting their decorations of flame high into the night, then fell back to earth in whistling bouquets of jagged flame.
>
> ROBERT GUILLAIN, *I Saw Tokyo Burning*, 1981

> ... life is more or less a lie, but then again that's exactly the way we want it to be.
>
> BOB DYLAN, *Chronicles*, 2004

## SYNONYMS

*Prisoners Exercising (after Doré)*

Otto Wacker went to jail. His lawyer promised to launch a further appeal to the highest court in the land, but the Supreme Court in Leipzig refused to hear the case. On January 30, 1933, another artist, who said that the subject of his canvas was not just some olive grove or almond tree but Germany and the world, became Reich chancellor. As Wacker languished in Gefängnis Tegel, the prison in the northwestern district of Berlin, Adolf Hitler began to reshape the Reich. His political art had all the authenticity of Wacker's Van Gogh paintings. He had rummaged through the German past and appropriated what might sell politically. The content he presented was derivative, a series of Germanic motifs. It was the way he presented these motifs that mattered: the style—agitated, insistent, engaging—excited and appealed. Hitler fitted the German mood, as did his message. Here was the sower writ large, framed by a heartening morning sun. *"Deutschland erwache!"* Germany awake!

Hitler's success was predicated on the failure of the "republic by reason." The Weimar Republic, despite early pretensions articulated in the constitution of 1919, never was the staid, rational statement in moderation it was designed to be. It was installation art on a grand scale, a fantastic panorama of commotion, imagination, and violence, literal and figurative, fuelled by a never-ending sense of emergency. Hitler and National Socialism were as much a product of the culture of Weimar as were Walter Gropius's architecture, Fritz Lang's films, and Marlene Dietrich's legs. It is often suggested that when Hitler was appointed chancellor, the curtain came down on the Weimar experience. But if Weimar

was a crucible of modernism, Hitler and his movement were an integral part of this confluence of energy.[1]

The Wacker affair, like many of the other scandals that marked the Weimar years, represented a miniature version of the broader dilemma played out politically on the national stage. Even though Wacker went to prison, it was the experts, and by corollary any notion of traditional authority, that lost the most respect in the prolonged and painful affair. "The collapse of the old reality, manifested in big and small scandals, took appropriate form in the art world in this fraud trial," wrote a contributor to the Berlin daily *Tägliche Rundschau*.[2] Similarly, another journalist, Moritz Goldstein, concluded one of his articles on the affair by asking "not only what authenticity is and where it is to be found but also whether there are any authentic pictures at all and whether or not the belief in genuine pictures is but a superstition."[3]

The loss of validity seemed to characterize all endeavour. The political structure of the Weimar Republic was not overthrown; it collapsed because it had no defenders. Theodor Adorno would argue that with the gradual decline of religion, the notion of authenticity had become central to bourgeois morality. The real and the true constituted for the bourgeois the basis of goodness and virtue. If authenticity was assaulted and denigrated, as it clearly was in the Wacker affair and in the Weimar period as a whole, then there was nothing solid left to hold on to. The entire middle-class belief system was gutted. This void Hitler and Nazism would fill with their fantasy world of myth and mastery. Eric Voegelin, the eminent political theorist who developed the idea of political religion, would speak of the "pseudo-identity" that Nazism conferred on its protagonists. They could all pretend. Even before Hitler's takeover of power, Max Osborn felt the earth quaking and feared that the entire structure—"*der Gesamtbau aller Dinge*"—was crumbling.[4]

The trials of Otto Wacker had ended, at least formally, but the never-ending challenge of the modern continued. Wacker had identified with the upheaval and change that characterized the age; he tried to ride its crest, and in doing so he became in fact an expression of the modern, a *faux monnayeur*. He rejected all the boundaries set up by tradition. For him the deed was everything—it had replaced meaning. The deed negated all former strictures.

Few people had any sympathy for Wacker's purported victims— the buyers of the questionable art. Most commentary implied that they deserved to be cheated. "Guilty are always those who have been cheated, because they were the stupid ones," wrote Curt Glaser. "As long as they believe in their little certificate, they are happy, and it would be a shame if they really had a genuine [Van Gogh] since the fake is good enough." The experts would lose their purpose only when buyers purchased art out of love rather than greed, he said. Glaser talked of the "authentication illness."[5]

Hitler's regime, too, would quickly be authenticated. The first international validation came from the Vatican, when the pope signed a concordat with the new German administration in July 1933. In subsequent years a long line of dignitaries paid their respects and expressed their admiration for Hitler's accomplishment: the former British prime minister David Lloyd George, the Canadian prime minister W.L. Mackenzie King, the aviator hero Charles Lindbergh, and others. In 1936 the world would come for the Berlin Olympics. Forty-nine countries participated, more than ever before. Their teams paraded past Hitler. The Canadians gave the Nazi salute.

That equally great poseur Benito Mussolini, from whom Hitler picked up many a trick, was one of the few who wondered about the Führer's substance. How authentic was this German

*Übermensch?* When the two met in Venice in 1938, Il Duce complained that Hitler looked "like a plumber in a raincoat."

## SYMBOL

*Undergrowth with Two Figures*

Who painted the Wacker pictures? No definitive answer to that question has ever been provided. No one accepts them as legitimate any longer, but no one has actually proved that they were fakes by identifying their source. Both Otto's father, Hans, and his brother, Leonhard, were able artists, with local and some national recognition, so may have been capable of producing them. Some see in the father's brush technique, in work from as early as 1914, similarities with Van Gogh, though Leonhard is the more likely candidate.[1] He participated in the annual Düsseldorf art exhibition—*Große Kunstausstellung Düsseldorf*—in 1920, 1922, 1924, and 1925. In 1922 he contributed to the city's international exhibition as well.[2] While the raid on his studio uncovered strong circumstantial evidence of involvement in his brother's misadventure, the vital piece that would seal the case against him and his brother never turned up—and to date never has. Leonhard attended both trials of his brother and testified briefly at the appeal, but the insufficient evidence collected by the criminal police meant that he was never pulled into the spotlight.

The speculation that the art came from Russia has never disappeared. The art journal *Kunstblatt* kept this idea alive after Wacker's sentencing.[3] Others have returned to this theory subsequently, positing that a few of the pictures may have come from a Russian source; that the Wackers then recognized a good thing and proceeded to milk the cash cow. Vincent Willem van Gogh eventually gave up pursuing the forgers of his uncle's work. "I had

indisputable proof of their activities in my hands," he said, "but I found myself faced with impregnable defenses erected by rich and powerful persons in whose interest it was that certain secrets should not be revealed."[4] The whirlpools of doubt, anger, and paranoia bubble violently, merge for a time, separate again, and flow on, without resolution, without end.

If the question "how?" has never been answered in the Wacker affair, the question "why?" is just as difficult. Was greed the sole motivation? Was Otto Wacker mentally disturbed, like Vincent? Did this working-class boy from Düsseldorf identify with the Dutch prodigy—with his late-nineteenth-century *mal du siècle*? Did he subscribe to a Nietzschean, Gidean, Wildean amorality— morality being for losers—that yearned to throw *eau de toilette* in the face of the pompous bourgeois? Did the act originate in anger or as a prank? Did he revel in what has been labelled, more recently, "duping delight," the joy accompanying the act of duplicity? We shall never know for certain, and perhaps that is as it should be.

What we do know is that in May 1932, shortly after the first trial, Otto Wacker became a card-carrying member of the Nazi Party—a *Parteigenosse*! That occurred a full nine months before Hitler took office.

The application for membership, which presumably took place some weeks before the trial began, speaks vociferously to his outlook. Wacker obviously identified with the aesthetics and morality of Nazism, a movement of denial and rejuvenation, of counterattack and assertion, of venom and invigoration. Yet while the movement was full of dichotomous energy, in the end Nazism was a celebration of the transcendent power of the affirmative deed. Nazism was a life force. And that is of course how Wacker must have seen his own predicament. He was a doer caught in the twilight of an outdated morality. If Nazism was a culture of the deed, so was Bolshevism in Russia, especially in its Stalinist

incarnation. Not surprisingly, Wacker was to be attracted to both, Hitlerism first, and Stalinism later.

Nazism claimed that its action was rooted in the German soul, and hence the images and the motifs that accompanied its action were for the most part traditional in nature. In that sense Nazism was a copy of the German record of heroism and affirmation, an attempt to replicate past German accomplishment. What was new was the energy, the urge, and the technology necessary to implement this will. In the context of affirmation and assertion, cultural and sexual, the question "why?" was immaterial. Life and victory were of the essence, not conscience, let alone pity. Nazism was, in short, much like the artworks peddled by Otto Wacker.

Wacker became a member of the Nazi Party on May Day, 1932— just after his first trial ended. He was member number 1,146,794.[5] He was awaiting his appeal and living at Schumannstrasse 66 at the time, not far from some of the gay bars in the upper part of the Friedrichstrasse. The location was a drastic comedown from the old address at Zimmerstrasse 98, a skip from the gallery district near Potsdamer Platz, not to mention the smart quarters on Viktoriastrasse, before his life began to unravel.

Why did Otto Wacker become a Nazi? His application form has not been retained, though his accreditation as a member has. He does not seem to have trumpeted his new political affiliation, certainly not to his Jewish lawyer, Ivan Goldschmidt, and none of the scant literature on him seems aware of his membership in the Nazi movement. Once Hitler was in power, in 1933, the rush to join the party became a veritable flood, and he would eventually make formal affiliation difficult. But in the spring of 1932 the application was still a deliberate decision rather than a fashionable or opportunistic act.

Ideals of masculinity and male bonding presumably had much to do with Wacker's choice. A militant nationalism based on the

camaraderie of the trenches had a powerful appeal to German youth. The Nazis glorified the *Frontgemeinschaft*, this front community, to which Hitler belonged. The trench experience of the Great War had involved a good deal of male bonding, and this esprit, this *Frontgeist*, carried over into the paramilitary organizations of the postwar world. Ernst Röhm, the head of the Nazi brownshirts, the Sturmabteilung or SA, exalted the image of the soldier. His storm troopers, instead of the emasculated and insipid professional army, he regarded as the true soldiers of the new Germany. Their commitment transcended bourgeois respectability. Well before wife and family came loyalty to comrades—a relationship forged in fire and cemented by blood.

The social and aesthetic appeal of Nazism must have been formidable for Wacker. Nazism was all about rebirth and re-creation, movement and danger, transgression and redemption, experience beyond boundaries set by convention or timidity—all at the same time. To a young man from the lower social orders who had visions of grandeur, the success of Hitler, this "Austrian corporal," and of much of the Nazi leadership cohort must have been mesmerizing. Hitler was a modern-day Napoleon, an outsider and, by definition, a revolutionary with imperial ambitions.

The sexual appeal of Nazism is also obvious. Uniforms and soldiering have always had an erotic dimension for both sexes. Many a young aesthete found Nazi exuberance exciting and sensuous—including the truncheons and the physicality. The Nazis, like the aesthetes, worshipped the body and the sun. Physical beauty was central to their aesthetic. The poet W.H. Auden admitted that he was at times intoxicated by Nazism. "I entirely agree with you about my tendency to National Socialism, and its dangers," he wrote to fellow poet Stephen Spender in October 1930, a month after the huge National Socialist gains in the September elections. Much later he distanced himself from those

inclinations and spoke of himself in the third person as "someone talented but near the border of sanity, who might well, in a year or two, become a Nazi."[6] On April 1, 1933, the day of boycott against Jewish stores, Auden's friend the writer Christopher Isherwood pointedly set off to a Jewish-owned department store to make a nominal purchase as a form of protest. Standing in SA uniform at the entrance was a young acquaintance from the Cosy Corner boy-bar that he and Auden had frequented. When in March 1934 the Politburo banned male homosexuality in the Soviet Union, the dramatist Maxim Gorky voiced support for the anti-sodomy law with the comment, "Destroy the homosexuals—fascism will disappear."[7]

Despite the high incidence of promiscuity in its ranks, and lingering rumours that Hitler himself had indulged, the Nazi regime turned against homosexuals. The hostility was based on the notion of "unnatural degeneracy." It picked up energy after the Night of the Long Knives in June 1934—that "cleansing" in the ranks of the party that saw the murder of Röhm and about two hundred other people. Röhm was well known as a homosexual, and the SA was home to many virile young men whose proclivities were to their own type. Hitler's eventual deputy and designated successor Hermann Göring told the press that Röhm and his ilk were plotting to overthrow the existing order. Homosexuals, claimed the Nazi regime, were untrustworthy creatures, they "disturbed the genetic stream" and were "unworthy on hereditary biological grounds."[8] However, their persecution was not as extensive or systematic as is sometimes implied. Despite the biological emphasis in Nazi theories of race, homosexuality tended to be regarded as a social disease rather than a biological condition. Some of the incorrigible ended up in concentration camps, but a death sentence was passed on very few.[9]

Otto Wacker was gay. He went to prison—and survived.

## SOPHIENSTRASSE

*Death's-Head Moth*

Otto Wacker served not only his one-year-seven-month sentence in prison but an extra three hundred days for the 30,000-mark fine—the price at the time of a lesser Van Gogh—that he had been required to pay but could not. He was released on December 4, 1935.[1] His sensations on liberation may have been similar to those of Franz Biberkopf, the anti-hero of Alfred Döblin's novel *Berlin Alexanderplatz,* who had served a four-year sentence in the same prison for beating his girlfriend to death: "He stood before the gate of Tegel prison and was free." Free? Hardly. Instead of revelling in a feeling of freedom, Biberkopf knows that the real punishment is only beginning: "He walked past the Tietz department store on the Rosenthalerstrasse and then turned right into the narrow Sophienstrasse. He thought, this street is dark; darkness is better."[2] Like Biberkopf, Weimar's everyman, Wacker now gravitated away from the bright lights, the bourgeois-feudal fantasies of the West End of Berlin, those that had produced so much trouble for him, and toward the proletarian quarters of the city's East. He sought shelter with family not far from that Rosenthalerstrasse that Franz Biberkopf had walked.

To pursue any activity in the arts in the Third Reich, one had to be a member of the appropriate authorizing "chamber" of cultural activity. In 1937 Wacker applied for official accreditation not as a dancer or an art dealer but, oddly enough, as an artist—a *Kunstmaler.* He applied for membership in the Chamber of Fine Arts. The upshot was not what he expected. Not only was his application rejected because of his criminal past but, in May, he was expelled from membership in the Nazi Party and banned from any activity, creative or commercial, in the fine arts. Police records reveal that as of August 2, 1937, he found refuge with his

brother-in-law Erich Gratkowski on the Brunnenstrasse at number 43. Gratkowski lived on the street at number 33, but at 43 he had a small art shop, called Gemäldehandlung Gratkowski. These venues were at the northern edge of Berlin-Centre, near the Bernauer Strasse, along which the Berlin Wall would eventually run. Today the Brunnenstrasse is once more full of galleries and art.

In early July 1939 the Gestapo secretly visited the Gratkowski gallery, pretending to be customers. What led to this police investigation is not mentioned in the documentation available. On July 31 the Gestapo official Meder informed the president of the Chamber of Culture that Wacker had been observed engaging in sales and promotion, contrary to the restrictions on his activity. On August 7 a Reich Chamber of Culture official dropped in at the shop and noticed that Wacker was still involved in dealings with clients. With suspicions substantiated, the Gestapo pursued the matter with Gratkowski. He assured the police that Wacker would in future be engaged only in bookkeeping at most, though he did indicate in a letter to the regional head of the Chamber of Fine Arts that the verdict in the trial had been flawed—*ein Fehlurteil.* "With my opinion I am not alone but in thoroughly good company," he wrote.

The bureaucrat on whose desk this letter landed would query Gratkowski's assertion with an ominous marginal note asking "in whose company?" Gratkowski also pointed out that Wacker's health had been seriously damaged by his long battle with the authorities. Should the Chamber of Culture seek to remove him from his current employ, he would not survive elsewhere. Nor would he be able to continue to support his parents, as he was doing. Gratkowksi signed off with the obligatory *Heil Hitler!*[3] He was called in for an interview on August 17 at 11 a.m. with a Dr. Schmidt, who headed the local office of the Reich Chamber

of Culture. His assurances about his brother-in-law, Otto, seemed to work for the time being. In 1943, however, the same cycle of accusation, investigation, and promise had to be repeated, with an apparently similar outcome.

In 1939 Wacker did fall seriously ill with lung disease, but he recovered.[4] At roughly the same time the court records of his earlier trials seem to have gone astray. On March 10, 1939, the Wacker files were signed out to the Berlin chief prosecutor's office. There the paper trail ends. Despite repeated requests and queries as far as Düsseldorf, the files seem never to have returned to their archival home.[5] Otto's mother died in 1941, and his father lived on in relative seclusion in Ferch, not far from Potsdam, on Lake Schwielow. In February 1942 the Berlin land registry office (Bodenregistratur) requested the court documents from the prosecutor's office, to no avail. Was this request prompted because Wacker was trying to sell some property? All the records show is that he, a homosexual, dancer, and convicted fraud artist, survived the Third Reich.

It took the better part of a year after the trial before the National Gallery and the state prosecutor's office finally returned the items either seized from the Wackers or lent by collectors to the authorities. In November 1933 Hans Wacker received the pictures taken from him more than four years earlier. He was expected to pay the delivery costs, from Berlin to the village of Ferch, but in a petition to the state prosecutor he pointed out that he could not come up with the required sum.[6] Otto's brother, Leonhard, finally received in March 1935 the nineteen items and some incidentals that had been confiscated from his Düsseldorf studio. Frames and glass were missing from a number of the pictures, but Leonhard did not wish to pursue the matter. He signed a waiver: "I declare that I have no further claims regarding either the confiscation or return of my pictures."[7]

Meanwhile, in March 1933 Willem Scherjon finally received delivery of two of the Wacker pictures he had purchased from the Matthiesen gallery, *Cypresses* (F 614) and a work now listed as, with appropriate adjectival abbreviation, *Männl. Bildnis*, "mle [male] image," from the state prosecutor's office. The latter was the small self-portrait (F 385) that had been the subject of much discussion during the trials. Because it had been declared fraudulent, no one but Scherjon was now willing to call it *Self-Portrait*. Both works were shipped to him in Amsterdam on March 27. Scherjon proceeded to display *Cypresses* in his gallery on the Herengracht as a genuine Van Gogh.[8] In August he acquired another Wacker picture, *Peasant with Pitchfork* (F 685), from the Goldschmidt firm, though at the time it, too, was still in the prosecutor's possession and would be shipped from the National Gallery.

The British writer John Lehmann was in Berlin when Hindenburg appointed Hitler chancellor and, some weeks later, when the Reichstag burned. Hitler used the fire to put in place the legal cornerstone of his Third Reich—the emergency decree that eliminated habeas corpus, permitting arrest and detention without trial. In his memoir *The Whispering Gallery*, Lehmann's description of those days is filled with images of incandescence. At the same time, however, while invoking candles, lights, and fire, he refers to Berlin as an "ice-bound city that was laid out like a patient about to undergo an operation without any anaesthetic at all."[9] The juxtaposition involves iridescence and pain. Similar extremes appear in other commentary. In one of his novels, Klaus Mann referred to Berlin as "a gigantic blazing dream."[10] Christopher Isherwood, in contrast, described Berlin in the winter of 1932–33 as "a skeleton which aches in the cold: it is my own skeleton aching." "The tickling and bottom-slapping days," he went on to say, "are over."

Yet, not long after Hitler's takeover of power, Isherwood went

for a walk, his last walk in Berlin before he returned to England. "The sun shines and Hitler is master of the city," he wrote in the present tense. The sun shines, the day is beautiful, and in the mirror of a shop Isherwood sees his own reflection. He is smiling. He is horrified. In the end he can't believe that any of his experiences in Berlin have been real.[11]

## REAPER

*Daubigny's Garden*

Ludwig Justi's assault on Otto Wacker, Julius Meier-Graefe, and the phalanx of Dutch collectors and critics had deeply paradoxical repercussions. While Justi, the official grand master of the German gallery world, was lamenting the amateurism of art expertise in Holland and Germany, his own abilities were called into serious question. In the process, the Weimar Republic lost even more credibility. Here again, events in the art community seemed to correspond to the fate of the Weimar bureaucratic and political order in general.

The Dutch circle of Van Gogh experts had been incensed by Justi's audacity in the Wacker affair. He, a German, and no authority on modern art, let alone Van Gogh, had no right to criticize Dutch scholarship on Van Gogh. Beginning in 1932 and continuing for several years, the Dutch contingent waged an unmitigated counterattack against the director of the National Gallery in Berlin. The journalist Cornelis Veth, art critic for Amsterdam's respected *De Telegraaf* and editor of the *Maandblad von beeldende Kunsten* (Visual Arts Monthly), launched the campaign with a pamphlet published in both Dutch and German on the eve of the first Wacker trial.[1] He was scathing toward Justi and would be joined by the primary Dutch targets of Justi's bile in the Wacker

brouhaha, H.P. Bremmer and Willem Scherjon. If Justi was going to cast doubt on the Wacker pictures they had acquired, then they would cast similar doubt on Justi's Van Gogh acquisitions. Justi's enemies in Germany, including Max Liebermann, were delighted by the aspersions directed at a man they had always regarded as a pompous bureaucrat with no real experience of the art world. They would join the chorus of invective that aimed to destroy the director of Germany's premier gallery.

The furor revolved around two of Justi's purchases for the National Gallery in 1929. Justi had acquired *Harvest* (F 628) from Bernheim-Jeune in Paris on June 5, 1929. The documentation about provenance indicated that the brothers Josse and Gaston Bernheim had purchased the painting in 1912 from the collection of the well-to-do Paris café owner Auguste Bauchy, and the brothers affirmed that it had been in their possession since. Théodore Duret had reproduced the picture in his 1916 volume on Van Gogh. However, Bernheim-Jeune could not establish how Bauchy had acquired the painting when Ludwig Thormaehlen, Justi's assistant, asked it to do so in 1932.[2] Thormaehlen got no further with Vincent Willem van Gogh when he approached him for information.[3]

Thormaehlen wanted to believe that Van Gogh's description, in a letter to Theo of September 1889, of a yellow field with a reaper was a reference to the National Gallery's harvest picture. "I then saw in this reaper—a vague figure struggling like a devil in the full heat of the day to reach the end of his toil—I then saw the image of death in it," Van Gogh had written, "in this sense that humanity would be the wheat being reaped. So if you like it's the opposite of that Sower I tried before. But in this death nothing sad, it takes place in broad daylight with a sun that floods everything with a light of fine gold."[4] However, Willem Scherjon, who based most of his own arguments for authenticity

on the literary evidence, claimed that this description applied to the harvest picture that he had purchased from Otto Wacker. In an article he published while the Wacker appeal was in session, he argued, moreover, that X-ray studies of the various harvest pictures cast more doubt on the National Gallery's version than on his.[5] Although doubts about the Justi *Harvest* picture would simmer for some time, and though it is now generally dismissed as a fake, it did not cause anywhere near the same stir as the *Daubigny* painting (F 776) that Justi had also purchased for the National Gallery in 1929. There were—and still are—two versions of *Daubigny's Garden*. The other, F 777, had been in the collection of the Swiss industrialist Rudolf Staechelin since 1917. In the autumn of 1932, while Wacker's appeal was under way, Scherjon published a catalogue of Van Gogh pictures from the Saint-Rémy and Auvers periods and, using excerpts from the Van Gogh letters, cast doubt on the Berlin *Daubigny*.[6] Justi made his own life more difficult now by suggesting that it was the other version, known as the Staechelin *Daubigny,* that was the lesser and probably fraudulent picture.

Once the crossfire had begun, at first privately and then in the public arena, Justi felt increasingly vulnerable and made every attempt to ascertain the provenance of the works that he, at great and controversial cost, had purchased in 1929. Why did he not do so before he made the purchases for the National Gallery? Why at that time did he behave much like the Berlin galleries he was condemning for buying questionable pictures from Otto Wacker? Probably because he feared, like the galleries, that were he not to act with dispatch, he would lose the works to a rival. Van Gogh's rocketing value pushed even the seasoned sailor into uncharted waters.

Scherjon now claimed that Justi's *Daubigny* had come from the Schuffenecker brothers, Émile and Amédée, who were known to

have copied or touched up Van Goghs early in the century. The editor of *Kunst und Künstler,* Karl Scheffler, whom Justi derided as a man "who cannot see,"7 gave credence to the charge in his journal. The onslaught mounted in February 1933, when the Dutch critic M.J. Schretlen declared the Berlin picture to be a fake.

Paul Rosenberg, the patrician Paris dealer from whom Justi acquired his *Daubigny,* insisted that Scherjon had things reversed. The Schuffeneckers had had the Staechelin *Daubigny* in their hands, not the Berlin version. Rosenberg said his records indicated that the Staechelin version had in fact been entrusted to him by the Schuffeneckers in 1910, but, unable to sell it, he had returned it to the brothers, who had then given it on commission to Eugène Blot, who ran a Paris gallery with a distinctly shady reputation. Blot had sold it to his friend the collector Louis Bernard, who in turn eventually passed his entire collection to Bernheim-Jeune. From there the Staechelin *Daubigny* went to Lausanne to the Galerie Vallotton, the Swiss representative of the Parisian dealer, where Staechelin finally purchased it in 1917.

By contrast, the Justi version, insisted Rosenberg, had had no such peripatetic past. It had been in the hands of the Van Gogh family in Holland when the Russian collector Sergei Shchukin had purchased it, but then in 1900 he had put it back on the market. Gaston Bernheim had bought the picture in March 1900 for 1,000 francs (about $200) at an auction at the Hôtel Drouot. In 1903 the artist Gustave Fayet, whose own work was often compared to Gauguin's, had acquired the picture, and he had held on to it until his death in 1925.8 Rosenberg threatened Scherjon with a lawsuit if he continued his allegations.9 And he told Justi to toughen up and stop behaving like a sissy: "You have acquired a marvel and it will always honour your career as the director of the museum."10 He dismissed Scherjon as a miserable little

parvenu whom no one had heard of until last year, whereas "the whole world bows to my opinion."[11] Rosenberg's vanity knew no bounds.

Stung by the suggestion that it was his version that might be a forgery, Rudolf Staechelin agreed to send his picture to Berlin in April 1934 for comparison. With the pictures side by side, many critics agreed that they were very different in brushstroke and colouring. In his authoritarian and self-justificatory manner, Justi concluded, "This comparison is decisive: the Berlin picture is entirely clear and entrancingly beautiful both as a whole and in its detail; the Staechelin unclear, confused in brushwork, dirty in colour. . . . All who have seen the two pictures side by side are taken by the beauty of the Berlin picture and consider the Basel picture not just weaker but in fact a fake."[12]

Staechelin was outraged by what he called Justi's "propaganda" in favour of the Berlin *Daubigny*. That summer he suggested that the two Daubigny pictures be sent to a neutral country for objective comparison and analysis. Then in December he invited the National Gallery to send its *Daubigny* to Basel in a reciprocal gesture. The National Gallery declined both requests. By then Justi had been dismissed by the Nazi regime and replaced by Eberhard Hanfstaengl, a cousin of Ernst "Putzi" Hanfstaengl, the Harvard-educated early admirer of Hitler. The new director would be no less pugnacious in his defence of the National Gallery's *Daubigny*.[13]

Staechelin was incensed by this lack of cooperation. In 1935, when an article by Alfred Hentzen appeared dismissing the Basel *Daubigny* as a fake, Staechelin initiated legal action to forbid the Berlin National Gallery to call its picture either *Garten Daubigny* or *Le Jardin de Daubigny*. When the Berlin gallery again refused to oblige, Staechelin took matters provocatively further. The Basel Art Museum was hosting an exhibition devoted to the

work of the German Expressionists Paula Modersohn-Becker and August Macke. Staechelin arranged for three Macke water-colours, on temporary loan from Berlin's National Gallery, to be seized. The furious businessman intended the seizure to serve as preliminary recompense in a damage suit he was launching against the German state gallery.[14]

The issue of the seizure went before the Swiss federal court in Lausanne. On June 18, 1936, it decided against Staechelin and insisted that the Macke watercolours be returned.[15] Hanfstaengl regarded Staechelin's behaviour as preposterous. Paul Rosenberg in Paris displayed a Gallic disdain for the ruckus. Why, he asked Hanfstaengl, are you spending so much time on this silly matter provoked by people who possess no authority and garner no respect? The street should not be allowed to decide questions of authenticity. The doubters he called *farceurs* and *ignorants*. Compared with himself—*reconnu du monde entier*—Scherjon was a nothing.[16]

By 1936 Eberhard Hanfstaengl and his staff at the National Gallery had weightier matters to ponder as the Nazi leadership began its campaign against "degenerate art," and the *Daubigny* affair, which had caused them consternation for the past three years, receded. The controversy had received much play in the national and provincial press. As late as March 1937 the *Berliner Tageblatt* ran an article on the *Daubigny* affair that summarized the debate and put it in the broader context of concern about authenticity. The Wacker trial was mentioned and a long passage quoted from the verdict.[17]

Otto Wacker was probably not pleased that his name was in the press again. Was it this article in the *Berliner Tageblatt* that caused him trouble? In May he would be expelled from the Nazi Party.

After his dismissal in July 1933, Ludwig Justi turned down an offer of early retirement. He was relegated to a position in the

library of the National Gallery. His downfall paralleled the disgrace of Meier-Graefe and De la Faille. The authenticity of the Van Gogh pictures he had purchased with such fanfare for the National Gallery was now questioned, his professional and administrative abilities doubted. Justi was a broken man, and his health suffered. He joined the ranks of the incapacitated.

## NIGHT LIGHT
*Starry Night*

For some people, Hitler's takeover of power in Germany in February and March 1933 demanded critical decisions. Thomas Mann was abroad when Hitler was appointed chancellor on January 30 and refused to return home. Others, such as the journalist and cultural critic Siegfried Kracauer, sensed a noose tightening around their necks in those first months of 1933 and felt forced to flee, in some cases for their lives, to Paris, or Prague, or London. "The whole of the Kurfürstendamm is emptying out in Paris," noted Harry Kessler in his diary in late June 1933.[1] But some, like the artist Emil Nolde, the philosopher Martin Heidegger, the doctor-poet Gottfried Benn, and the architect Ludwig Mies van der Rohe, had high hopes for the new regime. They looked on it as the embodiment of energy, youth, and self-assertion. That the Nazi hierarchy might respond favourably to experimental approaches in the arts seemed possible in those early days. "Northern Expressionism" was touted by its supporters as a continuation of the Gothic and Romantic in German art. Even Ludwig Justi, in charge of the National Gallery until the summer of 1933, was hopeful initially that the patriotic urge in National Socialism would lead to the reaffirmation of order and stability.

In the general turmoil and upheaval, what was clear was that art and aesthetics as a whole were to be important considerations in the running of the state. In many respects the Third Reich was all about beauty and joy: the re-creation of a strong Germany whose ethos would radiate throughout the world. A popular slogan announced "*Der deutsche Alltag soll schön sein*"—the German everyday should be beautiful. The workplace would be clean and bright, the body strong and healthy. From this vantage point the racism of Hitler and National Socialism was not an end in itself but a means. Strength through joy, beauty through racial honing: those were the goals.[2]

But the question remained, what was beauty for Hitler and the Nazis? Joseph Goebbels, the new minister of "enlightenment" and "propaganda," had always had a predilection for the modern. In his novel *Michael,* his hero is a miner but also a would-be wordsmith who frequents literary and artistic circles. Full of Nietzschean impulses, he seeks solution to the nation's and the world's ills not in politics but in spirituality. At one point Michael comments, "We today are all Expressionists. We are people who want to shape the world from within ourselves. . . . Expressionist world-feeling is explosive." In his diary he writes, "Politics destroys character." Van Gogh is often on his mind: "I hit on Van Gogh again. . . . It's not the painter I see, it's the human being, the God-seeker. I bought with my wages his moving letters to his brother Theo. The man is greater than the artist." Some of the subsequent passages sound as if they have been influenced directly by Van Gogh's letters.[3]

The novel had frequent reprintings after its first publication in 1929. None of these passages was altered. The critics were as far apart in their judgment of the book's merits as the politicians in their platforms. The respected and widely read Paul Fechter wanted in 1931 to nominate the book for the Kleist Prize, one of the highest literary honours in the land.[4]

The architect Albert Speer decorated Goebbels's private residence in 1933 and hung a few watercolours by Emil Nolde, taken from the National Gallery, on the walls. According to Speer, Goebbels and his wife were "delighted" with the paintings.[5] The Secessionist painter Leo von König, who had been a witness in the Wacker trial, made portraits of Goebbels, his wife, Magda, and their daughters.[6] Until 1935–36 Goebbels, though aware of Hitler's disapproval, continued to sponsor modern art. He served on the official committee for the March 1934 Berlin exhibition of Italian Futurist art; Gottfried Benn and F.T. Marinetti spoke at the opening. His ministry supported a Munich exhibition, *Berliner Kunst 1935*, which featured works by Ernst Barlach. Goebbels visited the exhibition and even purchased some pieces with ministry funds. Many artists, including Ernst Ludwig Kirchner and Emil Nolde, continued to believe that the Reich might in the end support modernist inclinations openly.[7]

Vincent van Gogh, while condemned by some, was still celebrated by others as a Germanic artist. In 1934 the critic Wilhelm Schramm saw in Van Gogh "a representation of the grandly barbaric," a spirit National Socialism was bringing to fruition. The following year a new biography of Van Gogh, by Heinz Wagenitz, credited the Dutchman with freeing German art from the chokehold of French Impressionism.[8]

But in late 1935 the mood began to shift. In September Hitler came out with a stinging condemnation of modern art in his speech to the Nuremberg party rally, and after that Goebbels backed off from his support of the modern. Gallery and museum directors removed blatantly modern items from showrooms.

In 1936–37 much of the modern art in state collections was liquidated. Some of the most prominent items were displayed in the notorious exhibition *Entartete Kunst* (Degenerate Art) that opened in Munich in July 1937 and then toured the country. That

exhibition was a huge success, shattering attendance records for an art exhibit in Germany. More than two million people saw the show in Munich, with attendance averaging around twenty thousand a day, and some three million in other parts of the Reich. The question arises about the motives of the audience. How many came to scoff, as the organizers intended? And how many came out of interest in this art, or even genuine admiration? By comparison, the exhibition of officially sanctioned art, which opened in the newly built House of German Art in Munich a day before the Degenerate Art exhibit, drew a total of just over 400,000 visitors during a four-month run, or some 3,200 a day. For every person who saw the "German" art in Munich, more than six were drawn to see the "degenerate" show.

The Kronprinzenpalais in Berlin, with its modern collection, closed its doors on July 5, 1937. When Eberhard Hanfstaengl refused to cooperate in the Degenerate Art action, he was dismissed on July 26. The National Gallery lost a total of 435 works from its collection. Subsequently, Goebbels and his Propaganda Ministry made arrangements for the sale of the purged art. Renowned dealers were engaged to sell these items abroad in return for foreign currency or traditional art. The Amsterdam banker Franz König bought Van Gogh's *Portrait of Dr. Gachet* and the Berlin National Gallery's version of the *Jardin de Daubigny*.

On June 30, 1939, a public auction was held at the Hotel National in Lucerne arranged by the Galerie Fischer. Theodor Fischer, the owner, had worked in the Cassirer gallery in Berlin in the 1920s. Nazi officials had put considerable effort into publicizing the event, displaying for ten days in May the 125 pieces to be auctioned. Prominent work by Franz Marc, Emil Nolde, Max Beckmann, and Lyonel Feininger, among others, was available. Included in the auction was a Van Gogh *Self-Portrait* (F 476). Van Gogh had created this personal memento, with its background of

pale veronese green, for Paul Gauguin in September 1888. Hugo von Tschudi had acquired the painting in 1906, and it had moved with him to Munich, where since 1919 it had resided in the New State Gallery until it was confiscated by the Nazis.

At the Galerie Fischer, little went as expected. The auction was a terrible disappointment for its owner. Thirty-eight lots remained unsold, including Picasso's *Head of Woman* and *The Absinthe Drinker*. But the Van Gogh sold. It was purchased by the New York dealer and editor of *Art News*, Alfred M. Frankfurter, on behalf of his client Maurice Wertheim. Wertheim had made his money in investment banking, had acquired the venerable journal *The Nation*, and would eventually head the American Jewish Committee during the war. His daughter, Barbara, born 1912, was to become the celebrated popular historian Barbara Tuchman. Wertheim paid 175,000 Swiss francs (almost $40,000) for the painting, considerably more than had been expected.[9]

The modern art that remained in Germany in private hands was enjoyed surreptitiously among the trusted. During the war much art, like everything else, was destroyed by bombing raids and other misfortune, though remarkable amounts of cultural treasures, from artwork to books, were saved through timely evacuation. Museums emptied, and many private collections were dispersed. The occupying armies were not particularly interested in art, though the Red Army was known to use art canvases for street signs.[10]

Despite Hitler's antipathy toward modern manifestations in visual art, his own gigantesque artwork, the Third Reich, had distinctly modernist features. Fire, wind, and cleansing were powerful motifs in Nazism, as they were in the Fascism of Mussolini. Il Duce was genuinely enamoured of F.T. Marinetti's Futurist associations of technology, speed, and war with hygiene and purification. He set about destroying the old centre of Rome,

for instance, in order to open the city to "sun and light."[11] The Third Reich's fascination with fire was inescapable: torchlight parades, book burnings, incineration of art, and eventually the cremation of human beings. Once the war began, Goebbels said that Hitler was "deeply impressed by photos of London burning," but the idea of New York consumed by fire really excited him— "skyscrapers being turned into gigantic burning torches, collapsing upon one another, the glow of the exploding city illuminating the dark sky."[12]

## STUDIO SANARY

*Old Man in Sorrow (On the Threshold of Eternity)*

Just as Vincent van Gogh had headed to Provence in search of peace and inspiration, so many of the protagonists in the German Van Gogh story sought refuge in the south of France. The little fishing village of Sanary-sur-Mer became the magnet. It lies west of Toulon, beyond the smart Riviera coast. Sanary was no Antibes or Beaulieu, let alone Cannes or Nice. It was off the *route nationale,* in a quiet corner of the brilliant Mediterranean. Painters had found sanctuary there early in the century. Writers came later.

Julius Meier-Graefe had moved to Saint-Cyr-sur-Mer, some twelve kilometres from Sanary, in 1930, in the midst of the horrors that the Wacker affair conjured up for him, returning only occasionally to Berlin. After the Nazi takeover of power in 1933, Sanary became a home away from home for countless German writers and artists. The roll call was impressive. The brothers Thomas and Heinrich Mann, Alfred Kantorowicz, Arnold Zweig, Lion Feuchtwanger, Emil Ludwig, Ernst Toller, Bertolt Brecht, Alfred Kerr, René Schickele, Bruno Frank, Rudolf Leonhard, and Franz

Werfel, along with Alma Mahler, were some of the writers who stayed for longer or shorter periods. Eugen Spiro, Leo von König, and Erich Klossowski were among the artists. Aldous Huxley lived nearby; Arthur Koestler visited. Baby Goldschmidt-Rothschild was present in 1936 when Feuchtwanger threw a party about which Schickele said, "Half the German emigration has gathered in Sanary."[1] The philosopher Ludwig Marcuse would call the village the new "capital of German literature": "the air was pregnant with brilliant aperçus, indiscretions, and quarrels."[2] Schickele set his novel *Die Witwe Bosca* (The Widow Bosca) in Sanary, changing the name to Ranas-sur-Mer.

Life could be pleasant in Sanary. Winter, if it came at all, was short. Accompanied by roses, white thyme, mimosa, and carnations, it was nothing like a northern European winter. Spring began in January. The locals had mixed feelings about the German interlopers. They willingly took money from them but also denounced them as Boches, Jews, and spies. When Meier-Graefe was pondering a longer lease on a house, the owner insisted on this clause: "In case of war between Germany and France, the rental contract will be annulled on the day war is declared without any indemnity from one party or the other."[3]

Political emotions ran high. Aldous Huxley, who had described the previous decade as one of "dissipated energies, of experiment and pastiche, of restlessness and hopeless uncertainty," had the sense now that everywhere he looked he saw "invisible vermin of hate, envy, anger crawling about."[4] The Germans brought their divisions with them. The highbrow *Dichterfürsten*—princes of poetry—were led by Thomas Mann, Meier-Graefe, and Schickele. This group had regular readings of works-in-progress and insisted on formalities. On one occasion the American novelist and occultist William Seabrook, who claimed to have indulged in cannibalism out of curiosity, gave a party. The host, despising any semblance

of convention, greeted his guests dressed only in khaki shorts. "Heinrich Mann, even more stiff and formal than his brother," Huxley's companion Sybille Bedford recounted, "arrived in a high collar and black coat, extending, like Monsieur de Charlus, two fingers to anyone offering to shake hands." The other German clan, dominated by Feuchtwanger and including Toller, Brecht, and Leonhard, was the Communist coterie. The two groups barely tolerated each other. The latent civil war that had existed in Germany before 1933 continued in the south of France. Both sides, however, looked down on the Anglo-Saxons.[5] It was all monstrously theatrical, and Sybille Bedford, with her Anglo-German background and her insistence that reality, imagination, and memory produced an inseparable mix, revelled in the atmosphere.

Meier-Graefe seemed quite at home. Bedford remembered him fondly from those days:

> Meier-Graefe was a relentless worker; his hours were from dawn till about 4 p.m., sustained by fruit and pots of China tea, his output half a page a day. . . . One went to see the Meier-Graefes for tea or dinner out of doors on their terrace above a cypress alley. Bush [as Annemarie Epstein was called], Meier-Graefe's wife, his third—she had eloped with him, running away from boarding school—was very young, practically a girl, and already as competent as she had to be: driving the car, running the house hospitably, typing the books, managing at the same time to get on with her own painting and to be gay and giggly.[6]

Ludwig Marcuse had the impression that Meier-Graefe, this "artist without a brush," was finally at peace, but Meier-Graefe's diary for these years of exile belies this contention. He remained as opinionated as ever, even if his public voice had been largely silenced.[7]

Few truly adapted to the new life. Thomas Mann's daughter, Monika, remembered, "My father spoke French, rode about in a Peugeot, and ate croissants, but his attachment to Goethe, German *Lieder*, and much else deepened."[8] Mann would admit to Albert Einstein that he was too German to accept exile with equanimity. Meier-Graefe remarked of the Manns in his diary, "They are not made for the south."[9] Money, though hardly mentioned, was a concern for all. Harry Kessler found the French coast too pricey. His fortune gone, he, aristocratic pauper, went to Palma, the capital of Mallorca, instead.

Sanary was a refuge but it was also a site of exile. Ludwig Marcuse claimed he loved every moment of his six years there— "my Sanary," he called it—but then he admitted that he also hated every moment, "my happy-unhappy years."[10] There were many other settings for these bifurcated emotions: Zürich and Ascona in Switzerland, Paris, Zagreb, Prague, and eventually London, Lisbon, New York, and Los Angeles. The arts community in Germany would be blown to the four corners of the earth, but their possessions rarely went with them. Margarete Mauthner left her Van Goghs in Germany, and Tilla Durieux disposed of hers. Van Gogh's *Railway Bridge over Avenue Montmajour* (F 480), which had once belonged to her, she last saw in Erich Maria Remarque's house in Ascona.[11]

Julius Meier-Graefe spent his final days in Saint-Cyr-sur-Mer near Sanary. He sought French citizenship but did not live to see it accorded. A deep melancholy pervades his last years. His diary for April 21, 1934, states, "I am having bad days, always tired, frequently so fragile that I can barely descend the stairs." The last entry, for May 18, 1935, records someone's arrival, but the name is illegible.[12] On June 21, 1935, he died. Annemarie would immigrate to California, then New York, and, in 1949, marry the writer Hermann Broch, again much older than she. In Broch's novelistic

work, as in Van Gogh's life and art and Meier-Graefe's imagination, reality and dream, prose and poetry, the classical and the modern all mix and mingle. Annemarie was clearly drawn to a type and perhaps a vision.[13]

Other players in the Van Gogh–Wacker story also faded from prominence as the political storms in Europe took precedence over mere art. Harry Kessler died in Lyons in 1937. Willem Scherjon passed away in 1938, and Helene Kröller-Müller a year later. Julius Meier-Graefe's son, by his second marriage, was killed at Stalingrad. Others lived on, but the spotlight had moved elsewhere.

In 1939 Jacob-Baart de la Faille amended his decision on the Wacker pictures—again. In a new edition of his catalogue raisonné he now included six of the Wacker items, instead of a mere five, bowing once more to Bremmer and Scherjon. However, his reputation had never recovered from the earlier scandal. Shortly after the Wacker trial he auctioned some pictures in Amsterdam purportedly by Vlaminck, Dufy, and Derain that were said to derive from the collection of a secretary of the Salon d'automne. As it turned out, the man in question, Chanterou by name, had never been secretary of the Salon, and the pictures were dismissed as fakes. De la Faille's reputation, said Berlin's tabloid *B. Z. am Mittag*, was "utterly extinguished."[14] His catalogue and enumeration continued to serve, despite the scorn heaped on them, as a basis of reference for the Van Gogh oeuvre, as they still do today.

## CRIME SCENE

*Landscape with Snow*

When Stephen Spender arrived in Hamburg in 1929 to visit his friend Erich Alport, scion of a distinguished merchant family, he was transfixed, as his thinly disguised

autobiographical novel *The Temple* reveals, by the paintings in the Alport home—works by Picasso, Derain, and Van Gogh, among others.[1] The Van Gogh was most likely *Restaurant de la Sirène at Asnières* (F 312), which Erich's mother, Valerie, had recently acquired from the Matthiesen gallery. When the Alports fled to Britain in 1937 they took their Van Gogh with them, and it was eventually bequeathed to Oxford's Ashmolean Museum. A number of other Van Goghs, once owned by Curt Herrmann of Berlin and Max Silberberg of Breslau, reached Britain in a similar manner. By the outbreak of the Second World War approximately sixty Van Gogh works were to be found in Britain.[2] Some of these pictures then made their way to the United States, which soon replaced Germany as Van Gogh's second home. Adoption by Americans bestowed a new popular dimension on the work of Van Gogh.

The United States was always a world apart. Harry Kessler had visited in 1923 and found the impact overwhelming, at least initially: "New York is overpowering. I would never have believed that any impression could have had the power so to disorient me. I am staggered by the monstrous effect of this city. By contrast London is almost provincial. Here is the modern Rome, the colossal world capital, the city that has the appearance of being the centre and the ruler of the modern world."[3]

In view of this contrast to old Europe, it was appropriate that in the 1930s Germany's passion for Van Gogh should pass to America.

If Alfred H. Barr Jr. was inspired by Ludwig Justi and the National Gallery in Berlin, he took the inspiration to a new level at the Museum of Modern Art in New York. Founded in 1929, the museum quickly became the centre of American modernism. Barr was its first director. His associate Beaumont Newhall compared the fervour of MoMA's initial years to "the early Christian

Church, for it was truly a crusade, and Alfred was our leader."[4] The painter and art historian John Golding, who grew up in Mexico and first visited New York as a young man, noted the impact MoMA had on his own development: "I subsequently came to realize that the scope of its collections and the displays and exhibitions it mounted provided a far more coherent overview of the development of twentieth-century art than could be seen in any European museum."[5]

From the start Barr was aware of the importance of Van Gogh to the development of modernism, and on hearing that the Kröller-Müller collection had basically been removed from public viewing after the 1930 exhibition at the Stedelijk in Amsterdam, he rushed to Europe to try to persuade Helene to release some of her pictures for showing in the United States. An agreement was reached to send thirty-five paintings and an equal number of drawings to New York. The financially harassed Helene asked for $10,000; Barr, the perspicacious director who knew insurance premiums would be high, got her to accept $7,500. Additional items were borrowed from other European museums, and on November 5, 1935, MoMA's Van Gogh exhibition opened with 127 works—drawings, watercolours, oil paintings. They were insured for more than $1 million.

The show was an unprecedented success. The lineup waiting for admission along West Fifty-third Street averaged three thousand people through the rest of the autumn and into the snowy New York winter. First Lady Eleanor Roosevelt visited five times. Led by Saks Fifth Avenue, Manhattan department stores created window displays to tie in with the exhibition. Helene Kröller-Müller wrote to a friend, "The excitement is so great that one feels the influence of the so-called Van Gogh colours throughout America, even in shop windows." The journal *Art News* commented on November 10, at the beginning of the run, "Seldom

has an exhibition aroused such enthusiasm ... and never within our memory has there been such constant visual reinforcement from unexpected sources.... Now prints of the greater part of the artist's oeuvre appear so inescapably in window after window that even the casual stroller is likely to gather without effort impressions that equal in extent those usually obtained by earnest students from special brochures and books."

After the New York date, the exhibit went on tour across America to ten cities—fifty others offered to host—generating enormous interest wherever it stopped. "The people came as though the museum was exhibiting the Sistine Chapel," remarked Howard Edgell of the Boston Museum of Fine Arts. A Cleveland newspaper columnist was flummoxed: "Just what combination of circumstances is it that causes people to flock in swarming multitudes to see the works of a single crazy Dutch painter as if he were a combination of Ringling Bros. Circus, Jack Benny and a two-headed horse?" Almost 900,000 people attended the various venues, paying 25 cents each for the privilege, 227,000 in San Francisco alone. MoMA hosted a farewell viewing in early 1937, and after Van Gogh had departed, Alfred Barr and the museum could revel in a handsome profit of some $50,000 from the enterprise.[6] Alfred M. Frankfurter, the editor of *Art News,* categorized the show as "the outstanding artistic success of the 'thirties, if not indeed of the history of American museums until then."[7]

Irving Stone's biography of Van Gogh, *Lust for Life,* which had first appeared a year earlier, in September 1934, went through two reprintings because of the tidal wave of enthusiasm. *Reader's Digest* produced a condensed version. Harcourt, Brace reprinted Meier-Graefe's *Vincent* early in 1934 as well. Frankfurter was inclined to credit much of the success of the MoMA show to Stone's fictional account, though he personally found the author's melodramatic approach impossible to read.[8]

In similar vein, some critics were not impressed by the bally-hoo and sensationalism that accompanied the Van Gogh exhibition's excursion across America. Louis LaBeaume of the Saint Louis Art Museum regretted the publicity, which emphasized the tragic side of Van Gogh's life, and compared the public interest to that of a crowd at a fire or the scene of a crime. Barr insisted later that he had done his "damnedest to keep both the commercial value and the morbidly sensational elements of Van Gogh's life out of the exhibition."[9] That was a futile effort, as the earlier German experience should have indicated. To an America wallowing in an economic depression of unprecedented and unimagined proportions, Van Gogh's dualities—his misery and grandeur, spirituality and Petrine denial, penury and posthumous wealth—touched American nerves in much the same way they had touched Germans earlier.

Irving Stone represented a link between the German and American reactions to the Van Gogh story. On his graduation from Berkeley and then the University of Southern California, with degrees in political science and economics, Stone, whose original name was Irving Tennenbaum, had won a theatre prize for a play and had gone off to Europe in 1926—to Paris, Antibes, and Florence—to develop his skills as a playwright. However, like Hugo von Hofmannsthal earlier, he was transfixed by the sight of some Van Gogh paintings and determined to chronicle the artist's life. His approach, the fictional biography, clearly owed a debt to Julius Meier-Graefe's work. The two studies have a similar modality, though Stone does heighten the melodrama common to both with his invented dialogue. In Stone, Meier-Graefe mutates into a Hollywood scriptwriter. "His shoulders and chest were massive," wrote the American in introducing Van Gogh, "his arms thick and powerful."

*Lust for Life* was first rejected by seventeen publishers, but after

being edited and severely pruned by his wife-to-be, Jean Factor, Stone's opus was accepted in January 1934 by Longmans, Green in New York and appeared in September to huge acclaim. It would be the basis for Vincente Minnelli's 1956 film of the same title, starring Kirk Douglas as Van Gogh and Anthony Quinn as Gauguin. After several other failed attempts to produce an acceptable film script, Norman Corwin, an accomplished writer of radio drama, adapted Stone's novel for the screen, though he later insisted that his script was based more directly on Van Gogh's own letters than on Stone's account.[10]

Although the Americans had entered the international art market in the years before the First World War, the massive exodus of creativity and art from the political turmoil of Europe in the 1930s moved that market to the United States. Dealers, collectors, and artists from Paris, Amsterdam, and Berlin suddenly comingled in closer proximity in New York than ever before in Europe. The Second World War, with its devastation and plunder, confirmed the shift in the art world's centre of gravity. *Art News* stated proudly in 1943, "Today America, and particularly New York, is virtually the art center of the world."[11]

The Parisian dealers Georges Wildenstein and Paul Rosenberg, both of whom fled to New York, put on Van Gogh exhibits there during the war. The Museum of Modern Art acquired its great Van Gogh prize, *Starry Night*, through Rosenberg in 1941. It had been part of the estate of Georgette van Stolk of Rotterdam when Rosenberg came by it in 1938—with the help of the otherwise repeatedly maligned Baart de la Faille.

Private collectors, usually with a European connection, also acquired Van Goghs. Among them was the Oppenheimer family of New York. Robert Oppenheimer, who eventually oversaw the conception and creation of the atomic bomb, the Manhattan Project, lived as a child on Riverside Drive overlooking the

Hudson River. His father, Julius, had arrived from Germany in 1888 and proceeded to make a modest fortune in the textile industry. He was an art lover—he married a painter, Ella Friedman—and spent much of his free time exploring New York's galleries and museums. Over the years the Oppenheimers acquired a stunning collection of Post-Impressionist and Fauvist works by Vuillard, Derain, and Renoir, but also Picasso's *Mother and Child* from his Blue period and three Van Goghs, including *Enclosed Field with Rising Sun* (F 737). These Van Goghs dominated a living room decorated in gilt.[12] At the Manhattan Project, Robert Oppenheimer would produce his own version of a rising sun, a scientific work of art "brighter than a thousand suns." Another American collector was Stephen Carlton Clark, heir to the Singer sewing machine fortune and chairman of the board at MoMA. He acquired *Night Café*, once in Morozov's hands, in 1933 and bequeathed it in 1960 to Yale University.[13]

The bestselling author Erich Maria Remarque was also to develop a passion for Van Gogh. In the wake of his mammoth international success as a writer who lived off the modern *mal du siècle*, Remarque was a spiritual confrère of Van Gogh. He had achieved the contrarian success that Van Gogh worked toward but desperately feared; he was driven from his homeland by that success, first to Switzerland and then to New York. He, nomadic anti-hero, often toyed with suicide. In *Arch of Triumph*, which he wrote during the war in exile in the United States and published in 1945, his main character, a doctor at once cynical and sentimental, notices some paintings on the wall of a Paris hotel room inhabited by refugees, all with a painful past. "In front of him, over the bed, hung an Arles landscape by Van Gogh in his best period. He took a step closer. There could be no doubt, the painting was genuine. . . . Ravic studied the Van Gogh. It was worth at least a million francs."[14]

The Van Gogh fetish reached north into Canada as well, even to the remote mining community of Cobalt in northern Ontario. There the self-styled critic Edward Buckman, who subscribed to the *Art Digest* and had read Irving Stone, wrote to the independent British critic and journalist Douglas Cooper to say how much he looked forward to Cooper's forthcoming English edition of the correspondence between Van Gogh and his friend the painter Émile Bernard. He hoped that the letters, which he said he knew well in their French version, would help clear up the "false impression" that Irving Stone had created about Van Gogh "as a man, thinker, and writer."[15]

In her biography of Roger Fry, who in 1910 had mounted a Post-Impressionist exhibition in London that had been greeted with vituperative protest, Virginia Woolf reflected in 1939 on how dramatically public taste had changed in the decades since. It was hard to believe that Cézanne, Gauguin, and Van Gogh had once been able to arouse such animosity. "If money is any test," she mused, Fry had been utterly vindicated. "Shares in Cézanne have risen immeasurably since 1910." She might have added that shares in Van Gogh had risen even more.[16]

Terence Rattigan's play *After the Dance* opened that summer, in June. Its subject was the fate of the Bright Young Things of an earlier generation. After the Great War the spotlight had been on that generation of youth because its predecessor had been wiped out in the war. And what had the Bright Young Things done in the spotlight? asks one character in the play. "You danced in it," replies another, in a withering tone.[17]

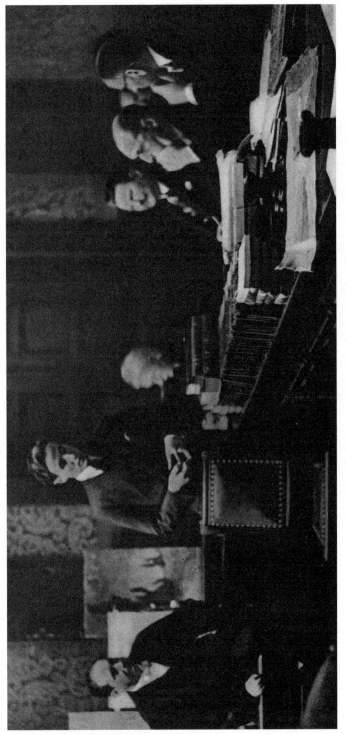

Wacker, always smartly dressed but otherwise self-effacing (when not performing), is seen here testifying at his trial. His lawyer, Ivan Goldschmidt, at left, appears pleased at what he is hearing from his client. The judges, at right, seem less convinced. From *Zeitbilder*, a Sunday supplement of the venerable Berlin daily the *Vossische Zeitung*, April 10, 1932.

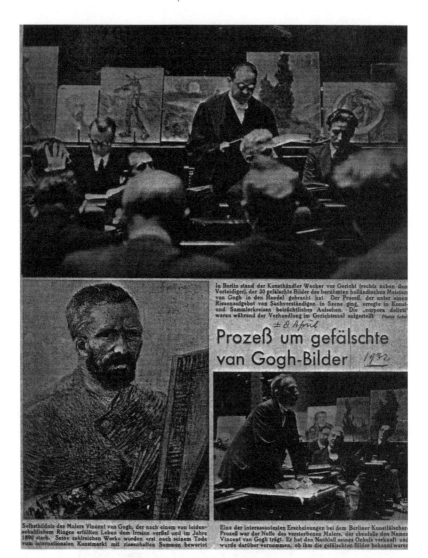

## Prozeß um gefälschte van Gogh-Bilder

This page is from an unidentified German newspaper, dated April 8, 1932. The top picture shows Wacker's lawyer, Ivan Goldschmidt, addressing the court; Wacker is on the right, and the Dutch police official Cornelis M. Garnier sits in front of Goldschmidt. The Wacker paintings, left to right, are *Sower* (F 691, partially hidden), *Self-Portrait* (F 385), *Peasant with Pitchfork (After Millet)* (F 685), *Sower* (F 705), *Cypresses* (F 616), and *Plate with Bread Rolls* (F 387). The picture lower left is of the genuine *Self-Portrait in Front of Easel* (F 522) on which the one (F 523) purchased by the American financial magnate Chester Dale was based. At lower right Vincent Willem van Gogh, the artist's nephew, is seen testifying. The three pictures on the right are *Zouave* (F 539), *Cypresses* (F 741), and, again, *Cypresses* (F 616).

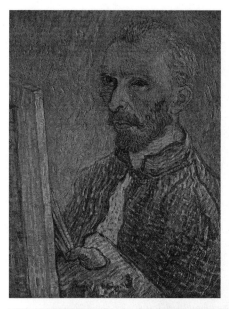

*Self-Portrait at Easel* (F 523), which all the experts initially accepted as genuine, was purchased by Chester Dale and later bequeathed, along with the rest of his collection, to the National Gallery of Art in Washington. There the Dale collection was accorded three rooms for permanent display, and the *Self-Portrait* was included in the gallery's initial catalogue, *Masterpieces of Painting,* published in 1944. Late in his life Dale is reported to have said: "I know of course that this is a controversial painting, but as long as I am alive, it will be genuine." Only in 1984, long after his death, did the National Gallery remove the painting from exhibition.

This painting, signed "LW 27," was found in Leonhard Wacker's Düsseldorf studio in May 1929 and regarded by the police as a preliminary study. It appears to be superimposed here on another picture with similar lines, presumably the *Wheat Field with Reaper* that was in his brother's possession.

Leni Riefenstahl, a dancer before she became an actor and then Hitler's favourite film director, turned the political stage into aesthetic enchantment and, some would argue, the lie into art. She associated dance with painting and translated that vision into a series of astonishing film documentaries. She wrote a screenplay about Van Gogh in preparation for a film, but, as she put it in her memoir, "that dream, like so many others, never came true."

Solar dance: the swastika as life force. Here the German Luftwaffe performs at a Nuremberg airshow in 1936.

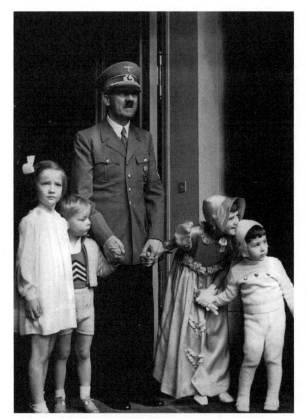

Hitler and Stalin as father figures: the authentic lie or the art of political theatre. Hitler is shown being greeted by children on his fiftieth birthday in 1939. He would marry only days before his suicide in April 1945 and, as far as we know, fathered no children. The Soviet poster, reading "Thank You, Comrade Stalin, for Our Happy Childhood," dates from 1936—after the collectivization of agriculture had taken its deadly toll and just as the Great Terror began.

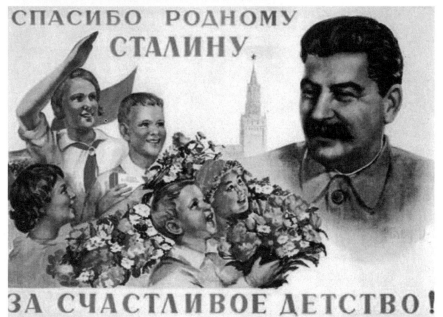

СПАСИБО РОДНОМУ СТАЛИНУ.

ЗА СЧАСТЛИВОЕ ДЕТСТВО!

A member of a group of artists calling themselves "The New Wilds," Rainer Fetting painted a series of pictures featuring Vincent van Gogh and the Berlin Wall. *Van Gogh and the Wall V,* from 1978, captures their aggressive defiance in garish blues and yellows slashed with crimson. When the wall collapsed, Fetting was fêted in East Berlin.

Banking in the name of Van Gogh. The Royal Bank of Scotland, which acquired Van Gogh Preferred Banking from ABN AMRO in 2007, promises to raise "wealth management" to an "art form." Pictured here is a branch in Shanghai.

# THE EFFECT

You try too hard to understand and that is a mistake.
JEAN COCTEAU, in his film script for *Orphée*, 1949

The kids want misery and death.
JOHN LYDON of the Sex Pistols

Bollywood or Hollywood? I like Bollywood
for the authenticity.
GEORGE SMITHERMAN, Toronto politician, 2009

# MENDER

*The Road Menders*

After the First World War, Van Gogh was associated with the agony of existential doubt. His brilliance had been his affirmative creativity in the context of debilitating misgivings. His mood was thought to correspond with the postwar German mood. Three decades later, after the unimaginable devastation of the Second World War, in which somewhere between fifty and seventy-five million human beings perished, in which all distinctions between civilians and soldiers, the permissible and the impossible, the imaginable and the unfathomable seemed to disappear, Van Gogh's life and work were seen to overlap with a much wider mindset. He was adopted ever more broadly as representative of resilience in the midst of anguish.

In September 1945, within four months of the end of fighting in Europe, the Stedelijk in Amsterdam mounted an exhibition of his work in order, it seemed, to make a statement about the vivacity of Dutch life after the long night of German occupation. No one seemed bothered by the irony implicit in using an artist who had taken his own life to celebrate the return of life—or by the fact that Van Gogh had been lionized as a Germanic artist. That exhibition continued to Maastricht and Heerlen early in 1946. Shows followed in Sweden, Denmark, and Belgium. In 1947 the Musée de l'Orangerie in Paris put on a vibrant Van Gogh exhibition. The critic Douglas Cooper was enchanted: "Whereas Van Gogh has been the keynote of so many New York seasons," he wrote, referring presumably to the great MoMA show almost a decade earlier and the Wildenstein and Rosenberg exhibits during the war, "we in Europe have been little favoured." He went

on to describe the intense "emotional experience" that the exhibition evoked in him.[1] Later that year, in December, the Tate in London put on a major Van Gogh show that then moved on to Birmingham and Glasgow in the new year. Vincent Willem van Gogh, now in middle age himself, was most surprised by the success of the Glasgow event, attended by 103,000 keen visitors. The queues had been enormous and the supply of catalogues had run out. "I am still wondering what it really is that attracted these big crowds," he wrote to Cooper. "Have you any idea? Is it the clearness, or the colouring, or the spirit or what?"[2] These questions were hardly new.

In Europe the art market and gallery life revived gradually, but New York retained its new pre-eminence as the centre of commerce in art. In October 1949 the Metropolitan Museum of Art opened a stunning exhibit of Van Gogh, larger even than the previous famed MoMA show. The crowds over the next three months were endless, the enthusiasm irrepressible. The museum's year-end report would state, "The major event . . . was the exhibition of 158 paintings, water colors, and drawings by Vincent van Gogh. . . . The Museum was given a free choice from the collections of V.W. van Gogh and the Kröller-Müller State Museum in Holland, and some of the artist's finest works were borrowed from institutions and private collectors in this country. Over 302,000 visitors came to see it—an unprecedented number for any Museum exhibition."[3]

These numbers made the earlier interwar exhibitions in Europe look like small private gatherings.

But New York was not alone in its interest in Van Gogh. The rest of America craved to see him, too. The Metropolitan's exhibit moved on to the Art Institute of Chicago, where it ran for two and a half months. A year earlier, in 1948, the Cleveland Museum had built a Van Gogh exhibition around its recent

acquisition of *The Road Menders* (F 657), that imposing picture of gnarled tree trunks in Saint-Rémy erupting like flames from the underworld. The trees evoke the power and historicity of nature set against the transience of human effort. In his appreciation of Van Gogh for the catalogue accompanying the exhibit, Henry S. Francis, the curator of paintings and prints at the museum, returned to the theme of fire. "The brilliant and sinuous flame-like style which Van Gogh attained ultimately was the consequence of his own intense visual perception." He went on to speak about the "crudeness and intense power" that this art exuded and the way Van Gogh's extraordinary creativity, especially in Provence, was witness "to the triumph of his genius over his infirmities."[4] Daniel Catton Rich, the director of Chicago's Art Institute, was thinking in similar terms when he identified Van Gogh's "moral austerity" and "grim acceptance of reality" as "an almost classical case study for Existentialism. . . . How can one explain the vast hordes of war survivors who stood in patient queues at Paris and London, to catch even a glimpse of his work? . . . Part of his continuing appeal may lie in his unique ability to suggest those tensions and dislocations under which man lives today."[5] Cyril Connolly might have been thinking of Van Gogh when he wrote world-wearily in December 1949, "It is closing time in the gardens of the West and from now on an artist will be judged only by the resonance of his solitude or the quality of his despair."[6]

It was Van Gogh's ability to capture anxiety in the framework of nature and tradition that made him so relevant to the modern and postmodern worlds. Despite the aura of madness that surrounded him, and the pre-war opinions of Karl Scheffler and Max Liebermann notwithstanding, his work did show remarkable control. Much of it was, in the eyes of Allan Kaprow in 1958, "astonishingly calm."[7] For Kaprow, who was instrumental in

developing the concept of performance art and whose work attempted to integrate art and life, Van Gogh was one of the last messengers of truth. Kaprow was depressed by the state of the art world in the 1950s. Cliché had replaced idea. "Everybody's cousin and Aunt Tillie is now some sort of abstract expressionist," he protested. Against this backdrop of frantic yet uninspired activity, Van Gogh was a giant.[8]

In keeping with public interest, Van Gogh's monetary value continued to rise meteorically. In 1935, for insurance purposes, Alfred Barr had valued each Van Gogh painting in his MoMA exhibition at $40,000. By 1951 the insurance estimate on *The Portrait of Dr. Gachet* was $200,000, and in 1970 the dealer Eric Stiebel appraised the same painting at $1.5 million.[9]

The commercial success of Van Gogh in America made some critics turn away from him, following, again, the pattern already established in Weimar Germany. The influential New York critic Clement Greenberg asked questions similar to those of Karl Scheffler earlier. "Is there craft competence, did Van Gogh have a professional command of his art? . . . Or was it his derangement that made him the painter that he was?"[10]

## SCHEHEREZADE

*Still Life: Potatoes in a Yellow Dish*

Art, along with everything else, got caught up in the politics of the Cold War. The divisions ran, once again, right through Germany. Was it poetic justice that Berlin's gallery district, just off the Potsdamer Platz, had been blown to smithereens by the RAF's Bomber Command and the advancing Red Army, and then, as relations between the occupying powers deteriorated, turned into a no-man's land of barbed wire, searchlights, and

watchtowers? The glamour and fervour of an earlier age gave way to the metallic chill of abstract dogma.

Otto Wacker had survived the war years living with his brother-in-law Erich Gratkowski on the Brunnenstrasse. With the division of Germany and Berlin into occupation zones, the street found itself in the Russian sector of the city. While denazification was one of the agreed goals of quadripartite rule in Germany, Soviet implementation of this policy would, perhaps surprisingly, prove less intrusive than the approach in the other zones, especially the American. The Soviet approach was inherently opportunistic, inspired by a desire to exact as much reparation from its zone of occupation as possible. Many former Nazi Party members would, as a result, scurry to the Soviet zone to hide.

Wacker had been a card-carrying Nazi, a *Pg*—short for the now dismissive *Parteigenosse*—and, as Allied occupation policy developed, he had good reason to remain in the Russian realm. He also had opportunity, under the shadow of a different power, to begin afresh, even to revive some of the familiar Russian themes from his past and ingratiate himself with the new rulers. The visual arts had got him into trouble. His earlier métier, dance, had not—certainly not to the same degree. So he returned to that pursuit and, shortly after the end of the war, found a position as a dancer and choreographer with the Theatre of Dance in the city of Weimar, also in the Soviet zone. There Henn Haas, a student of Mary Wigman and Rudolf von Laban, and a former lead soloist with the German National Theatre, was the newly appointed intendant. Wacker now changed his stage name to Olinto (from Olindo) Lovaël and made a point of cultivating his Russian refrain.

Once again a suspiciously fictive element surfaced. Berlin's *Tägliche Rundschau* newspaper reported in December 1945 that he, Olinto Lovaël, had "appeared in Holland and Belgium in

recent years under a pseudonym because he had been forbidden to dance in Germany on grounds that he had dared to dance to Russian music."[1] There is, however, no other evidence to suggest that Wacker had moved to occupied German territory during the war in order to dance, and it is likely that he invented this story, as he did so much else, for his own political and personal gain. Earlier he had pretended to be a dancer from Spain. Was he now claiming a previous affiliation with Diaghilev and the Ballets Russes?

In the Weimar Theatre of Dance his most frequent role was as the sultan in Rimsky-Korsakov's *Scheherezade,* the tale of the legendary Persian queen who was so mesmerizing a storyteller that she escaped the death planned for her. Wacker must have relished the ironies implicit in this plot line and identified more closely with the queen than with his own role as sultan. After all, he had mesmerized the world with his stories some two decades earlier. He seems to have taken care not to call attention to his past as an art dealer, but he probably still revelled in the memories of his life in the international spotlight. In 1946 he performed a dance number titled "Zouave" that he dedicated to Vincent van Gogh.[2]

In the Soviet zone, all artistic effort was intended to serve the political goal of Communism, and, under the tight censorship of the Socialist Unity Party (SED), reviews were invariably upbeat. One notice of a performance in Eisenach, for instance, applauded the "dignified authority and manliness" of Olinto Lovaël.[3] A rare critical review of Olinto Lovaël did appear in the Erfurt edition of the *Thüringische Volkszeitung* on April 22, 1947. Wacker had performed a number called "Byzantine Impression," based on the music of Mussorgsky, but the critic complained that the "attractive idea" had not been realized in the "performance."[4] That kind of mild rebuke, without detailed explication, was about as far as

criticism of officially sanctioned cultural enterprise could go. Reading between the lines suggests that Wacker's performance had been thoroughly uninspired. He was now nearing the age of fifty, and with his history of health problems, he had to consider his days as a performer numbered.

Despite the low-key approach of the Soviet military authorities to denazification, an accusation of Nazi Party membership was the ultimate form of denunciation in the postwar Soviet zone. Before artists could work or perform, they had to be members of the artists' union, the Gewerkschaft Kunst, and the union rules stated clearly that former Nazi Party members could not be admitted.[5] If differences within the arts community turned to acrimony, as they often did, the charge of party membership became a weapon in the arsenal of combat. Otto Wacker must have been terrified that details about his past might come to light, and it was in his interest to keep a low profile.[6]

However, as long as that past remained his personal secret, he presumably saw no reason to leave Soviet tutelage or even look to the West. In October 1949 the Russian occupation zone became the German Democratic Republic (DDR), claiming to be the sole legally constituted German state. In keeping with the aesthetic of "socialist realism" favoured in the Soviet Union, the DDR's political and cultural authorities emphasized "people's culture" (*Volkskunst*) and supported any effort to develop public interest in this folk culture. Wacker's stage career seems to have wound down at this time, but his previous experience in "old Spanish dance" offered him further opportunity in the Communist cultural scene as it developed. He could claim that he had long experience in popular cultural forms. Again he adapted: he turned into an ardent promoter of "social dance" in its various guises, both as performance and as a leisure activity. As the ideological rigidity of the regime hardened in the 1950s around the inflexible

East German Stalinist Walter Ulbricht, Otto Wacker proved to be a willing collaborator. He performed all the necessary pirouettes and made a modest living as a pseudo-apparatchik.

With the ideological emphasis on lay art, as opposed to professionalism and its association with commercialism, Wacker could claim to be an amateur artist from a working-class background. The art of his family, he could say, had emerged from its social condition. That approach fitted the party line perfectly. The DDR authorities were also concerned about generational renewal in the arts and were keen to support efforts to facilitate it.[7] Wacker received permission to open his own dance school in Berlin and appears to have run it without incident. He began to write newspaper columns, articles on dance for a journal called *Gesellschaftstanz* (Social Dance), published by the Central Committee of Free German Youth, and for another periodical titled *Heim und Bühne* (Home and Stage). He co-authored a pamphlet on social dancing for the benefit of East German youth. All this work appeared under his stage name.[8]

East German youth were fascinated by the dance styles that were emerging in the West. The jitterbug, an exuberant dance originating with African Americans in the 1930s and '40s, involved spectacularly gymnastic moves, with the male partner not just guiding but flinging his female companion around the dance floor. Its variation, jive dancing, dominated the Western dance floor through the 1950s. In the middle of the decade Elvis Presley caused a sensation with his upbeat rock 'n' roll music and accompanying wild gyrations. None of these trends were lost on the rebellious, or simply energetic, youth of the East.

An incident in the town of Naumburg an der Saale in January 1952 was typical of many other moments. There, an evening of dance at a local restaurant organized by the secondary school's senior students elicited irate protest from stolid party types.

According to the complaints of the town's more sedate musicians, the sounds emanating from the locale that evening bore no resemblance to music. It was "a crazy mêlée," insisted a letter of protest addressed to union authorities. "Hits like 'Black Panther,' 'In the Harem the Eunuchs Sit and Howl,' 'Oklahoma,' and other wild hot tunes followed one after the other." Dance music it certainly was not, declared the "community musicians" of Naumburg. And how those students danced! "Can we not put a stop to such wanton mischief?" The music teacher at the school was blamed for the shenanigans. "We protest most energetically about such incidents," concluded the petitioners, "and request that appropriate measures be taken."[9]

It was this form of Western degeneration and social degradation that Wacker now set out to counter. The introduction to his pamphlet on social dancing insisted that the whole point was to keep "German culture pure"—free of the "obscene influence of American un-culture." That Wacker, a former dancer and active participant in the Berlin cabaret scene at the height of its bittersweet glory, a man accused and convicted of fraud and deceit, should now have turned into a guardian of public morality was a delicious twist in the career of this twentieth-century mutant.

Wacker had protested his innocence during his trials. Now, however, it was in his interest to lie low and be known as Olinto Lovaël rather than Otto Wacker. To the occasional mention of the Wacker affair in the context of the mounting problem of art forgery in the postwar world, he wisely did not respond. However, in the autumn of 1966, as he experienced yet another bout of ill health and gave his address as Wallstrasse 60, not far from his old haunts in Berlin-Mitte, he did reveal himself in two letters to the writer Frank Arnau, who had published a book titled *Kunst der Fälscher—Fälscher der Kunst* (Art of Forgers—Forgers of Art) with Econ-Verlag in Düsseldorf, Wacker's old hometown. Arnau

had devoted a chapter to the Wacker affair, and Otto could no longer resist the temptation to comment. This had, after all, been his moment of glory, his fifteen minutes of fame.

Amid his generally inchoate remarks, Wacker implied that it was the high quality of Arnau's contribution that led him to end his silence. He wished to set the record straight, he said. But, as it turned out, he did nothing of the sort. He simply insisted, yet again, on his innocence. He stressed that third-party authorship of his pictures had never been established, despite the inquisition to which he had been subjected and despite police raids on him, his brother, and his father. After discussing his prison sentence, served in the Gefängnis Tegel, he concluded, "Though innocent I was condemned!"

The rambling but in essence declamatory five-page letter clarifies nothing. It is an assertion instead of a defence. It contains no new information, provides no serious response to any of the charges—merely denies. In this sense it is a continuation, at a distance of almost forty years from the events of 1927–28, of the vague story to which he had always adhered, of sworn secrecy and loyalty to the unknown Russian. Perhaps the most interesting detail in this otherwise disappointing statement centres on identity. The letterhead reveals the sender as Olinto Lovaël-Wacker. The signature, however, reads Otto Wacker-Lovaël.[10] Who was this man? The evidence suggests that he himself had no answer to that question. "They say," he tries to explain at one point, "that dance is a silent art. Hence my verbal-literary style may seem more or less inadequate and not always easily accessible." Silent art—*stumme Kunst*—indeed. Otto Wacker continued dancing, figuratively at any rate, to the very end of his life. He lived to see the Berlin Wall go up in August 1961; he died in East Berlin on October 13, 1970.

The source of the Wacker pictures has never been established.

# WALL

*Skull*

As the twentieth century advanced, with shattering effect, anyone involved with art in a creative, appreciative, or administrative capacity could not avoid the influence of Vincent van Gogh. But those artists most attuned to the all-pervasive and inescapable mood of crisis absorbed and reflected his influence most directly. Van Gogh had a huge impact on the pre-1914 German Expressionists, and then on the entire cultural milieu of the 1920s. In the post-1945 world the stimulus from his work and life penetrated all realms of endeavour even more. In 1957 the Irish-born artist Francis Bacon, known for his bold and vividly emotional figurative works, painted four *Studies for a Portrait of Van Gogh* inspired by the Dutch master's *Painter on His Way to Work* (F 448). This picture, also known as *Painter on the Road to Tarascon*, had been in the Kaiser Friedrich Museum in Magdeburg after 1912, but it disappeared during the Second World War. In 1959 Bacon produced *Head of a Man,* based on a Van Gogh self-portrait. Bacon would remark, "To me Van Gogh got very close to the real thing about art when he said, I can't remember the exact words, it's one of those extraordinary letters to his brother, which I read over and over again. 'What I do may be a lie . . . but it conveys reality more accurately.' That's a very complex thing. After all, it's not the so-called 'realist' painters who manage to convey reality best."[1] Bacon, a friend of Stephen Spender's, travelled to the Van Gogh haunts of Provence frequently and grouped Van Gogh with Rembrandt, Michelangelo, Velázquez, and Picasso in a "genius caste." "The job of the artist," he would add in words reminiscent of Van Gogh, "is always to deepen the mystery." Bacon, whose art is fearsome in its directness, deepened not only the mystery but also the anguish of life.

The German Neo-Expressionist Anselm Kiefer took this line of thought further by implying that life itself may be a lie, and art is the means by which we come to recognize it for what it is. He was deeply influenced by Van Gogh, by his juxtapositions: of light and darkness, sunflowers and crows, sower and reaper. Kiefer painted sunflowers, but rather than delivering the fulsome product of the sun in nature he emphasized the black seeds at the centre of the crown. To him the dark seeds were more significant than the bright garland of flower. Born in 1945, at *Stunde Null*, zero hour, Kiefer was burdened more by the suffering than the celebration of life. He obliterated any traditional idea of painting within his art—he called a 1974 work *Malen = Verbrennen* (To Paint = To Burn). Many of his fellow German Neo-Expressionists, too, were fascinated by images of fire and destruction. Art here is not merely a lie but the equivalent of the devastation that seems to be the essence of human creativity.

Kiefer has also been transfixed by the symbolism of the railway. For the nineteenth century the railway had implied liberation—a journey to hope and freedom. In Van Gogh's famous painting of his *Yellow House* (F 464), we see a train crossing a viaduct in the background. For Van Gogh the railway trestle had a suggestion of elevated optimism. For Anselm Kiefer, the railway denotes the exact opposite of freedom: "We see railway tracks somewhere, and we think of Auschwitz. And that won't change in a hurry."[2] In his 1986 painting *The Iron Path*, a railway track runs through a desolate landscape and, as it reaches the horizon, splits in three directions. We see empty boots on the track and olive branches, but no other sign of humanity. The viewer of this picture becomes the engine driver; the viewer must decide which of the three tracks to take. Is there a difference? Is this the path to a new trinity, that of death rather than life?

Kiefer's work was haunted by the poetic imagery of Paul Celan,

that Romanian-German-Jewish purveyor of modern angst. Celan, a native of Cernowitz in the Bukovina, had received a copy of Goethe's *Faust* at his bar mitzvah. He survived the Holocaust, but his parents did not. How was he subsequently to express himself? Could he even use the German language? And would not any notion of poetry automatically be a lie after Auschwitz? Celan's pained yet riveting verse would respond to but never claim to answer these excruciating questions. One poem, "Under a Picture," was dedicated to Van Gogh, whose disorientation he obviously shared to the utmost. Celan annihilated poetry within his poems—which he likened to a "wound / in which you . . . have to submerge."[3] No other postwar poet has had comparable acclaim. For both Kiefer and Celan the only authenticity can be death and the anguish, as one submerges in the wound, that precedes it. In 1970 Celan took his own life, in the city of light, Paris, in the river Seine.

In 1978 the Berlin artist Rainer Fetting, born in 1949 and a leading figure in a group of Berlin artists known as Die neuen Wilden (The New Wilds), produced a series of paintings about urban angst that he called *Van Gogh und Mauer* (Van Gogh and the Wall) and *Van Gogh und Landschaft* (Van Gogh and Landscape). The works picture disembodied figures reminiscent of Edvard Munch's *Scream* but also of Felix Nussbaum's premonition of terror from 1930, *Tanz an der Mauer* (Dance at the Wall), moving like apparitions through the horror-laden landscape of the Berlin Wall. In one of these pictures a lean, almost translucent, figure with a bright hat, face contorted, right hand clenched in a fist, moves aggressively toward the Wall. This is obviously Van Gogh. Is he on the road to Tarascon? The ghostlike apparition seems ready to pierce the Wall, to move beyond it, to the other side, as if the Wall, monstrously imposing in the picture, is no real deterrent. By the late 1970s the dramatic days

of tunnelling under, catapulting over, and crashing through the Wall were over, and for Fetting the Wall represents less a material than a mental obstruction. Politics, ideological divisions, indeed the self in its multiplicity and pathology are spiritualized by Fetting. In his work, in effect both alienating and engrossing, at once cold and engaging, he becomes Van Gogh—or Rembrandt or Velázquez, as the case may be—and in the process accepts the burdens, and madness, of history. Art, this "wild realist" seems to say, is more powerful and penetrating than politics. Art, in keeping with a long-standing German approach, subsumes politics.[4] Yet when asked why he paints his own portrait in the guise of Velázquez's Philip IV, he answers, "Why I do that? I do not know."[5]

After the Wall—this monument and metaphor, this dividing line between East and West, between Communism and capitalism—was broached in 1989, Fetting, who has acknowledged the early inspiration of J.M.W. Turner's pictures of ships on fire, was one of the first West Berlin artists to be invited to exhibit in East Berlin. His work was shown in a major exhibition in 1990 in the Altes Museum (Old Museum), on Museum Island, and then in the city of Weimar.

Vincent van Gogh was at that Berlin Wall in November 1989, on both sides. That year, that event, marked a spiritual uprising. It was not a revolution in any traditional political or social sense but the culmination of a malaise and a yearning, voiced above all by the Eastern and Central European intelligentsia. From Vytautas Landsbergis, the musicologist, and Václav Havel, the playwright, to Stefan Heym, the novelist, and Kurt Masur, the conductor, the intellectuals and artists in the Soviet sphere of influence stood at the forefront of the protests and demonstrations that called for reform and greater freedom—prompted in large part by Mikhail Gorbachev's evocations of *glasnost* and

*perestroika.* In Leipzig, the city of books and music, where the East German commotion was centred, the ritual of discussion, protestation, and demand reached back to 1982, when it had begun quietly with Monday evensong services in the Nikolaikirche (St. Nicholas church). In the late summer of 1989 these previously modest airings of frustration and wish—*Erneuerungsgedanken,* thoughts of renewal—became the focal point of ever larger gatherings in the central Leipzig churches, including St. Nicholas and St. Thomas, on both of which J.S. Bach had left an indelible mark. These Monday meetings reached a first crescendo on October 9, when, after the church services, a huge candlelit demonstration, between 70,000 and 100,000 strong, gathered in Karl Marx Square, where the opera house stood at one end and the famed Gewandhaus concert hall at the other. The mass of humanity then paraded along streets named after Goethe and Wagner. A statue of Gottfried Leibniz, the seventeenth-century philosopher who was born and educated in Leipzig, peered at the throngs from his station at the university, just off the square. On the following Mondays the numbers grew again: 120,000 on October 16, 250,000 on the twenty-third, and an estimated 300,000 on the thirtieth. By early November other East Germans were flocking to Leipzig to join the manifestations.

Three of the leading players in the Leipzig events were the Gewandhaus conductor Kurt Masur, the theologian Peter Zimmermann, and the cabaret artist Bernd-Lutz Lange. But these men of arts and letters, as well as those elsewhere in the German Democratic Republic and Eastern Europe who came to the fore, were marked less by confidence in their cause than by distress at the bankruptcy of the Soviet model of state socialism that had brought economic stagnancy, political corruption, and ecological disaster. They were at best reformers, hardly revolutionaries, thrust into prominence by philosophical and moral rather

than strictly political concerns. "Dialogue" and "No violence" were the slogans they invoked most frequently.

What united the reformers with their forebear, Vincent van Gogh, of a century earlier was their quest for a renewed spirituality, focusing as much on humanism as on Christianity, alongside their need to express themselves in artistic rather than political terms. Only they had moral credibility and dignity in a system where everyone else was compromised. The fact that within the Communist realm, dissidents had been depicted as mentally ill now accorded these outsiders added authority. On November 9 the border dividing the two Germanys was opened. The rallying cry in the East, "*Wir sind das Volk*" (We are the people), quickly turned into "*Wir sind ein Volk*" (We are one people). Within less than a year Germany was united. The events of 1989 represented a victory of spirit over power.[6] Rainer Fetting, Anselm Kiefer, and Vincent van Gogh had helped bring down the Wall. "His story rattles every castle," Meier-Graefe had once said of Van Gogh.

However, the momentous developments of that autumn and winter of 1989, especially the dramatic piercing of the Wall, and the subsequent fall of Communism throughout Eastern Europe marked not the beginning of clarity, as many had hoped, but the end of pretence in the guise of utopianism. The year 1989 marked a caesura in international politics comparable to 1914, as a measure of international balance and stability gave way again to a renewed fluidity and fragility. Nineteen eighty-nine was less culmination than termination. For many it marked the end of history—history as progressive affirmation and understanding. What eventually replaced that affirmation was a new wave of doubt, presented as opportunity. In 1989 theory died. Only the stories remained.

Nineteen eighty-nine saw the story of Vincent van Gogh writ large.

# OUR WEIMAR

*The State Lottery Office*

The Weimar experience used to be considered peculiar to
Germany, a lesson to the rest of the world how not to think,
feel, and live. Weimar was dismissed as a failure—politically
without question, but also culturally, because it, like Van Gogh
and Otto Wacker, lacked moderation. That was certainly the gist
of the early commentary on Weimar. As the twentieth century
unfolded, however, it became apparent that the Weimar experi-
ence, like Van Gogh's and Wacker's, had been but a prelude to the
broader Western story. The disenchantment that overwhelmed
Germany in the wake of the Great War had subsequently spread
to the West as a whole, as had the need to improvise beyond the
confines of inherited ideology and morality. The Weimar aes-
thetic had turned into the Western aesthetic; the Weimar mood
had become our mood. Our own quest for identity and purpose
often echoed that of Weimar.

The architecture of Walter Gropius and Ludwig Mies van der
Rohe, though tempered by the odd perfunctory bow to history
and tradition, remains the international style. It still dominates
the skylines of our urban world. In the home, too, the spare ele-
gance of the Bauhaus, the influential German school for crafts
and fine arts, metamorphosed, as the American novelist Tom
Wolfe would bemoan, into "our house." Margarete Schütte-
Lihotsky's 1926 "Frankfurt Kitchen," ergonomic, efficient, afford-
able, is now our kitchen. Our movies, literature, technology, and
mores connect to Weimar, to its urgency, anxiety, morbidity,
frenzy, and kitsch. The golem haunts and fascinates us; technical
wizardry we love and fear at the same time; our mood swings
between boredom and apocalypticism. Dada, Expressionism,
and Surrealism are permanent fixtures of our imagination. All

the while our need for sentimentality never wanes. In 1927 Ilya Ehrenburg counted twenty-two films with *Love* in their title, and three years later in *The Blue Angel* Marlene Dietrich sang, "Ich bin von Kopf bis Fuss auf Liebe eingestellt" (Falling in Love Again). While Grace Slick of Jefferson Airplane would lament, "When the truth is found to be lies, and all the joy within you dies," John Lennon and the rest of us would affirm, "All you need is love."

Albert Einstein, despite his association with ultimate destruction, became our favourite scientist; Paul Tillich, our favourite theologian. Our sociology bears the indelible imprint of Max Weber, our philosophy that of Martin Heidegger. The intense ambiguity of this intellectual contribution emerging from Weimar Germany—its deconstructive essence—would be evoked brilliantly by Michael Frayn in his play *Copenhagen*, where he focused on the contribution of the physicist Werner Heisenberg and his 1927 theory of uncertainty. In the final lines of the play Frayn has Heisenberg speculate that our very survival is predicated on the victory of uncertainty—"that final core of uncertainty at the heart of things."

A former world, with its cosmic implications—call it Newtonian, Victorian, or simply "enlightened"—had exploded in fragments in the wake of the Great War. Nowhere was this more evident than in Weimar. Siegfried Kracauer was emblematic of this shift in focus. He had ascribed meaning to the quotidian and the insignificant. The life of the street became for him the street of life. Bertolt Brecht and Kurt Weill articulated the same theme in their *Threepenny Opera*. But the post-1945 Western world, caught up in its own ironies, looked repeatedly for inspiration to the everflowing fount of Weimar. In 1959 Bobby Darin turned "Mack the Knife," from *The Threepenny Opera*, into a huge hit. When Bob Dylan intoned, "The times they are a-changin'," he was quoting

Bertolt Brecht's lyrics for Hanns Eisler's music. The rock band Steppenwolf, formed in 1967, was named after Hermann Hesse's novel about the mysterious Weimar outsider of the same name. The group—its vocalist John Kay was born in East Prussia—had hits like "Born to Be Wild," "Renegade," and "The Pusher." The enormous success of the stage and film adaptations of Christopher Isherwood's Berlin stories—first John van Druten's 1951 stage adaptation *I Am a Camera,* and then the 1972 Academy Award–winning film *Cabaret*—reflected our affinity to interwar Germany.

The world of Johnny Rotten, Sid Vicious, and the Sex Pistols in the 1970s was in fact intimately connected to that of Valeska Gert, Isherwood's Sally Bowles, and Berlin cabaret. "*Cabaret* was such a big influence then," a London punk rocker by the name of "Berlin" told the author Jon Savage, referring to the Hollywood version of Isherwood's tale. "It was a very strong image, that Weimar thing." Joel Grey, who played the cabaret emcee with panache, had left a lasting impression on "Berlin": "That was how my dress developed. I'd wear nothing but a white shirt, black tie, cropped black hair, black tights, imitation leather, a black jumper, and this fabulously high pair of black boots. . . . We'd go to Chaugeramas, a dingy dive where the worst transvestites went and all these businessmen. There was the Masquerade in Earls Court, there was Rob's . . . very chic. There was the Sombrero. I can't tell you the parallels between those days and *Goodbye to Berlin*. We were living it out, the whole bit."[1] Weimar Berlin had been resurrected in London. Youthful prank or not, in jest or in earnest, a member of the British royal family would later appear at a social event in Nazi regalia.

The aesthetic response of the West to the Second World War, to the second act of the horror show, was to reveal little original-ity. Whether we are talking about Abstract Expressionism, the Theatre of the Absurd, the Beat generation, or the spaced-out

flower children of Haight-Ashbury and Carnaby Street, it had all been done before. John Cage's 4' 33" virtuoso performance of musical silence—where he sat at a closed keyboard, hands raised at the ready, for four minutes and thirty-three seconds—was but a variation on the language of silence that Kafka and Döblin had specialized in. When Jim Dine drew an automobile, erased it, and then started over again, he was echoing Dada performance. Like Louis Napoleon's attempt to emulate his great-uncle, the post-1945 version of modernism was to be less a repeat than a copy of history.

Weimar had deprived Germany of its gods. The sense of loss was profound. We too have dispatched our gods and replaced them with celebrities. As in Weimar, biography is far more interesting to us than history, and art, education, and entertainment have fused. We want our children to be stars—idols, in fact—and our children play-act their stardom. Do they pretend they are politicians, generals, attorneys? Hardly. They want to be artists and actors. Students flock to film studies and drama programs in secondary school and university because they see them as stepping stones less to an understanding of the human predicament than to fame—to celebrity. The marquee, the red carpet, the camera flash are what bedazzle, not the pulpit or the bar.

When students rioted in Chicago in 1968 their demands included the abolition of money and the acknowledgement that every human being is an artist. Such is the legacy of Weimar. And such is the legacy of Vincent van Gogh.

# MANIA

*The White Orchard*

G ustav Klimt's portrait of Adele Bloch-Bauer sold for US$135 million in June 2006. Picasso's *Nude, Green Leaves and Bust* fetched US$106.5 million in May 2010. But the record for the twentieth century belongs to Van Gogh's *Portrait of Dr. Gachet,* which sold in May 1990 for $82.5 million. Before that, the bar had been set by his *Irises* ($53.9 million, in November 1987) and by a version of the *Sunflowers* ($39.9 million, in March 1987). While at the beginning of the new century, the twenty-first, the British art world was voting Marcel Duchamp's mischievously modified urinal, *Fountain,* the most influential artwork of the previous hundred years, it was Van Gogh's work that had fetched the highest prices and elicited the most affection.

Whenever, and wherever, a Van Gogh exhibition is held, it breaks attendance records. In the Netherlands the Van Gogh Museum is the central tourist attraction of the land—it outdoes the Rijksmuseum with its Rembrandts, the Anne Frank Museum, even the red-light district and the marijuana cafés. The sparsely furnished room in the Auberge Ravoux in Auvers, where Van Gogh died, attracts some seventy thousand pilgrims a year. Some of these visitors scatter family ashes over Vincent's grave, a short walk away. In poster art Van Gogh tops all the bestseller lists year after year. In 2006 four of his paintings dominated the top-ten list for poster sales in the United States, *Starry Night* and *Café Terrace at Night* heading the list.[1] One prominent critic has estimated that if one of the major Van Gogh sunflower paintings were to come on the market, it would fetch around $200 million.[2]

But it is not just Van Gogh's art that is of interest. His influence as a personality has become ubiquitous. Don McLean, the popular singer, is remembered basically for two songs: one,

"American Pie," the other, "Vincent" (or "Starry Starry Night," as it is also known). In an interview in 2005, McLean, who turned sixty that October, said of "American Pie," the number-one hit of 1971, whose lyrics ("Drove my Chevy to the levee") were always puzzling: "When I'm asked what the lyrics mean I simply say they mean that I don't have to work anymore unless I want to. What isn't realized," he continued, "is that 'Vincent,' a tribute to Van Gogh, was actually a bigger hit than 'American Pie.'"

The biographies, novels, plays, and musicals—even an opera—pour forth, and the films have come in a steady stream. Trevor Howard, Herbert Wilcox, Jean Renoir, Giuseppe Amato, Kirk Douglas, Vincente Minnelli, Akira Kurosawa, Alain Resnais, Paul Cox, and Robert Altman have been attracted to Van Gogh as a subject. No other artist has had as many feature films made about him. Irving Stone's *Lust for Life* remains in print, more than seventy years after its first appearance. Banks, streets, ships, computer hardware, and even oilfields have been named after Van Gogh. A brand of vodka and gin has taken his name. A recipe for a drink called "Starry Night" begins with the instructions, "Coat rim of martini glass with honey. Dip in chocolate cookie crumbs. In ice-filled shaker, combine vodka (such as Van Gogh Dutch Chocolate), absinthe and simple syrup. Shake thoroughly . . ."

Artists and troubadours have identified with him. A Serbian rock band appropriated his name. The singer, songwriter, and would-be visual artist Joni Mitchell painted her own portrait in the guise of Van Gogh, suggesting that she, too, had captured her pain in her art, for our sake. Art, in this view, becomes salvation, and the artist a martyr for the cause. The gruesome murder of the filmmaker Theo van Gogh (great-grandson of Vincent's brother Theo) by a Muslim extremist in Amsterdam in 2004 received enormous play in the international press. Both Van Goghs evoke images of martyrdom. Both, some were inclined to argue, died for

their art and for us. In one image affixed to a wall near the Amsterdam murder scene, the *T* in Theo was rendered as a cross. In short, Vincent—a loner and misfit during his own life—is everywhere now. Inescapable. And art? It will set us free.

As the popularity of Van Gogh grew in the latter half of the twentieth century, more and more supposedly lost Van Goghs were rediscovered. Most of them related to the cache of Van Gogh's early work that his mother had put into storage when she moved house in 1886 after the death of her husband. Otto Wacker's lawyer made reference to this lost art in his arguments for the defence in 1932. All the newly found work was of poor quality and, in contrast to the Wacker case, none of it managed to sway the experts.[3]

In the 1990s the question of authenticity took a different turn. Instead of new work appearing, previously unquestioned works were suddenly put in the spotlight, most famously the version of *Sunflowers* purchased in March 1987 by the Japanese insurance firm Yasuda for $39.9 million. Even the Musée d'Orsay's *Portrait of Dr. Gachet*, the second version of Gachet, has since been questioned. In recent years some thirty-eight pictures have been removed from display in various museums and galleries because their attribution to Van Gogh is questionable. The British critic Martin Bailey has claimed that prominent curators are now prepared to admit that somewhere between one hundred and two hundred formerly accepted Van Goghs may be fakes.[4] The Van Gogh Museum in Amsterdam has responded by undertaking the preparation of a new catalogue raisonné and by participating diligently in the development of new scientific methods of verification.

The 1980s witnessed a series of exhibitions devoted to stages of Van Gogh's creativity, his stays in Paris, Arles, Saint-Rémy, and Auvers. The hundredth anniversary of his death brought special

exhibition events in Amsterdam and Otterlo and rituals of pilgrimage at Auvers.[5] The scholarship, which seemed to mount from a trickle to a flood tide, was in turn intent on elucidating particulars and separating individual works from earlier broader interpretations, the "myths" surrounding Van Gogh. The general public was of course not especially interested in the particulars or the scholarship. It continued, however, to flock to the exhibitions, be they in Arles to celebrate the centenary of Van Gogh's stay in the city or in Los Angeles a decade later. *Blockbuster,* as both noun and adjective, now seemed to go hand in hand with *Van Gogh.* A headline in the *Los Angeles Times,* in its issue of May 16, 1999, read, "Night and Day. Van Gogh is the one this weekend. In what the [Los Angeles County] museum calls an unprecedented event, the exhibit is open round-the-clock for its final days. Even experts are unable to explain why the artist has such amazing appeal."

Van Gogh is ours. We are Van Gogh. We have consumed and subsumed his reality, above all his creative wonder and bewilderment. But we are also his equally enigmatic other, Otto Wacker, the poseur and facilitator. As we copy and digitize *sans cesse,* as our technology of reproduction obliterates any sense of permanence and constancy, the fraudster merges with the artist, and in the process all chance of authenticity may be lost.

# EPILOGUE

*Memory of the Garden at Etten*

In June 2009 the journalist Margot Cohen, of the *Wall Street Journal*, interviewed the Indonesian actor-comedian Butet Kartaredjasa, well known in his homeland for his audacious spoofs on authority and also for his extensive art collection. The latter consists largely of Indonesian work.

"Have you collected any works by foreign artists?" Cohen asks.

"Van Gogh!" the comedian replies, pointing to a copy of *Memory of the Garden at Etten*. "This is from Canada, where they have a technology of reproduction that I admire very much. Look at these strokes, the texture. If I have any businessmen friends who come over, I put it on the wall to impress them."

"Two years ago," he continues, "the painting was displayed at a local gallery as part of a show of works owned by various collectors. All of Yogya[karta] was amazed—'Wow, Butet owns a Van Gogh!'"[1]

# NOTES

### THE ISSUE

1. In Letter 515, to his brother Theo, from c. July 14, 1885, to be found in the recent six-volume edition *Vincent van Gogh: The Letters,* ed. Leo Jansen, Hans Luijten, and Nienke Bakker (New York: Thames and Hudson, 2009), available also at www.vangoghletters.org in both the original and in translation. Subsequent references to the Letters will provide an individual number, which can then be used to readily locate the appropriate letter at the website.

### VISION

1. Invitation to the exhibition, March 11, 1928, in the Olinto Lovaël file, Deutsches Tanzarchiv, Cologne. Olinto Lovaël was Wacker's stage name.

### SKY AGLOW

1. Klaus Fiedler, "Hans Wacker: Dem Geheimnis auf der Spur?" *Weltkunst* 9 (September 15, 2003), 1294–95. Also the assessment of Ludwig Thormaehlen, August 26, 1929, I/NG 723, Zentralarchiv Staatliche Museen zu Berlin (hereafter ZStM).
2. This material and much of what follows is a result of the diligence of Dr. Elisabeth Scheeben of the city archive, Stadtarchiv, Düsseldorf. The Stadtarchiv holds microfilmed records of the city's *Einwohnermeldekartei* or registration catalogue. Mussia Eisenstadt, "Bericht über den Prozess Wacker," *Kunst und Künstler* 31 (1932), 166–74, contains useful biographical detail.
3. In Michael Hofmann's introduction to Joseph Roth, *What I Saw: Reports from Berlin, 1920–1933,* trans. Michael Hofmann (New York: W.W. Norton, 2003), 18.

### SUN ON SUNS

1. G.-Albert Aurier, "Les Isolés: Vincent van Gogh," *Mercure de France,* January 1890: 24–29; reprinted and translated in Ronald Pickvance, *Van Gogh in Saint-Rémy*

*and Auvers* (New York: The Metropolitan Museum of Art and Harry N. Abrams, 1986), Appendix III.

2. The *Mercure de France* became the literary organ of French Symbolism and continued publication until 1965. On Aurier's interpretation of Van Gogh, see Patricia Mathews, "Aurier and Van Gogh: Criticism and Response," *Art Bulletin* 68, no. 1 (March 1986): 94–104.

3. Paul Gauguin, "Avant et après," *Mercure de France,* October 1903; reprinted in translation in Susan Alyson Stein, ed., *Van Gogh: A Retrospective* (New York: Park Lane, 1986), 123–28.

4. Louis Piérard, "Van Gogh au pays noir," *Mercure de France,* July 1913, in Jan Hulsker, *Vincent and Theo van Gogh: A Dual Biography,* ed. James M. Miller (Ann Arbor: Fuller, 1990), xi. Piérard's life of Van Gogh would appear in France in 1924 and in English translation the following year: *The Tragic Life of Vincent van Gogh,* trans. Herbert Garland (London: Castle, 1925), 1.

5. "L'Oeuvre de van Gogh c'est la Passion du Soleil." M.-A. Leblond, *Peintres de race,* in Jacob-Baart de la Faille, *L'Époque française de van Gogh* (Paris: Bernheim-Jeune, 1927), 29.

6. Antonin Artaud, *Van Gogh le suicidé de la société* (Paris: Gallimard, 1990), 7.

7. Letter 155, to Theo, from late June 1880.

8. Hulsker, *Vincent and Theo,* 24.

9. March 2, 1878, in Hulsker, *Vincent and Theo,* 59–60.

10. Letter 193, to Theo, on or about December 23, 1881.

11. On Theo and his work, see Richard Thomson, "Theo van Gogh: An Honest Broker," in Chris Stolwijk and Richard Thomson, *Theo van Gogh, 1857–1891: Art Dealer, Collector, and Brother of Vincent* (Amsterdam: Van Gogh Museum, 1999), 61–148; and John Rewald, "Theo van Gogh as Art Dealer," in *Studies in Post-Impressionism* (London: Thames and Hudson, 1986), 7–115.

12. Theo van Gogh to his mother, c. July 1886, Van Gogh Museum, b942V/1962.

13. On his relationships with other painters: Cornelia Homburg, "Vincent van Gogh and the Avant-Garde: Colleagues, Competitors, Friends," in Chris Stolwijk et al., *Van Gogh's Imaginary Museum: Exploring the Artist's Inner World* (Amsterdam: Van Gogh Museum, 2003), 113–22. Letter 569, to Horace Mann Livens, September or October 1886.

14. Hulsker, *Vincent and Theo,* 246.

15. Letters 635, to Theo, July 1, 1888, and 637, to Theo, July 8 or 9, 1888.

16. Letter 678, to Willemien van Gogh, about September 9 and 14, 1888.

17. Letter 676, to Theo, September 8, 1888.

18. Letter 635, to Theo, July 1, 1888.

19. Letter 752, to Theo, March 24, 1889.

20. Letter 650, to Theo, July 29, 1888.

21. Letter 665, to Émile Bernard, August 21, 1888.

22. Letter 631, to Theo, June 25, 1888.

23. Letter 678, to Willemien van Gogh, about September 9 and 14, 1888.

24. Martin Gayford, *The Yellow House: Van Gogh, Gauguin and Nine Turbulent Weeks in Arles* (London: Penguin, 2006), 15–16.

25. Letter 694, to Theo, October 3, 1888.

26. Roland Dorn, *Décoration: Vincent van Goghs Werkreihe für das Gelbe Haus in Arles* (Hildesheim: Olms, 1990).

27. Letter 724, to Theo, about December 11, 1888.

28. Victor Merlhès, ed., *Correspondance de Paul Gauguin* (Paris: Fondation Singer-Polignac, 1984), 284. Also Debora Silverman, *Van Gogh and Gauguin: The Search for Sacred Art* (New York: Farrar, Straus and Giroux, 2000), 223–64; and Douglas W. Druick and Peter Kort Zegers, *Van Gogh and Gauguin: The Studio of the South* (Chicago: The Art Institute; Amsterdam: Van Gogh Museum, 2001–2002).

29. The recent suggestion by Hans Kaufmann and Rita Wildegans that it was Gauguin who actually severed Van Gogh's ear is based on scant evidence; see their *Van Goghs Ohr: Paul Gauguin und der Pakt des Schweigens* (Berlin: Osburg, 2008). Martin Bailey's theory that news of Theo's engagement provoked the self-mutilation is also speculative; see his "Why Van Gogh Cut His Ear: New Clue," *Art Newspaper* 209, January 2010.

30. Albert J. Lubin, *Stranger on the Earth: A Psychological Biography of Vincent van Gogh* (New York: Holt, Rinehart and Winston, 1972), chapter 9; and Gayford, *Yellow House,* 337.

31. Hulsker, *Vincent and Theo,* 330.

32. Gayford, *Yellow House,* 10.

33. Alfred Nemeczek, *Van Gogh in Arles* (Munich: Prestel, 1995), 105.

34. Some thirty different diagnoses have been made, ranging from lead poisoning to neurosyphilis. See Dietrich Blumer, "The Illness of Vincent van Gogh," *The American Journal of Psychiatry* 159, no. 4 (April 2002): 519–26. Also, Erwin van Meekeren, *Starry Starry Night: Life and Psychiatric History of Vincent van Gogh* (Amsterdam: Benecke N.I., 2003). Most recently the Harvard neurologist Alice Flaherty has suggested that Van Gogh suffered from temporal lobe epilepsy, a condition that can lead to prodigious creativity: Juliet Rix, "Painting? I Can't Turn It Off," *Times* (London), July 14, 2007.

35. Letter 875, to Theo and Johanna van Gogh-Bonger, May 25, 1890.

36. Letter 898, to Theo and Johanna van Gogh-Bonger, July 10, 1890.

37. Letter, July 31, 1890, in Ronald Pickvance, ed., *"A Great Artist Is Dead": Letters of Condolence on Vincent van Gogh's Death* (Zwolle: Waanders, 1992), 33. Technically Van Gogh died on Tuesday, July 29, at 1:30 a.m.

38. Hulsker, *Vincent and Theo*, 447.

39. Hulsker, *Vincent and Theo*, 456.

### SPRING

1. Théodore Duret, *Vincent van Gogh* (Paris: Bernheim-Jeune, 1919), 45.

2. Stefan Koldehoff argues in his works *Vincent van Gogh: Mythos und Wirklichkeit* (Cologne: Dumont, 2003) and *Meier-Graefes van Gogh* (Nördlingen: Steinmeier, 2002) that the assertion that Van Gogh sold but one painting in his lifetime was one of many myths surrounding the artist, yet his evidence for any other formal sale remains slight. Martin Bailey speculates that Anna Boch bought a second Van Gogh, *Peach Blossom in the Crau* (F 514), shortly after the artist's death: *Van Gogh and Britain: Pioneer Collectors* (Edinburgh: National Galleries of Scotland, 2006), 18.

3. Robert Jensen, *Marketing Modernism in Fin-de-Siècle Europe* (Princeton: Princeton University Press, 1994); Robin Lenman, *Die Kunst, die Macht und das Geld: Zur Kulturgeschichte des kaiserlichen Deutschland 1871–1914* (Frankfurt: Campus, 1994); and also his essay "From 'Brown Sauce' to 'Plein Air': Taste and the Art Market in Germany," in Françoise Forster-Hahn, ed., *Imagining Modern German Culture: 1889–1910* (Washington: National Gallery of Art, 1996), 53–69.

4. Jensen, *Marketing Modernism*, 45–46.

5. Roland Dorn, "The Artistic Reception of Vincent van Gogh's Work," in Georg-W. Költzsch and Ronald de Leeuw, eds., *Vincent van Gogh and the Modern Movement 1890–1914*, trans. Eileen Martin (Freren: Luca-Verlag, 1990), 189.

6. On Van Gogh's fear of success, see Lubin, *Stranger on the Earth*, 237–39.

7. Patricia Mathews, "Aurier and Van Gogh: Criticism and Response," *Art Bulletin*, 68, no. 1 (March 1986): 94.

8. Fred Leeman, "Van Gogh's Posthumous Rise to Fame in the Low Countries—Holland and Belgium," in Georg-W. Költzsch and Ronald de Leeuw, eds., *Vincent van Gogh and the Modern Movement, 1890–1914*, trans. Eileen Martin (Freren: Luca-Verlag, 1990), 207–24. Also, Chris Stolwijk and Han Veenenbos, *The Account Book of Theo van Gogh and Jo van Gogh-Bonger* (Amsterdam: Van Gogh Museum, 2002). Julius Meier-Graefe estimated the Van Gogh oeuvre at some 600 paintings and 350 to 400 drawings, *Entwicklungsgeschichte der modernen Kunst*, I (Stuttgart: Hoffmann, 1904), 119.

9. V.W. van Gogh, "Memoir of J. van Gogh-Bonger," *The Complete Letters of Vincent Van Gogh*, 3 vols. (Boston: Little, Brown, 1958), I: lx, lxii.

10. Cynthia Saltzman, *Portrait of Dr. Gachet: The Story of a van Gogh Masterpiece, Modernism, Money, Politics, Collectors, Dealers, Taste, Greed, and Loss* (New York: Viking, 1998), 58; Carol M. Zemel, *The Formation of a Legend: Van Gogh Criticism 1890–1920* (Ann Arbor: UMI Research Press, 1980), 25.

11. Saltzman, *Gachet*, 65.

12. Leeman, "Van Gogh's Posthumous Rise," 219.

13. Rebecca Rabinow, *Cézanne to Picasso: Ambroise Vollard, Patron of the Avant-Garde* (New York: Metropolitan Museum of Modern Art, 2006).

### DEALER

1. *Vincent van Gogh* (Paris: Bernheim-Jeune, 1919), 101.

2. Lenman, "From 'Brown Sauce' to 'Plein Air,'" 64.

3. Julius Meier-Graefe, "Gegen die Kunstansprüche der Entente," undated manuscript, Nachlass Meier-Graefe, 94.190.16, Deutsches Literaturarchiv Marbach (hereafter DLA).

4. Hugo von Hofmannsthal, *Briefe eines Zurückgekehrten*, in *Gesammelte Werke in Einzelausgaben.Prosa II* (Frankfurt, 1951), 349. See also Hofmannsthal's essay "Die Farben," reprinted in Douglas Cooper, ed., *Zeichnungen und Aquarelle von Vincent van Gogh* (Basel: Holbein-Verlag, 1954).

5. Chris Stolwijk, *The Account Book of Theo van Gogh and Jo van Gogh-Bonger* (Amsterdam: Van Gogh Museum, 2002), 28.

6. Walter Feilchenfeldt, *Vincent van Gogh & Paul Cassirer, Berlin: The Reception of van Gogh in Germany from 1901 to 1914* (Amsterdam: Rijksmuseum Vincent van Gogh, 1988); Magdalena M. Moeller, "Van Gogh and Germany," in Georg-W. Költzsch and Ronald de Leeuw, eds., *Vincent van Gogh and the Modern Movement 1890–1914*, trans. Eileen Martin (Freren: Luca-Verlag, 1990): 312–408; Walter Feilchenfeldt, "Vincent van Gogh: His Collectors and Dealers," in ibid., 39–46; Ron Manheim, "The 'Germanic' van Gogh: A Case Study of Cultural Annexation," *Simiolus* 19, no. 4 (1989): 277–88.

7. Heinrich Mann, "Tilla Durieux," *Zeit und Bild* 2, no. 17 (April 23, 1913); and Alfred Döblin, "Der Schatten ohne Esel," March 14, 1923, in Alfred Döblin, *Ein Kerl muss eine Meinung haben: Berichte und Kritiken 1921–1924* (Olten: Walter-Verlag, 1976), 163.

8. Wilko von Abercron, *Eugen Spiro (1874 Breslau—1972 New York): Spiegel seines Jahrhunderts* (Alsbach: Drachen Verlag, 1990). On Breslau's social and religious complexion, Till van Rahden, *Juden und andere Breslauer: Die Beziehungen zwischen Juden, Protestanten und Katholiken in einer deutschen Großstadt von 1860 bis 1925* (Göttingen: Vandenhoeck & Ruprecht, 2000).

9. Tilla Durieux, *Meine ersten neunzig Jahre* (Munich: Herbig, 1971), 78.

10. Georg Brühl, *Die Cassirers: Streiter für den Impressionismus* (Leipzig: Edition Leipzig, 1991).

11. Ernst Barlach, *Ein selbsterzähltes Leben* (Munich: Piper, 1948), 43.

12. Durieux, *Meine ersten neunzig Jahre*, 128.

13. Ibid., 127–28.

14. Ibid., 134–36. Also, the useful study by Christian Kennert, *Paul Cassirer und sein Kreis: Ein Berliner Wegbereiter der Moderne* (Frankfurt: Lang, 1996), 64–66.

AESTHETE

1. In Burkhard Stenzel, "'. . . eine Verzauberung ins Helle und Heitere.' Harry Graf Kesslers Ideen zur Kulturerneuerung in Deutschland," in Wolfgang Bialas and Burkhard Stenzel, eds., *Die Weimarer Republik zwischen Metropole und Provinz* (Weimar: Böhlau, 1996), 30; also Laird McLeod Easton, *The Red Count: The Life and Times of Harry Kessler* (Berkeley: University of California Press, 2002).

2. Harry Graf Kessler, *Gesichter und Zeiten: Erinnerungen* (Berlin: S. Fischer, 1962), 38.

3. Letters from André Gide, December 1, 1903, and from Gordon Craig, July 13, 1904, Nachlass Kessler, DLA.

4. Harry Graf Kessler, *Künstler und Nationen: Aufsätze und Reden 1899–1933* (GS, Bd. 2), 297.

5. Joseph Chytry, *The Aesthetic State: A Quest in Modern German Thought* (Berkeley: University of California Press, 1989).

6. Letter to Maximilian Harden, May 23, 1909, Nachlass Kessler, DLA. On the kaiser's response to Kessler, Stenzel, "Verzauberung," 41.

SCRIBBLER

1. Diary, December 6, 1894, Harry Graf Kessler, *Das Tagebuch, Zweiter Band 1892–1897*, ed. Günter Riederer and Jörg Schuster (Stuttgart: Klett-Cotta, 2004), 300; as well as entries for March 15 and November 1, 1894, 251–52, 291.

2. Sybille Bedford, *Aldous Huxley: A Biography* (New York: Knopf, 1974), 258.

3. Gabriele Tergit, "Expertendämmerung," *Die Weltbühne* 28, no. 1 (1932): 598.

4. See Meier-Graefe's appreciation of Julius Levin in the *Frankfurter Zeitung*, January 28, 1932. The best critical treatment of Meier-Graefe is by Kenworth Moffett, *Meier-Graefe as Art Critic* (Munich: Prestel, 1973).

5. "Die Kunst nach dem Kriege," manuscript, Nachlass Meier-Graefe 94.190.21, DLA.

6. Julius Meier-Graefe, *Vincent*, 2 vols. (Munich: R. Piper, n.d. [1921]), I: 85.

7. Hugo von Hofmannsthal, *Briefwechsel mit Julius Meier-Graefe, 1905–1929*, ed. Ursula Renner (Freiburg: Rombach, 1998), 9.

8. Emil Schaeffer, "Bücher-Besprechungen," *Kunst und Künstler* 8 (1909–10): 271–73.

9. Julius Meier-Graefe, "Beiträge zu einer modernen Aesthetik," *Die Insel* 1 (May 1900), 206–12.

10. Julius Meier-Graefe, *Modern Art: Being a Contribution to a New System of Aesthetics,* trans. Florence Simmonds and George W. Chrystal, vol. 1 (London: Heinemann; New York: Putnam's Sons, 1908), 204.

11. Julius Meier-Graefe, *Vincent van Gogh* (Munich: R. Piper, 1910), 31–32, 77.

12. Meier-Graefe, *Modern Art,* 211.

13. Stefan Koldehoff, *Meier-Graefes van Gogh: Wie Fiktionen zu Fakten werden* (Nördlingen: Steinmeier, 2002), 9–10. Julius Meier-Graefe, *Kunst ist nicht für Kunstgeschichte da: Briefe und Dokumente,* ed. Catherine Krahmer (Göttingen: Wallstein Verlag, 2001), 337. Christian Lenz, "Julius Meier-Graefe and His Relation to Van Gogh," in *Vincent van Gogh and the Modern Movement, 1890–1914,* ed. Georg-W. Költzsch and Ronald de Leeuw (Freren: Luca-Verlag, 1990), 47–59.

14. "In Praise of Cézanne," *Burlington Magazine* 52 (February 1928): 98–99, in Jensen, *Marketing Modernism,* 239–40.

15. Julius Meier-Graefe, "Die van Gogh-Ausstellung," *Berliner Tageblatt,* June 12, 1914.

MADAM

1. Sam van Deventer, *Kröller-Müller: De Geschiedenis van een cultureel levenswerk* (Arnhem: J.S.R. van Deventer, 2004), 21–22, 116, and passim; Piet de Jonge, *Helene Kröller-Müller: Een Biografische Schets* (Otterlo: Kröller-Müller Museum, 2004), 45–49; and Hildelies Balk, *De Kunstpaus—H.P. Bremmer 1871–1956* (Bussum: Uitgeverij Thoth, 2006).

2. *Vincent van Gogh: Inleidende beschouwingen* (Amsterdam: W. Versluys, 1911), 1.

3. Ibid. Nicole Roepers, "De Strijd der Deskundigen: H.P. Bremmer en het Wackerproces," *Jong Holland* 2 (1993), 27.

4. The exact numbers vary. Sam van Deventer, *Kröller-Müller,* 108, lists specific numbers, as does the Kröller-Müller Museum's website. The discrepancies reflect the ongoing debate about authenticity.

SPIRIT

1. Henry van de Velde, *Geschichte meines Lebens* (Munich: Piper, 1962).

2. Roy Pascal, *From Naturalism to Expressionism: German Literature and Society 1880–1918* (London: Weidenfeld and Nicolson, 1973), 63; Mary Gluck, "Interpreting Primitivism, Mass Culture and Modernism: The Making of Wilhelm Worringer's Abraction and Empathy," *New German Critique,* no. 80 (Spring–Summer, 2000), 149–69; and Karl Ludwig Schneider, *Zerbrochene Formen: Wort und Bild im Expressionismus* (Hamburg: Hoffmann und Campe, 1967).

3. Friedrich Nietzsche, *The Will to Power* (London: Weidenfeld and Nicolson, 1967), 301.

4. Feilchenfeldt, "Vincent van Gogh: His Collectors and Dealers," 67.

5. Alexej von Jawlensky, "Memoir dictated to Lisa Kümmel, 1937," in Maria Jawlensky et al., *Alexej von Jawlensky: Catalogue Raisonné of the Oil Paintings*, vol. I, *Portraits 1890–1914* (London, 1991), 31.

6. Moeller, "Van Gogh and Germany," 320–21.

7. Ibid., 397. Also, Lovis Corinth, *Das Leben Walter Leistikows: Ein Stück Berliner Kulturgeschichte* (Berlin: Paul Cassirer Verlag, 1910), 55–56.

8. Robin Lenman, *Artists and Society in Germany, 1850–1914* (Manchester: Manchester University Press, 1997), 99.

9. Joseph Masheck, *Modernities: Art-Matters in the Present* (University Park, Pa.: Pennsylvania State University Press, 1993), 155–92.

10. Harry Graf Kessler, "Erlebnis mit Nietzsche," *Die neue Rundschau* 46, no. 1 (1935): 391–407; also Kessler, *Gesichter und Zeiten*, 209; and Burkhard Stenzel, *Harry Graf Kessler: Ein Leben zwischen Kultur und Politik* (Weimar, Cologne, Vienna: Böhlau Verlag, 1995), 40–41. Aldo Venurelli, "Die Enttäuschung der Macht. Zu Kesslers Nietzsche-Bild," in Gerhard Neumann and Günter Schnitzler, eds., *Harry Graf Kessler: Ein Wegbereiter der Moderne* (Freiburg: Rombach), 109–33.

11. Kessler, *Tagebücher*, May 17, 1893; in Bialas and Stenzel, *Weimarer Republik*, 40.

12. "Nietzsche," *Times Literary Supplement* 410 (November 18, 1909): 433–34; Rupert Brooke, "Democracy and the Arts," in *The Prose of Rupert Brooke*, ed. Christopher Hassall (London: Sidgwick and Jackson, 1956), 79; Kennert, *Cassirer*, 157.

13. Friedrich Nietzsche, *The Birth of Tragedy*, trans. Francis Golffing (New York: Anchor, 1956), II; Artaud, *Van Gogh*, 7.

14. Schneider, *Zerbrochene Formen*, 29.

15. Karl Jaspers, *Strindberg and van Gogh*, trans. Oskar Grunow and David Woloshin (Tucson: University of Arizona Press, 1977 [orig. 1922]), 203.

16. *Ein Protest deutscher Künstler* (Jena, 1911).

17. *Ausstellung Vincent van Gogh 1853–1890*, intro. E. Loeschmann (Dresden and Breslau: Galerie Ernst Arnold, 1912), 4.

18. Julius Meier-Graefe, "Handel und Händler," *Kunst und Künstler* 11 (1912–13): 196–210; Koldehoff, *Meier-Graefes van Gogh*, 56–57; Josef Kern, *Impressionismus im Wilhelminischen Deutschland* (Würzburg, 1989), 90ff; Lawrence Jeppson estimated that a Van Gogh worth $20 in 1890 was worth $15,000 by 1925: *The Fabulous Frauds: Fascinating Tales of Great Art Forgeries* (New York: Weybright and Talley, 1970), 82.

19. Feilchenfeldt, "Vincent van Gogh: His Collectors and Dealers," 40.

20. Ibid., 41.

STORM

1. Stefan Zweig, *The World of Yesterday: An Autobiography* (Lincoln: University of Nebraska Press, 1964), 223.

2. Diary, August 3, 1914, Ernst Barlach, *Güstrower Tagebuch 1914–1917* (Munich: Piper, 1981), 12.

3. Letter to Frau von Bodenhausen, November 25, 1914, Kessler, *Krieg und Zusammenbruch 1914/1918: Aus Feldpostbriefen von Harry Graf Kessler* (Weimar: Cranach-Presse, 1921), 21; Kennert, *Cassirer,* 126–27.

4. Richard Dehmel, *Zwischen Volk und Menschheit: Kriegstagebuch* (Berlin: S. Fischer, 1919), 9–13, 24. The artist Fritz Burger evoked the *Feuerzauber des Krieges*—the fiery magic of war: in Hansdieter Erbsmehl, "Der Erste Weltkrieg: Erwartung—Realität—Reaktion," in Patricia Rochard, ed., *Der Traum einer Neuen Welt: Berlin 1910–1933* (Mainz: Verlag Philipp von Zabern, 1989), 58.

5. Karen Monson, *Alban Berg* (Boston: Houghton Mifflin, 1979), 131. Similarly, when Aldous Huxley's house in the Hollywood Hills burned in 1961 during a brush fire, incinerating his archives, he remarked that the catastrophe had made him feel "extraordinarily clean." In Peter Conrad, *Modern Times, Modern Places* (New York: Knopf, 1999), 513.

6. Ernst Troeltsch, "Über die Maßstäbe zur Beurteilung historischer Dinge," *Historische Zeitschrift* 116 (1916): 1–47, esp. 46. Wilfred Owen in his poem "1914."

7. Geert Buelens, "Reciting Shells: Dada and, Dada in & Dadaists on the First World War," *Arcadia* 41, no. 2 (2006): 281.

8. Karl Scheffler, *Was will das werden? Ein Tagebuch im Kriege* (Leipzig, 1917), 16, 113–14, 201; Kennert, *Cassirer,* 219; Karl Scheffler, "Der Krieg," *Kunst und Künstler* 13 (1914–15): 1–4.

9. Dehmel, *Zwischen Volk und Menschheit,* 9–13.

10. See, for example, his diary entries for June and July 1895, Harry Graf Kessler, *Das Tagebuch, Zweiter Band 1892–1897,* ed. Günter Riederer and Jörg Schuster (Stuttgart: Klett-Cotta, 2004), 372–88.

11. Letter of August 23, 1914, Kessler, *Krieg und Zusammenbruch,* 5; Kennert, *Cassirer,* 126; Easton, *Red Count,* 222–23.

PHANTASMS

1. Hansdieter Erbsmehl, "Der Erste Weltkrieg: Erwartung—Realität—Reaktion," in Patricia Rochard, ed., *Der Traum einer Neuen Welt,* 58–59.

2. "Totentanz," *Kunst und Künstler* 13 (1915): 225; reprinted in *Karl Scheffler: Eine Auswahl seiner Essays aus Kunst und Leben, 1905–1950,* ed. Carl Georg Heise and Johannes Langner (Hamburg: Hauswedell, 1969), 84–85.

3. Hans Arp, *On My Way: Poetry and Essays, 1912–1947,* trans. Ralph Manheim (New York: Wittenborn, Schultz, 1948), 48; Tom Sandqvist, *Dada East: The Romanians of Cabaret Voltaire* (Cambridge, Ma.: MIT Press, 2005).

4. Tristan Tzara, "Memoirs of Dadaism," in Edmund Wilson, *Axel's Castle: A Study in the Imaginative Literature of 1870–1930* (New York: Scribner's, 1931), 304.

5. "Gegen die Kunstansprüche der Entente," manuscript, Nachlass Meier-Graefe 94.190.16, DLA.

6. Hugo Ball, "Totentanz," in Karl Riha and Waltraud Wende-Hohenberger, eds., *Dada Zürich: Texte, Manifeste, Dokumente* (Stuttgart: Reklam, 1992), 60–61.

7. Van de Velde, *Geschichte,* 389; in Kennert, *Cassirer,* 133. Also René Schickele's diary for 1918, "Tagebücher," *Werke in drei Bänden,* ed. Hermann Kesten, III (Cologne: Kiepenheuer & Witsch, 1959), 1013–1129; and Curt Riess, *Café Odeon* (Zürich: Europa Verlag, 1973), 130–32.

## WINDS

1. Durieux, *Meine ersten neunzig Jahre,* 293.

2. Paul Cassirer, "Utopische Plauderei," *Die weißen Blätter* 6, no. 3 (March 1919), 105–17; in Kennert, *Cassirer,* 162.

3. Diary, January 10, 1920, Kessler, *Aus den Tagebüchern,* 96.

4. Linda F. McGreevy, *Bitter Witness: Otto Dix and the Great War* (New York: Lang, 2001), 201.

5. Vicki Baum, *Grand Hotel,* trans. Basil Creighton (London: Pan, 1972), 7, 270.

6. Alfred Henschke, *Klabund Chansons: Streit- und Leidgedichte* (Vienna, 1930), 36–37; in Gerald Feldman, *The Great Disorder: Politics, Economics, and Society in the German Inflation* (New York: Oxford University Press, 1993), 538.

7. Julius Meier-Graefe, "Die doppelte Kurve," *Ganymed* I (1919), 12–52, esp. 47.

8. In April 1919 the art historian Wilhelm Ludwig Coellen remarked, "Before the political revolution came the revolution in art." In Martin H. Geyer, *Verkehrte Welt: Revolution, Inflation und Moderne, München 1914–1924* (Göttingen: Vandenhoeck & Ruprecht, 1998), 68.

9. Ronald Sanders, *The Days Grow Short: The Life and Music of Kurt Weill* (New York: Holt, Rinehart and Winston, 1980), 44.

10. Peter Jelavich, *Berlin Cabaret* (Cambridge: Harvard University Press, 1993), 231; Nikolaus's letter is quoted in Volker Kühn, ed., *Deutschlands Erwachen: Kabarett unterm Hakenkreuz 1933–1945* (Wiesbaden, 1989), 335; Durieux, *Meine ersten neunzig Jahre,* 275.

11. *Aus den Tagebüchern,* 218.

12. Ludwig Justi, *Werden—Wirken—Wissen: Lebenserinnerungen aus fünf Jahrzehnten,* ed. Thomas W. Gaehtgens and Kurt Winkler (Berlin: Nicolai, 2000), 441.

13. Wolfgang Bialas and Burkhard Stenzel's introduction to their edited volume *Weimarer Republik zwischen Metropole und Provinz* (Weimar: Böhlau, 1996), 3.

14. "Architektur," *Münchner Illustrierte Presse*, October 27, 1929, reprinted in translation in Joseph Roth, *What I Saw: Reports from Berlin 1920–1933*, trans. with introduction Michael Hofmann (New York: Norton, 2003), 115–18.

15. Blaise Cendrars, *L'ABC du cinéma*, in Ian Christie, "Film as a Modernist Art," in Christopher Wilk, ed., *Modernism 1914–1939: Designing a New World* (London: V & A Publications, 2006), 297. On the theme of technology and cinema, Curt Moreck, *Sittengeschichte des Kinos* (Dresden: Aretz, 1926), 7–18.

16. Klaus Mann, *Der fromme Tanz: Das Abenteuerbuch einer Jugend* (Berlin: Bruno Gmünder Verlag, 1982 [orig. 1925]), 5–6.

17. "Die Reportage photographiert das Leben," *Werke*, vol. I (Frankfurt: Suhrkamp, 2004), 216. Helmut Stalder, *Siegfried Kracauer: Das journalistische Werk in der "Frankfurter Zeitung," 1921–1933* (Würzburg: Königshausen und Neumann, 2003), 7.

18. Peter Jelavich, *Berlin Alexanderplatz: Radio, Film, and the Death of Weimar Culture* (Berkeley: University of California Press, 2006), 13–14.

19. Ezra Pound told Paul Bowles, who was composing music as well as writing poetry and fiction, that he should work in film. In Christopher Sawyer-Lauçanno, *An Invisible Spectator: A Biography of Paul Bowles* (New York: Weidenfeld and Nicolson, 1989), 98.

20. Frank Whitford, "The Many Faces of George Grosz," *The Berlin of George Grosz: Drawings, Watercolours and Prints, 1912–1920* (London: Royal Academy of Arts, 1997), 2–3.

21. Letter from Adorno to Berg, March 30, 1926, in Theodor W. Adorno, *Briefe und Briefwechsel Band 2: Theodor W. Adorno—Alban Berg Briefwechsel, 1925–1935*, ed. Henri Lonitz (Frankfurt: Suhrkamp, 1997), 76.

22. Adorno to Berg, November 19, 1926, Adorno, *Briefe und Briefwechsel Band 2*, 121.

23. Lionel Trilling, "Art and Neurosis" in his *The Liberal Imagination: Essays on Literature and Society* (London: Secker and Warburg, 1951), 181.

24. *Berlin Alexanderplatz: Die Geschichte vom Franz Biberkopf* (Munich: dtv, 1965), 145.

25. Erich Kästner, *Kästner für Erwachsene*, ed. Rudolf Walter Leonhardt (Frankfurt: S. Fischer, 1966), 62.

1. Klaus Mann, *Der Wendepunkt*, 132; cited in Widdig, *Culture and Inflation*, 207.

2. Curt Moreck, *Führer durch das "lasterhafte" Berlin* (Leipzig: Verlag moderner Stadtführer, 1931), 116.

3. Wassily Kandinsky, *Concerning the Spiritual in Art*, trans. M.T.H. Sadler (New York: Dover, 1977), 51.

4. Rudolf von Laban, *Ein Leben für den Tanz*, 117, quoted in Laure Guilbert, *Danser avec le IIIe Reich: Les danseurs modernes sous le nazisme* (Brussels: Éditions Complexe, 2000), 35.

5. Paul Tillich, "Tanz und Religion," *Gesammelte Werke* 13 (Stuttgart: Evangelisches Verlagswerk, 1972), 134. Also his *On the Boundary* (New York: Scribner, 1966), 68–71, where he argues that "culture is religious wherever human existence is subjected to ultimate questions."

6. Tillich, *On the Boundary*, 79. "In the New Testament, men possessed by demons are said to know more about Jesus than those who are normal."

7. Wilhelm and Marion Pauck, *Paul Tillich: His Life & Thought*, vol. I: *Life* (New York: Harper & Row, 1976), 76–77.

8. Guilbert, *Danser avec le IIIe Reich*, 46. On Monte Verità, see Martin Green, *Mountain of Truth: The Counterculture Begins, Ascona, 1900–1920* (Hanover, N.H.: University Press of New England, 1986), and Curt Riess, *Ascona: Geschichte des seltsamsten Dorfes der Welt* (Zürich: Europa Verlag, 1964). On Tillich, Hannah Tillich, *From Time to Time* (New York: Stein and Day, 1973), 24; Pauck, *Tillich*, 87, esp. 98–110.

9. Katie Roiphe, *Uncommon Arrangements: Seven Portraits of Married Life in London Literary Circles, 1910–1939* (New York: Dial, 2007).

10. Leni Riefenstahl, *A Memoir* (New York: St. Martin's, 1993), 34.

11. Ibid., 36.

12. Renate Berger, "Moments Can Change Your Life: Creative Crises in the Lives of Dancers in the 1920s," in Marsha Meskimmon and Shearer West, eds., *Visions of the "Neue Frau": Women and the Visual Arts in Weimar Germany* (Aldershot: Scolar Press, 1995), 89.

13. Riefenstahl, *A Memoir*, 34. Gert called Wigman Germany's "national dancer" on grounds that "Mary Wigman succeeds in confusing even the simplest matters." In Valeska Gert, "Mary Wigman und Valeska Gert," *Der Querschnitt* 6, no. 5 (May 1926): 361.

14. Valeska Gert, *Ich bin eine Hexe* (Munich: Knaur, 1989), 21.

15. October 23, 1917.

16. C.K. Roellingshoff, "Douglas und Valeska," *Lustige Blätter* (Berlin) 42, no. 6 (February 6, 1927), 10. Lillian Karina and Marion Kant, *Hitler's Dancers: German Modern Dance and the Third Reich*, trans. Jonathan Steinberg (New York: Berghahn, 2003), 21; Renate Berger, "Moments," 89–93. Also the review by F.B., "Valeska Gert: Groteske Tänze," *Kölner Tageblatt* 70 (February 7, 1918): 2.

17. Gert, *Ich bin eine Hexe*, 39–40.

18. a.m., "Valeska Gert," *Vossische Zeitung* (Berlin) 540, November 14, 1922, reporting on her performance in the Schwechtensaal.

19. Gert, "Mary Wigman und Valeska Gert," 362.

20. Harry Prinz, "Das Phänomen Valeska Gert," *Der Tanz* 3, no. 3 (March 1930); in the Valeska Gert file of the Deutsches Tanzarchiv, Cologne.

21. Fred Hildenbrandt, *Die Tänzerin Valeska Gert* (Stuttgart: Hadecke, 1928), 128. In his memoir, . . . *ich soll dich grüssen von Berlin, 1922–1932: Berliner Erinnerungen* (Munich: Ehrenwirth, 1966), 231, Hildenbrandt spoke of Gert's "brutal beauty."

22. Valeska Gert, *Mein Weg* (Leipzig: Devrient, 1931), 38.

23. Hildenbrandt, . . . *ich soll dich grüssen*, 124–25.

24. Bernd Widdig, *Culture and Inflation in Weimar Germany* (Berkeley: University of California Press, 2001), 7–8.

25. Curt Riess, *Das war ein Leben! Erinnerungen* (Munich: Langen Müller, 1986), 105.

### SODOMIA

1. Moreck, *Führer durch das "lasterhafte" Berlin*, 132. Thomas Mann's comments were in his lecture "Von Deutscher Republik," delivered October 13, 1922.

2. Jean-Claude Baker, *Josephine: The Hungry Heart* (New York: Random House, 1993), 124–33. Dorothy Rowe, *Representing Berlin: Sexuality and the City in Imperial and Weimar Germany* (Aldershot: Ashgate, 2003), argues that Berlin became a metaphor for sensuality.

3. Riess, *Das war ein Leben!*, 106.

4. Anatol Goldberg, *Ilya Ehrenburg, Revolutionary, Novelist, Poet, War Correspondent, Propagandist: The Extraordinary Epic of a Russian Survivor* (New York: Viking, 1984), 79.

5. Riess, *Das war ein Leben!* 106.

6. Werner Hegemann, *Das steinerne Berlin: Geschichte der grössten Mietskasernenstadt der Welt* (Lugano: Jakob Hegner, 1930), 344.

7. Diary, May 1, 1922, Käthe Kollwitz, *Die Tagebücher*, ed. Jutta Bohnke-Kollwitz (Berlin: Siedler, 1989), 531–32. The reference to the *Caveau des innocents* is to a Parisian dive near Les Halles that Kollwitz visited in 1904.

8. Diary, December 4, 1922, Kollwitz, *Die Tagebücher*, 542–43.

9. Moreck, *Führer durch das "lasterhafte" Berlin*, 140.

10. Hildenbrandt, . . . *ich soll dich grüssen*, 200–201; Lothar Fischer, *Tanz zwischen Rausch und Tod: Anita Berber, 1918–1928 in Berlin* (Berlin: Haude & Spener, 1984), 66.

11. Fischer, *Anita Berber*, 84. Also Berger, "Moments," 77–95.

12. Riess, *Das war ein Leben!*, 106.

13. Magnus Hirschfeld, *Von einst bis jetzt: Geschichte einer homosexuellen Bewegung 1897–1922*, ed. Manfred Herzer and James Steakley (Berlin: Verlag rosa Winkel,

1986), 43. These essays appeared in the homosexual journal *Die Freundschaft* in 1922–23 in fifty-three segments. In 1931 Curt Moreck put the number of male gay bars at eighty: *Führer durch das "lasterhafte" Berlin*, 134.

14. Mel Gordon, *Voluptuous Panic: The Erotic World of Weimar Berlin* (Los Angeles: Feral House, 2006), 90–91.

15. Hans-Georg Stümke, *Homosexuelle in Deutschland: Eine politische Geschichte* (Munich: Beck, 1989), 73–82; and Dagmar Herzog, *Sex After Fascism: Memory and Morality in Twentieth-Century Germany* (Princeton: Princeton University Press, 2005), 89.

16. Auden in a letter to Patience McElwee, December 1928, in Humphrey Carpenter, *W.H. Auden: A Biography* (Boston: Houghton Mifflin, 1981), 90; also Norman Page, *Auden and Isherwood: The Berlin Years* (New York: St. Martin's Press, 1998), 14. Crowley in Jonathan Fryer, *Isherwood: A Biography* (New York: Doubleday, 1978), 107.

17. Christopher Isherwood, *Christopher and His Kind 1929–1939* (London: Eyre Methuen, 1977), 10; John Sutherland, *Stephen Spender: The Authorized Biography* (London: Viking, 2004), 89; Carpenter, *Auden*, 104.

## SUN CHILD

1. Rudolf von Delius, *Mary Wigman* (1925), 32, in Green, *Mountain of Truth*, 193.

2. Suzy Solidor, in Baker, *Josephine*, 136.

3. Stephen Spender, *The Temple* (London: Faber and Faber, 1988), 113.

4. Fritz Giese, *Die Girlkultur* (1923), in Fischer, *Anita Berber*, 27.

5. Martin Green, *Children of the Sun: A Narrative of "Decadence" in England after 1918* (London: Constable, 1977).

6. Green, *Children of the Sun*, 35.

7. Rosie Ullstein, wife of Remarque's publisher Franz Ullstein, described Remarque as a temperamental naïf: RG [Rosie Gräfenberg], *Prelude to the Past* (New York: Morrow, 1934), 320–21; Leni Riefenstahl called Remarque "unusually gifted, yet hypersensitive, vulnerable": *A Memoir*, 65.

8. Cyril Connolly, *The Evening Colonnade* (New York: Harcourt Brace Jovanovich, 1975), 324. Norman Cameron called him "the Rupert Brooke of the Depression": David Pryce-Jones, *Cyril Connolly: Journal and Memoir* (New York: Ticknor & Fields, 1984), 268.

9. Rosamond Lehmann to Dadie Rylands, December 29, 1930, in Sutherland, *Spender*, 119.

10. Spender, *The Temple*, x, 132. Sutherland, *Spender*, 119, 227. Sylvia Townsend Warner described Spender as "an irritating idealist, always hatching a wounded feeling." Letter to Steven Clark, September 6, 1937, in Sylvia Townsend Warner,

*Letters*, ed. William Maxwell (London: Chatto and Windus, 1982), 49. Nicholas Jenkins, "Under-exposure" (review of John Sutherland's *Stephen Spender: The Authorized Biography*), *Times Literary Supplement*, August 13, 2004: 4; Page, *Auden and Isherwood*, 49. Isaiah Berlin called Spender "disarmingly innocent": Sutherland, *Spender*, 95.

11. André Gide, *Fruits of the Earth* (London: Secker and Warburg, 1949), 151; and William Plomer, *The Autobiography of William Plomer* (London: Cape, 1975), 274.

12. André Gide, *Les Faux-monnayeurs* (Paris: Gallimard, 1925), 59. Also Robert K. Martin, "Authority, Paternity and Currency in André Gide's 'Les faux-monnayeurs,'" *Modern Language Studies* 21, no. 3 (1991): 10–16.

13. Jaspers, *Strindberg and van Gogh*, 203.

## SHOWTIME

1. On the popularity of Spanish dance, see Hildenbrandt, . . . *ich soll dich grüssen*, 167–68.

2. On Saturdays at the Zentral-Diele on the Stallschreiberstrasse, there would be a "sailors' party." Moreck, *Führer durch das "lasterhafte" Berlin*, 136.

3. "Olindo Lovael," *Elegante Welt* 13, no. 3 (1924): 23. This time his name was spelled without the diacritics over the *e*.

## PALACE REVOLUTION

1. Recounted by Ludwig Justi, in "Fünf Jahre 'Kronprinzen-Palais': Eine Rundfrage," *Das Kunstblatt* 8 (1924): 239.

2. Ibid., 240. Also the introduction by Thomas W. Gaehtgens to Ludwig Justi, *Werden—Wirken—Wissen*, vii–xvii.

3. Fritz Wichert, in "Fünf Jahre 'Kronprinzen-Palais': Eine Rundfrage," *Das Kunstblatt* 8 (1924): 243.

4. Sven Kuhrau and Claudia Rückert, eds., *Der deutschen Kunst: Die Berliner Nationalgalerie und nationale Identität 1876–1997* (Berlin: Philo, 1998). Much was made in 2004 of the pivotal role of Justi and the Nationalgalerie in the birth of MoMA when Berlin's "American Season" featured an exhibition *MoMA in Berlin* at the Neue Nationalgalerie.

5. Paul Westheim, "Die tote Kunst der Gegenwart," *Das Kunstblatt* 9 (1925): 106–14 and 141–49; also his "Deutsche Kunst in Paris," *Das Kunstblatt* 15 (1931): 171–73.

6. Diary, November 6, 1922, Kollwitz, *Die Tagebücher*, 541.

7. Durieux, *Meine ersten neunzig Jahre*, 309.

8. Thomas Mann, *Unordnung und frühes Leid* (Berlin: S. Fischer, 1926), 11, 23, 49.

9. Thomas Mann, in an address in the United States in 1942, "Inflation: The Witches' Sabbath—Germany 1923," trans. Ralph Manheim, *Encounter* 44, no. 2 (February 1975): 63.

10. Paul Fechter, "Die nachexpressionistische Situation," *Das Kunstblatt* 7 (1923): 321–29.

## STORIES

1. Siegfried Kracauer, "The Biography as an Art Form of the New Bourgeoisie," *The Mass Ornament: Weimar Essays*, trans. Thomas Y. Levin (Cambridge: Harvard University Press, 1995), 101–105.

2. Else Gellhorn, "Tanz," *Das Kunstblatt* 12 (1928): 28. Leo Lowenthal, "German Popular Biographies: Culture's Bargain Counter," in Kurt H. Wolff and Barrington Moore Jr., eds., *The Critical Spirit: Essays in Honor of Herbert Marcuse* (Boston: Beacon Press, 1967), 267–83. Paul Westheim, "Die tote Kunst der Gegenwart," *Das Kunstblatt* 9 (1925): 106–14 and 141–49.

3. Elias Canetti, *The Torch in My Ear*, trans. Joachim Neugroschel (New York: Farrar Straus Giroux, 1982), 13–14.

4. In Moffett, *Meier-Graefe*, 124.

5. This passage by Meier-Graefe is quoted on an invitation, dated May 1924, from Herrn Flatow & Priemer, purveyors of antique furniture, Viktoriastrasse 29, Berlin W10. The invitation, to view seventeenth- and eighteenth-century pieces, is in the Julius Levin Nachlass, 61.342, DLA.

6. Johan Huizinga, "The Task of Cultural History," in *Men and Ideas*, trans. James S. Holmes and Hans van Marle (New York: Meridian, 1959), 49–51. Also Wilhelm Bauer, *Einführung in das Studium der Geschichte* (Tübingen: Mohr, 1928), 150.

7. Eckhardt Grünewald, *Ernst Kantorowicz und Stefan George* (Wiesbaden: Steiner, 1982), 91–93; Thomas Karlauf, *Stefan George: Die Entdeckung des Charisma* (Munich: Blessing, 2007); and H.J. Perrey, "Der 'Fall Emil Ludwig'—Ein Bericht über eine historiographische Kontroverse der ausgehenden Weimarer Republik," in *Geschichte in Wissenschaft und Unterricht* 43 (1992): 169–81.

8. E. Kehr, *Der Primat der Innenpolitik: Gesammelte Aufsätze zur preussisch-deutsche Sozialgeschichte im 19. und 20. Jahrhundert*, ed. H.-U. Wehler (Berlin: de Gruyter, 1965), 263.

9. Herbert S. Gorman, "Bizarre Career of a Mad French Painter," *New York Times*, April 22, 1923, BR5.

10. Hermann Kasack, "Aus 'Vincent,'" *Das Kunstblatt* 8 (1924): 48–52. A radio version of the play was to be presented by Radio Vorarlberg in March 1961, in the coldest days of the Cold War.

11. Werner Rieck, "Hermann Kasacks Drama Vincent," in Helmut John and Lonny Neumann, eds., *Hermann Kasack—Leben und Werk: Symposium 1993 in Potsdam* (Frankfurt: Peter Lang, 1994), 57–71; Martina Fromhold, *Hermann Kasack und der Rundfunk der Weimarer Republik: Ein Beitrag zur Geschichte des Wechselverhältnisses zwischen Literatur und Rundfunk* (Aachen: Alano Verlag, 1990), esp. 52–53; Heribert Besch, *Dichtung zwischen Vision und Wirklichkeit: Eine Analyse des Werkes von Hermann Kasack mit Tagebuchedition (1930–1943)* (St. Ingbert: Röhrig, 1992). About the reach of the radio program, Arno Schirokauer, a young philologist who had lost an eye in the war, remarked in 1929, "The ears of millions belong for the first time in history to the poet." Arno Schirokauer, *Kunstpolitik im Rundfunk* (1929); in Fromhold, *Hermann Kasack*, 13.

12. Carl Sternheim, "Felixmüller," *Der Cicerone* 15 (1923): 881–87; reprinted in Carl Sternheim, *Gesamtwerk*, vol. 6 (Neuwied am Rhein: Luchterhand, 1966), 279–83.

13. Siegfried Streicher, *Vincent van Gogh* (Zürich: Orell Füssli, 1929); in René Renggli, "Vincent van Gogh—ein Wahnsinniger?" *Schweizerische Ärtzezeitung* 85, no. 50 (2004): 2723.

14. Ron Manheim, "The 'Germanic' Van Gogh: A Case Study of Cultural Annexation," *Simiolus* 19, no. 4 (1989): 277–88.

15. Oskar Hagen, "Vincent van Gogh," *Ganymed* 2 (1920): 89–118, esp. 90 and 94. While at Göttingen, Hagen was responsible for the revival of Handel's operas and directed the Göttingen Handel Festival. His daughter was the actress Uta Hagen. Even though he immigrated to the United States in the late 1920s and joined the faculty at the University of Wisconsin in Madison, he was rumoured to be a Nazi sympathizer. The Oskar Hagen Papers are in the Wisconsin Music Archives.

16. G.F. Hartlaub, "Vincent van Gogh," *Der Cicerone* 14, no. 15 (1922), 653.

17. The conclusion to *Vincent* was reprinted: Julius Meier-Graefe, "Der Maler Vincent van Gogh," *Ganymed* 3 (1921), 174–80, esp. 179–80.

18. Joseph Goebbels, *Michael: Ein deutsches Schicksal in Tagebuchblättern* (Munich: Eher, 1931), 124.

## SAILOR BOY

1. Carola Schenk, "Max Slevogt und das Theater," in Sabine Fehlemann, ed., *Max Slevogt—Die Berliner Jahre* (Cologne: Wienand, 2005), 152–54.

2. Olinto Lovaël to Frank Arnau, October 11, 1966, Koldehoff dossier, Van Gogh Museum.

3. "Ausverkauf," *Kunst und Künstler* 18 (February 1920): 191. In Feldman, *Great Disorder*, 539–40.

4. In Stolwijk, *Account Book*, 30.

CERTIFIERS

1. Deposition by Bachmann, Stork, and Schwabe, lawyers for Perls, April 8, 1930, in the suit launched by Elsa Essberger in Hamburg, I/NG 723, ZStM.

2. Hilary Spurling has assembled a good deal of information on the Russian collectors in her two-volume biography of Henri Matisse, *The Unknown Matisse: A Life of Henri Matisse, the Early Years, 1869–1908* (New York: Knopf, 1999), and *Matisse the Master: A Life of Henri Matisse, the Conquest of Color, 1909–1954* (New York: Knopf, 2005). Also, Georg-W. Költzsch, *Morosow und Schtschukin, die russischen Sammler: Monet bis Picasso* (Cologne: DuMont, 1993); and Albert Kostenevich, "Sergei Shchukin and Ivan Morozov: Two Legendary Collectors," in *Voyage into Myth: French Painting from Gauguin to Matisse from the Hermitage Museum, Russia* (Toronto: Art Gallery of Ontario, 2002), 110–45; and Ilia Dorontchenkov, ed., *Russian and Soviet Views of Modern Western Art, 1890s to mid-1930s* (Berkeley: University of California Press, 2009).

3. Renate Schostack, "Schlecht darf es sein, aber Fälschung?" *Frankfurter Allgemeine Zeitung* 71, March 24, 2001. When the Royal Academy in London launched its exhibition *From Russia* in 2008, the descendents of Shchukin and Morozov claimed that 25 of the 120 works in the show were pictures illegally seized from their forebears. Chris Hastings and Stephanie Plenti, "Royal Academy 'Tried to Buy Off Owners,'" *Sunday Telegraph*, February 10, 2008. Also, Sean McMeekin, *History's Greatest Heist: The Looting of Russia by the Bolsheviks* (New Haven: Yale University Press, 2008).

4. Julius Meier-Graefe, "Die van-Gogh-Frage," *Berliner Tageblatt*, December 1, 1928.

5. Ivan Goldschmidt, "Der Fall Wacker," *Frankfurter Zeitung* 37, January 15, 1929.

6. Gabriele Tergit, "Expertendämmerung," *Die Weltbühne* 28, no. 1 (1932): 598.

7. "Halb echt—halb falsch," *Berliner Börsen-Courier*, April 12, 1932, M.

8. Henk Tromp, *De Strijd om de Echte Vincent van Gogh: De kunstexpert als brenger van een onwelkome boodschap 1900–1970* (Amsterdam: Mets & Schilt, 2006), 66.

CAVEAT EMPTOR

1. On Elias and his wife, Julie, see Durieux, *Meine ersten neunzig Jahre*, 143–44.

2. Frau Wolff-Essberger disputed this sum, suggesting instead a lower figure between 9,000 and 12,000 marks. Submission of her lawyers, Tentler, Kauffmann, Kersten, Scherzberg, and Martens to the Hamburg Landgericht, May 6, 1930, in I/NG 723, ZStM.

3. Elsa Wolff to Hugo Perls, February 24, 1926, I/NG 723, ZStM.

4. Of the Wacker pictures, *Zouave* (F 539), *The Plain at Auvers* (F 813), *Wheat Field* (F 823), and *Cypresses* (F 741) were on display. Submission of Dr. Bachmann on behalf of Hugo Perls, April 8, 1930, in I/NG 723, ZStM. Catalogue: *Französische Malerei des XIX. Jahrhunderts, Zweite Ausstellung* (Berlin: Hugo Perls, 1927).

5. Submission of Dr. Bachmann on behalf of Hugo Perls, April 8, 1930, in I/NG 723, ZStM.

6. *Impressionisten Sonderausstellung* (Berlin: Galerie M. Goldschmidt, 1928). See also Peter Kropmanns, "Kunstmarkt Berlin 1928," *MuseumsJournal* 13 (July 1999): 8–9.

7. Gisela Reiners, "Eine Villa, wie es in Hamburg keine zweite gibt," *Die Welt am Sonntag*, November 28, 2004.

8. See the list in "Millioenen Vervalsching," *De Telegraaf* (Amsterdam), December 1, 1928.

<div align="center">FAME</div>

1. Hegemann, *Das steinerne Berlin*, 332.

2. Testimony of Max Renkewitz, Wacker's secretary, in the A.M. de Wild summary of the trial proceedings, p. 10.

3. In 1927 some forty-three galleries, auction houses, and publishers were to be found in the area between Potsdamer Platz to the north and Derfflingerstrasse to the southwest: Kennert, *Cassirer*, 40.

4. The Stedelijk Museum of Amsterdam had mounted a major show of the drawings, 201 of them, in 1914–15. However, the war had overshadowed this event outside neutral Holland.

5. "Ausstellung von Zeichnungen van Goghs bei Otto Wacker, Berlin," *Kunst und Künstler* 26, no. 6 (January 1928): 150.

6. *Vincent van Gogh, der Zeichner: Erste grosse Ausstellung seiner Zeichnungen und Aquarelle* (Berlin: Otto Wacker, 1927).

7. Fritz Stahl, "Zeichnungen von van Gogh: In der Galerie Wacker," *Berliner Tageblatt*, December 16, 1927.

8. Bruno E. Werner, "Die Zeichnungen van Goghs: Zur Ausstellung in der Kunsthandlung Otto Wacker, Berlin," *Die Kunst: Monatshefte für freie und angewandte Kunst* 57 (1928): 191.

9. "Ausstellung von Zeichnungen van Goghs bei Otto Wacker, Berlin," *Kunst und Künstler* 26, no. 6 (January 1928): 150–51.

10. "Van Gogh-Ausstellungen in Berlin," *Kunst und Künstler* 26 (1927–28): 181.

11. In a recent article on Van Gogh literature, Anne Dumas has written, "Until the 1980s, the drawings had received scant attention." Anne Dumas, "The Van Gogh

Literature from 1990 to the Present: A Selective Review," *Van Gogh Museum Journal 2002* (2002): 42. In the 1980s Ronald Pickvance curated a number of important exhibitions at the Metropolitan Museum of Art that celebrated the drawings. Ronald Pickvance, *Van Gogh in Arles* (New York: Metropolitan Museum of Art, 1984), and *Van Gogh in Saint-Rémy and Auvers* (New York: Metropolitan Museum of Art, 1986–87).

12. Laura de Coppet and Alan Jones, *The Art Dealers* (New York: Clarkson N. Potter, 1984), 49.

13. The list is available in the submission of Dr. Bachmann on behalf of Hugo Perls, April 8, 1930, in I/NG 723, ZStM.

14. Pierre de Margerie was French ambassador to Germany from 1922 to 1931. At the age of seventy he was replaced by the celebrated Germanist and *normalien* André François-Poncet, who opened the doors of the French embassy on the Pariser Platz to Berliners even wider than did his predecessor.

SOURCE

1. Goldberg, *Ilya Ehrenburg*, 71–81; Robert C. Williams, *Culture in Exile: Russian Emigrés in Germany 1881–1941* (Ithaca: Cornell University Press, 1972), 125–40; Sorokin is quoted by Williams, 137.

ALARUM

1. The suspects were F 691, F 418a, F 527a, and F 625a. Feilchenfeldt's son, also Walter, put together a compendium of the Wacker pictures: "Van Gogh Fakes: The Wacker Affair, with an Illustrated Catalogue of the Forgeries," *Simiolus* 19, no. 4 (1989): 289–316.

2. A copy of the Cassirer catalogue, *Vincent van Gogh: Gemälde* (Berlin: Paul Cassirer, 1928), is in the Koldehoff dossier, Van Gogh Museum.

3. "Van Gogh-Ausstellungen in Berlin," *Kunst und Künstler* 26 (1927–28): 181.

4. M.O., "Unechte van Goghs," *Vossische Zeitung* (Berlin), November 29, 1928.

5. "Disputed van Goghs," *Morning Post* (London), November 30, 1928.

6. "Alleged Picture Forgeries," *Daily Telegraph* (London), November 29, 1928.

7. Letter to Franz Zatzenstein of the Matthiesen gallery, December 18, 1928, Matthiesen files, b8438, Van Gogh Museum.

8. "Millioenen Vervalsching: de 30 van Goghs," *De Telegraaf* (Amsterdam), December 1, 1928; *Het Vaterland* (The Hague), translated and reprinted in "De la Faille Replies to His Critics," *Art News* (New York), January 5, 1929; Jacob-Baart de la Faille, *Les faux van Gogh* (Paris: G. van Oest, 1930).

## ALEXANDERPLATZ

1. "Afwijkende Meengen over de v. Gogh-Falsificaties," *De Telegraaf* (Amsterdam), December 2, 1928.

2. "Otto Wacker aan het woord," *De Telegraaf* (Amsterdam), December 1, 1928.

3. "Otto Wacker terug in Berlijn," *De Telegraaf* (Amsterdam), December 2, 1928.

4. Moreck, *Führer durch das "lasterhafte" Berlin*, 187–210.

5. Paul Westheim, "Zum Thema: van Gogh-Fälschungen," *Berliner Börsen-Zeitung* 571, December 6, 1928.

6. Martin Knutzen, "Van Gogh und die Unverständigen," *Die Weltbühne*, February 15, 1929, 221–22.

7. "Neues von Van Gogh," *Berliner Morgenpost*, December 16, 1929.

8. Hugo Perls, *Warum ist Kamilla schön? Von Kunst, Künstlern und Kunsthandel* (Munich: List, 1962), 122. Perls makes little mention of the Wacker incident in his memoir and much mention of his personal ability, based on years of experience, to distinguish between real and fake Van Goghs.

## COUP

1. Her report on the activity of the Stichting is cited at length in Deventer, *Kröller-Müller*, 127–28.

2. Ludwig Justi, "Philologia Wackeriana," *Museum der Gegenwart* 3, no. 3 (1932): 120–27. See the correspondence for the show between Justi and Kröller-Müller in "Ausstellung Vincent van Gogh," I/NG723, ZStM.

3. Ludwig Thormaehlen to Thomas Brown, December 20, 1928, I/NG 723, ZStM. Similar letters to other owners are in the same file.

4. See the extensive correspondence between the National Gallery and owners of Wacker pictures in Handakte Ludwig Thormaehlen, I/NG1373, ZStM.

5. Ludwig Justi, "Van Gogh, die Kenner und Schriftsteller," *Vossische Zeitung* (Berlin), January 1, 1929, M.

6. Elsa Essberger to Justi, January 9, 1930, I/NG 723, ZStM; and the correspondence with Sigmund Gildemeister, in the same file. Gildemeister owned *Olive Trees* (F 713) and *Houses at Saintes-Maries* (F 421).

7. Helene Kröller-Müller to Geheimrat Justi, February 7, 1929, and Justi's reply, February 12, 1929, I/NG 723, ZStM.

8. J.M. Prange, "Twee valse Van Goghs?" *Het Parool* (Amsterdam), June 28, 1947; Wim Zaal, "Een paar zonnebloemen meer of minder," *Elsevier*, February 10, 1990, 67.

9. Paul Westheim, "Die van-Gogh-Affäre bedroht den Berliner Kunstmarkt," *8-Uhr-Abendblatt* (Berlin), May 10, 1929.

10. Justi to Dr. Barth, January 3, 1928, I/NG 723, ZStM. In this letter Justi expressed his doubts about *The Sower* (F 422), *Chestnut Tree in Blossom* (F 752), *Wheat Field with Reaper and Sun* (F 617), *View of Saintes-Maries* (F 416), *Pine Trees Against a Red Sky with Setting Sun* (F 652), *Evening Landscape with Rising Moon* (F 735).

11. Thormaehlen to P.O. Rave, February 18, 1929, I/NG 1373, ZStM.

12. M., "Der Stand der Untersuchung der van Gogh-Fälschungen," *Rheinisch-Westfälischer Zeitung*, February 2, 1930.

13. *Falsche Expertisen?—Falsche Experten!: Ein Beitrag zur posthumen Tragödie van Goghs* (Berlin: Ernst Pollak Verlag, 1932), 24.

14. The figures are based on ticket sales. Ludwig Thormaelen to Helene Kröller-Müller, October 15, 1932, I/NG723, ZStM. Helene padded the estimate in her report, putting the number at thirty thousand: Deventer, *Kröller-Müller*, 128.

15. Paul Ferdinand Schmidt, "Van Gogh und der Sinn der Kunstfälschungen," *Sozialistische Monatshefte* (Berlin) 35, no. 68 (January 1, 1929): 36.

16. Deventer, *Kröller-Müller*, 128.

## SURREALITY

1. "Vincent van Gogh," *Nieuwe Rotterdamsche Courant* (hereafter *NRC*), January 30, 1929.

2. Mussia Eisenstadt, "Das Ende des Wacker-Prozesses," *Frankfurter Zeitung*, December 15, 1932.

3. The first floor in Europe is the second floor in North America. Cees van Hoore, "De 'vervalser' van Van Gogh," *Leidsch Dagblad* (Leiden), March 3, 1990.

4. Paul Westheim, "Die van-Gogh-Affäre bedroht den Berliner Kunstmarkt," *8-Uhr-Abendblatt* (Berlin), May 10, 1929.

5. Otto Wacker to W. Scherjon, July 28, 1930, Archive Huinck & Scherjon 1930–1939, copy in Koldehoff dossier, Van Gogh Museum.

## SENSATION

1. Harry Graf Kessler, *Aus den Tagebüchern 1918–1937*, ed. Wolfgang Pfeiffer-Belli (Munich: dtv, 1965), 288.

2. Walter Gutman, "News and Gossip," *Creative Art*, February 1932, 157.

3. Max Liebermann, "Justi und seine Sachverständigen-Kommission," *Kunst und Künstler* 31, no. 3 (March 1932): 66.

4. "Justi ist es gelungen . . ." *Das Kunstblatt* 15 (1931): 60. "Die Van Goghs der Nationalgalerie," *Das Kunstblatt* 17 (1932): 18; Karl Scheffler, "Zum Ankauf des Van Gogh," *Kunst und Künstler* 31 (1932): 309; Max Liebermann, "Justi und seine Sachverständigen-Kommission," *Kunst und Künstler* 31, no. 3 (March 1932): 65–71;

"Liebermann gegen Justi," *Berliner Tageblatt*, March 15, 1932, M; M.O., "Liebermann und Justi," *Vossische Zeitung* (Berlin), March 15, 1932, A.

5. Karl Scheffler, "Die Jüngsten," *Kunst und Künstler* 11 (1912–13): 398.

6. Karl Scheffler, "Zum Ankauf des Van Gogh," *Kunst und Künstler* 31 (1932): 309. It was Justi's colleague Alfred Hentzen who would describe Scheffler as "*schulmeisterlich*" in his Postscript to Moffett's *Meier-Graefe*, 199.

7. Karl Scheffler, "Van Gogh als Grenzstein," *Kunst und Künstler* 31 (1932): 113–18.

8. Diary, December 8, 1929, Kessler, *Aus den Tagebüchern*, 294.

9. George Grosz contribution to Paul Westheim, "Gegen den Abbau des Geistes," *Das Kunstblatt* 16 (1931), 65–84, esp. 80–83.

10. Emily D. Bilski et al., *Art and Exile: Felix Nussbaum 1904–1944* (New York: Jewish Museum, 1985); Karl Georg Kaster, ed., *Felix Nussbaum: A Biography*, trans. Eileen Martin (Bramsche: Rasch, 1997).

## RAVENS

1. H.W., "Der Kampf um die van Goghs: Erklärungen de la Failles," *Vossische Zeitung* (Berlin), November 30, 1928, M; and J. Meier-Graefe, "Die van-Gogh-Frage," *Berliner Tageblatt*, December 1, 1928.

2. "Van Gogh Dispute Investigated by Berlin Police," *Art News*, January 5, 1929.

3. H.P. Bremmer, "Zur Frage der van Gogh-Fälschungen," *Deutsche Allgemeine Zeitung* 574, December 7, 1928.

4. The Scherjon letter to Dale is discussed in "Dale Van Gogh Traced by Letters," *Art News*, April 13, 1929. Later that year Scherjon published at his own expense *Een Studie over de door Vincent van Gogh te St. Remy geschilderde zelfportretten in verband met J.B. de la Faille's catalogue raisonné de l'oeuvre de Vincent van Gogh* (Utrecht: Scherjon, 1929).

5. W. Scherjon, "Het 'Valsche van Gogh' Drama," *Utrechtsch Dagblad*, July 6, 1929.

6. Willem Scherjon, "Vincent van Gogh," *NRC*, January 12, 1929, A; and J.-Baart de la Faille's response, "De vermeende Van Gogh-vervalschingen," *NRC*, January 24, 1929; also "De valsche van Goghs," *Het Vaderland* (The Hague), January 24, 1929. The exchange between Scherjon and De la Faille continued a week later: "De vermeende Van Gogh-vervalschingen," *NRC*, January 31, 1929.

7. Ludwig Justi, "Van Gogh, die Kenner und Schriftsteller," *Vossische Zeitung* (Berlin), January 27, 1929, M.

8. Justi, *Werden–Wirken–Wissen*, 442.

9. Letter 763, to Theo.

10. "Vincent van Gogh," *NRC*, January 27, 1929.

11. W. Scherjon, "Vincent van Gogh," *NRC*, January 12, 1929, A; and "Het beden-kelijk uitgangspunt in het Wacker-Proces," *Maandblad voor Beeldende Kunsten* 9, no. 11 (November 1932): 339–44.

12. Frank Davis, "A Page for Collectors," *London Illustrated News*, June 28, 1930, 1228.

13. "Achtung, Falschkunst!" *Das Kunstblatt* 13 (1929): 124; Koldehoff, *Vincent van Gogh*, 131.

## EVIDENCE

1. Letter 800, to Theo, September 5–6, 1889.

2. Sepp Schüller, *Fälscher, Händler und Experten: Das zwielichtige Abenteur der Kunstfälschungen* (Munich: Ehrenwirth Verlag, 1959), 111.

3. Letter of Hugo Perls to Alfred Kauffmann, lawyer to Elsa Wolff-Essberger, January 13, 1930, I/NG 723, ZStM.

4. Paul Westheim, "Um die van Gogh-Fälschungen," *Berliner Börsen-Zeitung*, August 21, 1931, A.

5. "Een nieuwe affaire Wacker," *De Telegraaf* (Amsterdam), July 10, 1929. Several lists of the items seized on May 8 and August 16, 1929, are in I/NG 723, ZStM. Also the letter there of Ludwig Thormaehlen to Kriminalkommissar Thomas, August 26, 1929.

6. Th. Stoperan, "Was wird aus den van Gogh-Fälschungen?" *Das Kunstblatt* 13 (November 1929): 345–47.

7. Pointing out the difficulties of the prosecution, Dr. H., "Der van Gogh-Schwindel," *Dresdner Nachrichten* 112, March 7, 1930.

8. "Das Rätsel der falschen van Goghs," *Der Montag Morgen* (Berlin), April 22, 1930.

9. Martin Knutzen, "Van Gogh und die Unverständigen," *Die Weltbühne*, February 15, 1929, 221–22.

10. Cornelis Veth, *Schoon Schip: Expertise naar echtheid en onechtheid inzake Vincent van Gogh* (Amsterdam: De Spiegel, 1932). Published also in a German version *Falsche Expertisen?—Falsche Experten!: Ein Beitrag zur posthumen Tragödie van Goghs* (Berlin: Ernst Pollak Verlag, 1932).

11. Veth's pamphlet—Max Osborn called it "a wild polemic"—was widely discussed in the Dutch press, and copies would be freely distributed at the Wacker trial. Ludwig Justi saw the hand of Willem Scherjon behind it all. M.O., "Neuer van Gogh-Lärm: Holländische Attacke gegen Berlin," *Vossische Zeitung* (Berlin), March 4, 1932, A. Ludwig Justi, "Philologia Wackeriana," *Museum der Gegenwart* 3, no. 3 (1932): 121.

12. Paul Westheim, "Um die van Gogh-Fälschungen," *Berliner Börsen-Zeitung*, August 21, 1931, A.

CELA N'EST PAS . . .

1. Kessler to Wilma de Brion, February 25 and 28, 1931, in Easton, *Red Count*, 388–89.

PRESENT SENSE

1. Gino Segrè, *Faust in Copenhagen* (New York: Viking, 2007); Graham Farmelo, *The Strangest Man: The Hidden Life of Paul Dirac, Mystic of the Atom* (New York: Basic books, 2009), 187–88.

SEANCE

1. The Schwurgerichtssaal of the Schöffengericht.
2. Max Osborn, *Vossische Zeitung* (Berlin), April 6, 1932.
3. Gabriele Tergit, "Expertendämmerung," *Die Weltbühne* 28, no. 1 (1932): 599.

SCRIPTS

1. Despite an exhaustive search, I have not been able to locate either transcripts of the trial or the judgment. Notes in the judicial documents of the Landesarchiv Berlin (A Rep. 358-02 Nr. 44998) indicate that the materials had already gone astray by 1942. Nevertheless, press coverage of the trial was extensive. An impressionistic transcript of the proceedings is to be found in the papers of the Dutch chemist A. Martin de Wild, who was called to testify as an expert witness (Doos 7, III, Rijsbureau voor Kunsthistorische Documentaie [hereafter RKD]). On the basis of the content, it is most likely that De Wild produced this account himself—toward the end of the document he uses the first person singular "ik." The interest of the note-taker waned as the trial dragged on. The entries for the first days are far more detailed than for later dates. A skeleton summary of the proceedings, based on press reports, has also been assembled by Nora Koldehoff, in Stefan Koldehoff, *Vincent van Gogh*, 265–79.
2. *Nieuwe Rotterdamsche Courant* (hereafter *NRC*), April 7, 1932, M.
3. *Het Vaderland* (The Hague), April 11, 1932, A.
4. "Van Gogh-Prozess, ein Kunst-Kongress," *8-Uhr-Abendblatt* (Berlin), April 6, 1932.
5. Siegfried Kracauer, "Kunst in Moabit," *Frankfurter Zeitung*, April 9, 1932, A; reprinted in *Berliner Nebeneinander: Ausgewählte Feuilletons, 1930-33*, ed. Andreas Volk (Zürich: Epocha, 1996), 178.
6. Gabriele Tergit, "Expertendämmerung," *Die Weltbühne* 28, no. 1 (1932): 597.
7. Gabriele Tergit, "Gestalten aus dem Femeprozeß," *Berliner Tageblatt*, March 25,

1927, reprinted in *Wer schießt aus Liebe? Gerichtsreportagen*, ed. Jens Brüning (Berlin, Verlag Das Neue Berlin, 1999), 80. See also the introduction to this collection, by Jens Brüning, esp. 5–6. Tergit's doctoral thesis was on the revolutions of 1848.

8. In the introduction by Jens Brüning in Tergit, *Wer schießt aus Liebe?*, 5.

9. "Prozess um van Gogh," *Berliner Morgenpost*, April 7, 1932; "Arabesken en het proces-Wacker," *Algemeen Handelsblad* (Amsterdam), October 25, 1932, includes a long description of Wacker's physical appearance and demeanour.

10. Goldstein wrote under the pseudonym Inquit, Latin for "he says." *Vossische Zeitung* (Berlin), April 7, 1932. Also, Moritz Goldstein, *Berliner Jahre: Erinnerungen, 1880–1933* (Munich: Verlag Dokumentation, 1977).

11. "Het van Gogh Prozess," 3, A.M. de Wild Papers, Doos 7, III, RKD.

12. Ibid.

13. Gabriele Tergit, "Expertendämmerung,"*Die Weltbühne* 28, no. 1 (1932): 597.

14. V.W. van Gogh to Josine van Gogh-Wibaut, April 6, 1932, b3486 V/1984, Van Gogh Museum.

### SEQUENCE

1. "Het proces over de Werken van Van Gogh te Berlijn," *NRC*, April 8, 1932, M.

2. Ibid. "Wacker will nicht krank sein," *Berliner Börsen-Courier* 162, April 7, 1932, A.

3. *Berliner Morgenpost*, April 7, 1932.

4. Siegfried Kracauer, "Kunst in Moabit," *Frankfurter Zeitung*, April 9, 1932, A.

5. Benno J. Stovkis, *Nasporingen omtrent Vincent van Gogh in Brabant* (1926); cited in Stefan Koldehoff, "When Myth Seems Stronger Than Scholarship: Van Gogh and the Problem of Authenticity," *Van Gogh Museum Journal 2002* (2002): 17.

6. Julius Meier-Graefe, "Die Franzosen in Berlin," *Der Cicerone* 19, no. 2 (1927): 43–59. See also the review "Chronik des Monats," *Kunst und Künstler* 25 (1926–27): 194–95. On Thannhauser, see Mario-Andreas von Lüttichau, "Die moderne Galerie Heinrich Thannhauser in München," in Henrike Junge, ed., *Avantgarde und Publikum: Zue Rezeption avangardistischer Kunst in Deutschland 1905–1933* (Cologne: Böhlau Verlag, 1992), 299–306.

7. "Het van Gogh Prozess," 6, A.M. de Wild Papers. Sir Robert Abdy seems to have owned F 521 briefly: Martin Bailey, *Van Gogh and Britain*, 32.

8. "Het proces over de Werken van Van Gogh te Berlijn," *NRC*, April 8, 1932, M.

### ETCETERA

1. "Kriminalisten im van Gogh-Prozess," *Berliner Tageblatt*, April 8, 1932, A.

2. "Het van Gogh Prozess," 11, A.M. de Wild Papers.

3. *NRC*, April 9, 1932, M.

4. *Het Vaderland* (The Hague), April 11, 1932, A. A typescript of the articles from *Het Vaderland* dealing with the Wacker trial is to be found in the De Wild Papers, Doos 6, II, RKD.

5. Kracauer, "Kunst in Moabit," *Frankfurter Zeitung*, April 9, 1932, A; and his *Schriften*, I: 216.

## PLUS ÇA CHANGE . . .

1. Vincent Willem van Gogh to De la Faille, March 18, 1932, NED Kunstenaars Van Gogh Vervalsingsaffaires Wacker, Press Documentation, RKD.

2. The handwritten statement, dated April 10, 1932, is to be found in ibid. Also, the report "Het proces over de werken van Van Gogh," in *NRC*, April 12, 1932, M.

3. "Het van Gogh Prozess," 14, A.M. de Wild Papers.

4. *Het Vaderland* (The Hague), April 14, 1932, A.

## APPRECIATION

1. Alfred Hentzen in his postscript for Moffett, *Meier-Graefe*, 200.

2. Gabriele Tergit, "Expertendämmerung," *Die Weltbühne* 28, no. 1 (1932): 598.

3. "Eigen Brief," *Het Vaterland* (The Hague), April 14, 1932.

4. "Het van Gogh Prozess," 16, A.M. de Wild Papers; Tergit, "Expertendämmerung," 598. The pictures Bremmer considered genuine: 418, 625a, 385, 523, 614, 639; false: 421, 387, 521, 691, 823, 685, 813, 539, 741, 704, 713.

5. Genuine: 418, 625a, 523, 614, 639.

6. "Het van Gogh Prozess," 17, A.M. de Wild Papers.

## EXPERTS

1. Fake: 729, 823, 527a, 418a, 710, 741a, 710a. Genuine: 625a, 639, 614, 385, 824, 736.

2. Matthiesen gallery to Scherjon, April 22, 1932, b8480, Matthiesen Collection, Van Gogh Museum.

## SOUL

1. A reproduction is to be found in *Der Cicerone* 19 (1927): 377.

2. G.K. Chesterton once said, "Art is limitation; the essence of every picture is the frame." In G.K. Chesterton, *Basic Chesterton: Orthodoxy* (Springfield, Ill.: Templegate, 1984), chapter 3. On framing Van Gogh, Ann Hoenigswald, "Vincent van Gogh: His Frames, and the Presentation of Paintings," *Burlington Magazine* 130, no. 1022 (May 1988): 367–72.

SUMMATIONS

1. "Plaidoyer für Wacker," *Berliner Tageblatt*, April 17, 1932, M.
2. *NRC*, April 17, 1932, M.
3. "Die Kunstexpertise vor Gericht," *Der Abend* (Berlin), April 19, 1932.
4. "Wenn Sachverständige irren . . ." *Berliner Börsen Zeitung*, April 17, 1932, M.

SENTENCE

1. Elsa Wollheim to Levin, Nachlass Julius Levin, DLA.
2. Kaspar Hauser [Kurt Tucholsky], "Expertise," *Die Weltbühne* 28, no. 1 (1932): 633–34.
3. *NRC*, April 20, 1932, M.
4. "1 Jahr Gefängnis für Wacker," *Berliner Börsen-Courier* 182, April 19, 1932, A.
5. Max Osborn, "Lehren des van Gogh-Prozesses," *Vossische Zeitung* (Berlin), April 20, 1932, M.

APPEAL

1. Otto Liebmann to Justi, April 28, 1932, I/NG 723, ZStM. I have found no indication that Justi accepted the invitation.
2. *Het Vaderland* (The Hague), November 1, 1932, M, refers to his "extraordinary energy."
3. Mussia Eisenstadt, "Prozess Wacker: Der Tragikomödie zweiter Teil," *Kunst und Künstler* 32 (1933): 32–34. On Wacker's testimony, extensive reportage and direct quotation in "Arabesken en het proces-Wacker," *Algemeen Handelsblad* (Amsterdam), October 25, 1932.
4. "Demasqué," *Algemeen Handelsblad* (Amsterdam), November 13, 1932.
5. "De Techniek in dienst van de kunstwetenschap," *Algemeen Handelsblad* (Amsterdam), November 17, 1932.
6. "Arabesken en het proces-Wacker," *Algemeen Handelsblad* (Amsterdam), October 25, 1932.
7. Mussia Eisenstadt, "Prozess Wacker: Der Tragikomödie zweiter Teil," *Kunst und Künstler* 32 (1933): 34; also her "Das Ende des Wacker-Prozesses," *Frankfurter Zeitung*, December 15, 1932.
8. *NRC*, December 4, 1932, M; *Het Vaderland* (The Hague), December 3, 1932, M.
9. "If you want the state of mind of pre-Nazi Germany compactly rendered, read Hans Fallada's Little Man, What Now? That post-war generation grew up to explode and it has exploded," wrote H.G. Wells in 1939: "The Munich Crisis and the Nazi Religion," in H.G. Wells, *Journalism and Prophecy*

*1893–1946: An Anthology*, ed. W. Warren Wagar (Boston: Houghton Mifflin, 1964): 230.

10. *NRC*, December 4, 1932, M.

11. Mussia Eisenstadt, "Prozess Wacker: Der Tragikomödie zweiter Teil," *Kunst und Künstler* 32 (1933): 32–34.

12. Ibid., 34.

## SYNONYMS

1. On the relationship between political and cultural extremism, see Roger Griffin, *Modernism and Fascism: The Sense of a Beginning under Mussolini and Hitler* (London: Palgrave Macmillan, 2007).

2. F.N., "Epilog zum Wackerprozess," *Tägliche Rundschau* (Berlin), December 8, 1932.

3. Inquit, *Vossische Zeitung* (Berlin), April 13, 1932, M.

4. Victor Klemperer, *LTI: Notizbuch eines Philologen* (Leipzig: Reclam, 1996); Max Osborn, "Lehren des van Gogh-Prozesses," *Vossische Zeitung* (Berlin), April 20, 1932, M; "De Catastrophe der Experts," *Algemeen Handelsblad* (Amsterdam), April 17, 1932.

5. Curt Glaser and Hans Purrmann, "Die gefälschte Kunst—Expertisen, Restaurierungen, Fälschungen," *Kunst und Künstler* 26 (1927–28): 291–94.

## SYMBOL

1. Klaus Fiedler, "Hans Wacker: Dem Geheimnis auf der Spur?" *Weltkunst* 9, September 15, 2003, 1294–95. Fiedler reports, but does not document, that Otto Wacker told a Berlin art collector years later that his father forged the Van Goghs.

2. Catalogues for these exhibitions are in the Stadtarchiv Düsseldorf.

3. "Falschkunst," *Das Kunstblatt* 16 (1932): 93–94.

4. Jeppson, *Fabulous Frauds*, 103.

5. Reichskartei, MFKL T0009, Bundesarchiv Berlin-Lichterfelde.

6. Auden, *The Map of All My Youth: Early Works, Friends, and Influences (Auden Studies I)* eds. Katherine Bucknell and Nicholas Jenkins (Oxford: Clarendon Press, 1990), 62.

7. Dan Healey, *Homosexual Desire in Revolutionary Russia: The Regulation of Sexual and Gender Dissent* (Chicago: University of Chicago Press, 2001), 182–90. On the importance of the sexuality and the body in any interpretation of the Third Reich, see Dagmar Herzog, *Sex After Fascism: Memory and Morality in Twentieth-Century Germany* (Princeton: Princeton University Press, 2005).

8. Karina and Kant, *Hitler's Dancers*, 40. Richard Plant, *The Pink Triangle: The Nazi War Against Homosexuals* (New York: Henry Holt, 1986).

9. Harry Oosterhuis, "Medicine, Male Bonding and Homosexuality in Nazi Germany," *Journal of Contemporary History* 32, no. 2 (1997): 187–205; Geoffrey J. Giles, "The Denial of Homosexuality: Same-sex Incidents in Himmler's SS and Police," *Journal of the History of Sexuality* 11, no. 1–2 (2002): 256–90.

### SOPHIENSTRASSE

1. A Rep. 358–02 Nr. 44998, Landesarchiv Berlin.

2. Döblin, *Berlin Alexanderplatz*, 8–9.

3. Erich Gratkowski to Landesleiter der Reichskammer der bildenden Künste, August 10, 1939, Lesefilm G 90, Bild-Nr. 782–813, Bundesarchiv Berlin Lichterfelde.

4. "Otto Wacker," Reichskartei NSDAP, Bundesarchiv Berlin Lichterfelde. Also the Reichskulturkammer files, RK/Personalvorgänge betr. Bildende Künstler, A–Z, Mischprovenienz, Vorl. Signatur 2401026319, Lesefilm G 90, Bild–Nr. 782–813, Otto Wacker, Bundesarchiv Berlin Lichterfelde.

5. A Rep. 358–02 Nr. 44998, Landesarchiv Berlin.

6. Hans Wacker to the Generalstaatsanwalt, January 2, 1934, I/NG 723, ZStM.

7. A copy of the list, dated March 27, 1935, of items returned, is in I/NG 723, ZStM.

8. "Een van Gogh uit de collectie Otto Wacker," *De Telegraaf* (Amsterdam), April 17, 1934, A.

9. John Lehmann, *The Whispering Gallery: Autobiography I* (New York: Harcourt, Brace, 1955), 209. The section is titled "Towards the Fire."

10. Klaus Mann, *Der fromme Tanz*, part 2, chapter 5.

11. Isherwood, *Goodbye to Berlin*, 184, 186, 204.

### REAPER

1. Cornelis Veth, *Schoon Schip: Expertise naar echtheid en onechtheid inzake Vincent van Gogh* (Amsterdam: De Spiegel, 1932); and in German *Falsche Expertisen?— Falsche Experten!: Ein Beitrag zur posthumen Tragödie van Goghs* (Berlin: Ernst Pollak Verlag, 1932).

2. Paul Ebstein, on behalf of Bernheim-Jeune, to Thormaehlen, October 17, 1932, I/NG 535, ZStM. Thormaehlen to Alfred Gold, Paris, November 10, 1932, I/NG 534.

3. Thormaehlen to V.W. van Gogh, October 25, 1932, I/NG 532, ZStM.

4. Letter 800, to Theo, September 5–6, 1889.

5. W. Scherjon, "Het bedenkelijk uitgangspunt in het Wacker-Proces," *Maandblad voor Beeldende Kunsten* 9, no. 11 (November 1932): 339–44.

6. Willem Scherjon, *Catalogue des tableaux par Vincent van Gogh décrits dans ses lettres: périodes: St. Rémy et Auvers sur Oise* (Utrecht: Oosthoek, 1932).

7. Justi to Paul Rosenberg, April 16, 1934, I/NG 533, ZStM.

8. Adolf (in France he called himself Adolphe) Wuester in letters to Alfred Hentzen, May 17, 1934, and June 23, 1934, I/NG 533, ZStM. Alfred Hentzen used this information from Wuester in his article "Der Garten Daubignys von Vincent van Gogh," *Zeitschrift für Kunstgeschichte* 4, no. 5–6 (1935): 326.

9. Paul Rosenberg to Justi, letters of April 15, 1933, I/NG 723, and July 26, 1933, I/NG 533, ZStM.

10. Rosenberg to Justi, April 15, 1933, I/NG 723, ZStM.

11. Rosenberg to Justi, February 7, 1932, I/NG 723, ZStM.

12. Justi to Rosenberg, April 16, 1934, I/NG 533, ZStM.

13. Hanfstaengel to Staechelin, December 17, 1934, I/NG 533, ZStM.

14. Ernst Saxer, of the Basel legal firm of Küry, Saxer, Küry, to Hanfstaengl, March 16 and October 23, 1935, and the associated correspondence, I/NG 533, ZStM.

15. The decision is available in I/NG 533, ZStM.

16. Rosenberg to Hentzen, October 13, 1936, I/NG 533, ZStM.

17. F.N., "Der Streit um das letzte Werk van Goghs," *Berliner Tageblatt*, March 12, 1937.

## NIGHT LIGHT

1. Harry Graf Kessler, diary, June 23, 1933, *Aus den Tagebüchern*, 363.

2. Shelley Baranowski, *Strength Through Joy: Consumerism and Mass Tourism in the Third Reich* (Cambridge: Cambridge University Press, 2004), esp. chapter 3; and Peter Reichel, *Der schöne Schein des Dritten Reichs: Faszination und Gewalt des Faschismus* (Munich: Hanser, 1991).

3. Joseph Goebbels, *Michael*, 77, 81–82, 144, 158.

4. Heinz Pol, "Goebbels als Dichter," *Die Weltbühne* 27, no. 4 (January 27, 1931): 105–106.

5. Albert Speer, *Inside the Third Reich: Memoirs*, trans. Richard and Clara Winston (New York: Macmillan, 1970), 27.

6. Alexandra Bechter, *Leo von König 1871–1944: Leben und Werk* (Darmstadt: WP Druck & Verlag, 2000).

7. Jonathan Petropoulos, *Art as Politics in the Third Reich* (Chapel Hill: University of North Carolina Press, 1996), 21–45 and passim.

8. Koldehoff, *Mythos*, 162.

9. Wertheim, who died in 1950, bequeathed his stunning collection of Impressionist and Post-Impressionist art to the Fogg Art Museum at Harvard University. John O'Brian, *Degas to Matisse: The Maurice Wertheim Collection*, preface by Barbara Wertheim Tuchman and Anne Wertheim Werner (New York: Abrams, 1988). Petropoulos, *Art as Politics*, 81–82.

10. Jonathan Petropoulos, *The Faustian Bargain: The Art World in Nazi Germany* (New York: Oxford University Press, 2000), 71–72.

11. Paul Baxa, *Roads and Ruins: The Symbolic Landscape of Fascist Rome* (Toronto: University of Toronto Press, 2010).

12. Frederic Spotts, *Hitler and the Power of Aesthetics* (London: Hutchinson, 2002), 113.

## STUDIO SANARY

1. Letter to Annette Kolb, September 14, 1936, cited in Ulrike Erhard, "Literarisches Exil in Sanary-sur-Mer in den dreissiger und vierziger Jahren," in Gerd Koch, ed., *Literarisches Leben, Exil und Nationalsozialismus: Berlin—Antwerpen—Sanary-sur-Mer—Lippoldsberg* (Frankfurt: Brandes & Apsel, 1996), 75.

2. Ludwig Marcuse, *Mein zwanzigstes Jahrhundert: Auf dem Weg zu einer Autobiographie* (Frankfurt: Fischer, 1968), 155.

3. Anatole Ducros to Meier-Graefe, May 22, 1930, Nachlass Meier-Graefe, 94.190.131, DLA.

4. Aldous Huxley, *Along the Road: Notes and Essays of a Tourist* (London: Chatto and Windus, 1925), 197–98; and letter to Naomi Mitchison, in Sybille Bedford, *Aldous Huxley: A Biography* (New York: Knopf, 1974), 274.

5. Bedford, *Aldous Huxley*, 276–77.

6. Ibid., 258. Annemarie Meier-Graefe's mother had sent her at age sixteen to secretarial school.

7. Marcuse has a lengthy section on Meier-Graefe in *Mein zwanzigstes Jahrhundert*, 157–59.

8. Monika Mann, *Vergangenes und Gegenwärtiges: Lebenserinnerungen* (1986), 89, quoted in Manfred Flügge, *Wider Willen im Paradies: Deutsche Schriftstellar im Exil in Sanary-sur-Mer* (Berlin: Aufbau, 1996), 77.

9. Diary entry, September 23, 1933, Tagebuch 3, Teil 1, Nachlass Meier-Graefe, DLA.

10. Marcuse, *Mein zwanzigstes Jahrhundert*, 154.

11. Durieux, *Meine ersten neunzig Jahre*, 338.

12. Tagebuch 3, Teil 1, Nachlass Meier-Graefe, DLA.

13. See the outstanding edition, by Paul Michael Lützeler, of letters: *Der Tod im Exil: Hermann Broch Annemarie Meier-Graefe Briefwechsel 1950/51* (Frankfurt: Suhrkamp, 2001).

14. "Falschkunst," *Das Kunstblatt* 16 (1932): 94; L.B., "Köpenickiade der Kunst," *B. Z. am Mittag* (Berlin), December 7, 1932.

CRIME SCENE

1. Spender, *Temple*, 26, 31.

2. Bailey, *Van Gogh and Britain*, 32, 110.

3. Easton, *Red Count*, 328–39.

4. Alice Goldfarb Marquis, *Alfred H. Barr Jr.: Missionary for the Modern* (Chicago: Contemporary Books, 1989), 139.

5. John Golding, *Visions of the Modern* (Berkeley: University of California Press, 1994), 7.

6. Steve Spence, "Van Gogh in Alabama, 1936," *Representations* 75 (Summer 2001): 35–36. Goldfarb Marquis, *Alfred H. Barr Jr.*, 132–33; Saltzman, *Gachet*, 234; Piet de Jonge, *Helene Kröller-Müller*, 129.

7. Saltzman, *Gachet*, 235.

8. Ibid.

9. Goldfarb Marquis, *Alfred H. Barr Jr.*, 134.

10. The Irving Stone Collection is housed in the Bancroft Library at Berkeley. Randal Brandt, "Irving Stone's Lust for Learning," *Bancroftiana: Newsletter of the Friends of the Bancroft Library* 123 (Fall 2003).

11. O'Brian, *Degas to Matisse*, 29.

12. The other two were *First Steps (After Millet)* (F 668) and one of the three portraits Van Gogh produced of Adeline Ravoux: Kai Bird and Martin J. Sherman, *American Prometheus: The Triumph and Tragedy of J. Robert Oppenheimer* (New York: Knopf, 2005).

13. On Clark, see Nicholas Fox Weber, *The Clarks of Cooperstown: Their Singer Sewing Machine Fortune, Their Great and Influential Art Collections, Their Forty-Year Feud* (New York: Knopf, 2007).

14. Erich Maria Remarque, *Arch of Triumph*, trans. Walter Sorell and Denver Lindley (New York: D. Appleton-Century, 1945), 350–52.

15. Edward Buckman to Douglas Cooper, November 20, 1937, in the Douglas Cooper Papers, Box 11, File 2, Getty Research Institute, Los Angeles. Edward Buckman, "Cobalt and the Artists," *Gold Magazine*, April 1934; and "With Canadian Pioneers," *Magazine of Art* 30, no. 9 (September 1937): 568–71, 586, 588. Yvonne McKague Housser's painting *Cobalt 1931* gives an impression of the ramshackle nature of the town: in Charles C. Hill, *Canadian Painting in the Thirties* (Ottawa: National Gallery of Canada, 1975), 37.

16. Virginia Woolf, *Roger Fry: A Biography* (Toronto: Macmillan, 1940), 159.

17. D.J. Taylor, *Bright Young People: The Rise and Fall of a Generation, 1918–1940* (London: Chatto and Windus, 2007).

MENDER

1. Douglas Cooper, "Van Gogh Exhibition: Musée de l'Orangerie, Paris," *Burlington Magazine* 89, no. 529 (April 1947): 104–105.
2. March 4, 1948, Douglas Cooper Correspondence, Box 2, File 71, Getty Research Institute, Los Angeles. Also Frances Fowle, "Van Gogh in Scotland," in Martin Bailey, *Van Gogh and Britain*, 37. The Glasgow show set an attendance record for the gallery that would not be outdone for the rest of the century.
3. *The Metropolitan Museum of Art Bulletin*, New Series, 9, no. 1, Incorporating the Eightieth Annual Report of the Trustees for the Year 1949 (Summer 1950): 26.
4. *Work by Vincent van Gogh: Catalogue of a Loan Exhibition at The Cleveland Museum of Art*, November 2 through December 12, 1948 (Cleveland: The Cleveland Museum of Art, 1948), 11–13.
5. Saltzman, *Gachet*, 233.
6. In the last volume of *Horizon*, a journal he edited with Stephen Spender. Also, Roger Kimball, "Closing Time? Jacques Barzun on Western culture," *New Criterion*, June 18, 2000.
7. Kaprow's manuscript "'The Plain of La Crau' by Vincent van Gogh" (1958), Allan Kaprow Papers, ID no. 980063, Box 46, File 10, Special Collections, Getty Research Institute, Los Angeles.
8. "The Principles of Modern Art," 1959, in ibid., File 11.
9. Saltzman, *Gachet*, 236, 241.
10. Clement Greenberg, *Clement Greenberg: The Collected Essays and Criticism*, ed. John O'Brian (Chicago: University of Chicago Press, 1993), I: 160; in Saltzman, *Gachet*, 237–38.

SCHEHEREZADE

1. The *Tägliche Rundschau* report is reprinted as "Ein 'Theater des Tanzes': Neue Kunstform im neuen Deutschland," *Freiheit Halle*, December 1945, from the clipping files of the Tanzarchiv Leipzig, in the Koldehoff dossier, Van Gogh Museum.
2. The program is in the Olinto Lovaël file in the Deutsches Tanzarchiv, Cologne.
3. "Das Theater des Tanzes in Eisenach," an undated review from August 1946, in the Tanzarchiv Leipzig, copy in Koldehoff dossier, Van Gogh Museum.
4. El., "'Solistentänze,'" *Thüringische Volkszeitung* (Erfurt), April 22, 1947.
5. Stipulations regarding membership in the union, p. 15 of the *Mitgliedsbuch*, Gewerkschaft Kunst DY 43/95, SAPMO-Bundesarchiv Berlin-Lichterfelde.
6. On the transition from one authoritarian regime to the next, see Alan McDougall, "A Duty to Forget? The 'Hitler Youth Generation' and the Transition

from Nazism to Communism in Postwar East Germany, c. 1945–49," *German History* 26, no. 1 (January 2008): 24–46.

7. "Problemspiegel zur Tagung des Zentralvortandes der Gewerkschaft Kunst über Probleme des künstlerischen Nachwuchses," November 11, 1965, Gewerkschaft Kunst DY 43/792, SAPMO-Bundesarchiv Berlin-Lichterfelde.

8. Olinto Lovaël, "'Wetterleuchten,' Tanztrilogie," *Theater der Zeit* 6, no. 5 (1950): 37; Olinto Lovaël and Wilhelm Böttner, "Neue Wege im Bühnenbau," *Theater der Zeit* 6, no. 9 (1950): Olinto Lovaël and Joachim Verch, *Gesellschaftstanz*, issues 1–8 (Berlin: Verlag Junge Welt, 1954–55); the same, "Die beiden Walzer," *Heim und Bühne* 1, no. 1 (1956): 62–66; the same, "Tänze aus Kuba," *Heim und Bühne* 1, no. 2 (1956): 91–97; the same, "Foxtrot und Boogie-Woogie richtig getanzt," *Heim und Bühne* 1, no. 3 (1956): 88–93. The pamphlet was co-authored with Joachim Verch, *Gesellschaftstanz* (Berlin: Verlag Neues Leben, 1955).

9. The FDGB Gewerkschaft Kunst, Gemeinschafts-Orchester of Naumburg launched a protest, January 24, 1952, signed by Mathes, and sent to the local Naumburg, Sachsen-Anhalt, and Berlin Gewerkschaft authorities. Gewerkschaft Kunst DY 43, no. 95, SAPMO-Bundesarchiv Berlin-Lichterfelde. Also Ute G. Poiger, *Jazz, Rock, and Rebels: Cold War Politics and American Culture in a Divided Germany* (Berkeley: University of California Press, 2000), 58–59 and passim.

10. A copy of the second letter, dated October 11, 1966, is in the Koldehoff dossier in the Van Gogh Museum.

WALL

1. See the interview with Bacon, "Reality Conveyed by a Lie," in Michael Peppiatt, *Francis Bacon: Studies for a Portrait* (New Haven: Yale University Press, 2008), 142–49.

2. Andrea Lauterwein, *Anselm Kiefer / Paul Celan: Myth, Mourning and Memory*, trans. David H. Wilson (London: Thames and Hudson, 2007), 146.

3. In his 1967 poem "At Brancusi's, the Two of Us": Lauterwein, *Anselm Kiefer / Paul Celan*, 102, 146, and passim.

4. Michael Nungesser, "Der einstige Junge Wilde vor roten Rosen," *Berliner Zeitung*, May 28, 1999, F20; essays by Lothar Romain, Donald Kuspit, and Demosthenes Davvetas in Rainer Fetting, *Selbst / Self Portraits* (Berlin: Nicolai, 1999); interview with Karl Pfefferle in Rainer Fetting, *Los Angeles Surfscapes* (Bielefeld: Kerber, 2004); and Daniel Spanke, ed., *Rainer Fetting trifft Lovis Corinth—Wilde Malerei über die Zeit* (Bielefeld: Kerber, 2005).

5. Interview with Daniel Spanke, in *Rainer Fetting trifft Lovis Corinth*, 81.

6. Wolfgang Schneider, ed., *Leipziger Demontagebuch* (Leipzig: Kiepenhauer, 1990); Wolf Lepenies, *The Seduction of Culture in German History* (Princeton: Princeton University Press, 2006), chapter 9.

OUR WEIMAR

1. Jon Savage, *England's Dreaming: Sex Pistols and Punk Rock* (London: Faber and Faber, 1991), 184–85. On Bob Dylan's debt to Brecht, see Alex Ross, *The Rest Is Noise: Listening to the Twentieth Century* (New York: Farrar, Straus and Giroux, 2007), 193–94.

MANIA

1. In the top-ten rankings produced by OverstockArt.com in 2006, Van Gogh's *Starry Night* and *Café Terrace at Night* held positions one and two, while *Irises* and *Sunflowers* occupied positions eight and nine. No other artist had more than one picture in the top-ten list.

2. Bailey, *Van Gogh and Britain*, 34.

3. Stefan Koldehoff has documented a number of these cases: "When Myth Seems Stronger Than Scholarship: Van Gogh and the Problem of Authenticity," *Van Gogh Museum Journal 2002* (Amsterdam: Van Gogh Museum, 2002): 9–25.

4. Martin Bailey, "Forty-five van Gogh Fakes?" *The Art Newspaper* 8, no. 72 (1997): 1; also the works of Benoit Landais, especially *La Folie Gachet: Des Van Gogh d'outre-tombe* (Brussels: Les Impressions Nouvelles, 2009).

5. Nathalie Heinich, *La Gloire de Van Gogh: Essai d'anthropologie de l'admiration* (Paris: Éditions de Minuit, 1991), 169ff.

EPILOGUE

1. Margot Cohen, "The Collector: Butet Kartaredjasa," *Wall Street Journal* (New York), June 19, 2009.

## ACKNOWLEDGEMENTS
*Farmhouse in Provence*

*I should make formal acknowledgement to the authors*
*whom I have pillaged . . . if I could recollect them all.*

GEORGE BERNARD SHAW

in his introduction to *Man and Superman*, 1903

Those who read this work or some of my earlier efforts will see that I shy from traditional category. Consequently, if forced to identify myself in academic nomenclature, I say with hesitation that I am a cultural historian. What that means exactly I am not sure except that it is probably the loosest (and, tellingly, the most common) of the designations currently available to the historical guild. What I most definitely am not is an art historian in any normal sense. Van Gogh scholarship is, as this book details, a domain dotted with danger, and had I known at the outset what I know now, I am not sure I would have had the courage to venture forth. Still, my debt to those who have laboured in these fields before me, risking life and limb, will be obvious. I bow to a host of scholars but especially to Stefan Koldehoff, without whose legwork and generosity of spirit this project would have proved much more difficult.

I am also deeply indebted to the many archivists and administrators who helped along the way: Monique Hageman, Fieke Pabst, and Patricia Schuil at the Van Gogh Museum in Amsterdam; Lidy Visser, Anna Stoutjesdyk, and Hans Wijgergangs at the Rijksbureau voor Kunsthistorische Documentatie in The Hague; Barbara Götze at the Zentralarchiv Staatliche Museen, and Anke Matelowski, Stiftung Archiv der Akademie der Künste, in Berlin;

Wolfgang Knoblauch, Berlin-Brandenburgische Akademie der Wissenschaften; Simone Langner, Bundesarchiv Berlin-Lichterfelde; Bianca Welzing-Bräutigam, Landesarchiv Berlin; Elisabeth Scheeben, Stadtarchiv Düsseldorf; Klaus Sator, Deutsches Tanzarchiv Cologne; Rainer Laabs, Axel Springer Verlag, Berlin; Tracey Schuster, Getty Research Institute, Los Angeles; and a host of archivists at that remarkable repository that is the Deutsche Literaturarchiv in Marbach. To the initiative and dedication of David Brooks in Toronto, we all bow for making much of the Van Gogh material available online.

Lora Carney read an earlier version of the text and offered astute advice. Rosemary Shipton, my editor, worked with extraordinary patience and grace to correct errors and clarify my prose, as did my copy editor, Alison Reid, who, moreover, saved me from some egregious slips. At Knopf Canada, Louise Dennys accepted this book; the ever diligent and dependable Zoë Maslow kept me on schedule and always cheered me up; and Scott Richardson delighted with his creativity. So did my editors, especially Kathleen McDermott, at Harvard University Press. For other forms of assistance and inspiration I thank Knut Ahnert, John Bassili, Boris Castel, Barney Gilmore, Roger Griffin, Robin Lenman, Amanda Lewis, Vernon Lidtke, John Mayo, Deirdre Molina, Sten Nadolny, Dennis Reid, Rob Riemen, John Simpson, Binnaz Toprak, Vincent Tovell, Henk Tromp, and Bogomila Welsh-Ovcharov. My excellent students Jeff Bowersox and Todd Craver provided essential research assistance, and Todd's project on Siegfried Kracauer inspired us both. My colleagues Kwon-loi Shun, John Coleman, William Bowen, Monica Hretsina, and Elizabeth Seres gave necessary encouragement, material and practical. The Social Sciences and Humanities Research Council of Canada generously supported the project, as did the Principal's Research Fund at

my former academic home, the Scarborough campus of the University of Toronto.

Some of the ideas here have been presented in earlier form in lectures and essays. I acknowledge with particular pleasure the invitations of St. Jerome's University to offer the Laurence A. Cummings Lecture in Cultural History, of Boğaziçi University in Istanbul to help celebrate its 140th anniversary, and of the editors of *Queen's Quarterly* and *Descant* to contribute to their pages.

My wife, Jayne, sister Mudite, and agent Beverley Slopen have, as always, been unstinting with their patience and support. With one of my sons, Roland, I had particularly rewarding conversation about the issues broached here.

This project germinated many years ago in Provence. The remarkable year our family spent in the heart of "Van Gogh country" at the Mas Saint-Jérôme near Arles resulted from a felicitous exchange with the late James Joll and the gracious hospitality of Stephen and Natasha Spender. In the last year of the millennium we learned that the Mas Saint-Jérôme, where once we had spent a fairy-tale year, had burned, in a fire fanned by the mistral. What was left was a charred ruin adjacent to a rose garden.

*Toronto and Kipawa*
*September 2011*

# PHOTO CREDITS

Grateful acknowledgement is expressed to the following people and sources for permission to reprint these images. In the event of an inadvertent omission or error regarding copyright, please notify the publisher.

Page vi (top) © Rainer Fetting/SODRAC (2011); bpk, Berlin/Hamburger Bahnhof-Museum für Gegenwart, Nationalgalerie, Staatliche Museen, Berlin/Jochen Littkemann/Art Resource, NY; (bottom) © kangotraveler

# INDEX

Note to users: All index references to named paintings will be found listed together under the heading of "paintings." Works by painters other than Vincent van Gogh or his imitators are followed by the painter's name in parentheses. (Individual painters are also referenced alphabetically throughout this index.) Paintings identified by De la Faille catalogue numbers are followed by corresponding F-numbers in parentheses. For each painting believed to be a forgery first sold by Otto Wacker, the F-number is followed by the designation "O.W."

MODRIS EKSTEINS is professor emeritus of history at the University of Toronto. His bestselling, acclaimed *Rites of Spring* was published in nine countries, won the Wallace K. Ferguson Prize and the Trillium Book Award, and was named one of the Best Books of the Year by the *Globe and Mail* and the *New York Times*. *Walking Since Daybreak* was also a national bestseller, winner of the Pearson Writers' Trust Non-Fiction Prize, and was named one of the Best Books of 2000 by the *Times Literary Supplement*, the *Los Angeles Times*, and the *Globe and Mail*.

The body of *Solar Dance* has been set in a digitized form of Caslon, a typeface based on the original 1734 designs of William Caslon. Caslon is generally regarded as the first British type-founder of consequence.

The display heads are set in Futura, designed in 1927 by Paul Renner. Renner, born in Prussia in 1878, disliked many forms of modern culture, including abstract art, jazz, and cinema, yet he admired the functionalist motifs of modernism. More than a graphic designer, he made a significant contribution to modern typography through his teaching and writing. Two of his major texts are *Typografie als Kunst* (*Typography as Art*) and *Die Kunst der Typographie* (*The Art of Typography*). Both books established a modern set of guidelines for proper book design.

Renner made his opposition to the Nazis very clear, notably in his book *Kultur-bolschewismus?* (*Cultural Bolshevism?*). After the Nazis seized power in 1933, he was arrested and dismissed from his teaching post in Munich, and went into a period of internal exile. He died in Hödingen, Germany in 1956.